100 Works of Art That Will Define Our Age

100 WORKS OF ART THAT WILL DEFINE OUR AGE

KELLY GROVIER

Thames & Hudson

Kelly Grovier is a writer and art critic. His articles have appeared in *The Observer* and the *Times Literary Supplement*, to which he frequently contributes. He is the author of three books and numerous essays for exhibition catalogues, and is the co-founder of the journal *European Romantic Review*, devoted to the interdisciplinary study of nineteenth-century art and literature.

Cover image: Matthew Barney, production still from **Cremaster 4**, 1994. Courtesy Gladstone Gallery, New York/Brussels. Photo Michael James O'Brien. © 1994 Matthew Barney

First published in the United Kingdom in 2013 by Thames & Hudson Ltd, 181A High Holborn, London WC1V 7QX

Reprinted 2014

100 Works of Art That Will Define Our Age © 2013 Thames & Hudson Ltd, London
Text © 2013 Kelly Grovier

Designed by Matilda Saxow

British Library Cataloguing-in-Publication Data
A catalogue record for this book is available from the British Library

ISBN 978-0-500-23907-0

Printed and bound in Singapore by Tien Wah Press (Pte) Ltd

To find out about all our publications, please visit **www.thamesandhudson.com**. There you can subscribe to our e-newsletter, browse or download our current catalogue, and buy any titles that are in print.

Contents

Introduction: Art of the Now 008–015

100 Works

001 **The Artist is Present** (2010) MARINA ABRAMOVIĆ 018–019

002 **Sunflower Seeds** (2010) AI WEIWEI 020–023

003 **The Source** (2012) DOUG AITKEN 024–025

004 **The Blacker Gachet** (2005-6) MARK ALEXANDER 026–027

005 **Fabiola** (1994-) FRANCIS ALŸS 028–031

006 **Gnaw** (1992) JANINE ANTONI 032–035

007 **How It Is** (2009) MIROSLAW BALKA 036–039

008 **Flower Thrower** (2007) BANKSY 040–041

009 **Cremaster 4** (1994) MATTHEW BARNEY 042–045

010 **Personnes** (2010) CHRISTIAN BOLTANSKI 046–047

011 **Don't Miss a Sec** (2003) MONICA BONVICINI 052–055

012 **Maman** (1999) LOUISE BOURGEOIS 056–057

013 **Sex** (2003) GLENN BROWN 058–059

014 **What My Dad Gave Me** (2008) CHRIS BURDEN 060–061

015 **De l'azur au Temple du Ciel** (2004) DANIEL BUREN 062–063

016 **Take Care of Yourself** (2007) SOPHIE CALLE 064–065

017 **Yes Rasta** (2000) PATRICK CARIOU 070–071

018 **L.O.V.E.** (2010) MAURIZIO CATTELAN 072–073

019 **Hell** (1999-2000) JAKE AND DINOS CHAPMAN 074–077

020 **The Gates** (1979-2005) CHRISTO AND JEANNE-CLAUDE 078–081

021 **Self-Portrait** (1997) CHUCK CLOSE 082–083

022 **Work No. 227, the lights going on and off** (2000) MARTIN CREED 084–085

023 **The Pink Tree** (1999) JOHN CURRIN 086–087

024 **Folk Archive** (2000-7) JEREMY DELLER AND ALAN KANE 088–091

025 **Blotter** (1993) PETER DOIG 092–093

026 **Win, Place or Show** (1998) STAN DOUGLAS 094–095

027 **Against the Wall** (2009) MARLENE DUMAS 096–099

028 **The Weather Project** (2003) OLAFUR ELIASSON 100–101

029 **Prada Marfa** (2005) ELMGREEN & DRAGSET 102–103

030 **My Bed** (1998) TRACEY EMIN 104–105

031 **Benefits Supervisor Sleeping** (1995) LUCIAN FREUD 106–107

032 **Misty and Jimmy Paulette in a taxi, NYC** (1991) NAN GOLDIN 108–109

033 'Untitled' (Golden) (1995) FELIX GONZALEZ-TORRES — 110–113

034 Angel of the North (1998) ANTONY GORMLEY — 114–115

035 Darkroom (2006) SHEELA GOWDA — 120–121

036 Line of Control (2008) SUBODH GUPTA — 122–123

037 Chicago, Board of Trade II (1999) ANDREAS GURSKY — 124–125

038 Myra (1995) MARCUS HARVEY — 126–127

039 Light Sentence (1992) MONA HATOUM — 128–129

040 Witness (2000) SUSAN HILLER — 130–133

041 Cavemanman (2002) THOMAS HIRSCHHORN — 138–141

042 For the Love of God (2007) DAMIEN HIRST — 142–143

043 Bigger Trees Near Warter or/ou Peinture sur le Motif pour le Nouvel Age Post-Photographique (2007) DAVID HOCKNEY — 144–145

044 Test Site (2006) CARSTEN HÖLLER — 146–149

045 Projections (1996-) JENNY HOLZER — 150–153

046 Untitled (Passage II) (2002) CRISTINA IGLESIAS — 154–155

047 Cloud Gate (2004) ANISH KAPOOR — 156–157

048 One Million Years (1969-) ON KAWARA — 158–159

049 Day Is Done (2005) MIKE KELLEY — 160–163

050 Stereoscope (1998-99) WILLIAM KENTRIDGE — 164–165

051 Die berühmten Orden der Nacht (1997) ANSELM KIEFER — 166–167

052 METRO-Net World Connection (1993-97) MARTIN KIPPENBERGER — 168–171

053 Puppy (1992) JEFF KOONS — 172–173

054 Untitled (Your body is a battleground) (1989) BARBARA KRUGER — 174–175

055 Au Naturel (1994) SARAH LUCAS — 176–177

056 Blockhead (2003) PAUL MCCARTHY — 178–179

057 Deadpan (1997) STEVE MCQUEEN — 180–181

058 The Clock (2010) CHRISTIAN MARCLAY — 182–183

059 Casino (2005) ANNETTE MESSAGER — 188–191

060 Departures (2009) POLLY MORGAN — 192–193

061 Dead Dad (1996-97) RON MUECK — 194–195

062 Kaikai Kiki (2000-) TAKASHI MURAKAMI — 196–197

063 Backlash Blues (2004) WANGECHI MUTU — 198–199

064 For Beginners (all the combinations of the thumb and fingers) (2010) BRUCE NAUMAN — 200–201

065 The Coral Reef (2000) MIKE NELSON — 206–209

066 Rebellious Silence (1994) SHIRIN NESHAT — 210–211

067 Leviathan Thot (2006) ERNESTO NETO — 212–215

068 The Holy Virgin Mary (1996) CHRIS OFILI — 216–217

069 Black Kites (1997) GABRIEL OROZCO — 218–219

070 Breathless (2001) CORNELIA PARKER — 220–221

071 The Vanity of Small Differences (2012) GRAYSON PERRY — 222–225

072 Self (1991–) MARC QUINN — 226–227

073 The Atlas Group Archive (1999–) WALID RAAD — 228–231

074 Vater (2007) NEO RAUCH — 232–233

075 Dog Woman (1994) PAULA REGO — 234–235

076 Cage (2006) GERHARD RICHTER — 236–237

077 Open My Glade (Flatten) (2000) PIPILOTTI RIST — 238–241

078 Untitled (2003) DORIS SALCEDO — 242–243

079 Propped (1992) JENNY SAVILLE — 244–245

080 The Beauty of Death (unmade) GREGOR SCHNEIDER — 246–247

081 Doric (2008–) SEAN SCULLY — 248–249

082 Blind Spot (2002–3) RICHARD SERRA — 250–251

083 The Garden of Earthly Delights (2003) RAQIB SHAW — 256–259

084 Clowns (2003–4) CINDY SHERMAN — 260–261

085 245 m3 (2006) SANTIAGO SIERRA — 262–263

086 Home Within Home (2008–) DO HO SUH — 264–267

087 Freischwimmer (2003–) WOLFGANG TILLMANS — 268–269

088 Apartment (2002–) RIRKRIT TIRAVANIJA — 274–275

089 Pop (1993) GAVIN TURK — 276–277

090 Easter (2006) LUC TUYMANS — 278–279

091 The Rose (2008) CY TWOMBLY — 280–283

092 The Greeting (1995) BILL VIOLA — 284–285

093 Gone, An Historical Romance of a Civil War as it Occurred between the Dusky Thighs of One Young Negress and Her Heart (1994) KARA WALKER — 286–287

094 After 'Invisible Man' by Ralph Ellison, the Prologue (1999–2000) JEFF WALL — 288–289

095 State Britain (2007) MARK WALLINGER — 290–293

096 Signs that say what you want them to say and not Signs that say what someone else wants you to say (1992–93) GILLIAN WEARING — 294–297

097 The Nameless Library (2000) RACHEL WHITEREAD — 298–299

098 Seven Intellectuals in a Bamboo Forest (2003–7) YANG FUDONG — 300–303

099 Bloodlines: Big Family (1993–) ZHANG XIAOGANG — 304–305

100 Democracies (2009) ARTUR ŻMIJEWSKI — 306–307

Artist Biographies & Selected Sources — 308–313

List of Illustrations — 314–317

Acknowledgments — 317

Index — 318–320

Introduction

ART
OF THE
NOW

On 19 September 1889, Vincent Van Gogh wrote a letter to his brother Theo in which he reflected on a group of some nine paintings he had recently completed. 'In all this batch', Van Gogh wrote, 'I think nothing at all good save the field of wheat, the mountain, the orchard, the olives with the blue hills and the portrait and the entrance to the quarry.' 'The rest', he confessed, 'says nothing to me, because it lacks individual intention and feeling in the lines.' Among the works that the painter was convinced were failures was a swirling study of the evening sky that would come to be known as *The Starry Night*.

It is difficult now from our contemporary vantage to concur with a judgment that could dismiss such an emotionally intense visual statement as lacking 'individual intention', let alone 'feeling in the lines'. For many critics and casual admirers alike, *The Starry Night* is the work that captures most stirringly not only Van Gogh's volatile imagination but also the creative volatility of his age. Addled by depression, the artist was incapable of comprehending the scale of his achievement. Nor was this a momentary lapse of aesthetic judgment or passing flash of artistic modesty. Two months after writing to Theo, he was still berating his work in a letter to the painter Émile Bernard, haranguing himself for 'be[ing] led astray into reaching for stars that are too big – another failure – and I have had my fill of that.'

Every age is defined by the art it inspires. It is as impossible to think of the aspirations of the High Renaissance and not conjure the contrapuntal pose of Michelangelo's *David* (1501–4), as it is to reflect on the atrocities of the Spanish Civil War without calling to mind the brutal distortions of Picasso's *Guernica* (1937) – or to muse on the tempestuous temperament of the late nineteenth century without summoning the turbulence of *The Starry Night*. For in every era, an elite group of works succeeds in transcending the tethers of history, the ephemeral intrigues of politics and the intimate entanglements of the artist's personal life, while at the same time capturing the essence of the generation that generated it. It is that elusive ability to look forwards and backwards in time that arguably defines 'masterpiece'.

So what of our own era? What are the works of art whose voices will still be discernible over the clamour of cultural expression years, decades and even centuries from now? Drawing attention to the vision, skill and passion of a wide range of artists from every corner of the world, the present book dares to nominate one hundred works of contemporary art – whether paintings, sculptures, photographs, drawings, tapestries, installations, performances, multimedia pieces or video – that have earned the nod of history and have the creative propulsion to endure.

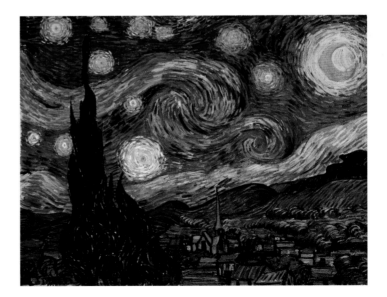

Vincent Van Gogh, **The Starry Night**, 1889

If undertaken even fifty years ago, a volume with similar ambitions would have found itself negotiating a morass of emerging and declining movements. The challenge then would have been to select the most telling exemplars of distinct schools, from Abstract Expressionism to Minimalism, Op Art to Pop Art. Though a number of new schools have gained prominence in the past twenty-five years, designations such as Internet Art or Virtual Art tend to indicate a preference for one medium over another rather than demonstrate allegiance to any agreed principles. Equally, none utterly supersedes another in the way we often oversimplify the domino of movements in the unfolding of art history: Mannerism toppling into Baroque, Romanticism into Realism, Expressionism into Abstract Expressionism... This apparent lawlessness of aesthetic purpose led one critic, the venerable intellectual Arthur Danto, to declare in the mid-1980s that we were in fact approaching 'the end of art' – by which he meant not the end of remarkable artistic expression or the creation of great works, but the end of dominance by any one school, geographic centre or ideology. Successive eras of 'imitation' and 'ideology' had finally given way, he wrote, to a 'post-historical' age – a beginning after the end – a free-for-all of substance and style in which 'anything goes'. The art of the now constituted 'the final moment in the master narrative...

the end of the story'. Political philosopher Francis Fukuyama corroborated Danto's conclusion several years later with his own provocative assertion that mankind had reached 'the end of history' – that the acceleration of democracy around the globe, following the collapse of Soviet communism, marked the final chapter in the teleology of ideological struggle.

Whether or not these post-Hegelian prognostications will be proven right down the unlit corridors of the future is anyone's guess. It is, however, against these assessments that this book seeks to identify the artistic achievements that have managed so far to remain afloat amid the remarkable storms of our unsettled era: from the fall of the Berlin Wall and unrest in Tiananmen Square to the traumas of September 11, 2001, and the blossoming of the Arab Spring; from the surging markets of the 1990s to the economic calamities of the global financial crash in 2008 and the teetering of Europe's single currency in a climate of stringent austerity and alarming social turmoil. The individual works selected here have been chosen for their ability to resonate as metaphors of our time and for their durability in crystallizing reflections on where the story of art has thus far reached – and where it may lead from here.

The intention behind the discussions accompanying each work is to explore its wider possibilities, emotionally and

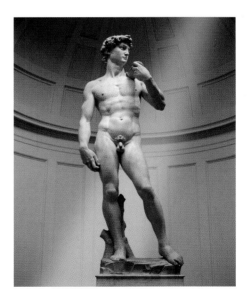

Michelangelo, **David**, 1501–4

poetically, rather than to offer a purely objective gloss on how the work in question was conceived and constructed or how it fits into the career or vision of the artist who created it. The aim is not merely to learn about the works but from them – to explore them for what they can reveal to us about ourselves, our age and the meaning of art today. Not every work is equally admired. In certain instances a piece may be found wanting on aesthetic or even moral grounds but is nevertheless recognized for its capacity to articulate something fundamental about the era and its artistic sensibilities. Taken together, these one hundred artworks expose an astonishing range of contemporary preoccupation. Those that may seem flippant or glib on their surface, such as Jeff Koons's enormous topiary sculpture, *Puppy* (1992), or Monica Bonvicini's mischievously mirrored public toilet, *Don't Miss a Sec* (2003), confess surprising allegiances to forgotten political pasts when closely interrogated.

Every work included here is discovered to have an unexpected secret life that informs its effect from well below its surface. For many of the pieces, this secret life expresses itself in dialogue with works from earlier eras. It is not, of course, unusual to discuss how a particular artist may have been influenced by an earlier imagination, or to demonstrate in what ways a given painting or sculpture echoes the works

that came before it. But this is a book about the power of individual creations to communicate with one another across time, not about the creative intentions of notable craftsmen. Identifying allusions to past masters can only take us so far in our appreciation of a work's enduring achievement. Our task is at once broader and bolder: to anticipate the resonance of a work forward in time, into the unknown of history's unfolding, while also looking backwards to an 'ideal order' of definitive works that have transcended the vicissitudes of the ages that provoked them. 'What happens when a new work of art is created,' T. S. Eliot wrote in 1919,

> is something that happens simultaneously to all the works of art which preceded it. The existing monuments form an ideal order among themselves, which is modified by the introduction of the new (the really new) work of art among them...the *whole* existing order must be, if ever so slightly, altered; and so the relations, proportions, values of each work of art toward the whole are readjusted...

The works that define an era are not, that is to say, merely those thought likely to influence the as yet inconceivable art of the future, but those that have the power to alter, 'if ever so slightly', works of the past – and, therefore, our

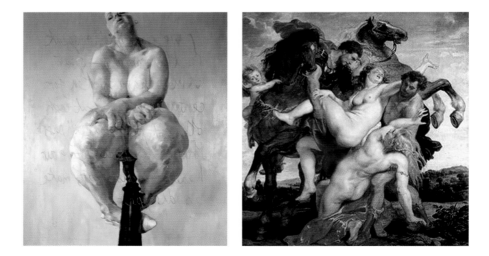

Right: Jenny Saville, **Propped**, 1992

Far right: Peter Paul Rubens, **The Rape of the Daughters of Leucippus**, 1617–18

understanding of them. 'What we call the beginning', Eliot later says in his poem 'Little Gidding' (1942), 'is often the end / And to make an end is to make a beginning. / The end is where we start from.' The end from which *we* make our start is forever shifting forward. As Rembrandt's dusky chiaroscuro of the seventeenth century altered cultural appreciation of da Vinci's spiritualizing sfumato of two centuries earlier, so Rothko's etherealizing veils of the twentieth century cast the visions of both Old Masters in a new light.

To measure this elastic relationship between works, take the following example from our selection. While commentators on the canvases of British portraitist Jenny Saville frequently emphasize her awareness of, and indebtedness to, the Baroque master Peter Paul Rubens, and in particular his choreography of the female form, influence is not a river that flows in only one direction. Saville's nude self-portrait *Propped* (1992) similarly induces nascent meaning in another work (though perhaps unexpectedly in a predecessor, not successor): the fifteenth-century Flemish artist Jan Van Eyck's *The Arnolfini Portrait* (1434). In Saville's canvas, Van Eyck's pioneering distortions of perspective, as experimented with in the convex shapes reflecting back from the bulbous mirror bolted to the back wall of his interior, have swelled, centuries later, into overwhelming prominence. In a ricochet

of mounting significance, the later work reflects tellingly back on the earlier one, complicating Van Eyck's vision. *Propped* introduces into the otherwise static art historical debate over the physical condition of the woman at the forefront of *The Arnolfini Portrait* – whether or not she is pregnant – layers of psychological anxiety about the shape of the female body and society's perception of it. Saville's canvas thus contemporizes Van Eyck's, synchronizing the two to an eternal present.

'Nor is it properly said,' Augustine explains in *Confessions*, outlining an understanding of time that accommodates the order proposed here, '"there be three times: past, present and to come"; yet perchance it might be properly said "there be three times: a present of things past, a present of things present, and a present of things to come."' Great art never finishes. It forever participates in the ceaseless becoming of human expression in ways that far exceed the creative intentions of the artist who made it. Van Eyck's work, one could say, ultimately relies on Saville's for its ever-evolving significance just as the first word of a sentence relies on the last.

Thus the grammar of art is cumulative, building syllable by syllable, work by work, and the sentence never ends. In the mystical space of Eliot's 'ideal order', like an endlessly erased and rewritten enunciation, the meanings of Van

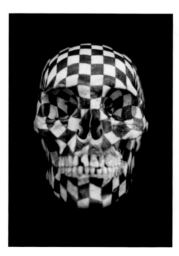 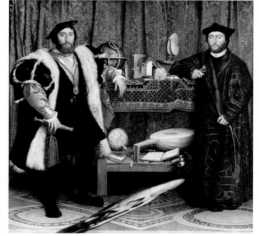

Right: Gabriel Orozco, **Black Kites**, 1997

Far right: Hans Holbein the Younger, **The Ambassadors**, 1533

Gogh's *The Starry Night* and *Portrait of Dr Gachet* (1890) are likewise modified, as we will see, by Anselm Kiefer's *Die berühmten Orden der Nacht* (The Renowned Orders of the Night, 1997) and Mark Alexander's *The Blacker Gachet* series (2005–6). No less compellingly, Gabriel Orozco's stencilled skull, *Black Kites* (1997), alters the significance of Hans Holbein the Younger's *The Ambassadors* (1533), while Grayson Perry's tapestry *#Lamentation* from *The Vanity of Small Differences* (2012) unweaves the values of Rogier van der Weyden's celebrated *The Lamentation of Christ* (c. 1460–64). In each case, the earlier work is transformed in the light of the new work, thereby revealing how great art defines its age most by providing greater, though never complete, definition to the entire sweep of cultural history. In the context of truly remarkable art ('the really new', as Eliot says), the most static of art is never static at all but respires with an intensity that invigorates the works that came before it *and* those that will come after it.

Nor is this synergy of old and new one that exists merely between works of visual art. In order to demonstrate the resonance of a given work in social imagination, frequent reference is made in the entries that follow not only to the vivid creative expressions of Old Masters, but also to salient works by philosophers, poets, novelists, eccentric travellers, forgotten inventors, film directors, composers and the coiners of words. Just as John Currin's double portrait *The Pink Tree* (1999) is shown to repaint Lucas Cranach the Elder's *Venus* (1532), Sean Scully's *Doric* series (2008–) re-sculpts the language of the third-century dualist Plotinus, and Ai Weiwei's *Sunflower Seeds* (2010) recomposes the granular complexities of the ancient conundrum the Sorites Paradox.

The secret lives of the works selected here articulate themselves through an astounding array of visual accents involving a range of media and technique without obvious parallel in the history of creative expression. While the traditional genres of painting, drawing, textile and sculpture continue to inspire innovative practitioners (notwithstanding the mournful cry one occasionally hears, lamenting that the first of these has yet again died a death) and are well represented in the ensuing pages of this volume, it is the sensational rise to at least equal prominence of installation, performance, environmental, urban, digital and video art that is especially thrilling to record.

Thrilling too is the sheer scale to which the contemporary artistic imagination has become accustomed to working. Nearly one third of the works featured here either exceeds the dimensions of a traditional gallery or consumes such spaces completely. Whatever else the art of the now is, it's big and

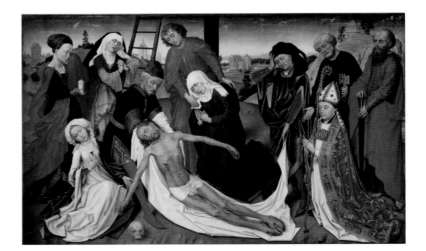

Rogier van der Weyden, **The Lamentation of Christ**, c. 1460–64

getting bigger. Unsurprisingly, few venues can adequately accommodate this growing gigantism of expression, while institutions that can, such as Tate Modern with its titanic Turbine Hall (over five storeys in height and 152 metres long) and the sprawling pavilions of the Venice Biennale, inevitably nominate themselves as chief incubators of overpowering installations. If there is something slightly disproportionate about the number of works included here that are connected with these venues, such disproportion mirrors the role these institutions have come to serve in showcasing physically oversized works. In several instances, pieces commissioned as contributions to Tate Modern's celebrated Unilever Series, which dominated the cubic acreage of the Turbine Hall for thirteen years between 2000 and 2012, dramatically rose to the occasion, both physically as well as critically. To have excluded Louise Bourgeois's *Maman* (1999), Olafur Eliasson's *The Weather Project* (2003) or Miroslaw Balka's *How It Is* (2009) in order to avoid including too many works associated with a single exhibition space would have been to introduce an arbitrary criterion of selection. These are works that define our age irrespective of where they once stood.

Collectively, the works represented reflect remarkable shifts both in the materials from which art is made (and in the scale to which art has grown), as well as in who is making it.

This book takes 1989 as its starting point – the end point of Robert Hughes's celebrated survey of modern art, *The Shock of the New: Art and the Century of Change*, published in 1991. That landmark overview featured some 269 illustrations of works, but only eight by female artists (or less than three per cent). In contrast, approximately one third of the present study is devoted to works created by women. The leap in proportion is neither a rebuke to Hughes's criteria nor an exercise in politically correct tokenism, but in accord with the true state of creative achievement today, despite the fact that such achievement is not always adequately reflected in the share of recognition, blockbuster shows or major awards.

That Van Gogh was unable to appreciate or predict the enduring awe that *The Starry Night* would arouse tells us more than how difficult it is to speculate about the probable survival in social consciousness of any given painting or sculpture, installation or film. His masterpiece is also a metaphor for the improbable resonance of any work of art, whose fragile wavelengths of emotional vibrancy jostle for regard amid the galactic output of innumerable nameless creators. Yet, this book begins with the conviction that some works burn brighter and exert a greater pull on the fabric of artistic expression that flows towards and stretches away from them.

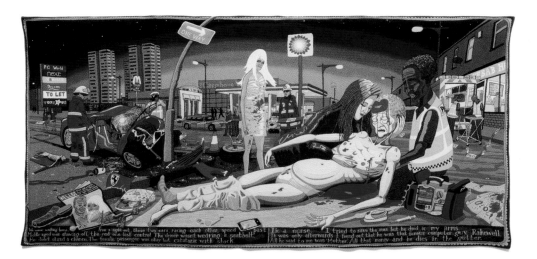

Grayson Perry, **#Lamentation**, from the series **The Vanity of Small Differences**, 2012

Just looking? Can a work of art ever succeed in stripping away everything apart from the visitor's undistracted stare? Such is the challenge Belgrade-born performance artist Marina Abramović set herself in her demanding 2010 work *The Artist is Present*. For two and a half months, from mid-March to the end of May, Abramović sat in the Museum of Modern Art, New York, as participants were invited to take turns looking into her eyes for as long as they wished, or could bear, to participate. For 736 and a half hours, the artist stared stony-faced as wave after wave of strangers met her inscrutable gaze across a low table. Portraits of volunteers – photographed and preserved by the museum – reveal the range of expressions provoked by Abramović's static countenance: amusement and fear, boredom and despair.

Before long, support groups for 'survivors' of the experience were being established on social-media websites, where sitters attested to the unexpected intensity of the work. It was as though centuries of cumulative staring inside museums had finally reached saturation point and an object had begun to vibrate back the penetrating glare. Whatever prejudices a sitter had held about the significance of Abramović's work, once seated there was no escaping the reality that he or she was confronting the actual eyes of another human being, vulnerable and inches away. Clichés

collapsed. *Eye for an eye. Seeing is believing. Windows of the soul.* In the mute dialogue of the seer seeing and the seer seen, divisions between artist, art and visitor suddenly dissolved. Here, there was nothing to purchase or reject. Everyone, even the work itself, was just looking.

The exhausting display reasserted Abramović's status as among the most indefatigable performance artists of her era. Since the 1970s, she has established a threshold of endurance that few peers have crossed. In her early work *Lips of Thomas* (1975), the artist challenged the default passivity typical of audiences by inflicting a sequence of disturbing abuses on her naked body seemingly triggered by their gaze – consuming unconscionable quantities of honey and wine, slicing the shape of a Soviet pentalpha into her own stomach with a sharp blade, violently flagellating her back with a whip – all the while daring onlookers to stop her. Few did.

Abramović's career has coincided with the acceleration of news media that breaks down distinctions between entertainment and the chronicling of suffering unfolding in real time, accentuating the sense in which her work is a metaphor for public complacency in the face of avoidable pain. Just looking? For forty years Abramović has challenged visitors to stare into the eyes of such detachment.

Opposite: Marina Abramović, **The Artist is Present**, 2010. Performance at the Museum of Modern Art, New York, duration 2.5 months

Right: Marina Abramović, re-performance of **Lips of Thomas** (1975) at the Guggenheim Museum, New York, 2005

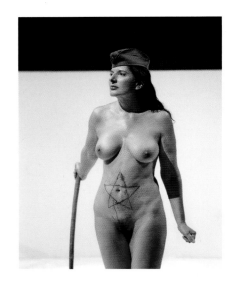

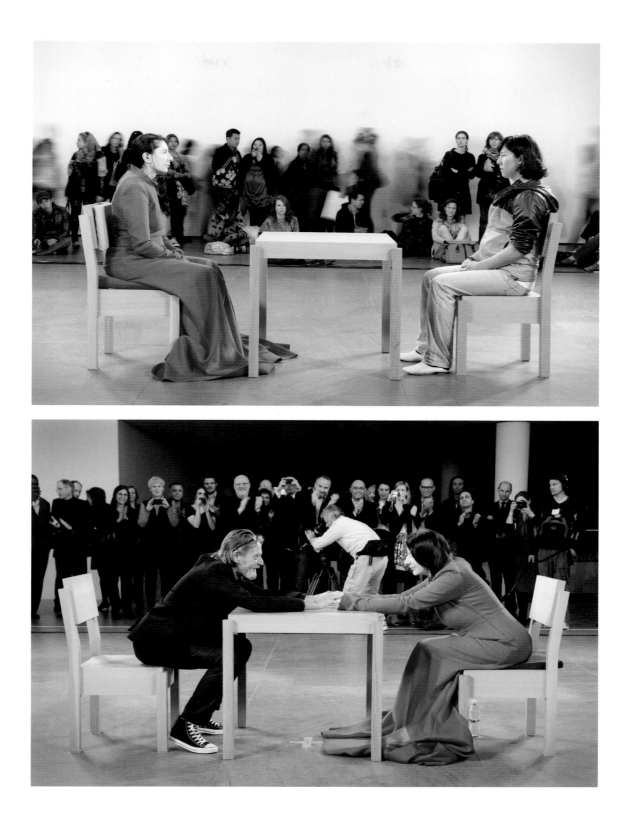

Where do you draw the line? No other work of art has posed that question, with all its ethical, spiritual and political implications, as profoundly as Chinese artist Ai Weiwei's sculpture *Sunflower Seeds*. In philosophy, an age-old conundrum known as the Sorites Paradox (or 'the problem of the heap') presents the puzzle that if a single stone or bean or grain of rice cannot be said to constitute a pile or heap (and if merely adding another and another does not make it so), where does one finally draw the line in declaring the sudden appearance of a heap? Where, in other words, does the identity of the individual cease and that of the group or collective begin? Ai Weiwei boldly recast this ancient riddle in the form of one hundred million individually crafted porcelain sunflower seeds – each one hand-sculpted and delicately painted into a convincingly dimpled, grey-and-white striated husk by one of 1,600 artisans in the Chinese city of Jingdezhen.

The brainchild of an outspoken critic of human rights abuses perpetrated by the Chinese government, *Sunflower Seeds* provokes political interpretation and debate. Is the work a comment on the anonymity of mass production or the dehumanizing consequences of commercial exploitation? Or both? Contrived to keep the struggling ceramic workers of Jingdezhen from financial ruin, the seeds sow themselves along the border between commodity and art. When the work was first unveiled in the yawning space that is Tate Modern's Turbine Hall in October 2010, the artist's vision of visitors engaging joyfully or meditatively with the installation – of children playfully scooping the sculpted seeds into mounds while adults watch them slide from their fists like so many days and years – was shattered when it was determined that the dust generated by the friction of porcelain on porcelain could pose serious respiratory risks. Soon barricades were erected, drawing an institutionally imposed line between the sculpture and the throngs of visitors that had made the pilgrimage to see it. Experienced from an enforced distance, the hush of small, smooth shapes blurred into a wide tarmac of indistinct gravelly oneness. The beauty and identity of each individual seed, which the artist had endeavoured to celebrate, retreated into intangible abstraction.

Opposite: Ai Weiwei, **Sunflower Seeds**, 2010. Installation at Tate Modern, London. Porcelain and paint, dimensions specific to site

Right: Ai Weiwei holds a handful of his 100 million sunflower seeds, 2010

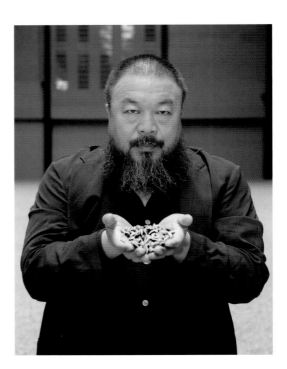

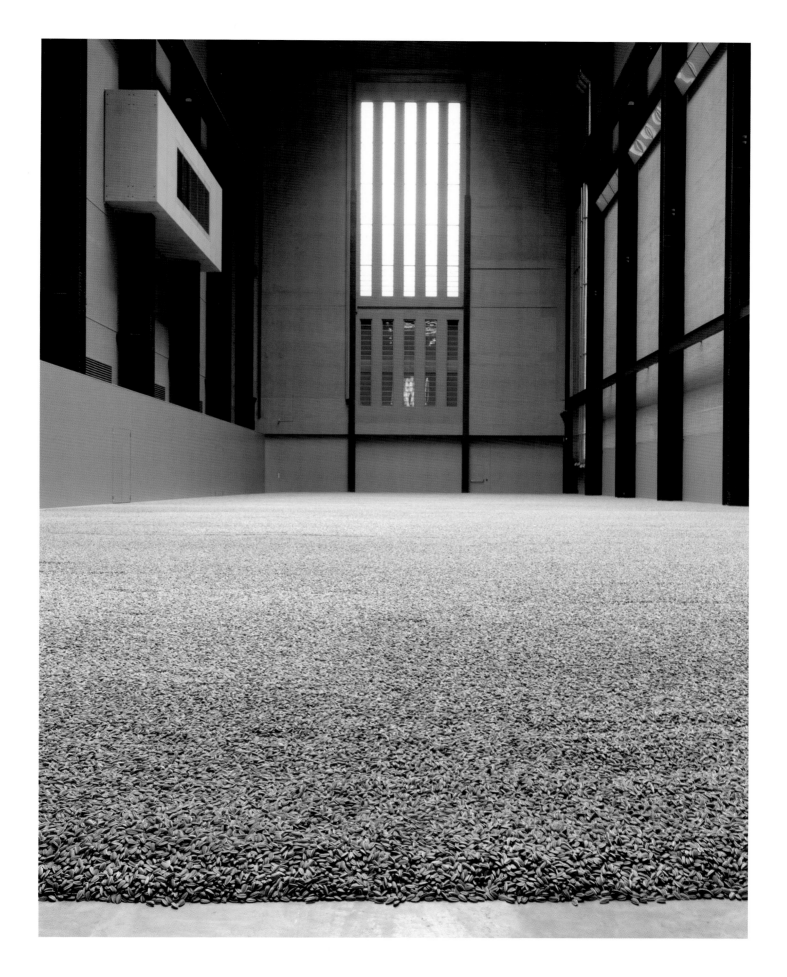

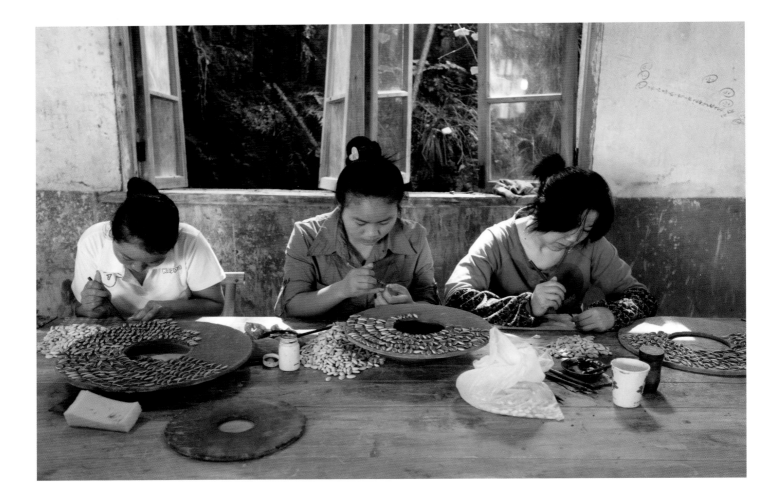

Above: Making sunflower seeds,
Jingdezhen, China, 2010

Opposite: Ai Weiwei, **Sunflower
Seeds** (detail), 2010

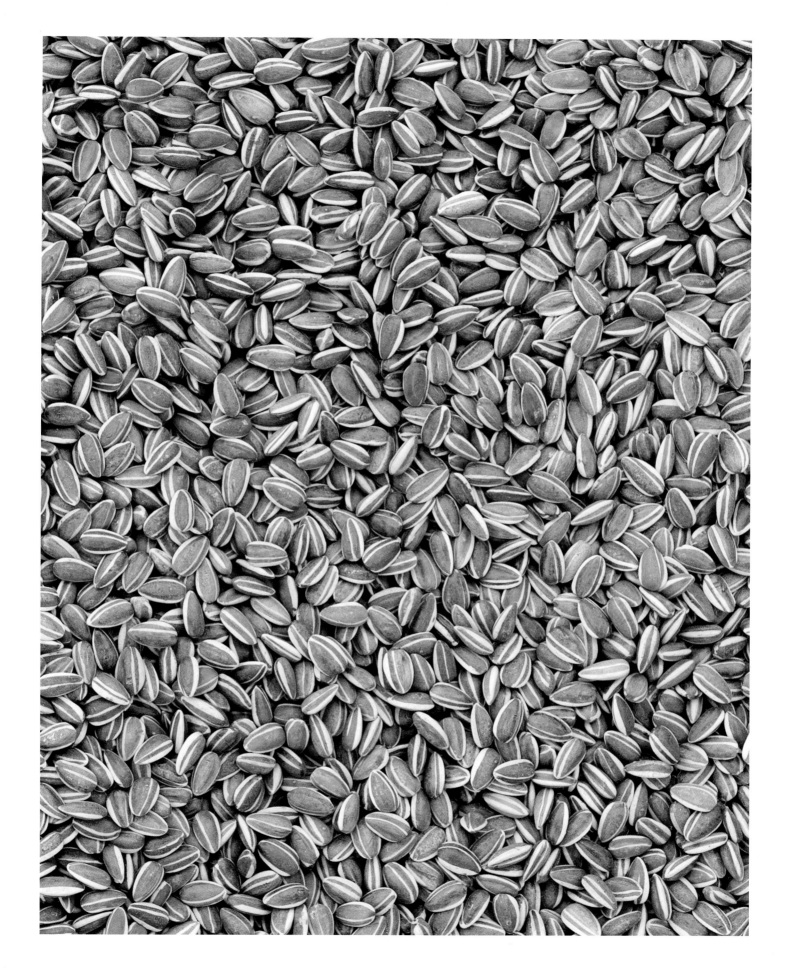

'I find I was in error', British painter and Royal Academician Sir Joshua Reynolds is said to have admitted to the painter Robert Barker in 1791, 'in supposing your invention could never succeed, for the present exhibition proves it to be capable of producing effects and representing nature in a manner far superior to the limited scale of pictures in general.' The 'invention' that Reynolds regretted doubting was an ingenious cylindrical canvas – soon installed within a rotunda near London's Leicester Square – that was designed to give visitors, gathered in the centre of the structure, the impression of gazing over uninterrupted views stretching in every direction. Barker christened his contraption a 'panorama' (from the Greek for 'all' and 'sight'), and to judge from the pavilion erected beside Tate Liverpool in 2012, its influence on cultural consciousness has yet to be exhausted.

The Source, conceived for the Liverpool Biennial, brought together the visions of American artist Doug Aitken and Tanzanian-born British architect David Adjaye. Like Barker's contrivance, Aitken and Adjaye's device aimed to widen our vista on the capabilities of the imagination. Visitors entered the darkened interior of Adjaye's panorama-like rotunda (made of wood, corrugated acrylic and bitumen panels) to discover on the walls that curved around them six large screens. On each screen, excerpts from some eighteen interviews – conducted by Aitken with leading painters, musicians, architects, actors and photographers – played in unending loops. To stand in the centre of the pavilion was to be assaulted from all sides by a half-dozen voices clamouring for regard. Spin around and the intense expression on each of the projected faces – whether that of actress Tilda Swinton,

performance artist Ryan Trecartin, White Stripes musician and songwriter Jack White or Swiss architect Jacques Herzog – might pull you in the direction of an individual screen.

Two centuries earlier, viewers standing within Barker's panorama were drawn to the details of a surging seascape or a picturesque vista that slowly orbited around them. Visitors to *The Source* were lured instead by dramatic gesticulations and half-heard phrases as each of the interviewees reflected on the mysterious origins of creativity. At any given moment one's ear might catch a glimpse of the influential multimedia artist Mike Kelley insisting 'repetition isn't just repetition', while in the same instant architect Liz Diller muses 'what it takes to do creative work is naïveté', just as legendary photographer William Egglestone asserts that a picture is the 'saturation point of sign-occupied space', and Adjaye himself sensationally asks, 'how do you dissolve the building?' One cannot help wondering whether this restless display, with its determination to crunch every conversation down to disposable sound bites, was intended to mock an intellectually bulimic appetite, prevalent in our Twittering culture, that is only interested in swallowing what can easily be regurgitated.

At night, after visitors vacated the structure, the six screens were retracted so that the projections seeped through the clear acrylic corrugation, transforming the exterior of Adjaye's rotunda into a carousel of passionate faces, which passersby could now appreciate without the self-cancelling chatter that gibbered on throughout the day. When seen under these conditions, Aitken's conversations took on the allure of spirits conjured in crystal.

Opposite: Doug Aitken, **The Source**, 2012. Installation at Tate Liverpool. Various media, dimensions specific to site

Right: Cross-section of Robert Barker's **Panorama**, 1801

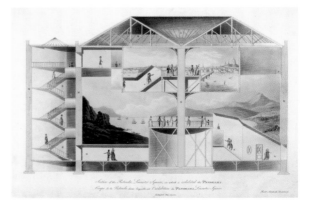

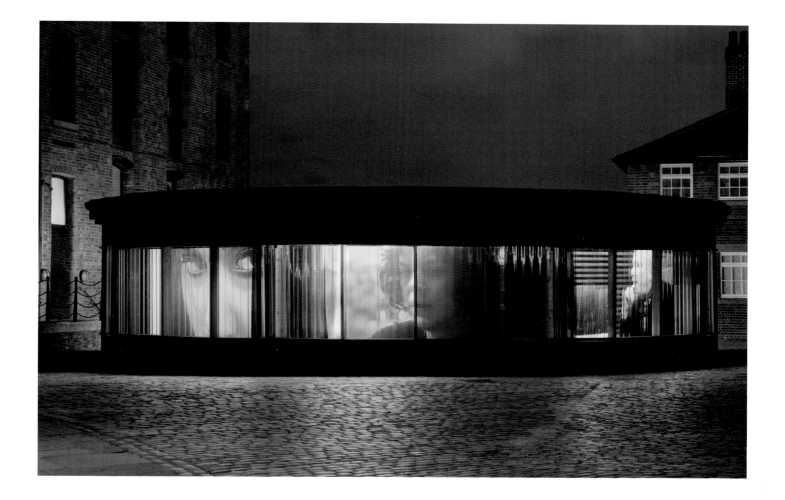

The project of predicting which works will, in time, define our age is admittedly macabre, death-aware, and reverberates with something of the grim frenzy of realizing one's roof is on fire and there is time enough only to grab a photo or two from the doomed walls. But which ones? For what can we really know about the longings of those who will come after us – decades, centuries, hence? 'There are modern heads', Vincent Van Gogh wrote to his sister Willemien in June 1890, 'that may be looked at for a long time, and that may perhaps be looked back on with longing a hundred years later.' Referring to a portrait he had just completed of the French physician Dr Paul-Ferdinand Gachet, who attended to the artist in the last months and weeks of his life ('with a melancholy expression ... sad but gentle, yet clear and intelligent'), Van Gogh's words vibrate with an eerie prescience when reflected upon a hundred years later. In May 1990, Ryoei Saito, a Japanese businessman, acquired Van Gogh's portrait of Dr Gachet at auction in New York for $82.4 million, then the highest price ever paid for a canvas. If that shocked the art world, what followed took its breath away: a year after acquiring the painting, the new owner announced that he wished to be cremated with the iconic work. Saito died in 1996. The fate of the portrait, not seen in public since, remains unknown.

Such is the mysterious back-story to one of the era's most enigmatic works, the 2005–6 series of thirteen canvases collectively entitled *The Blacker Gachet*. From the deepening abyss of cultural loss, British painter Mark Alexander fossicked not slavish replicas of the vanished work but fossils of its

endlessly echoing absence. Every trace of the burnt sunflower gold of Gachet's furrowed face and chin-burdened wrist has been drained, as has the starry-night blue of the sky behind him. All that remains is the black woollen weave of the doctor's collar, which has bled out from the painting's centre to overwhelm the work in unrelenting darkness. In Van Gogh's depiction, the vase of foxgloves on the table beside Gachet – from which the heart medication Digitalis can be distilled – is there principally to denote the sitter's profession. But in the context of Alexander's poignant reinvention, these drooping purple petals – also known as 'Deadman's Bells' for their potentially lethal toxicity and ability to induce deranged visions of altered colours – become the substance on which the viewer has overdosed, altering his or her perception of the works.

The physical disappearance of Van Gogh's portrait of Dr Gachet has become a metaphor for the painting's dissolution into the collective unconscious – that primordial pit from which all art is arguably excavated and into which all objects eventually disappear. Van Gogh's intuition that he had found a face destined to be longed for, destined to be carved again and again through the dark dilation of every era's eyes, has proved to be as uncanny as it was true. Whatever the fate of Van Gogh's missing canvas, Mark Alexander's *The Blacker Gachet* provides a profound portrait of irreducible loss and endless becoming – of what the poet Wallace Stevens described as the 'Nothing that is not there and the nothing that is.'

Opposite: Mark Alexander, **The Blacker Gachet X**, from the series **The Blacker Gachet**, 2005. Oil on canvas with artist-designed frame, 88 × 76.5 cm (34⅝ × 30⅛ in.)

Right: Vincent Van Gogh, **Portrait of Dr Gachet**, 1890

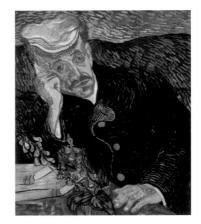

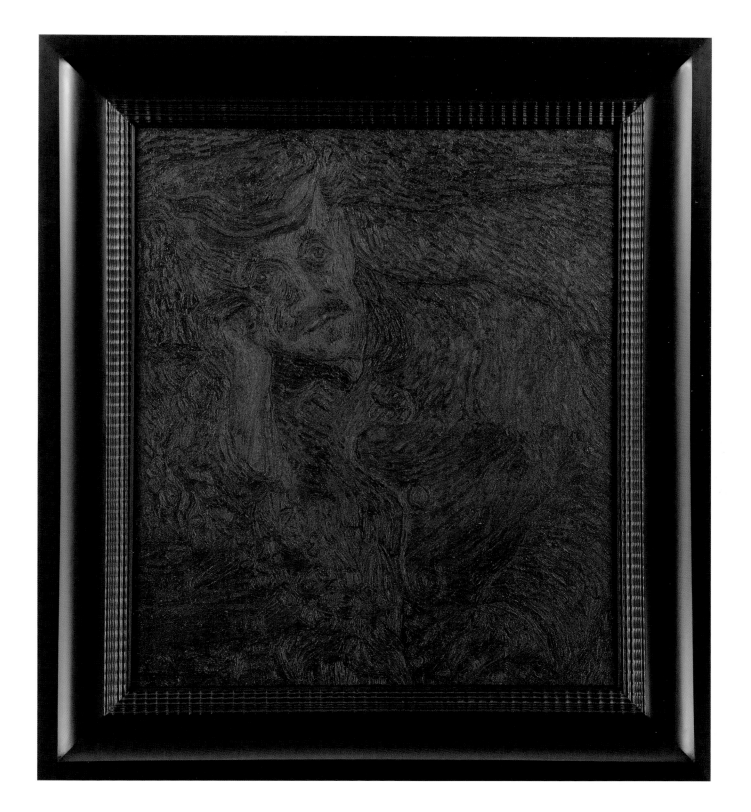

It is always risky to repeat a trick. Especially when the trick isn't yours. One might have thought at this stage in the unfolding of art history that the repetitive display of iconic portraits, as though mass-produced for commercial consumption, was a gimmick to which Andy Warhol would retain eternal copyright. But Francis Alÿs's evolving installation *Fabiola* reveals that Warhol's old dog of inert visual repetition is still capable of hopping through new and more profound hoops. The work consists of a collection of painted profiles of the obscure fourth-century Christian icon Saint Fabiola. A victim of spousal abuse, the Roman matron and follower of Saint Jerome fell out of favour with the Church after she divorced her violent husband and remarried. Her life of extraordinary philanthropy towards the poor, however, which included the founding of a hospital in Rome and a hospice in nearby Portus, helped to refurbish her reputation with Christian authorities and paved the way for her eventual canonization.

Though Alÿs cannot be credited with actually painting any of the images that comprise the installation, the repetition is not the product of a soulless Warhol-like factory churning out silk-screened celebrity. The over four hundred canvases that now constitute *Fabiola* (having grown from an initial group of some twenty-eight when first exhibited in 1994) were all salvaged by Alÿs from far-flung flea markets, car-boot sales and bric-a-brac shops across Europe and Mexico, where the Belgian artist works. The individual identities of the artists responsible for the constituent canvases are largely unknown. It is thought that a popular novel by an English

Cardinal, *Fabiola, or the Church of the Catacombs*, published in 1854, is what rescued the forgotten saint from cultural neglect. Restored to popular consciousness, Fabiola attracted the attention of the French artist Jean-Jacques Henner, whose 1885 depiction of the saint in profile – forehead shadowed by a heavy veil – recalled the contours of Titian's portraits and quickly gained a steady following of amateur copyists who would endlessly reinterpret Henner's now-lost original.

But what does Fabiola mean to her invisible flock? This is what is so fascinating about Alÿs's masterpiece: rather than heavy-handedly stamping the collection with a single silk-screened meaning, the artist allows visitors to determine for themselves what role Fabiola played in the otherwise irrecoverable imaginations that lie behind the separate works. Where the loose brushiness of one version, for example, suggests she may have been primarily an icon of defiant self-determination to one devotee, the painstaking mosaic of seeds and modest beans out of which her countenance has been constructed in another work implies the artist's alignment with the asceticism she was also known for, and made some reviewers wonder whether the work in question was not itself a sacrifice of personal sustenance. Though Alÿs is not in general thought of as a Surrealist, entering the rooms of a *Fabiola* installation is a dreamlike and uncanny experience as hundreds of faces turn away, averting their eyes. Upon leaving, this visitor could not help wondering whether, if the cacophony of the world could be quieted for an instant, the only sound remaining might be the slow hush of a brush somewhere stroking the cheek of a woman in a red cloak.

Francis Alÿs, **Fabiola** (detail), 1994–.
Installation at the National Portrait
Gallery, London, 2009. Various media,
dimensions vary with installation

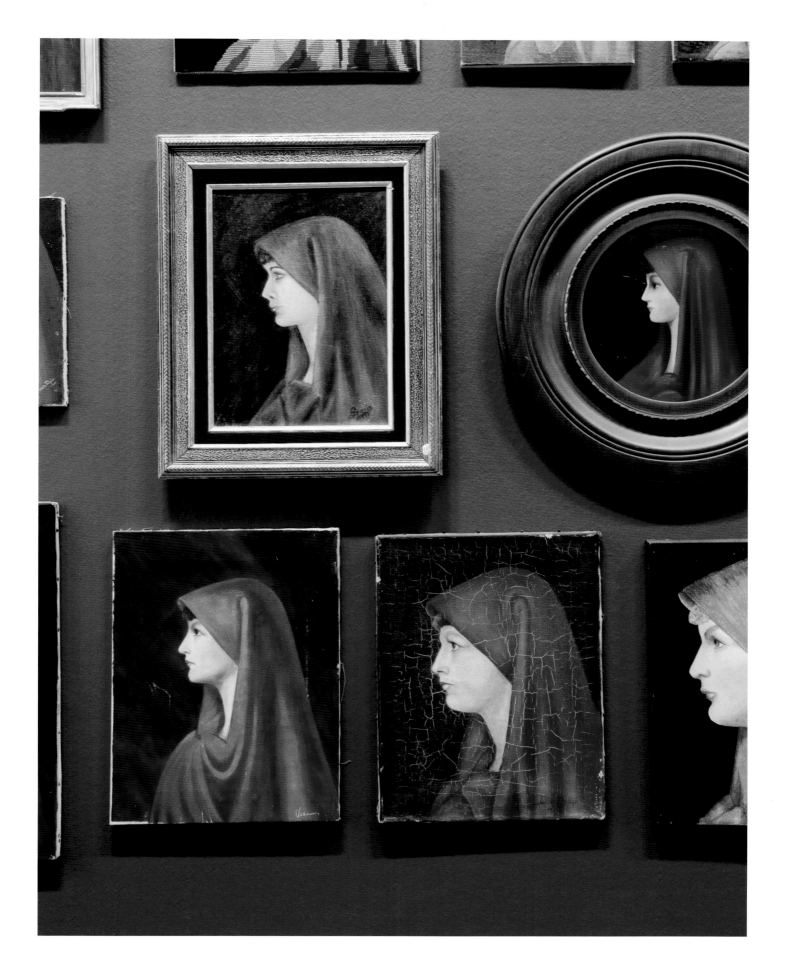

Francis Alÿs, **Fabiola**, 1994–. Installation at
the National Portrait Gallery, London, 2009

What's eating you? The connection between consumption and identity, sustenance and the soul, is instinctive, cliché, the stuff of a thousand sayings. *Food for thought. Gut feeling. You are what you eat.* It is likewise a theme that invigorates Bahamas-born American artist Janine Antoni's intriguing 1992 work *Gnaw*. Central to Antoni's seemingly minimalist installation are two enormous ragged blocks, one chocolate, the other lard. Weighing 272 kg each, these hulking crate-sized chunks initially seem to be the mouldered remnants of a ruined structure or monument – edible Rosetta stones densely inscribed with indecipherable scrawl. Up close, however, what appeared to be the ravages of chisel, weather or time reveal themselves for what they are: innumerable teeth marks nibbled into the calorific monoliths. Look up, and through the doorway that leads into the next gallery you catch sight of where exactly the ingested chocolate and lard have gone, with glass display cases holding scores of heart-shaped candy boxes and hundreds of tubes of lipsticks all fashioned from the chewed and spat-out cocoa and fat.

Hailed by some critics as a descendant of process art (which emphasized the making over the made), *Gnaw* takes the genre in an unexpected direction, challenging viewers not to take for granted those processes, whether biological or commercial, that lie behind products often considered formative in the shaping of our identities.

A cheap extravagance for many, chocolate has been the cause of inestimable exploitation in developing regions and the reversal of process embodied by Antoni's work, whereby what has already been chewed is then reshaped into frivolous romantic treats, serves as a nauseating nudge to rethink our habits of thoughtless consumption.

More unsettling still are the missing mouthfuls of lard from the white waxen lump. The mastication and expectoration of the very substance (fat) that is the cause of so much self-esteem-destroying anxiety for women and girls, as part of a perverse manufacture of superficial beauty products such as lipstick, amplifies an element of acerbic satire characteristic of Antoni's works. In her performance piece *Loving Care* (1993), for instance, the artist crawled around a gallery allowing her long black hair, which she had dunked in cheap high-street hair dye, to serve as an absurd brush with which she flailed colour across the floor, all the while driving visitors from the room. Like *Gnaw*, *Loving Care* reveals the futility of everyday beauty and retail rituals, especially those that mindlessly inflict damage on the self-confidence of women. Her works also serve as self-reflective jibes at the pretentiousness of the very industry in which she participates, not to mention such macho icons as Jackson Pollock whose flinging and flicking she parodies. Janine Antoni has given the art world a great deal to chew on.

Opposite: Janine Antoni, **Gnaw**, 1992. Blocks of chocolate and lard gnawed by the artist, each 272 kg (600 lbs), 61 × 61 × 61 cm (24 × 24 × 24 in.); 45 heart-shaped packages for chocolate made from chewed chocolate removed from the chocolate cube and 400 lipsticks made with pigment, beeswax and chewed lard removed from the lard cube

Right: Janine Antoni, **Loving Care**, 1993. Performance with Loving Care hair dye (Natural Black) at Anthony d'Offay Gallery, London

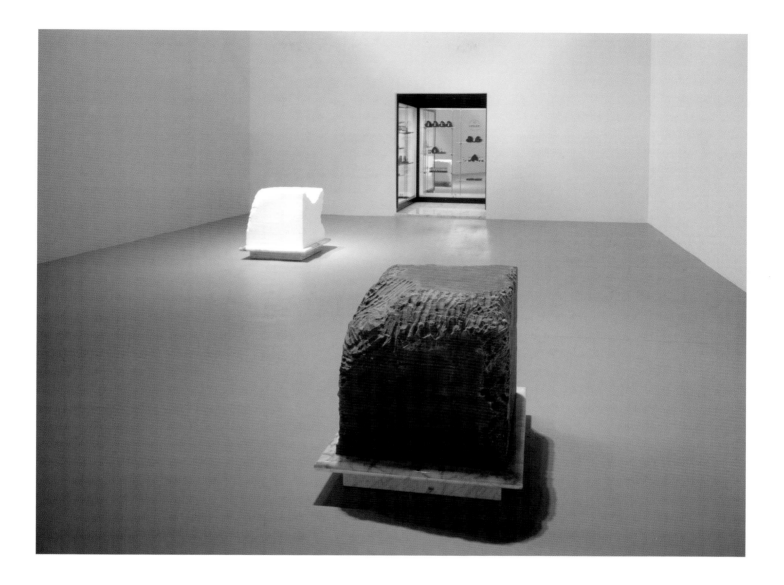

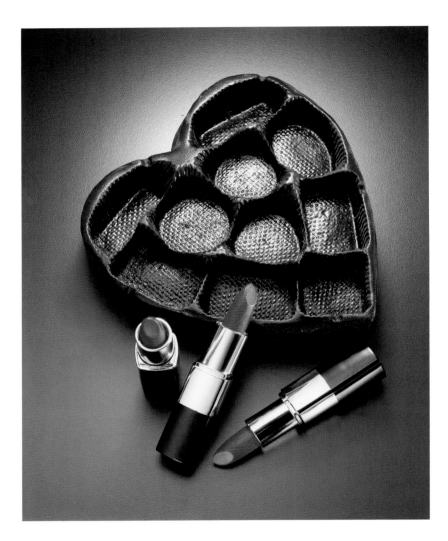

Above: Janine Antoni, **Gnaw** (detail), 1992

Opposite: Janine Antoni, **Gnaw**, 1992.
Installation view of lard gnawed by the artist

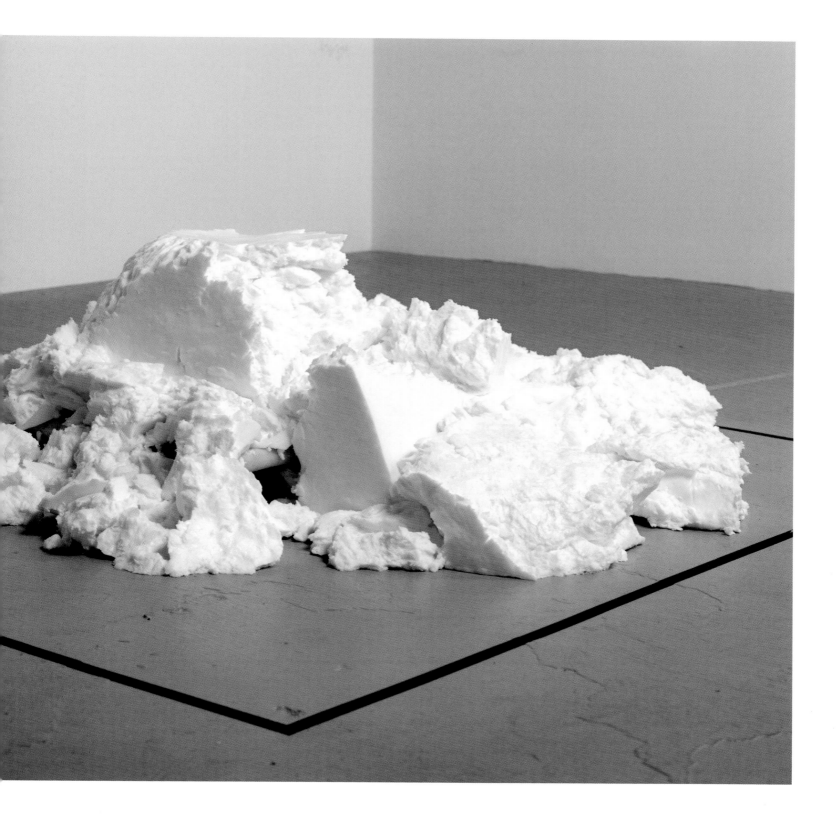

'**All I know**', the Irish Nobel laureate Seamus Heaney begins one of his poems, 'is a door into the dark.' After an encounter with artist Miroslaw Balka's remarkable 2009 installation, *How It Is*, which presented visitors to Tate Modern's Turbine Hall with a fearsome threshold into unrelenting blackness, one could well have said the same. The work consisted of a giant steel box (measuring thirteen metres high, ten metres wide and thirty metres long) propped precariously onto puny two-metre-high stilts. After examining the imposing structure, a cross between a shipping container and a military rendition tank, visitors ascended a ramp that took them into the facility itself – an ominous space from which all light had been vacuumed so completely that some reviewers commented that the air itself felt transformed into something heavier, tangible, an impression amplified by the crushed velvet texture of the blackened walls.

Analogies with historical nightmares of human confinement, concentration and eventual annihilation were lost on few. Balka himself discussed with eloquence the dark light that Nazi extermination camps in his native Poland shed on interpretations of the installation. As with all great works, *How It Is* managed to retain the poignancy of that immediate connotation while never confining itself, as it were, to any single interpretation. Each step into Balka's

oblivion constituted an act of faith in the benign design of all that's unseen, as one penetrated deeper and deeper into the unknown. In that sense, the work's meaning transcended any particular horror or allusion to the invisible suffering of those trafficked everyday across national borders in shipping containers, and offered instead an allegory for the unpredictable vessel that is every relationship we enter.

In life, Balka's work seemed to assert, darkness is 'how it is' – a phrase that alludes to the title of a 1961 novel by Samuel Beckett, which chronicles an endless existential slog through mud. For some critics, being swaddled in Balka's palpable darkness was unexpectedly uplifting – its dense cloud of unknowing precipitating an inner awareness that went beyond the senses. For others, the experience was unnervingly annihilating, a touch too close to the incalculable void of black holes, dark matter and death. 'I had a dream, which was not all a dream', Lord Byron begins his poem 'Darkness', with language that could have been inspired by Balka's dislimning machine:

> The bright sun was extinguished, and the stars
> Did wander darkling in the eternal space,
> Rayless, and pathless, and the icy earth
> Swung blind and blackening in the moonless air.

Miroslaw Balka, **How It Is**, 2009. Installation at Tate Modern, London. Steel, 13 × 10 × 30 m (42 ft 8⅛ in. × 32 ft 10¾ in. × 98 ft 5⅛ in.)

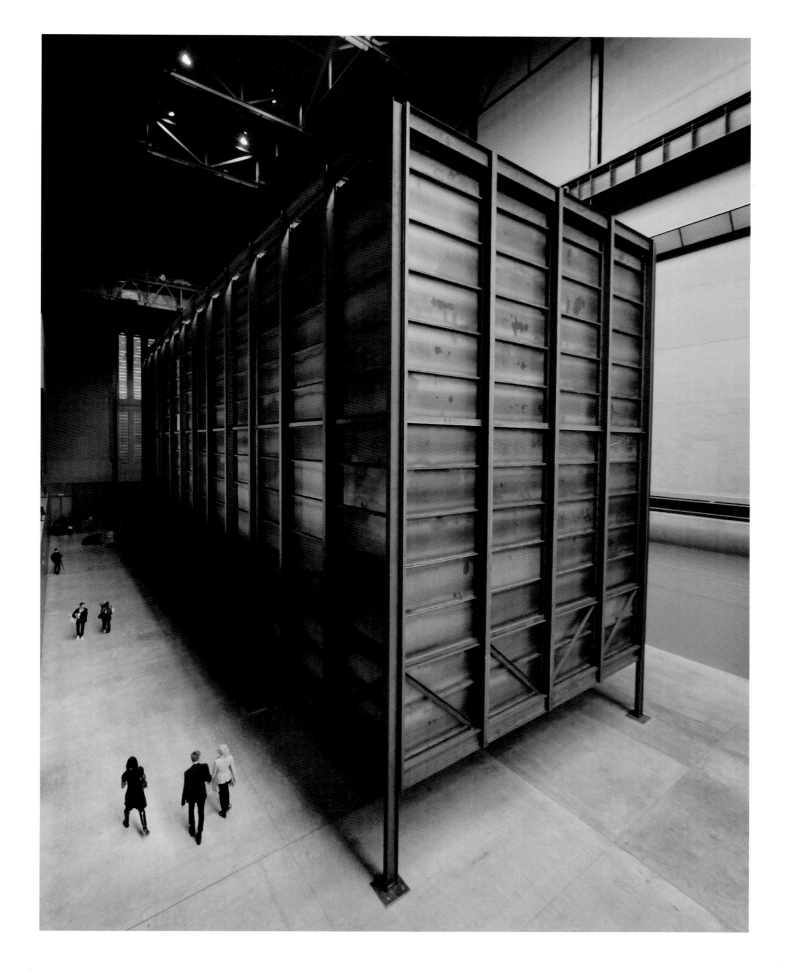

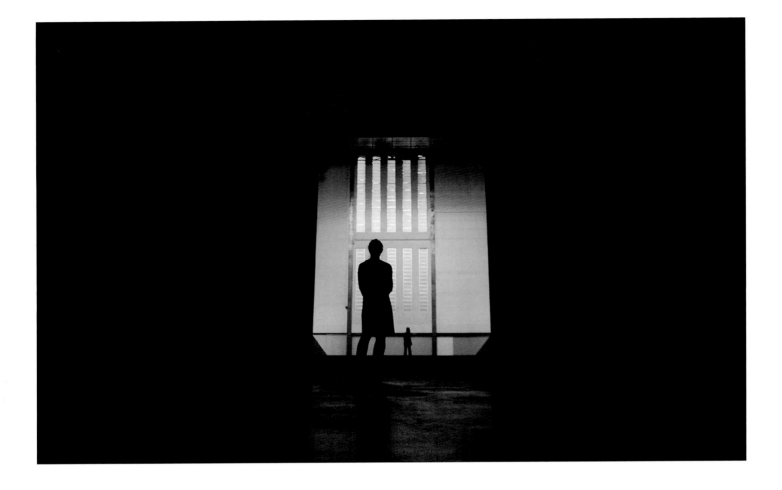

Above: Looking out from within Miroslaw
Balka's **How It Is**, 2009

Opposite: Lighting briefly illuminates the
cavernous interior of **How It Is**, 2009

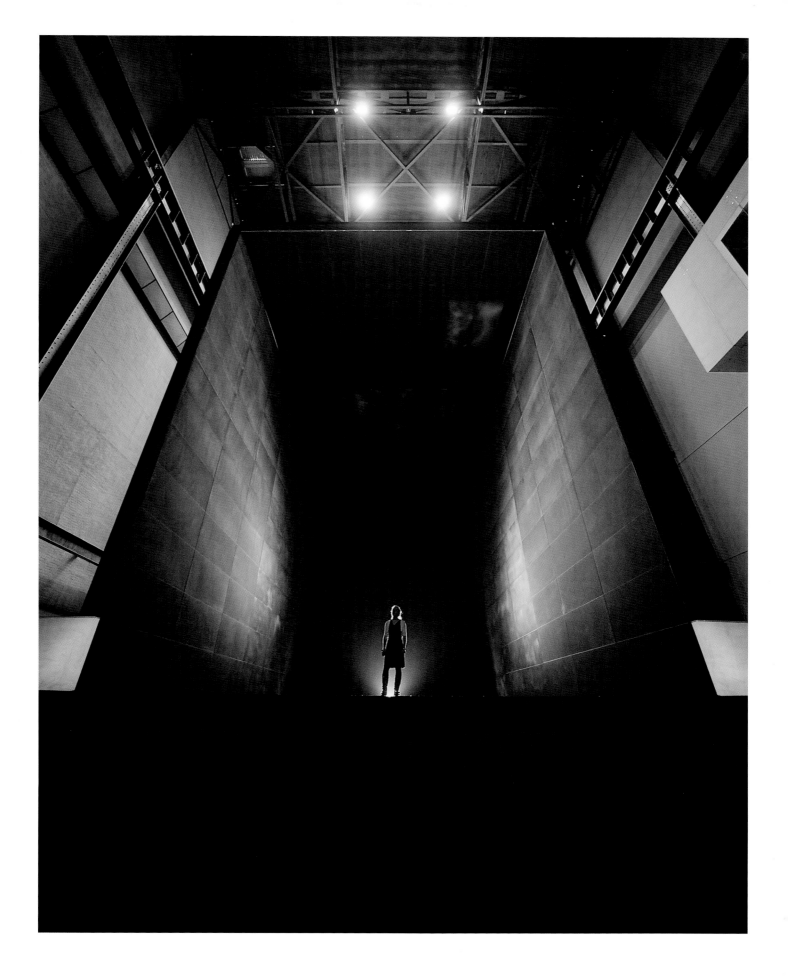

Art is defacement. The word 'deface' derives from a composite of the Old French prefix *des–*, meaning 'away from', and the Latin *faciēs* for 'appearance'. In a sense, the 'appearance' of something 'away from' itself, separate from its actual being, is a good definition of all representational art. Jasper Johns, for example, might be said to have defaced the American flag not by desecrating actual incarnations of the Stars and Stripes, but by moving the symbol's appearance away from itself. To create is to deface. Perhaps it is this fundamental quality that makes the mischievous defacements of British graffiti artist Banksy resonate with such primal, ante-intellectual urgency. Ante-, as opposed to anti- (though there is plenty of implied protest in the camera-shy graffitist's wry spray can) because this is work that succeeds viscerally, not thoughtfully, agitating a response prior to the ignition of discernment or reflection. Banksy's genius lies in his ability to engineer in the mind of the passerby a sudden dislocation of everyday urban signs and signifiers from their expected meanings.

Nowhere is this more memorably achieved than in the artist's signature work, popularly known as *Flower Thrower*, undertaken in the West Bank in 2005. Everything about the image, from the subject's partially masked face to his aggressive stance, denotes menace, whether thuggishly anti-social, conscientiously political or confrontationally sectarian. This shabby shadow of dystopian intimidation, fossilized to the wall, is the silhouette of a thousand nameless rousers in trouble spots around the world, endlessly discharging their crude rounds as we watch on the nightly news. But modify one element of this otherwise archetypal stencil of rage or survival, a bouquet for the stone or Molotov cocktail, and the image is simultaneously stripped and reloaded with meaning. Not intellectual meaning, but emotional meaning, or value, that resists precise formulation.

Flower Thrower is appealing principally because it doesn't and cannot explain itself. In that sense, Banksy's efforts are nearer to Surrealism than to protest art. His are absurdist vandalisms which it would be churlish, and foolish, to attempt to understand in the context of any assiduous advocacy of a legitimate agenda. To interpret the flowers as standing insipidly for peace, or to regard the figure on the verge of hurling them as a misunderstood propagator of love and happiness, is to demote the power of the piece to the level of saccharine slogan. *Spread the love, man. Give peace a chance.* Banksy is better than that. Given the chance, he would likely deface those clichés into something absurd and unexpected too, moving them away from their fatigued hippyism. Like Salvador Dalí before him, Banksy is a prankster, one who has traded in the Surrealist's spit-whittled moustache and addiction to attention for a shoplifter's hoodie and the cover of night – defacing, as it were, the very face of the artist.

Banksy, **Flower Thrower**, 2005. Stencil, spray-paint on building wall in the West Bank, approx. 4.5 × 4.5 m (15 × 15 ft)

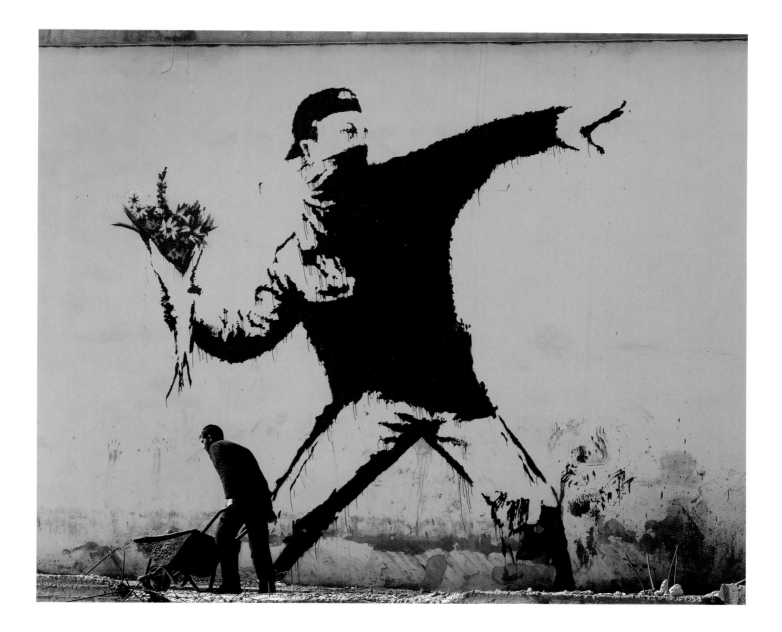

It's all about the hook. Every great work of art has one – that element that pulls you in and holds you there, the invisible catch that transforms a work's meaning from the particular to the universal. And what better metaphor to capture the metamorphosing hook of art than the cremaster, the sharp latch by which the delicate chrysalis hangs from the silken pad woven by the caterpillar, making possible the eventual awakening of the butterfly? No work of contemporary art embodies that transformative truth more intriguingly than American multimedia artist Matthew Barney's 1994 film *Cremaster 4* (the first in an elaborate cycle devoted to exploring the endless regeneration of life and art).

The forty-two minute work features the artist in the role of a preening redheaded satyr dressed in a white three-piece suit and known within the filmmaker's curious cosmology as the Loughton Candidate (named after a breed of rusty-woollen sheep, Manx Loaghtan, unique to the Isle of Man, where the work was filmed). Three brutish fairies attend to the Candidate in his hideout at the end of a long nineteenth-century pier. They slip smooth opalescent balls into his pockets and affix dance taps to his shoes, upon which he proceeds rhythmically to jig around a slowly widening hole in the floor, into which he eventually falls, plunging deep into the sea below. The balance of the film follows the satyr's arduous journey through an oozy duct, crowded with slippery protuberances, that some reviewers have interpreted as representing the secretory canals of conception, birth or both.

Meanwhile, teams of sidecar motorcycles (also indigenous to the location) race each other in opposite directions around the isle.

It's all as messy as it is mesmerizing, but what does it mean? An inchoate recasting of creation myths, spliced together from seemingly incoherent cultural scraps – satyrs and sidecars, fertility and fairies – the film suggests an endless slippage of unassigned signs, a chrysalis of shifting symbolism forever on the verge of assuming stable shape. The Loughton Candidate represents not only the ultimate creation of the artist but also its yet to be released seed, suspended between the made and the unmade. This is hinted at by the title's other meaning: in anatomy, 'cremaster' (derived from a Greek word meaning 'suspender') refers to the tissue of the spermatic cord, from which the testicles hang. The term was first used in the seventeenth-century English lexicon *New World of Words* (1678): '*Cremaster*, the Muscle, that holds up the Stones.' Untethered testes, slipping and skittering like lost lozenges on a leather seat, are bizarre leitmotifs of the film.

For much of the ensuing decade after the film's release, concepts introduced in *Cremaster 4* underwent increasingly complex metamorphosis in one of the most ambitious cinematic projects in contemporary art, inspiring four further films (*Cremasters 1, 2, 3* and *5*), as well as a range of auxiliary artistic merchandise. The result is an elaborate odyssey of indeterminate meaning and ambiguous transformation that hooks its viewers and keeps them hanging.

Matthew Barney, film stills from **Cremaster 4**, 1994. 35 mm film, 42 minutes

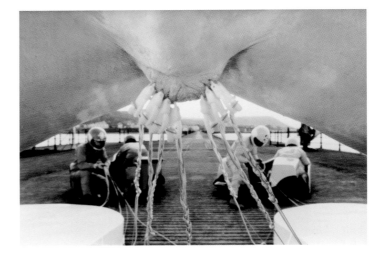

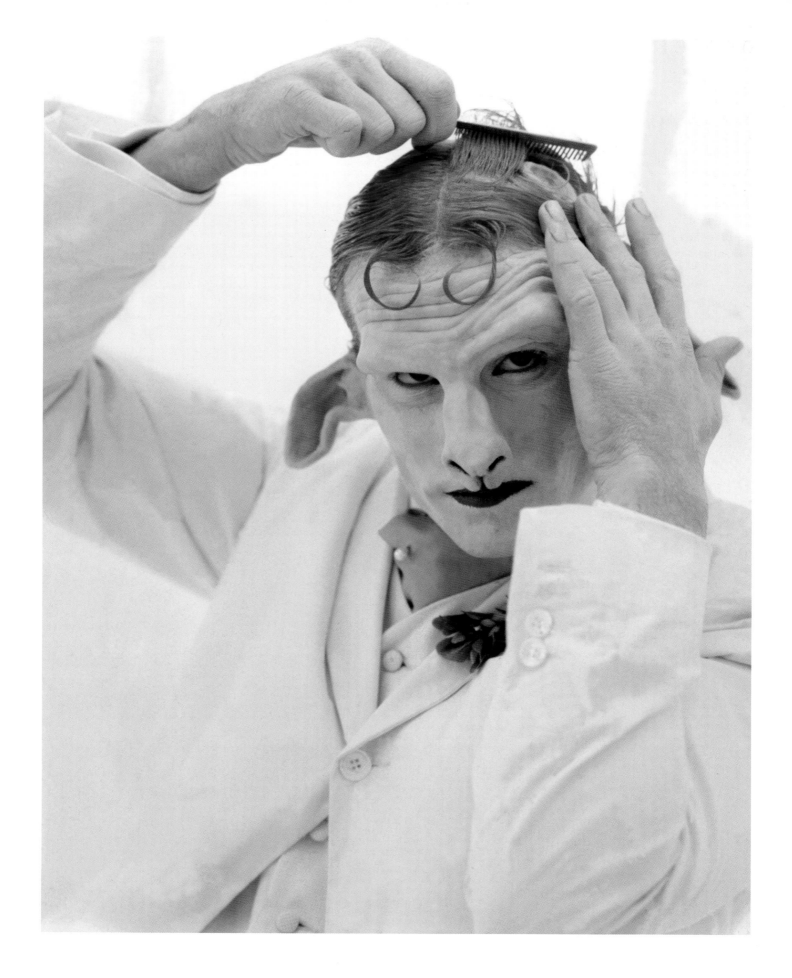

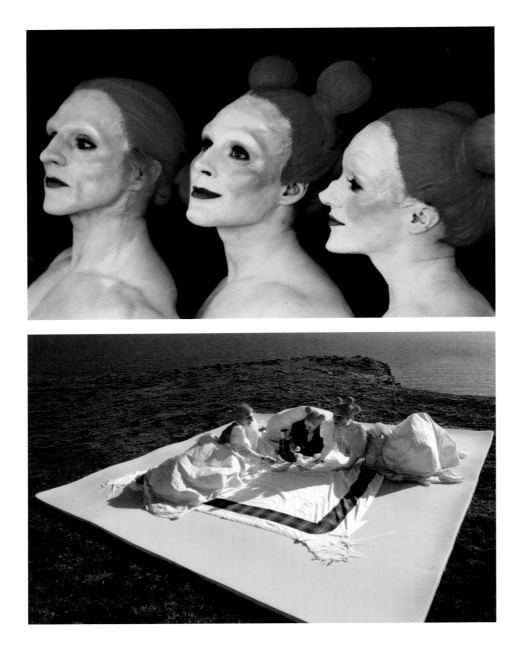

Matthew Barney, film stills from **Cremaster 4**, 1994

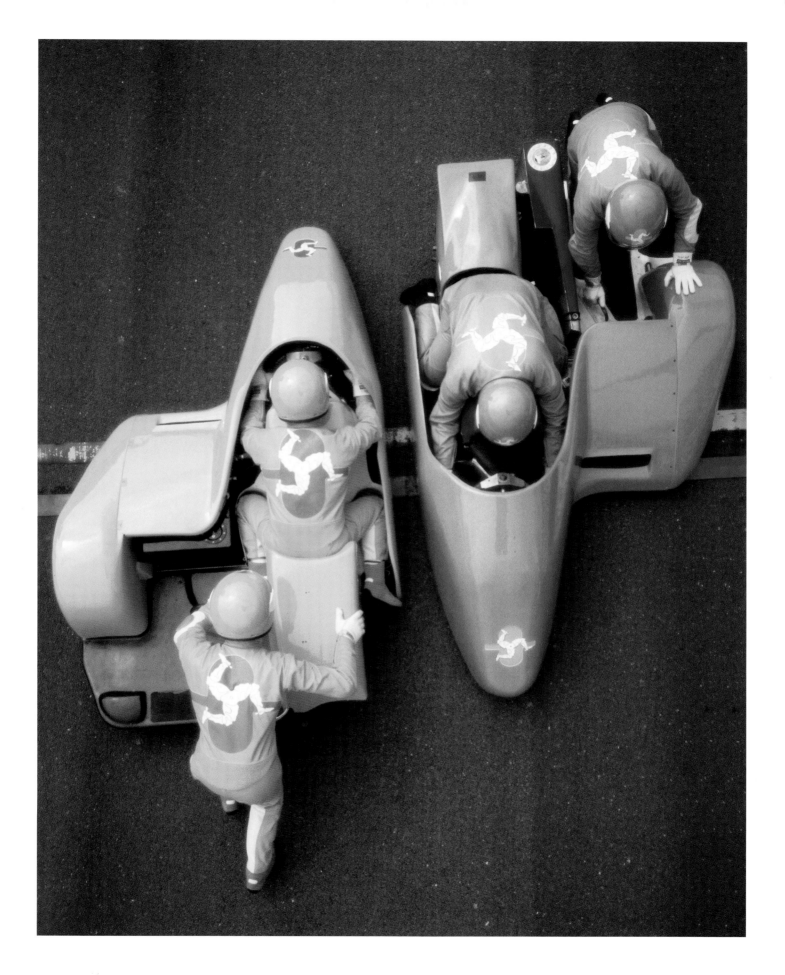

What will survive of us? The attempt to answer that question arguably motivates every work of art. Every sketch, poem or sonata is, in some sense, an anchor thrown into the shallow waters of an ever-encroaching oblivion, a desperate shot at lingering here a little longer. But what of the banal reality of our everyday material detritus after the last shovelful of earth has been flung into place? What becomes of all those abandoned books and photographs, those calendars and shoes? Particularly poignant to contemplate is the legacy of one's deserted clothes, those flimsy membranes that participate in both the public and private spheres of our existence. We spend our lives tinkering with these disposable shells as though they could reflect something authentic about our being, only to leave them hanging limply in a dark closet or with arms folded in a drawer, useless as discarded ghosts, when we eventually depart.

The inevitable shedding of our second skins was at the centre of Christian Boltanski's sprawling installation *Personnes*, set in the vast openness of Paris's Grand Palais for the 'Monumenta 2010' exhibition. The work consisted of acre upon acre of orderly allotments strewn with clothes – carefully measured fields of jumbled fabric all overseen by an enormous mound of some fifty tonnes of wadded shirts and dresses, denim and polyester, viscose blouses and woollen jumpers. But to whom did this sartorial crush belong? All of us, appeared to be the answer, and no one at all (the title means both).

Aurally animating the eerie installation was a strange syncopated squish of what one eventually recognized as beating hearts, thousands of them, as acoustically crumpled as the garments that filled the endless expanse. Over and over again a huge mechanical claw hovering above the summit of the pyramidal mound would suddenly lower, relax its metal fingers, clench a handful of rags, rise clear of the pile, then drop them again in an absurd Sisyphean exercise of endless material acquisition and disposal. The result was a slow plucking at the threads of consciousness, a gradual disrobing of the soul. What will survive of us? By posing such a question, Boltanski's overwhelming work inevitably lay bare an even starker one: what naked nowhere lies beyond?

Christian Boltanski, **Personnes**, 2010.
Installation at the Grand Palais, Paris.
Various media, dimensions specific to site

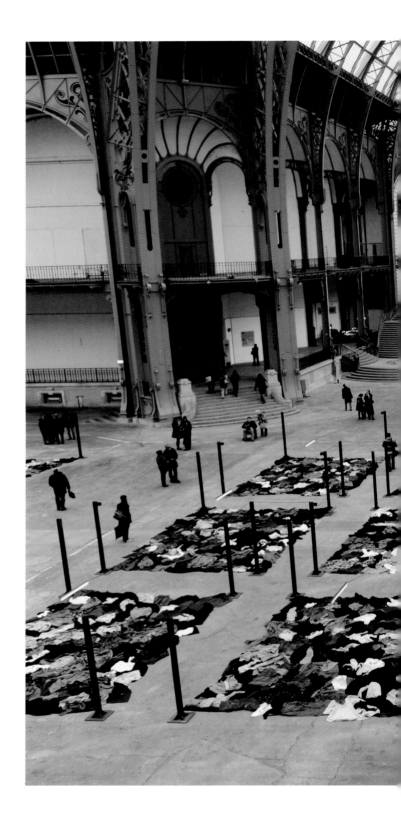

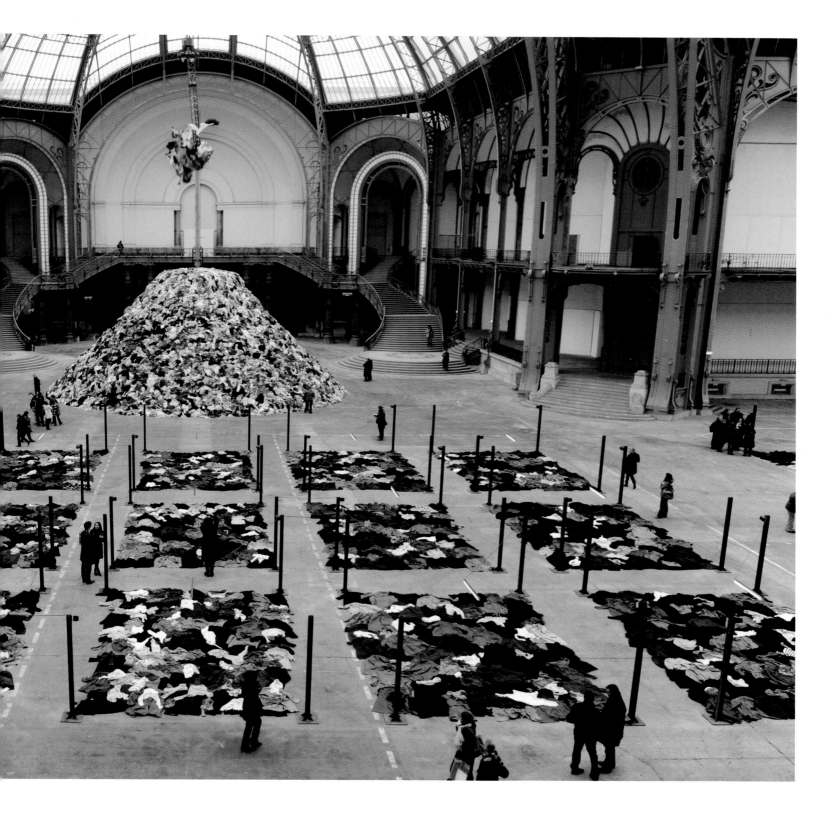

MUST
ART BE
TRANS-
FORM-
ATIVE?

What does one prefer? An art that struggles to change the social contract, but fails? Or one that seeks to please and amuse, and succeeds?

ROBERT HUGHES

011　Don't Miss a Sec (2003)　MONICA BONVICINI

If, as Shakespeare wrote, 'we owe God a death', who or what will now assume the vacated throne of the unseen seer? Technology? The surveillance state? Art? Contemporary worries concerning visibility and concealment are at the heart of Monica Bonvicini's sculpture *Don't Miss a Sec*. Installed initially on a street beside Tate Britain, London, in 2003, the work offered itself to passersby as a functioning public toilet, but with a mischievous twist: the four walls comprising the cubicle were in fact one-way mirrors. When seen from the outside, the squat, square structure crisply reflected its surroundings. Tourists checked their hair in it, businesspeople straightened ties and hemlines, students licked their teeth clean. From the inside, however, the space was unsettlingly transparent, wall-less, devoid of the privacy one typically requires to follow through with the task at hand. Seeing all came with a price. Many who dared to engage with the piece would confess afterwards to suffering a paralyzing performance anxiety. To step outside the cube was to move from being the observer to the observed.

Was the work intended merely as a scatological prank – a contemporary take on Marcel Duchamp's 1917 anti-art urinal, *Fountain*? Or is it appropriate to read into the sculpture dilemmas of modern surveillance? That the artist acquired the lavatory's austere stainless steel fixtures from a penitentiary supplier may be a clue that something more profound was always at play. The provenance of the toilet and washbasin summons the intriguing, though now erased, penal history of the site on which Bonvicini first chose to erect her work. In 1799, the philosopher and social reformer Jeremy Bentham purchased the land with the intention of constructing there a new type of 'prison-machine' based on theories that physical and psychological transparency could rehabilitate prisoners. The prison's design – eventually abandoned – was to resemble the cross-section of a sliced orange. At the pips, a central watchtower would house the prison warden who could see in 360° rotation into every one of the inmates' cells, which would radiate from the tower like so many juicy segments. The logic behind the contraption was the warden's ability to see everything without ever being seen himself, a dynamic achieved by the use of ingenious blinds.

Nearly two centuries later, in 1975, the controversial French theorist Michel Foucault resurrected Bentham's never-realized plans as a metaphor for the insidious surveillance that he believed was being assembled all around us as a replacement for religion, in which both the warden/god and inmate/mortal are equally imprisoned, and no one controls the machine. The genius of Bonvicini's work is its ability to address such social, theological and psychological concerns in an ostensibly unpretentious form linked to the basest of human urges – to suggest, in the cheekiest of ways, that to don the omniscient cloak of invisibility isn't all it's cracked up to be.

Opposite: Monica Bonvicini, **Don't Miss a Sec**, 2003. Installation at City Hall, Rotterdam, 2004. Two-way mirror structure, stainless steel, toilet unit, concrete floor, aluminium and fluorescent lights, 2.5 × 1.4 × 1.9 m (8 ft 2⅜ in. × 4 ft 7⅛ in. × 6 ft 3¼ in.)

Right: Cross-section of Jeremy Bentham's **Panopticon**, c. 1790

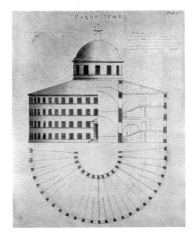

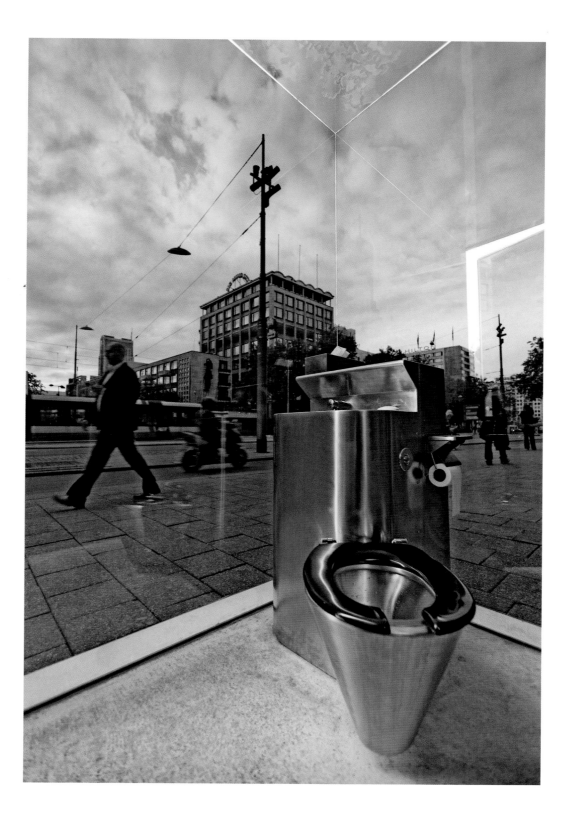

Monica Bonvicini, **Don't Miss a Sec**, 2003.
Installation at Art Basel, Switzerland, 2004

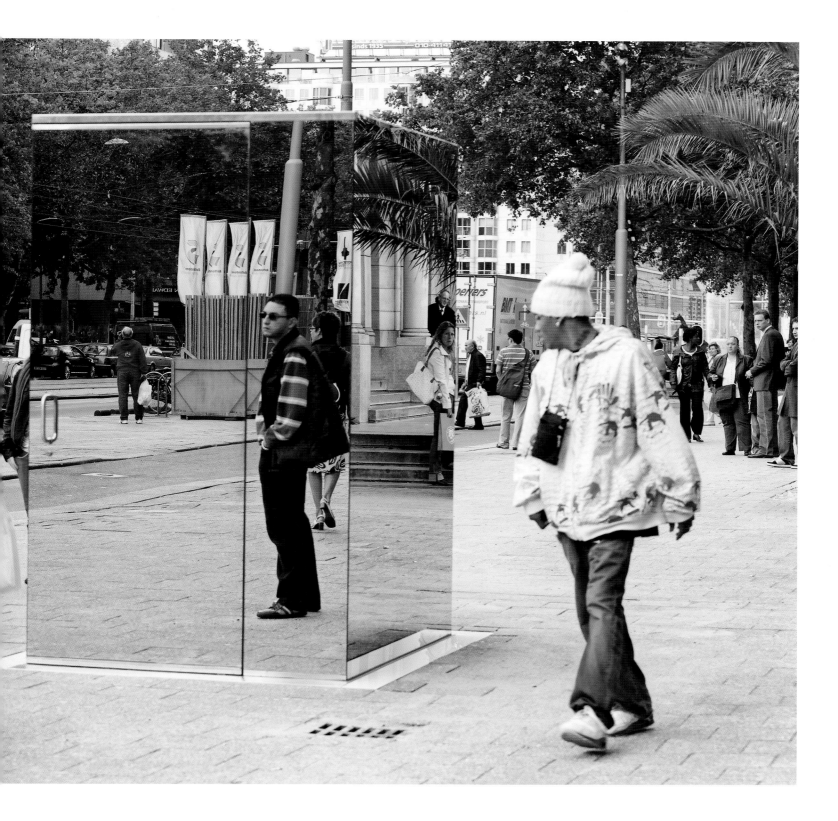

Hardwired for flight, newly hatched spiderlings on the coast of New England engage in a pair of rituals known as 'tiptoeing' and 'kiting'. Aiming their abdomens heavenwards, the young weavers fire into gusts of wind gossamers that knit themselves with mathematical precision into polygonal parachutes that will carry them out to watery deaths at sea. Robert Lowell describes the strange procession in his poem 'Mr Edwards and the Spider' (1946): 'Where gnarled November makes the spiders fly / Into the apparitions of the sky, / They purpose nothing but their ease and die.'

I'm reminded of the senseless beauty of the spider's self-sacrifice by an incident in the early life of the French artist Louise Bourgeois, who in her early twenties was studying mathematics at the Sorbonne when her mother, a gifted weaver, suddenly died. Days later, as the desperate young artist walked with her father along the banks of the Bièvre River, so the recollection goes, she threw herself in. From that point forward, the world in which Bourgeois resurfaced, rescued by a father whom she never trusted, would be loomed over by the memory of her mother, whose ghostly presence Bourgeois would spend the rest of her life spinning into being. For over half a century, from an early ink sketch in 1947 to the work that Bourgeois created as the first artist to exhibit in Tate Modern's Turbine Hall in spring 2000 (a towering bronze, steel and marble sculpture entitled *Maman*) and beyond, the spider has emerged as the main symbol of that all-enveloping presence. 'The Spider is an ode to my mother,' the artist explained:

Like a spider, my mother was a weaver. My family was in the business of tapestry restoration, and my mother was in charge of the workshop. Like spiders, my mother was very clever. Spiders are friendly presences that eat mosquitoes. We know that mosquitoes spread diseases and are therefore unwanted. So, spiders are helpful and protective, just like my mother.

Since antiquity and the myth of young Arachne (whose arrogance in her weaving was punished by a jealous goddess), the spider, at once nurturing and lethal, alien and domestic, has sidled its way across cultural consciousness as an ambiguous symbol for the risks of creativity. One could almost map the achievements of postwar modern art against Bourgeois's slow incubation of the deeply personal yet universal symbol, whose alluring web expertly ensnares in her work an astonishing array of styles and media, from Surrealism to Abstraction, watercolour to installation. To stand looking out from beneath the splayed legs of her near nine-metre-high sculpture, whose static steel lurch has attracted crowds at exhibitions across the world, is to see the horizon sliced into the jagged segments of Bourgeois's profoundest love and deepest fears, to be carried off into the current of one of the past century's most singular imaginations.

On 8 November 2011, just over a year after Bourgeois's death at the age of ninety-eight, a smaller, 2.4-metre-tall version of the work fetched $10.7 million at auction in New York, the highest price paid for a work by a female artist to date (over $76 million less than the most ever paid for a contemporary work by a man).

Louise Bourgeois, **Maman**, 1999. Permanent installation at the Guggenheim Museum, Bilbao. Bronze, marble and stainless steel, 8.95 × 9.80 × 11.60 m (29 ft 6⅜ in. × 32 ft 2⅞ in. × 38 ft 1⅜ in.), edition 2 of 6 + A. P.

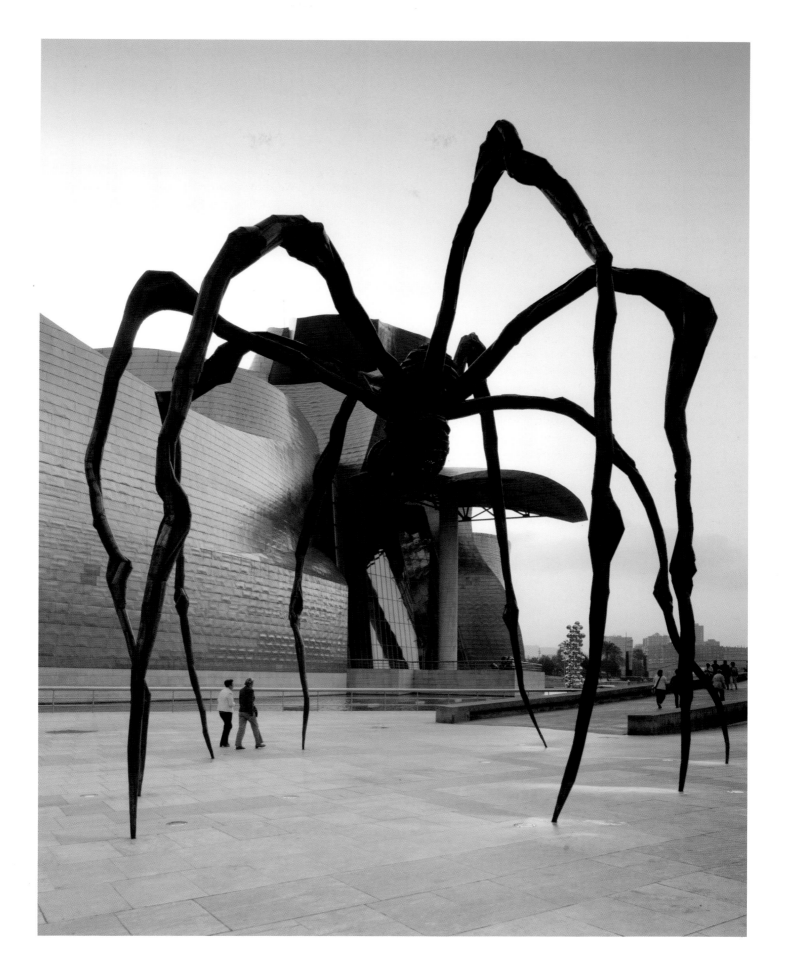

British artist Glenn Brown would rather you didn't recognize him on the street. For the past ten years, when asked by publishers or publicists for a photograph of himself to appear alongside his work in books or catalogues, Brown has invariably only permitted instead the reproduction of the enigmatically entitled *Sex*, a portrait he painted in 2003 of what appears to be a decomposing sixteenth-century courtier. Refusing to pose for photographs, Brown has explained to interviewers that the reason he remains visually evasive is to keep alive the possibility that any one of his portraits could contain elements of self-portraiture, a potential that would be forfeited if his face were more widely known. For Brown, it seems, preserving the mystery of his own features enlivens every one of his works with added intrigue, as though there existed some mystical continuum between the texture of life and the texture of art. This carefully managed invisibility allows Brown to assume in the minds of those who view his work an endless array of possible identities, unrestricted to time or place. In a sense, every work is a self-portrait, and none is.

The instinct to operate utterly incognito is only complicated in Brown's case by his ceaseless borrowing of artistic subjects from the past, which the viewer feels he or she has encountered countless times before on the half-remembered walls of half-remembered museums. But in Brown's hands, the familiar pose and countenance of a stock Elizabethan sitter, as in the case of *Sex*, undergo an unsettling transformation of temperament and tone, the refined fabric of the decorative ruff and the figure's supple complexion beginning to dissolve into a swirl of acidic decomposition. The skin's sickly hue and spectral film fogging the sightless eyes suggest a slow unravelling of substance and sense, held together only by the conventions of artistic posture. The eerily absent stare recalls the silvery sockets of Modigliani's unpupiled portraits.

What can be gleaned about an individual when gazing into the face of a work of art? That portraits are never portraits of the sitter but portraits of the artist's absent eyes, jittering in a timeless void, conjuring faces from the artificial detritus of art history? Perhaps this is the likeness of Brown after all, a prototype for the perennial painter who ages, Dorian Gray-like, only through his works. Glenn Brown would rather you didn't recognize him on the street but in the far-away stare of every portrait you have ever seen.

Glenn Brown, **Sex**, 2003. Oil on panel,
126 × 85.1 × 2.9 cm (49⅝ × 33½ × 1⅛ in.)

What do art and death have in common? Nothing less, it turns out, than a small box of tiny construction beams and a fistful of bolts and screws. When American toymaker A. C. Gilbert invented the legendary Erector Set in 1911, providing millions of children with the necessary materials from which anything could be engineered, from miniature Ferris wheels and fairground carousels to small-scale suspension bridges and toy factories (and even, according to version No. 12½, released in 1949, a 'Mysterious Walking Giant'), few would have predicted that, with the right imagination and sufficient perseverance, within a century these same modest components would create both a working death machine and one of the age's most memorable works of contemporary art.

In February 1998, police in the state of Michigan seized a bizarre contraption devised by the physician Jack Kevorkian (better known as 'Dr Death' for his flouting of laws restricting euthanasia); it had allegedly been used by Kevorkian to assist a quadriplegic man end his life the day before. The ingeniously concocted gadget, which required the merest movement of the suffering patient's head to activate, was incongruously construed from the same rudimentary Erector beams that

American artist Chris Burden, one decade later, would use to build a monument to childhood aspiration: an over nineteen-metre-tall toy skyscraper nostalgically entitled *What My Dad Gave Me*. The one million teensy trusses and threaded nuts required to construct the painstaking replica of the Rockefeller Center's GE Building (faithful to the width-to-height ratio of the famous Art Deco skyscraper) were tightened into one piece in Los Angeles before being winched into place near the work's inspiration in the Rockefeller Center plaza.

The intricate metallic lattice of the oversized plaything seemed at once fragile and formidable, glinting in the June and July sun like a delicate crystallite palace, while at the same time shouldering its surroundings with assured geometric sturdiness. For those who admired the work's ambition, Burden had managed to snap together the very DNA of childlike imagination and creative wonder. Where Kevorkian, who called his gizmo the 'Mercitron' (or mercy machine), found in a scattering of screws and pulleys the ingredients of a dignified death, Burden saw something else: a blueprint of innocence, a double helix of life's awe.

Chris Burden, **What My Dad Gave Me**, 2008.
Installation at Rockefeller Center, New York.
Approx. 1 million stainless steel Mysto Type I
Erector parts, nuts and bolts, and stainless
steel base plate, 19.96 × 3.51 × 3.43 m (65 ft
6¾ in. × 11 ft 6¼ in. × 11 ft 3 in.)

If the by now fatigued question 'What is art?' begs wearily never to be asked again, why not try another: 'Where is art?' This is the conundrum that French artist Daniel Buren has been forcing us to face for the past fifty years. 'Give me a museum', Picasso is said to have boasted, 'and I'll fill it.' The statement is usually cited as an example of the artist's unrupturable reservoir of self-confidence but it also implies that objects can only be validated as art within the orthodox confines of a museum. Picasso could as easily have asserted, 'Give me a stadium or a street or a desert and I'll fill it.' The issue, in other words, is not one of how much space, but of what sort of space.

That art should be consigned to the margins of our experience has been Buren's burden since the 1960s when, unable to afford a studio of his own, he began working 'in situ' on the streets of Paris, insinuating his works into unsuspecting public spaces. It's there that he devised his relentless visual vocabulary of alternating white and coloured stripes – each, without variation, 8.7 cm wide – to which he would adhere for the next five decades. Buren's stripes, neither representational nor abstract, soon became a kind of guerrilla flag with which he could radically stake claim to public property – from bus stops in Los Angeles to museums in New York – daring those who encountered the relentless pattern either to assign or deny it meaning. Most famously (and controversially), Buren's imaginative reclamation of municipal space took the form of black-and-white striped stone columns of varying heights arranged in the courtyard of the seventeenth-century Palais Royal in Paris for a work entitled *Les Deux Plateaux* (The Two Levels, 1986). Clashing irreverently with the aging Richelieuian grandeur of the space, Buren's columns appeared to rise up through the city's skin to herald a new dynamism of artistic vision not confinable to the parlours of the privileged.

Nearly two decades later, and Buren's stripes have become a global logo, a brand, whose sponsorship every international art institution is eager to win. In 2004, to coincide with the opening of the French cultural year in China, Buren was invited to design a grand walkway leading to the Temple of Heaven in Beijing, which he lined with blue-and-white striped banners, *De l'azur au Temple du Ciel* (From the sky to the Temple of Heaven). The sight of Buren's once iconoclastic stripes, rippling victoriously in situ on imperial property thousands of kilometres from where he made his radical start, must surely have been the most emphatic symbol that Buren had succeeded in tearing down the museum walls. Where is art? As Daniel Buren's triumphant stripes prove, it's anywhere you can dream.

Opposite: Daniel Buren, **De l'azur au Temple du Ciel** (From the sky to the Temple of Heaven), 2004. Permanent installation at the Temple of Heaven, Beijing. Various media, dimensions specific to site

Right: Daniel Buren, **Les Deux Plateaux** (The Two Levels), 1986. Permanent installation at Palais Royal, Paris

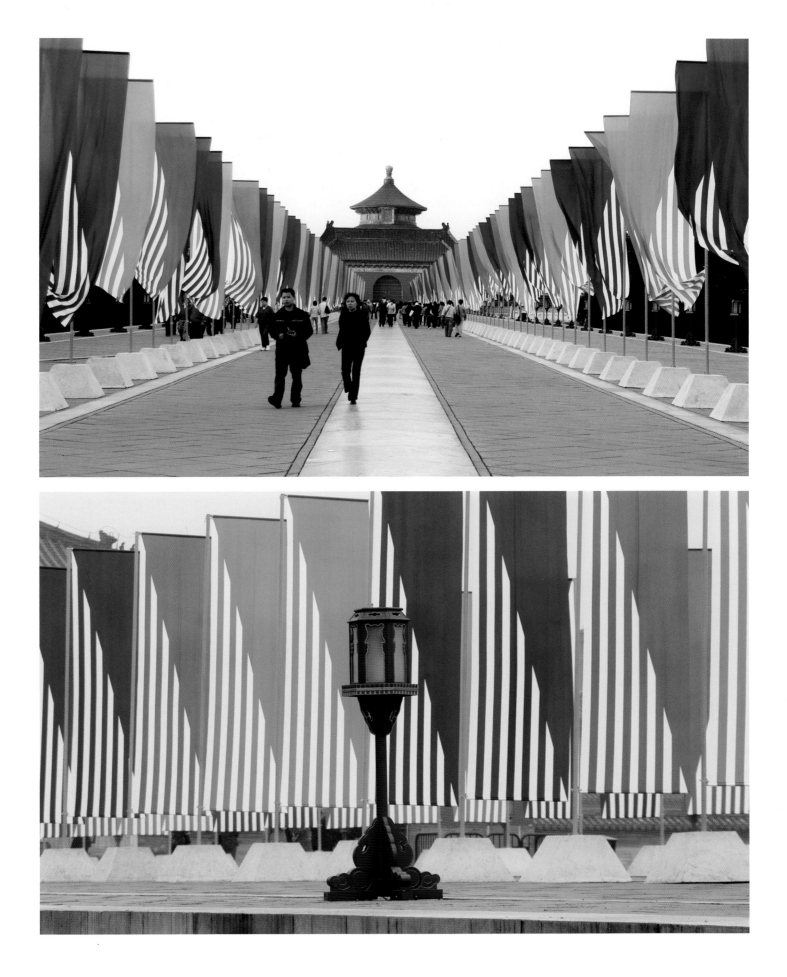

When fifty-one-year-old French artist Sophie Calle received an email from her lover abruptly ending their relationship, the trauma triggered that unsettling sensation we have all experienced, where familiar words suddenly appear strange, misshapen and without meaning. The flippant farewell with which the message concluded, 'Prenez soin de vous' ('Take care of yourself'), was especially disorientating. What, the artist wondered, could the phrase possibly mean? This question invigorates Calle's intense multimedia installation *Take Care of Yourself*, for which she invited 107 women to interpret, from their unique professional perspectives, the befuddling email. The result is an oversized dossier of diverse textual analyses, films and photographs in which the message is deconstructed over and over again. The services of a scriptural scholar were solicited, and those of a clown; an expert on social manners was brought in and so too was a forensic psychiatrist; there's the testimony of a chess master and that of a sexologist; an opera singer was consulted, as was a puppeteer.

Many of these interpretations take the form of filmed readings of the callous email in which the performances at once exude the professional temperament and preoccupations of the participants, and capture a shared bewilderment and pain. The installation also includes evidence of the relentless tests to which Calle subjected the email, from fastidious copy-editing to cartoonish animation, from tarot readings to the marksmanship of an expert sniper, whose bullets punched three clean holes in a printout of the message. The pebbled white-out of a Braille translation of the email contrasts elsewhere with the cold linearity of the supermarket barcode into which the words have been commodified and the mosaic of a crossword-puzzle version also on display. Calle's exhaustive and exhausting efforts to come to terms with the harsh meaning of these sentences and words gather into an unexpected poignancy. The installation becomes a metaphor for the disorientation we all feel in the face of the universe's indecipherable scrawls, which so often we interpret as indifference and abandonment.

The work fits inevitably in the *oeuvre* of an artist known for her tireless and often controversial search for clues to life's elusive meaning. Calle first attracted attention in 1980, when she stalked an unsuspecting man she had met in Paris all the way to Venice, eventually exhibiting photographs she had taken over the course of this self-assigned surveillance. A year later, her own existence became the target of clandestine observation after the artist consented to her mother hiring a private investigator to follow her and record her movements in documents that she would later curate and exhibit. For other works, she has served as a chambermaid in an Italian hotel, combing through the personal effects of unwitting guests and photographing their belongings, and even once, upon finding a stranger's misplaced address book on the street, she proceeded to call everyone listed in an attempt to build a profile of its oblivious owner, preserving transcripts of the interviews for later publication. *Take Care of Yourself* is yet another ambitious example of the lengths to which Calle will go to exert a scrutinizing gaze on herself and others in order to expose the strangeness of all we say and do.

Opposite: Sophie Calle, **Rifle Shooter, Sandy Morin**, from **Take Care of Yourself**, 2007. Print dry mounted on aluminium, wooden frame, 112.4 × 139.7 cm (44¼ × 55 in.); paper printed on wood, LED lights, wooden frame, glass, 52 × 52 cm (20½ × 20½ in.)

Right: Sophie Calle, **Take Care of Yourself**, 2007. Installation at Paula Cooper Gallery, New York, 2009. Various media, dimensions specific to site

IS ALL
ART
NOSTAL·
GIC?

Art is longing.
You never arrive,
but you keep
going in the hope
that you will.

ANSELM KIEFER

Must art be transformative? According to Circuit Court judge D. B. Parker, in a ruling delivered in Manhattan in April 2013, the answer is yes. It was Parker who wrote the decision of a three-judge panel that presided over a key intellectual-property-rights case involving French photographer Patrick Cariou, who had accused American artist Richard Prince of stealing images from his book about Rastafarians, *Yes Rasta*, published in 2000. The work that Cariou objected to was a series of collages Prince unveiled in 2007, entitled *Canal Zone*. Although the collages relied, often substantially, on photographs from Cariou's book, no permission was ever sought or granted.

For nearly thirty years, Prince has built a formidable reputation as a practitioner of so-called appropriation art, which involves the incorporation of other artists' works, often without official licence. Prince came to prominence in the 1980s with his painstakingly precise 're-photographs' of Marlboro cigarette advertisements, taking advantage, as all appropriation artists do, of a loophole in copyright law known as 'fair use', which permits the adoption of another person's work provided some degree of conversion of the original has occurred. But what constitutes sufficient transformation? Prince's alterations to Cariou's photographs were often minimal, in one instance involving merely blotting out the eyes and mouth of a portrait and pasting in a cut-out of a guitar. Other collages revealed little more intervention than contrasting fragments of Cariou's portraits with swatches of pornography. When several of the works sold for a total of $10 million, provoking the French photographer's outrage and subsequent decision to take legal action, Prince's contested technique attracted attention from an art world petrified that a ruling against the appropriationist could prove devastating for collectors and museums across the world. And there was reason for concern. A decision that found the unauthorized assumption of images in violation of copyright law could conceivably force the surrendering of such pieces to the copyright holders whose works had been borrowed, potentially gutting both private and public collections.

The case brought by Cariou against Prince called attention to the extent to which so much contemporary art relies on adaptations of adopted material and resuscitates age-old questions about originality *ex nihilo* and the nature of creativity: whether any work can adequately be severed from the unfolding narrative of images and ideas that inspired it. In April 2013, Judge Parker's panel ruled two to one in favour of Prince, substantially overturning an earlier ruling in March 2011 that had concluded insufficient 'transformation' of the original photographs had been achieved by Prince and demanded the relinquishment of the collages to the plaintiff.

That's not to say Prince is out of the proverbial woods. Five of the contested works, including the man with the pasted-in guitar, are due to be handed over to the District Court for further analysis of the scale of 'transformation' undertaken by the appropriationist. The eventual resolution of Cariou vs. Prince, with all its ramifications to the artistic imagination and the art market alike, is as likely to define the next age as the initial clash has helped to define our own.

Patrick Cariou, photograph
from the book **Yes Rasta**, 2000

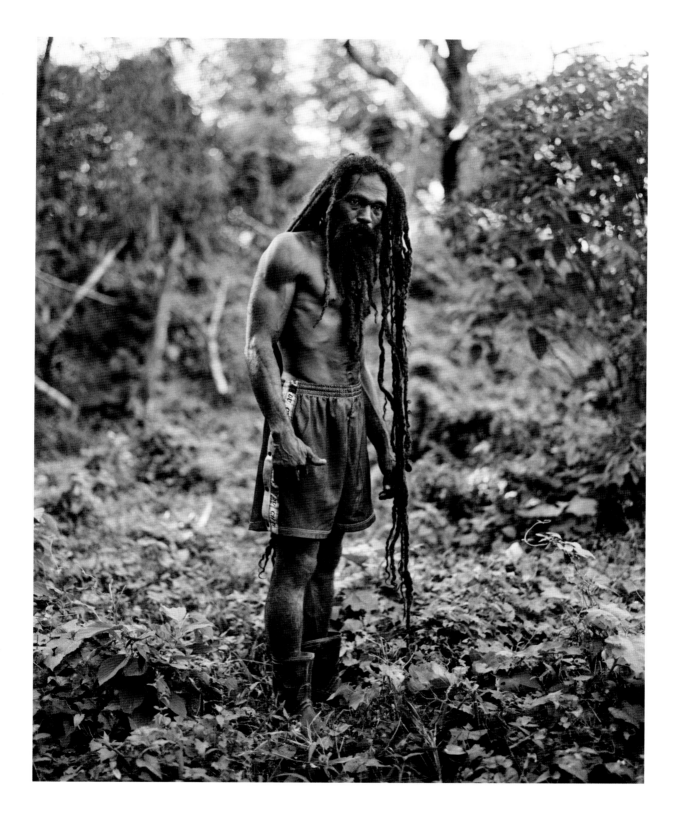

Says who? Knowingly or not, it is a question we ask of every work of art. Is the muscular equestrian statue, neighing in the old town square, an obnoxious relic of triumphalist vanity or a moving tribute to military courage? Our attitude may depend on whether the piece was paid for by the man in the saddle or by those he liberated. Ambiguity makes the mind grow fonder and a riddling indeterminacy about the point of view of Maurizio Cattelan's 2010 sculpture *L.O.V.E.* rescues the work from a surface crudeness that might otherwise have swamped its power. The eleven-metre-tall statue of a hand that appears to be raising its middle finger in adolescent defiance caused a considerable stir when it was unveiled in Milan's Piazza degli Affari, beside the city's stock exchange. Influential financiers, offended by what they perceived to be a profane gesture of collective social opprobrium, relocated meetings. Business schools cancelled conferences scheduled to be held in adjoining buildings. Executives with plush offices facing the Piazza demanded new digs away from the crass eyesore.

But insult is in the eye of the beholder. A closer look at the work reveals that the oversized extremity is not in fact curling its stony fingers back to emphasize a single offending digit, in the manner of what Americans call 'flipping the bird' – a supposedly phallic gesture of belittlement that can be traced as far back as fourth-century BC Athens and the Greek philosopher Diogenes, who allegedly declared while making it 'this is the great demagogue!' Rather, the sculpture actually depicts a disabled hand, whose index, ring and pinkie fingers have all been broken off.

The artist has explained that the intention behind the piece was to disfigure the fascist salute of Mussolini. Perhaps. But at a time when the world was reeling like never before from the effects of fiscal abuse and the introduction of austerity measures, which seemed to inflict pain on everyone but bankers, Cattelan's provocative decision to point his finger in the heart of Italy's financial centre left few in doubt that first impressions of the work's message were right. Still, the question of whom is flipping whom off remains unsolved. Is this the hand of the people symbolically jabbing their anger towards the financiers who brought the world to the brink of collapse or is it, adding insult to injury, the other way around?

Maurizio Cattelan, **L.O.V.E.**, 2010.
Installation at Piazza degli Affari, Milan.
White 'P' Carrara marble hand, 4.70
× 2.20 × 0.72 m (15 ft 5⅛ in. × 7 ft 3⅛ in.
× 2 ft 4⅜ in.); bright Roman travertine
base, 4.70 × 4.70 × 6.30 m (15 ft 5⅛ in.
× 15 ft 5⅛ in. × 20 ft 8⅞ in.); full height
11 m (36 ft 1⅛ in.)

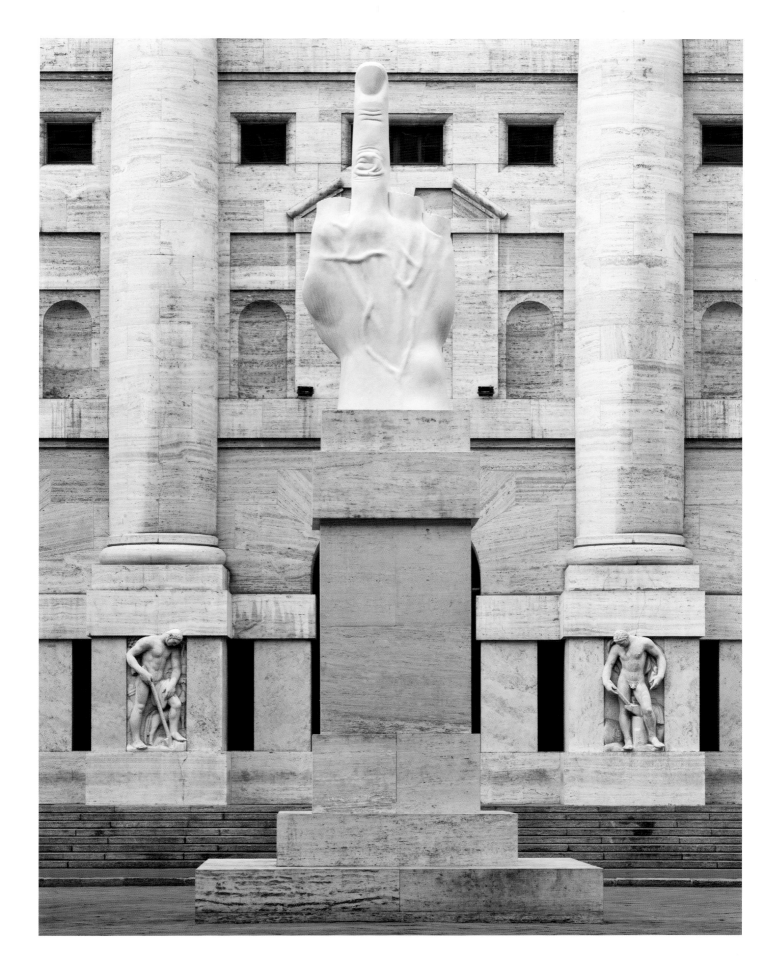

'What happens if you make a work of art where you say, "no, it's only nasty"?' The question was posed by the British artists Jake and Dinos Chapman when an interviewer asked if their work might, despite its apparent offensiveness and depravity, have 'spiritual' or 'uplifting' dimensions to it. 'My easy answer to that', Jake fired back, 'is no, and quite vehemently'. However animated the conversation may have seemed, it paled beside an exchange from 2003, which stunned even the brothers' most ardent admirers. When asked if 'transgression' was crucial to their vision, Jake replied 'yes' and explained that their work performed 'a good social service like the children who killed Jamie Bulger'. His allusion to the abduction, torture and brutal murder in 1993 of a two-year-old child by a pair of ten-year-olds was as repugnant as it was telling, shedding dark light on a decade of dark collaboration.

After years of staging mutilated mannequins in scenes of disturbing abuse, in 1999 the Chapmans embarked upon the work for which they would become best known: nine glass-enclosed dioramas arranged in the shape of an inverted Nazi swastika, entitled *Hell*. Each showcase featured miniature figures revelling in fantasies of the Holocaust. The obsessiveness that characterized the work, which incorporated thousands of toy soldiers positioned into vignettes of genocidal horror, begged for diagnosis, like the doodlings of a deranged toddler. Describing the tableaux as 'immensely sadistic', Jake insisted to one journalist that it was 'a work which doesn't respond morally to something which has become so cloaked in morality.' The suggestion that morality is merely a disposable mantle that has been fashionably draped across the Holocaust – and one that can be dispensed with as cavalierly as the Cubists rejected conventional perspective and the Fauvists did away with representational colour – offended many.

In the years following the unveiling of *Hell* (which was destroyed in a warehouse fire in 2004), the brothers turned their attention to the defacement of a rare set of prints by Goya and to the display of original works on paper by Adolf Hitler, to which the pair had added details in order to boast of their collaboration with the Führer. Is this, as the smug title of a retrospective of their work in 2006 taunted, 'bad art for bad people'? I'm with Jake: this is work with absolutely no redeeming qualities. Nothing but nasty.

In an age of creative mash-ups, in which Jane Austen and zombies converge in the narrative of a novel and cowboys and aliens share a screen, why shouldn't violent psychopathic slurs and displays of sickening inhumanity be elevated to the status of art? To answer that question one has to be prepared first to establish principles, those close cousins of the morals that Jake and Dinos toss off as unfashionably outmoded. The Chapmans's unrelenting vulgarity has ground the lens through which our era of 'anything goes' can be brought into focus. Befuddled by the attention accorded them, critic Robert Hughes dismissed the pair as 'twerps, whose names will be forgotten a few years from now'. We'll see.

Opposite: Jake and Dinos Chapman, **Hell** (detail), 1999–2000

Right: Jake and Dinos Chapman, **Hell**, 1999–2000. Installation at the Royal Academy of Arts, London, 2000. Nine vitrines, each fibreglass, plastic and mixed media; eight vitrines 2.15 × 1.29 × 2.50 m (7 ft 2⅜ in. × 4 ft 3⅛ in. × 8 ft 2⅜ in.); central vitrine 2.15 × 1.28 × 1.28 m (7 ft 2 in. × 4 ft 3⅛ in. × 4 ft 3⅛ in.)

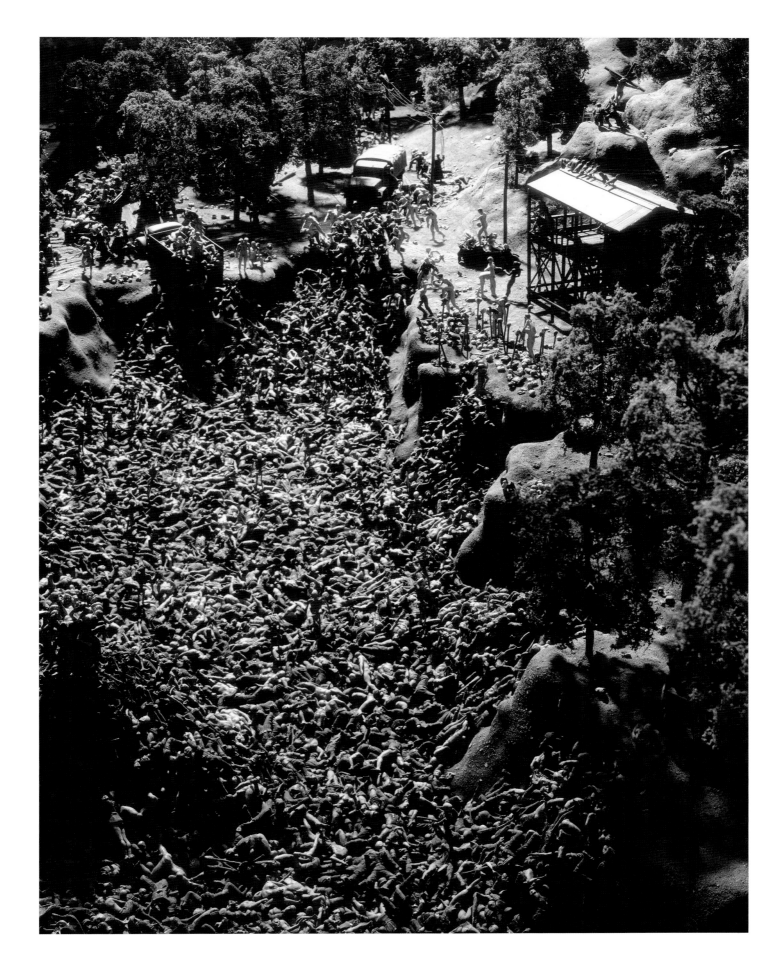

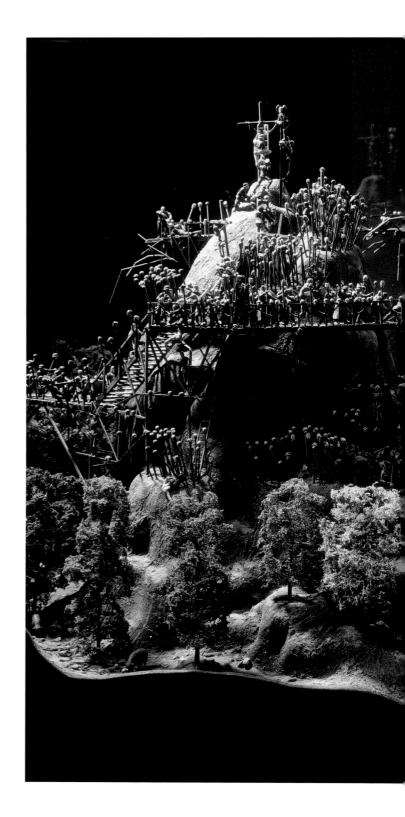

Jake and Dinos Chapman,
Hell (detail), 1999–2000

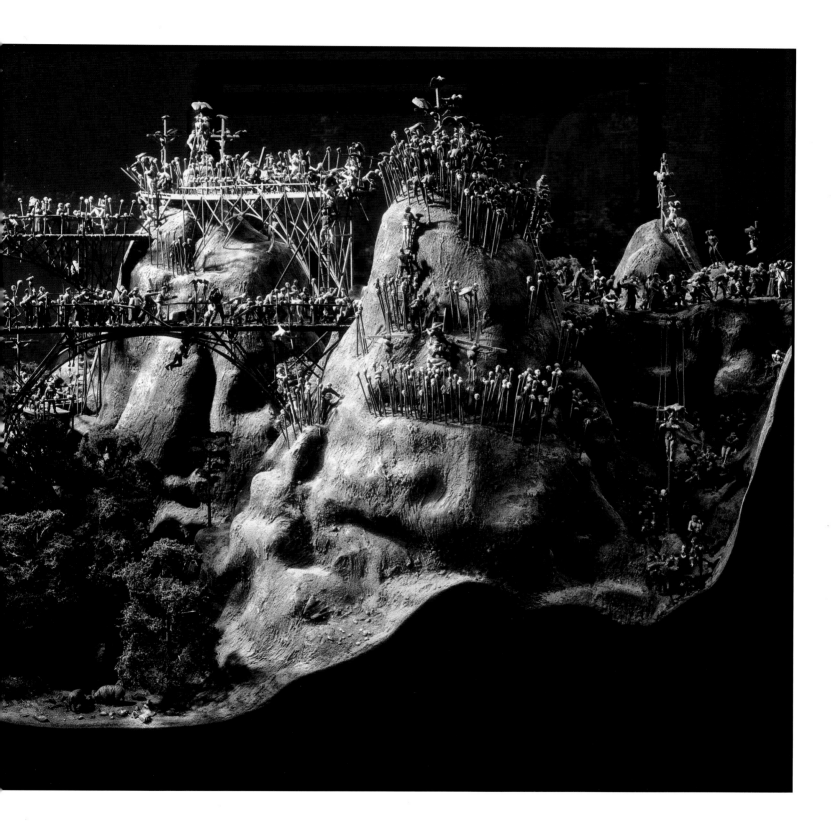

Are you coming or going? It's the question posed by every gate and one that Christo and Jeanne-Claude's sprawling public installation, which snaked across all 843 acres of Manhattan's Central Park for sixteen days in February 2005, asked precisely 7,503 times. That is how many oversized vinyl door frames, draped with pleated swathes of bright fabric, the artists erected, transforming the meandering paths of one of the city's most adored spaces into flowing rivers of orange and awe, for what was heralded as the largest work of art ever attempted in New York City.

While some works commemorate great events, others *are* great events. This was certainly the case for *The Gates*, which took the couple twenty-six years, $21 million and four successive mayors to realize. When pressed to explain the symbolic significance of the ambitious work, the artists insisted it was never intended to represent or commemorate anything in particular, but to be merely a source of beauty and joy – a gift to the city, an occasion for celebration in and of itself. Some visitors refused to accept that the project had no hidden meaning and attempted to decipher anything that could be interpreted as code. Perhaps, some speculated, the

nearly one hundred thousand square metres of saffron fabric was a clue. Was the billowing of bright colour intended to echo the robes of Buddhist monks, who dye their garments in turmeric and jackfruit? Others saw in the door frames a resemblance with the vermilion torii gates that lead to Shinto shrines in Japan, reinforcing the suspicion that the project was secretly laced with Eastern significance.

But for most, the quiet philosophy of the humble gate was sufficient to pass through again and again against a white-out of snow, leaving and re-entering one's life every few strides. Never the destination itself, a gate stands between here and there, now and then. Once erected on the perimeters of ancient cities, gates have a way of surviving, however ruinously, even when the structures and civilizations to which they were designed to offer entrance or enforce expulsion have long since dissolved and blown away. Though Christo and Jeanne-Claude's gates only existed for sixteen days, for those who revelled in their fleeting existence, the posterns implanted themselves onto the blueprints of their mind, demarcating the invisible passageways we forever take into and out of ourselves.

Opposite: Christo and Jeanne-Claude,
The Gates, 1979–2005. Installation in Central
Park, New York, 2005. 7,503 gates, each vinyl
and cloth; 4.88 × 1.68–5.49 m (16 ft × 5 ft
6 in.–18 ft)

Overleaf: Christo and Jeanne-Claude,
The Gates, 1979–2005. Aerial view of
installation in Central Park, New York, 2005

021 Self-Portrait (1997) CHUCK CLOSE

Art heals. The assertion is more than merely rhetorical or wishful when it comes to the life and work of American portrait painter Chuck Close, who suffers from the rare cognitive disorder prosopagnosia, or face blindness. Put simply, Close cannot recall faces and for him the creative act of portraiture has come to be a kind of psycho-physiotherapy that helps him flex and strengthen otherwise unresponsive muscles of memory.

For Close, the process of surveying at enormous scale the contours and undulations of a human countenance, breaking its features down into a plotted grid, is like mapping an undiscovered country – an alien territory that the artist is then able to conquer one square at a time. Close cognitively reclaims each square of the grid by translating the curves and colours it contains into an abstract system of amoebic squirts. Eventually, these squirts will cohere in the viewer's eye when seen from a distance. Up close, the discrete squiggles continue to squirm and divide like well-behaved bacteria in a Petri dish.

Over time, Close's own face has become as inviting a laboratory slide to analyse as any other specimen – an obsession that accelerated after the artist suffered a devastating spinal artery collapse in December 1988, which triggered a seizure that left him temporarily paralysed below the neck. A protracted period of rehabilitation returned sufficient movement to the arms enabling Close to resume painting. The likenesses that have followed, most notably his 1997 *Self-Portrait*, vibrate with hidden knowledge. The tension between the grid's constituent squares (each one containing an amorphous molecule) and the larger mosaic of the face that they combine to form seems charged with an understanding of how the infinitesimal collects into the infinite – how the perishable components of our material existence figure in a larger design. One senses that the cells that compose the artist's face could easily be reassembled or anagramized into one's own and that our ability to recognize the humanity of others is the key to recognizing who we are.

Chuck Close, **Self-Portrait**, 1997. Oil on canvas, 2.59 × 2.13 m (8 ft 6 in. × 7 ft)

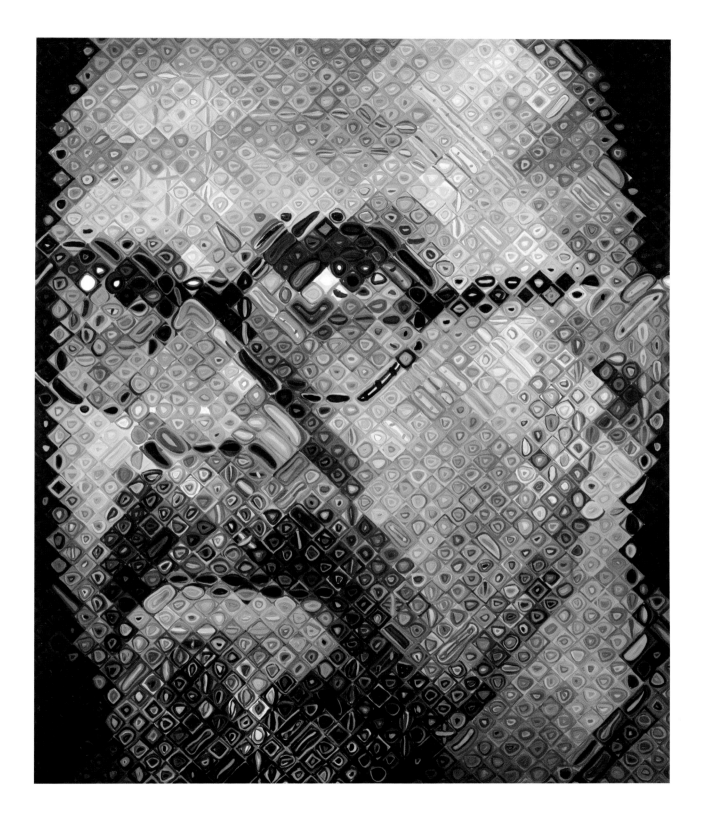

Work No. 227, the lights going on and off
(2000) M A R T I N C R E E D

A child dies of hunger. You blink. A crime is committed in England. Someone somewhere in the world goes blind. The frequency of each of these occurrences is every five seconds. Five seconds, so it seems, is the simultaneously mundane and meaningful unit in which our lives can be micro-measured. So essential is this puny calibration one feels there ought to be a dedicated word for its fundamental duration: a 'pentecond', perhaps, or better still, a 'creed'. No artist has seized upon the cosmic and quotidian significance of the five-second interval more elegantly or controversially than the British artist Martin Creed, whose installation *Work No. 227, the lights going on and off* tripped the fuse of many detractors when it was first exhibited in 2000.

Composed merely of a simple timer programmed to switch the lights alternately on and off every five seconds in an otherwise empty gallery, Creed's minimalist gesture was greeted both by admiration and abject contempt. Those who appreciated the work compared its pared-down power to American composer John Cage's avant-garde experiments with silence and sound; this was powerful postmodern poetry,

they insisted, whose syllables were as primal and profound as darkness and light. Those who derided the project were convinced it amounted to nothing more than a botched DIY job and believed an art world that could celebrate such a display was hard-wired for inanity.

Not long after Creed's exhibition opened, an artist living in Hampstead, north London, by the name of Jacqueline Crofton, awoke from a dream in which she was hurling eggs at the empty walls that hosted the provocative light feature. When she confided in her husband, he was horrified at the subconscious violence. One can only imagine then how he felt when hours later news emerged of his wife's arrest at Tate Britain for defacing, while awake, that same work of art. 'I have nothing against Creed', Mrs Crofton, who was banned for life from entering another Tate gallery, would later explain to a reporter, 'although I do not think his work can be considered art. At worst, *The lights going on and off* is an electrical work. At best it is philosophy.' Was she right? Yes … No … Yes … No … Yes … No … Yes … No … Yes … No … Yes … No … Yes … No …

Martin Creed, **Work No. 227, the lights going on and off**, 2000. Installation at the Museum of Modern Art, New York, 2007. Lighting, 5 seconds on, 5 seconds off, dimensions vary with installation

Where do we go from here? It's a question that every artist, in every age, must ask. For writers, the challenge famously lies in overcoming the paralyzing 'anxiety of influence' – the fear that everything has already been said or written. This anxiety leads, some believe, to unintentional misreadings of the great works of the past in order to justify rewriting them in a new voice. As Cervantes rewrote Dante, so Tolstoy rewrote Cervantes, and so the family tree of literature branches out into the unknown of imaginative space. But what is the equivalent phenomenon in art? The paintings of American porno-portraitist John Currin, that's what, particularly his 1999 double portrait *The Pink Tree*, a perfect example of the endless recasting of old into new.

To encounter Currin's pair of frolicsome strawberry-blonde nudes, nymphing around in the timeless nowhere of an idealized world, is to experience déjà vu. Surely we've seen these fantasized bodies before, haven't we? Haven't these stylized heads and inscrutable smirks, these narrow shoulders and perfect porcelain skin, all set off against an eternalizing blackness, been shamelessly lifted from the early Renaissance easels of Botticelli, say, or Lucas Cranach the Elder? Yes and no. Comparing a representative work of the latter, Cranach's *Venus* of 1532, with Currin's traipsing twosome exposes how the anxiety of influence plays out on the canvases of one of the most sought-after American painters working today; Currin misreads Cranach and then repaints him.

Cranach manipulated the contours of the human form in order to express a lilting musicality consistent with his era's belief in the cosmic harmonies of bodies. The sensuous and complementary curves of belly and back, shoulders and thigh, are accentuated by the neutral space in which the solitary figure poses. By contrast, Currin's fantasy is all about the rumpus of inharmoniously intersecting limbs, the knobble of elbows and knock of knees, suspended against a fleshy pink castration of severed branches.

Neither Cranach's nor Currin's bodies equate to any reality of human form, but Currin's artificiality emerges self-consciously from the context of contemporary pornographic representations of women, and its distortions follow the new norms of synthetic augmentation. Today, the music of the spheres is orchestrated by the nip and tuck of the plastic surgeon's scalpel. If Cranach's *Venus* is all about the essence of natural seduction, Currin's *The Pink Tree* is all about frustration with the phony constructs of unnatural beauty. Though Currin's nudes are no more a reflection of actual female beauty than airbrushed pin-ups of the 1950s, his decision to act out his deceptions in the rehabilitated visual space of Old Masters – perhaps a way of redeeming depictions of women in his earlier work that some had dismissed as misogynistic – has proved extremely clever from a sales point of view. No one ever said that the anxiety of influence meant an anxiety of affluence.

Opposite: John Currin, **The Pink Tree**, 1999.
Oil on canvas, 1.98 × 1.22 m (6 ft 6 in. × 4 ft)

Right: Lucas Cranach the Elder, **Venus**, 1532

A mechanical elephant by the name of Snowdrop. The sign on a hairdresser's shopfront that reads, 'It will grow back'. A double-portrait of the London gangsters, the Kray twins, tattooed to someone's leg. A photograph of a smiley face traced in the dust on the back of a white van. Graffiti on a brick wall in Leamington Spa that pleads 'Give Violence a Chance'. Is any of this art? It is now. For eight years, from 2000 to 2007, British artists Jeremy Deller and Alan Kane busied themselves preserving evidence of the informal folk aesthetic we encounter every day in public spaces, yet rarely accord the status of art. Consisting of over two hundred and eighty objects and images, from a pincushion in the form of an ambulance to a Michael Jackson scarecrow, from photos of a face-pulling competition to protest banners, the *Folk Archive* installation, later preserved as an internet website, embraces a curious array of material that challenges us to ask not 'What is art?' but 'What isn't?'

If, as George Howard Opdyke wrote in his 1933 study *Art and Nature Appreciation*, 'fine art is where you find it, and fine artists where you find them, no matter what the art', Deller and Kane's project is an egalitarian omnium gatherum of creative energy intent on widening our conceptions about who makes fine art to include just about everybody. As such, the work is a subversive rejoinder to those who would deride the achievements of contemporary artists by insisting 'Hell, I could do that.' The *Folk Archive*'s response isn't to make a pretentious case for a work's invisible sophistication, but instead to say, 'You already did.' The result is a rich documentary of hidden creativity and imaginative ambition that does not require the elite validation of galleries. Such cultural inclusiveness might be compared with the ambitions of other works explored in this volume, especially Mike Kelley's nostalgic hodgepodge of Americana, *Day is Done* (2005), and Mark Wallinger's protest display, *State Britain* (2007).

Opposite: Jeremy Deller and Alan Kane, **Folk Archive**, 2000–7. Installation at Kunsthalle Basel featuring banner by Ed Hall, 2005

Right: Jeremy Deller and Alan Kane, **Pizza Rut**, Blackpool, 2005, from the **Folk Archive**, 2000–7

Above, clockwise from top left:
Jeremy Deller and Alan Kane, **Rural
Freedom Fighter**, Whitehall, 1999;
Graffiti, Leamington Spa, 2004;
Mobile food wagon, Ely, 2004;
Shack, Dungeness, 2005; all from
the **Folk Archive**, 2000-7

Opposite: Jeremy Deller and Alan Kane,
**Snowdrop the mechanical elephant
and Peter Clare**, Egremont, 2004, from
the **Folk Archive**, 2000-7

025 Blotter (1993) PETER DOIG

On 22 November 1963, within hours of the death of author C. S. Lewis and the assassination of John F. Kennedy, a cancer-stricken Aldous Huxley, unable to speak, jotted a note to his wife requesting 'LSD, 100 µg, intramuscular'. She complied and within hours of injecting him, the author of *Brave New World* (1932), *The Art of Seeing* (1942) and *The Doors of Perception* (1954), was also dead. It wasn't the first time Huxley had sought to swing wide the hinges of his senses and blot out the ache of the everyday, though in the past he tended to soak the acid into a small tab of paper, known as a *blotter*, which he would then suck until tripping. Though we tend to associate the psychedelic drug chiefly with the counterculture of the 1960s, for which Huxley became a kind of patron saint, few individual works of art from that era can compete with the success a generation later of Peter Doig's psychologically intense painting *Blotter*.

Doig's is a work that absorbs into its palette the intense sensual immersion relished by users of the illicit drug.

On its most literal level, the 1993 painting depicts a scene, preserved in an old photograph, from the Scottish-born artist's childhood: his brother stands on a frozen pond that the two boys have dangerously flooded with water in order to alter the texture of their reflections. But soaking into that surface are Doig's own occasional experiments with LSD as a teenager, as well as allusions to the texture of some of his earliest canvases, which he drenched in paint.

So much sousing – physical, psychological and creative – commands the total absorption of the viewer. The child's fixation on his reflection in the work becomes our fixation, a rippling out of sense and self that overwhelms the image, uniting the seen, the seer and the scene. 'The urge to transcend self-conscious selfhood', Huxley asserts in *The Doors of Perception*, a work devoted to his experiences with hallucinogens, 'is a principal appetite of the soul.' *Blotter* satisfies that urge by exploring one soul's utter saturation into something beyond itself.

Peter Doig, **Blotter**, 1993. Oil on canvas,
2.49 × 1.99 m (8 ft 2 in. × 6 ft 6¼ in.)

'The eye', W. H. Auden once explained, 'tends to be impatient, craves the novel, and is bored by repetition'. The occasion for the Anglo-American poet's remark was an attempt to account for the unique demands of our different senses in apprehending works of art, and he was drawing a distinction between what 'the ear' (which, he says, 'tends to be lazy') enjoys and what the eye demands. But is he right? Is repetition a device that only appeals to the ear and makes the eye grow weary? Not if we take seriously the serious work of Canadian artist Stan Douglas, whose 1998 video installation *Win, Place or Show*, might best be understood as a rebuke to Auden's assertion. Relying entirely on the profundity of visual repetition, Douglas features in side-by-side windows on the same screen ceaseless loops of a spirited and ultimately violent confrontation between two men, Donny and Bob. Douglas's hectic visual music, is achieved by slicing the six-minute interaction between Donny and Bob down to six narrative components – the cracking of a joke, the outlining of a conspiracy theory, consulting a newspaper, a quarrel, the flipping of a coin and a brawl – each of which were filmed from a variety of angles.

These multiple cuts were in turn fed into a sophisticated computer program that shuffles their order before rebroadcasting them onto the screen, such that the exact same version of the meeting between the two men could only recur, with continuous play, every two years. The result is a knotted string theory of human interaction that manages to remain essentially the same while forever changing. 'I have used repetitious structures from certain musical forms', Douglas has explained, describing the inspiration for his complex patterning of experience, in an effort to achieve an uncanny 'confrontation with the mechanical world'. Douglas's dizzying display offers a metaphor for how we ceaselessly reanalyse instances in our lives and highlights the risk in devoting our time to what has been rather than to the endless possibilities of what still might be.

The setting for the various variations is a replica of a 1950s apartment complex that was designed, but never built, in the artist's native Vancouver – a hypothetical space that exists outside the unfolding of linear time. Before long, the surreality of space and recycling of action becomes claustrophobic, like a mechanized nightmare. However fleeting the initial incident or altercation, the replay is never ending. We're aware that the only way out of the moment is closure, yet there is always another angle to consider, another perspective to scrutinize, as though repetition has become both the disease and the cure. 'If repetition makes us ill,' the French philosopher Giles Deleuze once wrote, as if describing the paradox of Douglas's curious machine, 'it also heals us; if it enchains and destroys us, it also frees us.'

Stan Douglas, film stills from **Win, Place or Show**, 1998. Two-channel video projection, four-channel soundtrack and 204,023 variations with an average duration of 6 minutes each, edition of 3

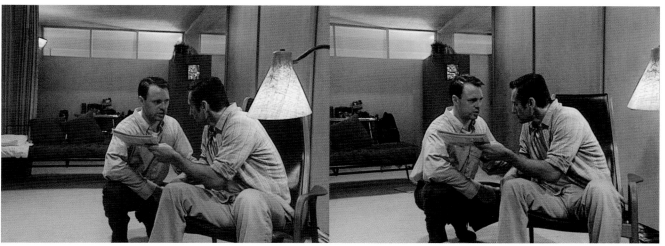

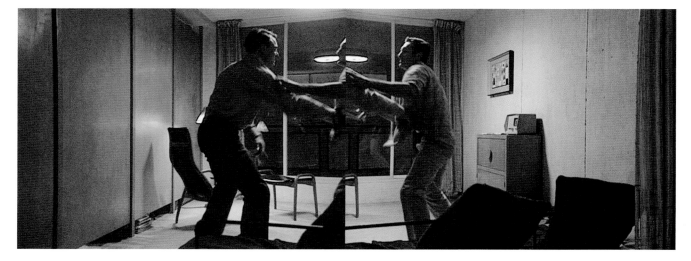

'Something there is', American poet Robert Frost once wrote, 'that doesn't love a wall.' And that something, according to artist Marlene Dumas, is art itself. 'A painting', she provocatively insists, 'needs a wall to object to.' Art, in other words, which conventionally relies on walls for its residency and display, lives in a perpetual state of tension, argument and anxiety. Art is an angry neighbour. It pushes the boundaries and upsets the stones. Wake one morning to discover that the walls you've depended on for definition and demarcation have all been knocked down or disturbed, and you'll know who the culprit is: art. Nowhere is Dumas's certainty in the fundamentally contentious nature of art more conspicuous than in her spring 2010 exhibition, 'Against the Wall', which explored from a variety of angles the tropes of physical, religious, psychological and political division that trouble the terrains of Israel and Palestine.

Dumas's upbringing amid the frictions of apartheid South Africa taught her a great deal about the complexities of segregation. Through these paintings, she exploits the viewer's expectations and prejudices about which particular historical wall she is likely depicting in any given work, from the famous Wailing Wall in Jerusalem to the stretches of security fence that controversially separate the conflicting communities. There are two sides to every wall and Dumas's expertly orchestrated ambiguities of perspective are deliberately disorientating, dissolving these generic partitions entirely.

In this courageously levelling series, the distinctions between groups – those praying at an ancient holy edifice and those being frisked at a makeshift checkpoint – blur into a shared posture of humanity. We're all against the wall now. This is, of course, the same posture that visitors to galleries inevitably find themselves adopting while looking at her works: people staring at a wall of people staring at a wall. In a sense, Dumas's paintings have become the very objects to which her art objects. Someone there is that doesn't love a wall. This is art that tears down walls by building them.

Opposite top: Marlene Dumas, **The Wall**, from the series **Against the Wall**, 2009. Oil on linen, 1.8 × 3 m (5 ft 11⅛ in. × 9 ft 10⅛ in.)

Opposite bottom: Marlene Dumas, **Wall Wailing**, from the series **Against the Wall**, 2009. Oil on linen, 1.8 × 3 m (5 ft 11⅛ in. × 9 ft 10⅛ in.)

Marlene Dumas, **Wall Weeping**, from
the series **Against the Wall**, 2009. Oil on
linen, 1.8 × 3 m (5 ft 11⅞ in. × 9 ft 10⅛ in.)

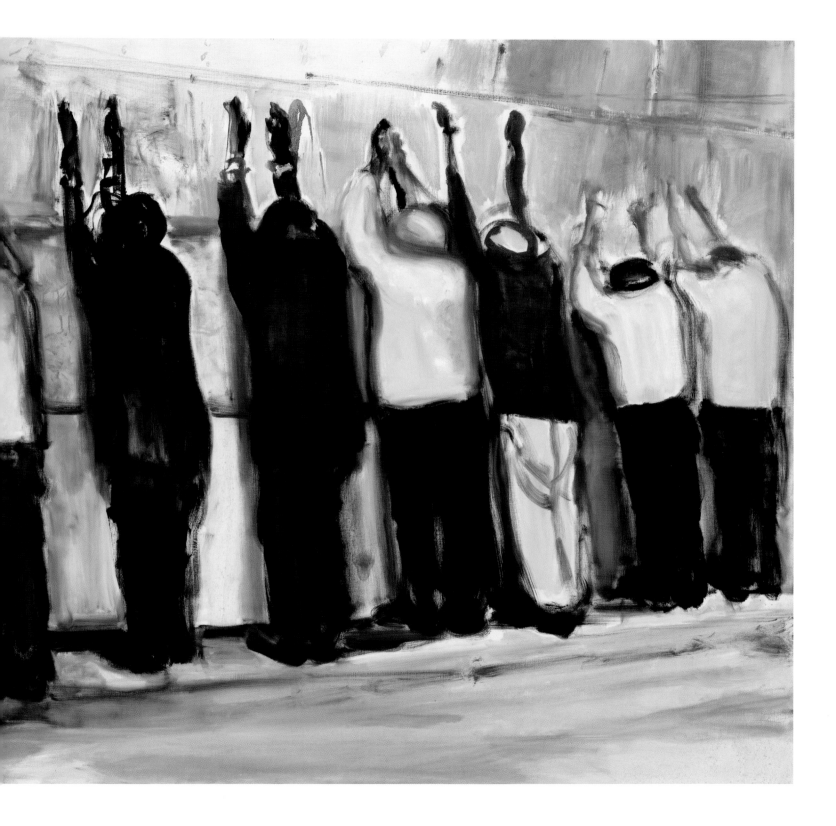

Between 1590 and 1592, some seventy self-confessed Scottish witches were one by one burned at the stake. Their crime? Climate control. The group of Tempestarii, or weather-makers, was convicted of having met with the Devil by moonlight for the purpose of conjuring a series of violent storms that nearly killed King James VI on his voyage to Copenhagen to marry Princess Anne of Denmark. The incident, no doubt, tells us less about the actual meteorological prowess of the accused than about the psychological temperature of the age. Similarly, the success of Olafur Eliasson's bewitching *The Weather Project*, which attracted over two million visitors to Tate Modern's Turbine Hall between October 2003 and March 2004, tells us a great deal about the anxieties and preoccupations of our own age.

The work consisted of an enormous amber sun, suspended supernaturally in the hall's canyon-like space. Though its position in the east of the hazy expanse suggested a rising orb, the eerie aura of something slowly being extinguished was unmistakably, if disorientatingly, that of an all-consuming sunset. Through a simple trick of mist and mirror, Eliasson magicked the appearance of an incinerating sky. The glow generated from the nearly twenty-thousand-watt wall of sodium streetlights, its brilliance echoing in the mirror above, was amplified by a breeze of sugar water. Visitors were left feeling as though they had been lured into the solar soup of J. M. W. Turner's *The Angel Standing in the Sun* (1846), as they watched each other dissolve like hastily sketched silhouettes into a weave of annihilating light. It was this sense of imminent dissolution that made *The Weather Project* so transformative and unsettling an experience.

For most of us whose lives are choreographed against the accelerating debate about the consequences of climate change, the soundness of arguments on either side is a matter beyond our proving. Believing the science or not, however, will not dispel the haunting spirits who whisper to us that 'we live in an old chaos of the sun', that our species' days are numbered in the rings of a weakening corona. Time is running out. Eliasson's elegantly disquieting work reminds us that, these days, when we talk about the weather, we dabble equally in science and superstition, in forbearance and fear.

Opposite and right: Olafur Eliasson, **The Weather Project**, 2003. Installation at Turbine Hall, Tate Modern, London. Monofrequency lights, projection foil, haze machines, mirror foil, aluminium, scaffolding, dimensions specific to site

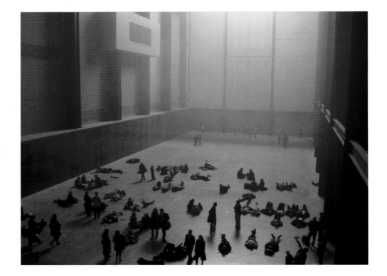

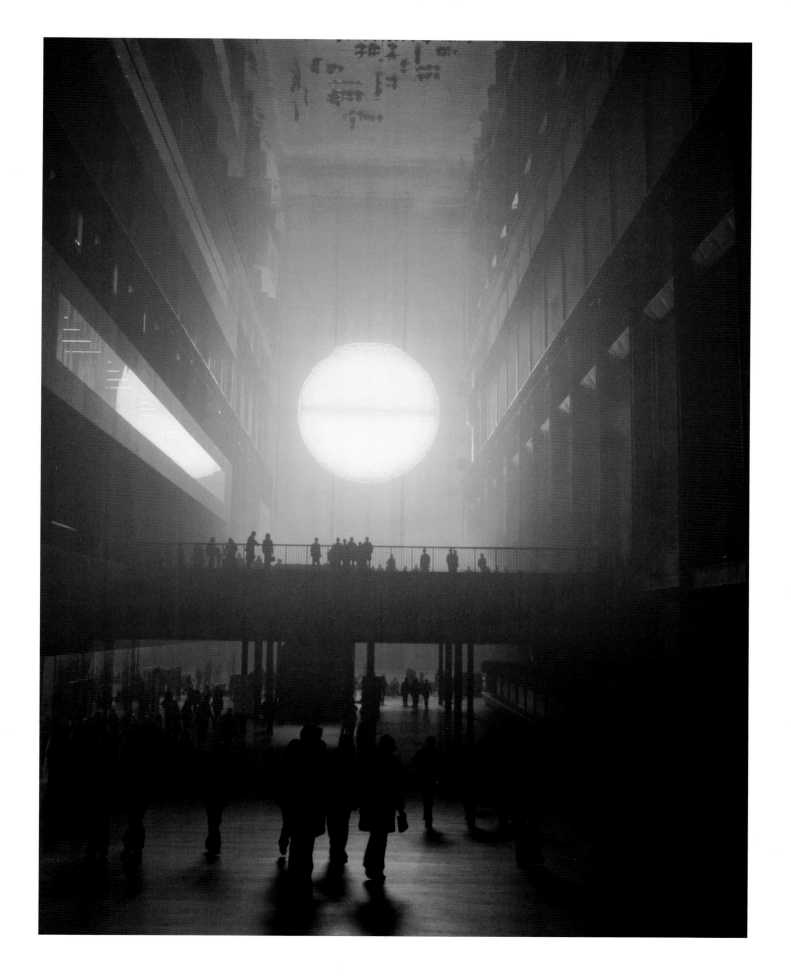

Ever since Leonardo da Vinci's *Mona Lisa* was stolen from the Louvre on 21 August 1911, high-profile art theft has been on the rise. The era to which this book is devoted was all but inaugurated by what has been described as the biggest heist in cultural history, when on 18 March 1990 thirteen works estimated to be worth over $300 million (including paintings by Vermeer, Rembrandt, Manet and Degas) were lifted from the Isabella Stewart Gardner Museum in Boston. Since then, 2005 was a particularly bad (and bizarre) year, witnessing the unlawful removal of three works by Edvard Munch from a hotel in Norway, one 2.1 tonne bronze sculpture of a reclining figure from the Henry Moore Foundation in England and fourteen right-footed, high-heeled shoes from an abandoned shop in the deserted landscape of West Texas.

If the last of these strikes you as out of step with the gravity of the other objects listed, then the artists responsible for creating the burgled work, Scandinavian sculptors and installationists Michael Elmgreen and Ingar Dragset may well feel they have succeeded. Committed since the mid-1990s to questioning traditional ideas about what constitutes art and an artistic venue, Elmgreen & Dragset created a stir in 2005 by constructing a perfect replica of a Prada fashion boutique along US Route 90, thirty-seven miles from the small town of Marfa, Texas (population 2,100). Through the windows of the never-opened shop, bemused onlookers were left to meditate on the immaculately arranged handbags and stylish floor-display footwear of the luxury Italian brand. As the seemingly sole-surviving remnant of an otherwise obliterated civilization, the permanent installation challenges visitors to reflect on what fragmented monuments our age will leave behind for future generations to gaze on. Where the ancient Egyptians gave us the pyramids, and Bronze Age Britons handed down Stonehenge, perhaps our era's contribution to the collective debris of annihilated cultures will be a yummy selection of purple suede 'bootie pumps' and some to-die-for open-toed, brushed-leather sandals.

Three days after the work was unveiled to mingled hoopla and local consternation, modern-day descendants of sacrilegious tomb raiders broke into the surreal installation (which the artists had hoped would remain undisturbed until the ravages of time had had their way) and made off with the entire inventory of handbags and right-footed display samples. As if to prove their actions were motivated by more than mere material gain, the vandals left behind cryptic glyphs spray-painted across the walls for future adventurers to contemplate: 'Dumb Dum Dum'.

Elmgreen & Dragset, **Prada Marfa**, 2005.
Permanent installation on US Route 90,
near Marfa, Texas. Adobe bricks, plaster,
aluminium frames, glass panes, MDF, paint,
carpet, Prada shoes and bags, 7.6 × 4.7
× 4.8 m (24 ft 11¼ in. × 15 ft 5 in. × 15 ft 9 in.)

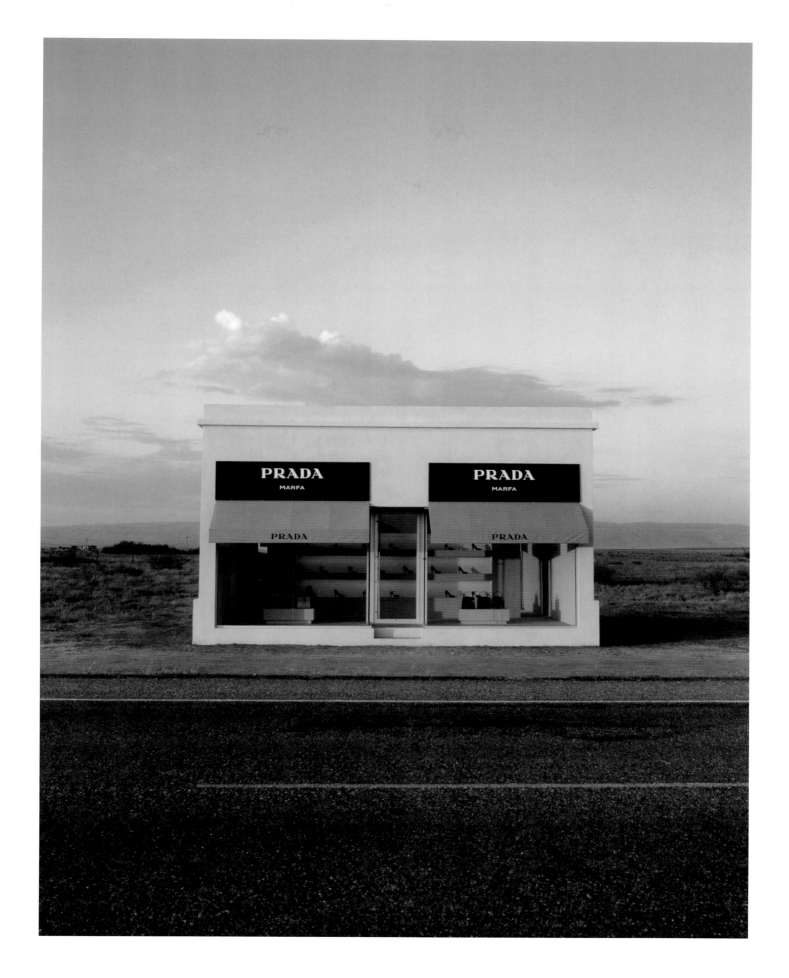

Every work of art, like every bed, conceals a secret. Over two centuries before British artist Tracey Emin caused a stir by asking visitors to contemplate the wrinkles of her rumpled installation *My Bed* (1998), the art world was transfixed by the inscrutable folds of an equally provocative mattress. If any work of art can be said to define its age, Swiss-born artist Henry Fuseli's *The Nightmare* (which featured a swooning girl squatted on by a ghoulish incubus) is prototypical, becoming in the years and decades after it first appeared in 1781 the most reproduced, pirated and parodied visual work of the era. The canvas's dishevelled sheets, crumpled throws and curious bedside assortment of bottles, books and mirrors are pregnant with the controversial disarray of Emin's notorious installation some two hundred years later.

In the stains of Emin's unkempt sheets are centuries of artistic discretion and emotional restraint on which the artist is desperate to pull back the covers. The piece may be self-regardingly entitled *My Bed*, but there is a sense in which this is the prop of a thousand works before it, unceremoniously stripped bare: the bed from which Rembrandt's lover Hendrickje is forever rising, the bed on which Velázquez's Venus stares at her reflection for eternity, the bed on which Goya's alternately nude and clothed Majas endlessly recline. Those who approached the piece forensically, attempting to detect some meaningful narrative from the abandoned bottles of alcohol, the wads of knickers and cigarette butts strewn across the floor, were desperate to work out where the artist had disappeared to after waking. Similar concerns over the whereabouts of the artist were raised by those who derided the work, convinced the piece lacked any evidence of craftsmanship or artistic vision. For them, Emin's bed represented the most flagrant example yet of sensation over skill.

Many years after the unveiling of Fuseli's *Nightmare*, a work as lampooned and lauded in its own day as Emin's bed in ours, conservationists discovered a hidden portrait on the reverse of the canvas, thought to be the likeness of a woman for whom Fuseli had fanned an unrequited flame. The asymmetrical crumpling of bedclothes on Emin's bed implies a similar lopsidedness of emotional commitment, as though half the work were waiting for someone unlikely to return. Like Fuseli's painting, Emin's mattress hides as much as it exposes: the half-hint of something tucked above the bed skirt, the unblinking stare of a stuffed animal that, like the horse in *The Nightmare*, has seen too much: the tossing and turning, the breakdowns, the strangers. Behind its stretch of stained linen, every bed, like every work of art, conceals a secret.

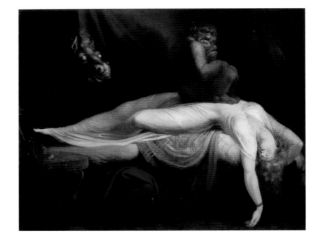

Opposite: Tracey Emin, **My Bed**, 1998.
Mattress, linens, pillows and objects,
0.8 × 2.1 × 2.3 m (2 ft 7½ in. × 6 ft 10⅝ in.
× 7 ft 6½ in.)

Right: Henry Fuseli, **The Nightmare**, 1781

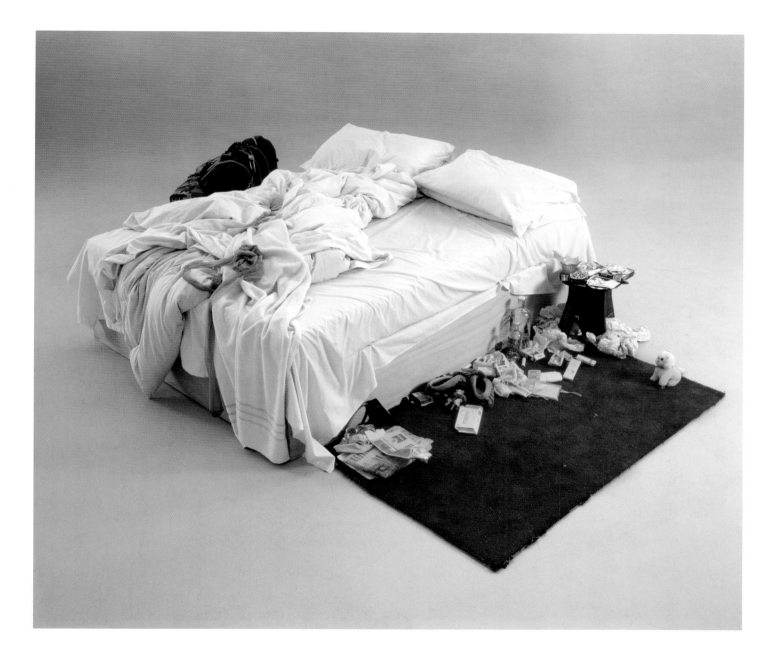

Some great works of art grow into their significance.
Cometh the hour, cometh the canvas, as it were. This is
the case for Lucian Freud's 1995 undulating nude *Benefits
Supervisor Sleeping*, whose hummocks of slumbering skin
made headlines in May 2008 when it fetched $33 million, the
highest price ever attracted at auction for a work by a living
artist. But the piece is less representative of a breakthrough
phase in the artist's by then well-honed mastery of
allegorizing the profundities of flesh with the profundities of
paint, than it is a metaphor for the grim realities of excess
to which the world was on the verge of awakening.

When the canvas, which depicts the social worker Sue
Tilley (to whom Freud had been introduced in 1994), was
brought by Christie's to hammer in Manhattan, it was for
many the unlikely first sign of the coming financial
cataclysms of the autumn. The work's seller was French
financier Guy Naggar, and the profit from the hasty sale
would go to shoring up the balance sheet of his crumbling
property empire (which had recently spent $250 million
snapping up forty-seven apartment blocks in Harlem).
Suddenly Freud's somnolent portrait began absorbing into its
mottled complexion layers of unexpected cultural meaning.
Looked at one way, the painting's subject, napping obliviously
as global tremors were gathering strength, was a symbol
for precisely the demographic of low-income individuals
whose precarious futures were being exploited by
unregulated banking schemes. Financial giants such as
Naggar soon found themselves being crushed under the
unshiftable weight of the kind of debt-weary, benefit-
reliant clients whom Tilley spent her days compassionately
assisting. Why, at this particular moment in the unfolding of
his corporate demise, Naggar should reach for this particular
portrait to offload, arguably says as much about the
meaning of the work as it does about the property mogul's
finances. In order to survive, Naggar would have to dislodge
himself from the drowsing weight of Tilley and all those
she represented.

While there is much to admire locally in the painting
and in the knolls of skin that fold with a material inevitability
into the fabric of the dilapidated couch, Freud's work takes
on its iconicity when situated in the broader narrative of the
age, which none of his portraits of socially higher-ranking
individuals (from Kate Moss to Queen Elizabeth II) can really
claim. When, in his song 'I and I', Bob Dylan predicted that
'the world could come to an end tonight, but that's all right;
she should still be there sleeping when I get back', he could
well have been presaging the slow apocalyptic snooze of
Freud's recumbent masterpiece.

Lucian Freud, **Benefits Supervisor Sleeping**,
1995. Oil on canvas, 1.5 × 2.2 m (4 ft 11 in.
× 7 ft 2⅜ in.)

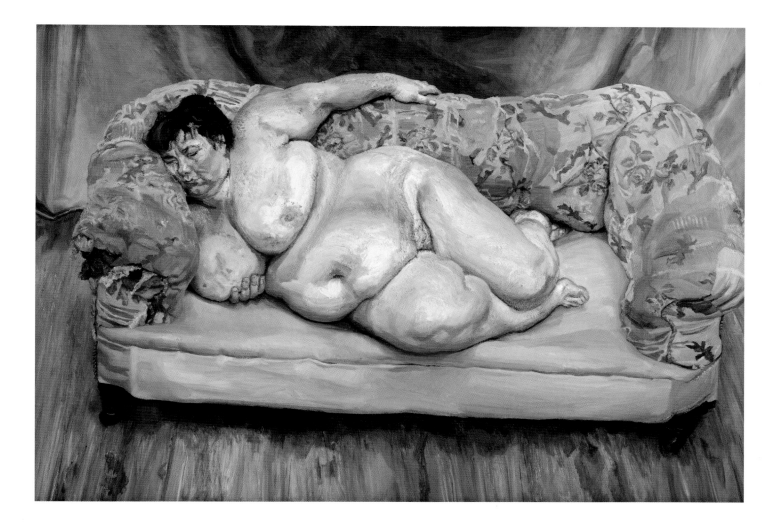

'In the first experiments which I made for obtaining portraits from the life,' wrote the nineteenth-century American scientist and inventor John William Draper, 'the face of the sitter was dusted with a white powder, under an idea that otherwise no impression could be obtained.' Draper is credited with capturing the very first photographs of living subjects – a challenge that the originators of the medium, Louis Daguerre and Joseph Nicéphore Niépce, had failed to overcome. Though Draper's belief that it was necessary to apply white powder to a sitter's face would prove unfounded, from the very start, it seems, the impulse to photograph and the impulse to mask went hand in hand. Little wonder that a century and a half after Draper undertook his 'first experiments', between 1839 and 1840, one senses something fundamental in the powdered-face intensity of Nan Goldin's celebrated double portrait *Misty and Jimmy Paulette in a taxi, NYC* (1991).

Goldin came to prominence in the 1980s with a series of photographs devoted to violent relationships and drug abuse, but found herself at the start of the 1990s returning to an earlier preoccupation: chronicling the flamboyant transvestites and glamorous drag queens of New York clubs who were determined to carve out unconventional identities for themselves. 'I wanted to pay homage', Goldin has said 'to show them how beautiful they were.' 'I never saw them as men dressing up as women, but as something entirely different ... I had no desire to unmask them with my camera.'

For Goldin, portraiture is an act of validation, motivated by the desire to help those she captures fit into society. By encouraging her subjects to maintain their masks, she manages to preserve scenes of penetrating authenticity that would otherwise not be possible, in a sense proving the accuracy of John William Draper's instinct that, without such disguise, 'no impression could be obtained'. 'Since my early teens', Goldin confesses in her book *The Other Side* (1993), in which the photograph of Misty and Jimmy Paulette was first published, 'I'd lived by an Oscar Wilde saying, that you are who you pretend to be.' The ironic aphorism to which Goldin is referring appears in the Irish writer's 1891 essay 'The Critic as Artist' and could well serve as a caption for the undisguisable achievement of the photographer's disguising work: 'Man is least himself when he talks in his own person. Give him a mask and he will tell you the truth.'

Nan Goldin, **Misty and Jimmy Paulette in a taxi, NYC**, 1991. Cibachrome print, 102 × 152 cm (40 × 60 in.)

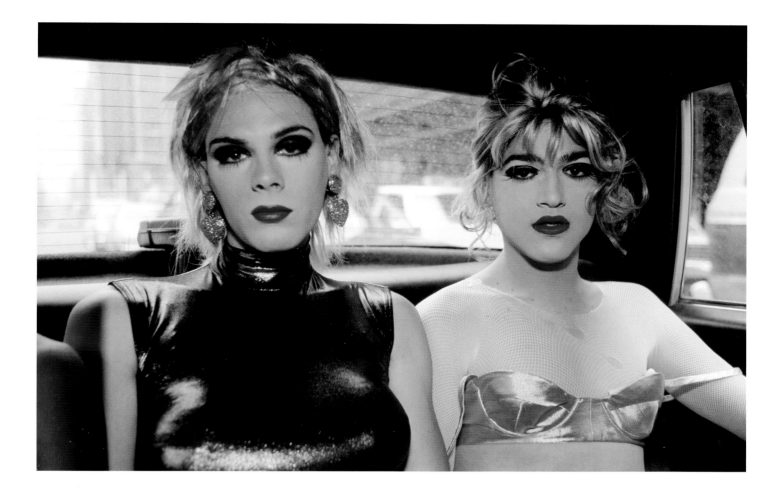

Our aim is to fill a museum of the future, a structure of absurd philosophical size capable of accommodating enormous installations and colossal outdoor sculpture, yet with space enough, conceptually, for only one hundred definitive works. When it comes to exiting the final gallery of our hypothetical institution, with all the symbolic meaning we might attach to such an act of leave taking (death, perhaps, or ghostly transcendence), it is worth asking which work might register our departure most movingly – which work might itself be moved by our own movement as we slip from one mystical space to the next?

Cuban-American artist Felix Gonzalez-Torres's 1995 work *'Untitled' (Golden)*, among his last creations before the artist died of AIDS the following year, nominates itself as a credible candidate. The piece takes the form of a huge, shimmering beaded curtain, strung ceiling to floor between or across rooms in the galleries in which it is exhibited, and consisting of thousands of strands of tiny, faceted, faux-gilded baubles. Access to either side of the work requires walking into and through Gonzalez-Torres's glistening blind, spreading its strands wide to accommodate the conveyance of one's body from here to there, only to hear whooshing behind the hush of the heavy threads. The semi-lucent sheen of the kinetic sculpture, once shuddered still again, ghosts whatever remains behind it into an otherworldly opulence.

This is the Philosopher's Stone that mystics have searched for for centuries, shattered to shiny smithereens then needled into a delicate finery that converts crass substance into something purer and evanescent. The drapes' resemblance to unceasing rain and the fluid motion of shapes through its dazzling screen like buffeting gales evoke forces of nature. To engage with the work's swaying materiality by slipping from one space to the next is to undergo an elegantly simple yet profound rite of passage. In the months before his own passing, the artist in a sense found himself inviting his visitors to rehearse the journey he was soon to take from one side to the other. 'Death is the veil', the Romantic poet Percy Bysshe Shelley wrote in his drama *Prometheus Unbound*, 'which those who live call life; / They sleep, and it is lifted.'

Felix Gonzalez-Torres, **'Untitled' (Golden),** 1995. Installation at the Guggenheim Museum, New York, 2009. Strands of beads and hanging device, dimensions vary with installation

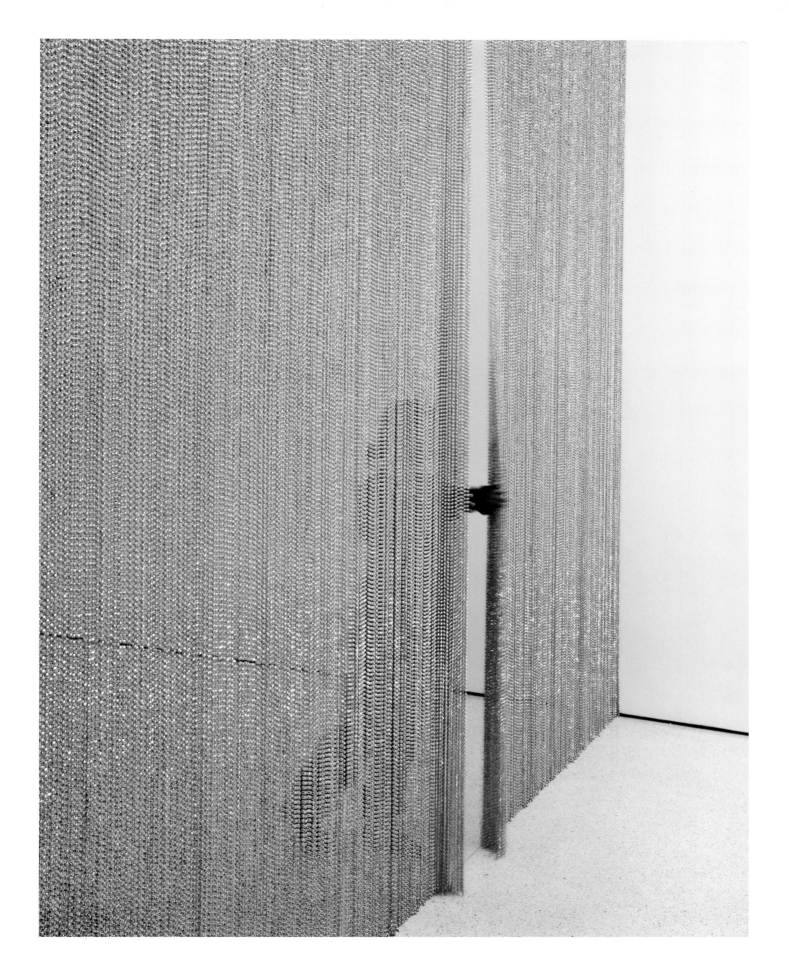

Felix Gonzalez-Torres, **'Untitled' (Golden)**,
1995. Installation at WIELS Contemporary
Art Centre, Belgium, 2010

Art is seance, a summoning of demons and angels. The ghostly veil of the last object we looked at, Felix Gonzalez-Torres's untitled installation of faceted beads, provides a shimmering metaphor for art's ability to facilitate contact across the divide, between the past and the present, the living and the dead. And though its delicate construction may seem far removed from the hulking stature of our next work, the product of British sculptor Antony Gormley, a sense of mystical transport unites the sensibility of the two pieces. 'The dark is in love with forms of light', so the twentieth-century American poet Thomas McGrath began a short lyric in 1964, his next words uncannily anticipating Gormley's imagination a generation later: 'Stars shine clearest in darkest night: / I summon the angel of the North.'

As if answering McGrath's curious call, Gormley's 1998 steel sculpture *Angel of the North*, conceived as a towering tribute to Tyneside, England, weighs in at over two hundred tonnes, rises twenty metres into the air, and stretches its stylized industrial wings fifty-four metres wide. Among the largest permanently displayed works of contemporary art visible anywhere in the United Kingdom, *Angel of the North* symbolizes the irrepressible spirit of a place whose economic prospects have steadily declined over the past several decades, particularly with the collapse of the British shipbuilding industry. Poised on a hill in Gateshead, forever on the verge of thrusting heavenward into impossible flight or of swooping down to embrace a weary multitude in its indomitable wings, the *Angel of the North*, robed in a timeless patina, looms like an oversized relic excavated from some region of the region's soul.

If that is the inspirational public energy the work is intended to generate, the sculpture also figures more ambiguously in the *oeuvre* of an artist who has spent his career insinuating shapes into situations that are as much intended to unsettle onlookers as reassure them. One of Gormley's best-known works, *Field* – initially undertaken in 1989 – threatens to overwhelm visitors with its visual stampede of summoned imps, some tens of thousands of small terracotta figurines, crammed into a gallery like an army of miniature marching golems, their plaintive earthen faces raised inscrutably. Like the huge Tyneside sculpture, *Field* challenges onlookers to reassess not only expectations of figurative scale – the relative proportions of body to space, form and formlessness – but also the very nature of the beings with whom we share our universe. Dwarfed by *Angel of the North* on the one hand and Gulliverized into giants by *Field* on the other, we sense in Gormley's spiritual shapes the same exploitation of primal opposites that has forever captivated man's imagination: weight and weightlessness, darkness and light. Art is seance. We're never alone. I summon the angel of the north.

Opposite: Antony Gormley, **Angel of the North** (Gateshead), 1998. Permanent installation at Gateshead, England. Steel, 20 × 54 × 2.2 m (65 ft 7½ in. × 177 ft 2 in. × 7 ft 2⅝ in.)

Right: Antony Gormley, **European Field**, 1993

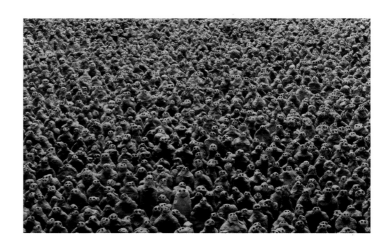

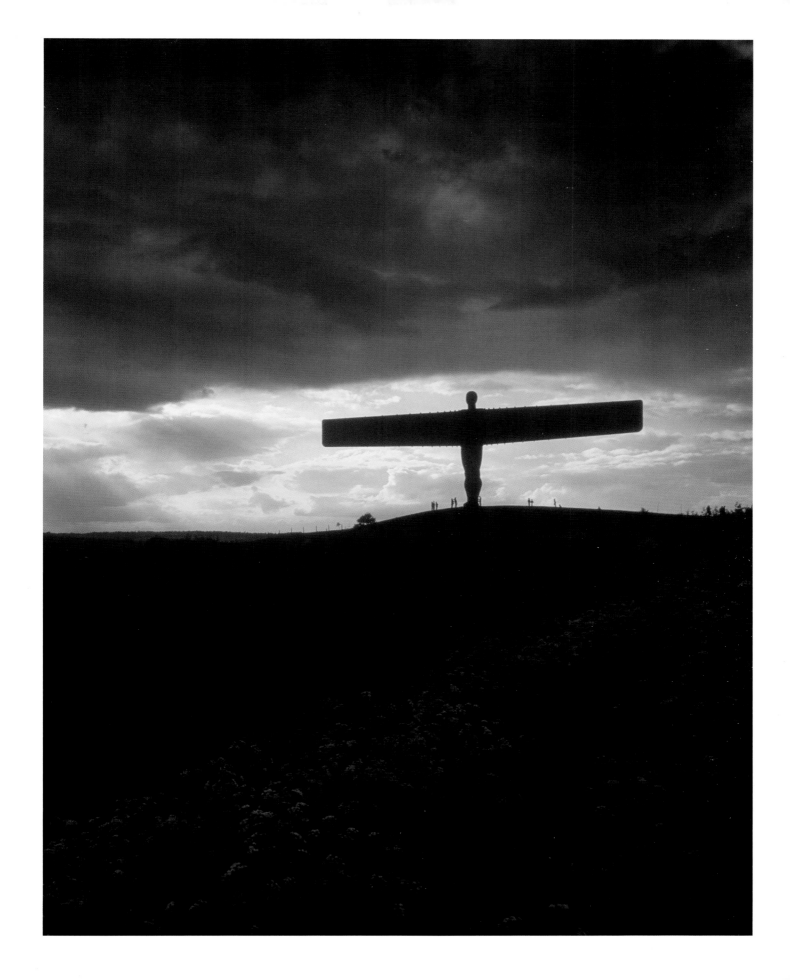

DOES ART STILL HAVE THE POWER TO FORGE NEW MYTHS?

Artists don't
make objects.
Artists make
mythologies.

ANISH KAPOOR

If, as Oscar Wilde famously concluded, 'we are all in the gutter, but some of us are looking at the stars,' the Indian artist Sheela Gowda is a kind of Galileo of the contemporary art world, and her 2006 installation *Darkroom* compelling proof that the ramshackle world of the here and now can nevertheless provide glimpses of the great beyond. The work is comprised of rusty, burned-out tar drums assembled into a small dwelling. The rounded, turret-like corners of the structure give the over two-metre-high installation the appearance of a battered toy castle – its flimsy future pinned in on all sides by the chess-like encroachment of these menacing steel rooks.

Gowda acquired the empty drums from highway workers, who have become depressingly accustomed to supplying impoverished families with the grubby resource from which rickety roadside homes can be cumbersomely crafted. Indeed, before the visitor enters the low, cramped doorway of Gowda's contraption, grim expectations of what may await – the diminished horizons of opportunities and dreams – are stoked by this pile of worried corrugated steel, which resembles an abandoned outpost at the end of the world. So how much more startled one is to rise from his or her knees once inside into what seems like an endless expanse of darkness, punctuated only by points of constelling light overhead, pinpricks that the artist punched into the steel.

The majesty of this conjured heaven, contrasted with the depravity of the work's façade, demands contemplation. Putting to one side the troubling socio-economic plight that the piece importantly calls attention to, movement into and out of the structure offers a stirring metaphor for the unrecorded shuttlings we all experience from the mundane to the epiphanic. Such alchemy of the overlooked ordinary has been at the heart of Gowda's work for the past twenty years. By experimenting in other works with such inauspicious materials as strands of hair and cow dung (years before Chris Ofili), she has sought to shine a light on social causes while always managing to salvage from the wreckage of abuse the promise of beauty. For Sheela Gowda, the art of the gutter and the art of the stars are two sides of the same brilliant, battered coin.

Opposite: Sheela Gowda, **Darkroom**, 2006. Tar drums, tar drum sheets, asphalt and mirrors, 2.39 × 2.59 × 3.05 m (7 ft 10 in. × 8 ft 6 in. × 10 ft)

Right: Sheela Gowda, **Darkroom** (interior view), 2006

Is there a better word to describe the state of contemporary art than the Old English term *nonesmanneslonde*? Dating back to the Domesday Book that William the Conqueror commissioned in 1086 to assess the English territories he'd invaded, the term gave rise to the modern phrase 'no man's land', which the *Oxford English Dictionary* defines variously as 'a state of confusion or uncertainty', 'a stretch of disputed territory', and 'a dangerous or forbidden place'. In the near millennium since its coinage, the phrase has been applied to a range of contested territories where neither the pen nor the sword managed to establish an agreement of borders.

In recent decades, the phrase has lost ground to another – 'line of control' – which has been applied to the long-standing dispute between India and Pakistan over the rightful ownership of the former princely state of Jammu and Kashmir. Corresponding to no official legal demarcation of international borders, the 'line of control' denotes the de facto if disputed boundary between the two countries. As seemingly irresolvable as art itself, it provides the perfect title for one of the era's most iconic works linked to the region: Indian artist Subodh Gupta's 2008 sculpture *Line of Control*. The work consists of twenty-six tonnes of stainless steel pots, pans and utensils arranged implausibly into a billowing ten-metre-high mushroom cloud of polish and gleam, blurring the line that separates the domestic and the political. Some saw in the artist's decision to use kitchen paraphernalia as the constituent elements of his work an oblique comment on the changing role of women in Indian culture, a symbol for the time bomb of profound gender inequality and human rights abuses that threatens to destabilize the society.

The origins of the work can be traced back to a drawing the artist made nearly a decade earlier, when tensions between Pakistan (which had recently tested its first atomic weapon) and India over the ownership of Jammu and Kashmir were provoking fears that the dispute might end in nuclear conflict, with a pyrocumulus cloud resembling those that rose over Hiroshima and Nagasaki in 1945. 'They were having conversations', Gupta has recalled, 'like how many people were going to die if India used its nuclear power. It chilled my heart.' But the genius behind the eventual large-scale articulation of Gupta's nightmare is its ability to bring the horror home, as it were, to domesticate the otherwise unutterable fear by breaking it down into an accessible lexicon of skillets and muffin tins to which everyone can immediately relate. However heroic or satisfying sword-rattling may seem, the consequence of crossing the line or of losing control is not a drama that plays out in a theoretical *nonesmanneslonde*, but one that would be felt around the world at every table of every home.

Subodh Gupta, **Line of Control**, 2008.
Installation at Tate Britain, London, 2009.
Stainless steel and steel structure, stainless steel utensils, 10 × 10 × 10 m (32 ft 9¾ in. × 32 ft 9¾ in. × 32 ft 9¾ in.)

Is art the chicken or the egg? Do great works, that is to say, document or dictate the way we see? Take Georges Seurat's pointillist masterpiece, *A Sunday Afternoon on the Island of La Grande Jatte – 1884* (1884–86), which introduced to the world his signature technique of separating colours into individually painted dots that from a distance the eye mixes together. Though Seurat conceived his work at the same time that Swiss mathematician Johann Jakob Balmer was revealing his formula for how the visible spectrum of light separates from the hydrogen atom, the synchronicity of creation establishes no provable influence of art on optics or vice versa. All we can say for sure is that both Seurat and Balmer were living prisms through which the same spirit of the age dazzlingly passed.

A similar synchronicity of spirit illuminates photographer Andreas Gursky's 1999 photograph *Chicago, Board of Trade II*, which appeared at a landmark moment in the digital revolution. Capturing the vibrant bustle of the world's oldest commodities exchange, Gursky's large-scale C-print is a work of remarkable visual manipulation, involving the double-exposure of some parts of the image and the accentuation of its colours in order to convey the intense energy that electrifies the trading floor. From a distance, the over three-metre-wide image reduces the thrumming crowd to a blur of indistinct pixels, the direct digital descendants of the dots that combined to form Seurat's *A Sunday Afternoon*. Gursky is the chick hatched from Seurat's optical egg.

The German artist is unlikely to have known as he created his image that at that same moment Nikon was preparing to release the first affordable professional-grade digital camera, changing photography forever. Before long, the digital manipulations and enhancements that invigorated Gursky's image would be available to millions as film and negatives became all but obsolete. In a sense, we have all hatched back into Seurats, pointillizing our lives into digital dots to be zapped across the ether. But where Seurat had intended his optical technique to heighten our sense of what constitutes humanity, there is something negating and vaguely dehumanizing about the backward zoom of Gursky's lens, as though the individuals recorded by his work have been reduced to the very grains of the commodities they sell.

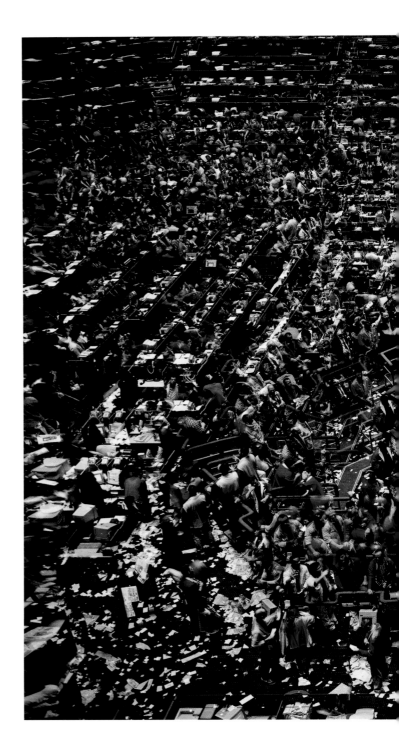

Andreas Gursky, **Chicago, Board of Trade II**, 1999. C-print, 205 × 335 × 6.2 cm (6 ft 8¾ in. × 10 ft 11½ in. × 2½ in.)

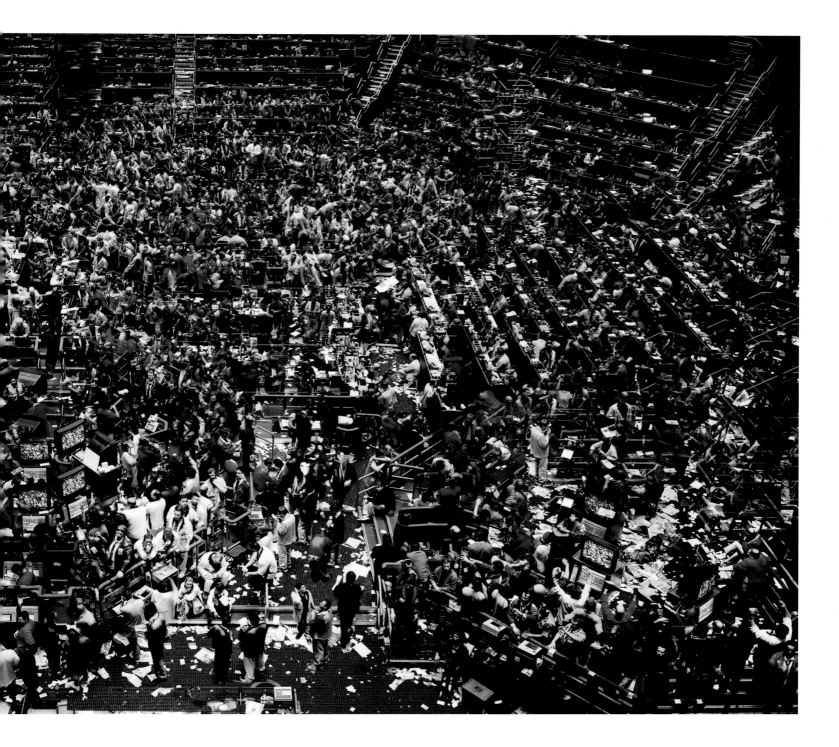

On **18 September 1997,** a French artist by the name of Jacques Rolé exited London's Royal Academy of Art, strolled across a bustling Piccadilly, entered the glamorous department store Fortnum & Mason, purchased half a dozen eggs from the shop's exclusive food hall, crossed back to the crowded exhibition galleries of the RA and began hurling the batch, one by one, at a large portrait of a woman. Quickly restrained by an off-duty police officer, Rolé was not the first individual that afternoon to be detained for vandalizing this particular work. Less than an hour earlier, another artist, Peter Fisher, had approached the portrait before looking around to make certain no security guards were within easy striking distance. Confident the coast was clear, Fisher began flinging the India ink that he had smuggled into the exhibition for the sole purpose of destroying the image. Before gallery staff could intervene, Fisher had violently torn the portrait from the wall.

The work in question was British artist Marcus Harvey's large-scale likeness of the notorious murderer Myra Hindley, who, along with her accomplice Ian Brady, had been imprisoned thirty years earlier for the torture and killing of five children in the north of England between 1963 and 1965. Based on a well-known black-and-white photograph of Hindley that had circulated in the media at the time of her trial, with bleached-white hair and a masklike expression, *Myra* is comprised of plaster moulds of children's handprints in the evocative style of playschool crafts. That the countenance of so much evil should be construed from the fossils of so much innocence was for many an irony too far and appeared to recast Hindley in the counterfeit currency of celebrity.

The violent reaction the work provoked from visitors to the Royal Academy's now notorious 'Sensation' exhibition of 1997 was, needless to say, not the first or last instance of artistic defacement. (*The Mona Lisa* has been the target of routine attacks; in one year alone, 1956, it suffered separate assaults involving the spraying of acid and the throwing of rocks.) But what made the siege on *Myra* unique was the public's response, which largely supported the assailants. Over the ensuing days and weeks, the British tabloid press made little effort to conceal its approval of such vigilante vandalism or to mask its outrage over the display of what one paper called 'the most hated portrait in Britain'. A reporter for *The Mirror* dismissed the work as 'sick', while a journalist for *The Evening Standard* could hardly hide his own candid assessment of the work, referring to the Royal Academy as 'unrepentant' in its refusal not to withdraw the portrait in the face of so much public reproach.

To be memorialized in a work of art, so the dominant sentiment appeared to be, is an honour, an elevation of one's status to the level of icon. By selecting Myra Hindley as a subject for representation, Marcus Harvey might as well have set a place for her at an eternal table beside the Virgin Mary. Nor was the popular press alone in protesting against the Academy's judgment in featuring, let alone defending, the provocative portrait. Four distinguished Academicians, including the celebrated Scottish crucifixionist Craigie Aitchison, temporarily resigned from the institution. So fierce and menacing was the accelerating opprobrium, the artist reportedly feared for his safety and refused to allow pictures of his own face to circulate in the media.

Marcus Harvey, **Myra**, 1995. Acrylic on canvas, 3.96 × 3.20 m (13 ft × 10 ft 6 in.)

Question: How many Surrealists does it take to screw in a light bulb? *Answer:* Fish. No one can remember whose joke it is, but that sudden sense of displacement that the punch line triggers also animates Mona Hatoum's installation *Light Sentence*. The single light bulb on which the work's effect depends – rising and falling within a blind alley of wire lockers – is not the only element being screwed with, so too is the visitor's certainty in the stability of his or her surroundings. A complex mesh of shadows cast against the gallery's walls, woven by the vertical motion of the bulb, lifts then sinks, scrunches then spins. 'When it touches the floor and rolls over,' the critic William Feaver observed, 'the shadows lurch, shiver, then steady again and subside as the bulb is spooled up to overhead height.'

We may be free from the imprisonment of the metal wires, but the shadows impose an unsettling incarceration all their own, shifting, twisting, weaving the unutterable grammar of the existential sentence we all find ourselves serving. Suddenly, we are the trapped eyes pacing about 'the constantly passing bars' of Rainer Maria Rilke's famous poem 'The Panther'. 'It seems to him', the poet writes of the wretched beast 'there are / a thousand bars; and behind the bars, no world.'

If 'shades of the prison house begin to close upon' us from childhood, as Wordsworth once asserted, for Hatoum the cells have always been demarcated by the violence of national borders and threatening definitions of identity. Born in Beirut to Palestinian parents, the future artist moved to London to complete her studies and emerged there as a young artist in the 1980s. After experimenting with performance art, she found her visual voice in the manipulation of everyday objects. Hers is a world in which one is forever crossing the innocuous borders of the ordinary into realms of breathtaking abuse. In *Light Sentence*, the result is a psychologically powerful phantasmagoria of incarcerating shadows that transcends politics and the gruelling confines of gender, race or religion. If the history of art is the history of shadows, Hatoum's soulful silhouettes have inscribed a significant passage.

Mona Hatoum, **Light Sentence**, 1992.
Installation at the Centre Pompidou, Paris,
1994. Wire mesh lockers, motorized light
bulb, 1.98 × 1.85 × 4.90 m (6 ft 6 in. × 6 ft
⅞ in. × 16 ft 1 in.)

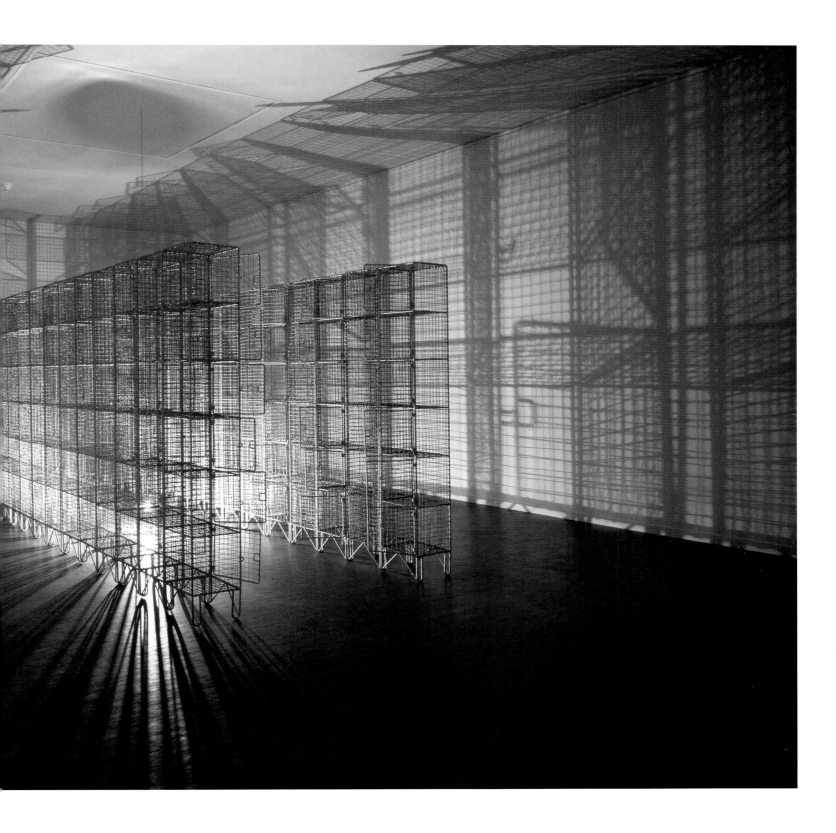

Are we alone? It's the question every astrobiologist and UFO-spotter asks. And every artist. Every work of art is a time capsule hurled into the great beyond of human feeling and unpredictable response, a Hubble launched into the unknown. Is contact ever made? Ask the aging crew of Skylab 3, the manned space mission launched in July 1973, on whose otherworldly suits the embraceable arms of da Vinci's drawing *The Vitruvian Man* (c. 1487) were emblazoned. Ask the American artist Susan Hiller, whose mixed-media installation *Witness* provides visitors with a motherboard of voices and visions: the accounts of individuals who've seen the light and survived the visit.

The work consists of countless audio wires dangling from the ceiling at uneven lengths. Each chord ends in a disc-shaped speaker, giving the frozen sonic shower the look of a suspended star fall or alien invasion. Walking among the bungeed constellation, from which a hum of garbled speech in a variety of languages and accents indistinctly emanates,

the visitor is soon compelled to lift an earpiece and listen in, as if retrieving a shell from a deserted beach and holding it to one's ear. The testimony chattering back is not the ambiguous murmur of a hollow conch, however, but that of a witness to paranormal sightings and alien visitation. These are the vocal chords of those who've seen and lived to tell, strung like a forest of clandestine confession.

There is frequent talk of a great light. Consensus or malarkey? Who can say. 'Listening to these people whispering in your ears', Hiller has said, 'is like being a priest in a confessional....The stories are examples of contemporary visionary experience. Only today people see UFOs where once they saw angels.' For all its borderline New Ageism, *Witness* is surprisingly less eccentric than essential, not merely a grand metaphor for the weave of voices from which every work of art is made, but an allegory for what visitors seek from art in the first place: evidence that there is more to being here than meets the eye.

Opposite: Susan Hiller, **Witness**, 2000.
Installation at The Chapel, London.
400 speakers, wiring, steel structure,
10 CD players, switching equipment and
lights, approx. 7 × 9 m (23 ft × 29 ft 6 in.)

Right: Susan Hiller, **Witness** (detail), 2000

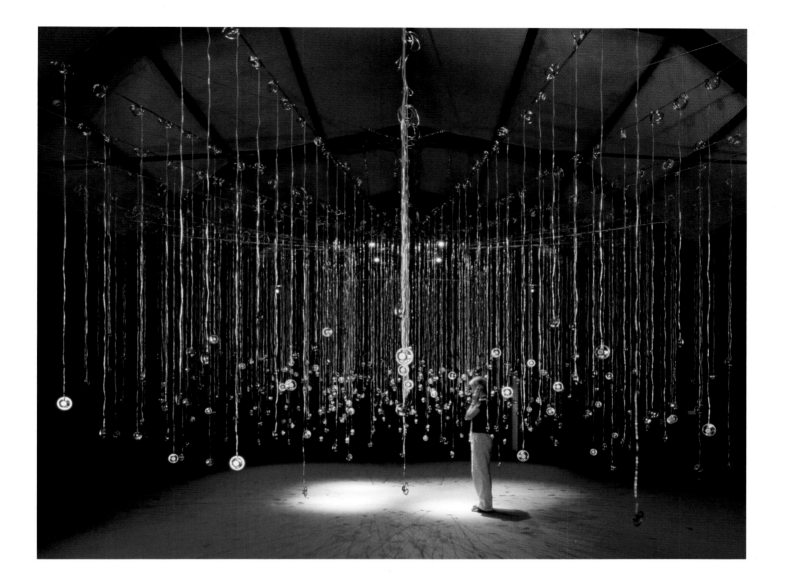

Susan Hiller, **Witness** (detail), 2000

CAN ART GO TOO FAR?

The enemy of
art is the absence
of limitations.

ORSON WELLES

'At eighteen', F. Scott Fitzgerald wrote in 1920, 'our convictions are hills from which we look; at forty-five they are caves in which we hide.' Who knows whether the Swiss artist Thomas Hirschhorn is a reader of Fitzgerald, but it seems more than mere coincidence that at the age of forty-five he began constructing an elaborate system of caves out of wood and cardboard held together by miles of packing tape. If the American novelist was right, these sprawling hiding places symbolize deeply entrenched convictions, but which ones? To navigate the slick gullet of Hirschhorn's work is to encounter the half-digested detritus of high and low culture. Stacks of books (including philosophical, sociological and theological titles) clash with crass cut-outs from girlie magazines and political manifestos that have been taped haphazardly to the walls of the disposable grotto. The debris of crumpled aluminium cans, decapitated mannequins and effigies wrapped in baking foil only add to the surreal ambiance. Is this the hideout of a harmless recluse or the subterranean lair of the psychopath who refuses to disclose where he has hidden the little girl?

With every inch that we progress into Hirschhorn's bizarre blizzard of disconnected enunciations it becomes clearer and clearer that we are no longer seeking clues to the identity of the supposed inhabitant of these preposterous premises, but rather hints to our own identities. The artist has merely taken a sample from contemporary culture and incubated it in the curious laboratory of his work. How visitors diagnose the symptoms will ultimately reveal more about the convictions they themselves hold or hide from than it will about the artist's. Take, for example, the inscrutable equation scrawled again and again across the inside of one of Hirschhorn's rooms: '1 Man = 1 Man'. Is it a simple plea for suffrage (a restatement of 'one man, one vote'), a closed system that excludes women, or a hopeless arithmetic for 'it is what it is'?

After a while, attempts to decipher the interior begin to feel as desperate as the stabs anthropologists take in determining the meaning behind the early cave drawings at Lascaux, in south-west France, a video of which (or rather a video of a replica of which) plays on one of the walls in an endless loop, its cultural status diminished to that of a pin-up girl. Ultimately, what Hirschhorn has constructed from cardboard and packing tape is an enormous care package addressed to the world, which we must open to find ourselves. And what will we discover when we do? That depends on whether you are eighteen or forty-five.

Opposite: Thomas Hirschhorn,
Cavemanman, 2002. Installation at
the Carnegie Museum of Art, Pittsburgh,
2008. Various media, dimensions vary
with installation

Overleaf, left: Thomas Hirschhorn,
Cavemanman, 2002. Installation at
the Hayward Gallery, London, 2009

Overleaf, right: Thomas Hirschhorn,
Cavemanman, 2002. Installation at the
Walker Art Center, Minneapolis, 2006

Can art conquer death? When Damien Hirst's 1,106-carat diamond-encrusted skull, *For the Love of God*, was first exhibited in London in 2007, a chorus of critics answered in the affirmative. A contributor to *Frieze* magazine poetically speculated that this, the most expensive piece of contemporary art ever created, 'will witness the end of time'. 'When God's last breath blows across the ashes of the world,' Tom Morton wrote, 'this terrible object will remain.' It's an unfalsifiable prediction, of course, as preposterously unprovable as asserting which works will define our age. But the critic's confidence does raise a perennial question about the durability of any artefact, a dilemma that glitters beguilingly from the priceless sockets and appalling guffaw of Hirst's ostentatious talking point.

A platinum cast, made from the salvaged skull of a thirty-five-year-old eighteenth-century European and purchased from a shop in Islington, London, provides the base for the 8,601 cobbled, or *pavé*-laid, diamonds, which the Mayfair jewellers Bentley & Skinner set for the artist. As if this weren't opulent enough, mounted to the forehead is a large pink pear-shaped diamond, a kind of mythic third eye, which wants to nudge the work's potential meaning in the direction of the supernatural. Hirst himself initially downplayed the skull's significance, dismissing it as 'a silly idea'. But what idea was he referring to? Nothing we know about the Aztecs – whose priests wore human skulls as regalia, decorated with mosaics of dazzling turquoise and black lignite, in honour of their god Tezcatlipoca, or 'Smoking Mirror' – suggests that they regarded as silly their attempts to bridge the living and the dead. Perhaps what unsettles the seriousness of Hirst's work, even in the mind of the savvy operator who designed it, is an abiding suspicion that the clichéd ambition of materially defeating time, of outspending death, is a yawn we've seen before, if never so sparklingly.

Students of archaeology and literature may well scrutinize the piece for an ironic caption or knowing wink to the visitor, such as the inscription the Egyptian pharaoh Ozymandias had chiselled into the pediment of a statue that commemorated him, famously paraphrased by Shelley: 'Look on my works ye mighty and despair'. The modernist poet T. S. Eliot once wrote of the Jacobean dramatist John Webster, that he 'saw the skull beneath the skin'. And Webster himself, in his play *The Duchess of Malfi*, explored the futility of riches in the face of imminent death:

> What would it pleasure me to have my throat cut
> With diamonds? or to be smothered
> With cassia? or to be shot to death with pearls?
> I know death hath ten thousand several doors
> For men to take their exits; and 'tis found
> They go on such strange geometrical hinges ...

What a strange geometrical hinge Hirst's outrageous jaw is. It defines our age eloquently, an era of recycled retro that forgot it was retro. When the skull was first unveiled as part of the British artist's exhibition 'Beyond Belief', the lavish security it enjoyed, as though it were the rediscovered crown jewels of a legendary realm, led many to attach to it an invincibility that could laugh in the face of time's ravaging, as though a work that could truly conquer death had at last been found. Others may have seen little more than a gaudy trick, which the slightest wrinkle in a gallery rug might send smashing into eight thousand broken engagement rings.

Damien Hirst, **For the Love of God**, 2007.
Platinum, diamonds and human teeth,
17.1 × 12.7 × 19.1 cm (6¾ × 5 × 7½ in.)

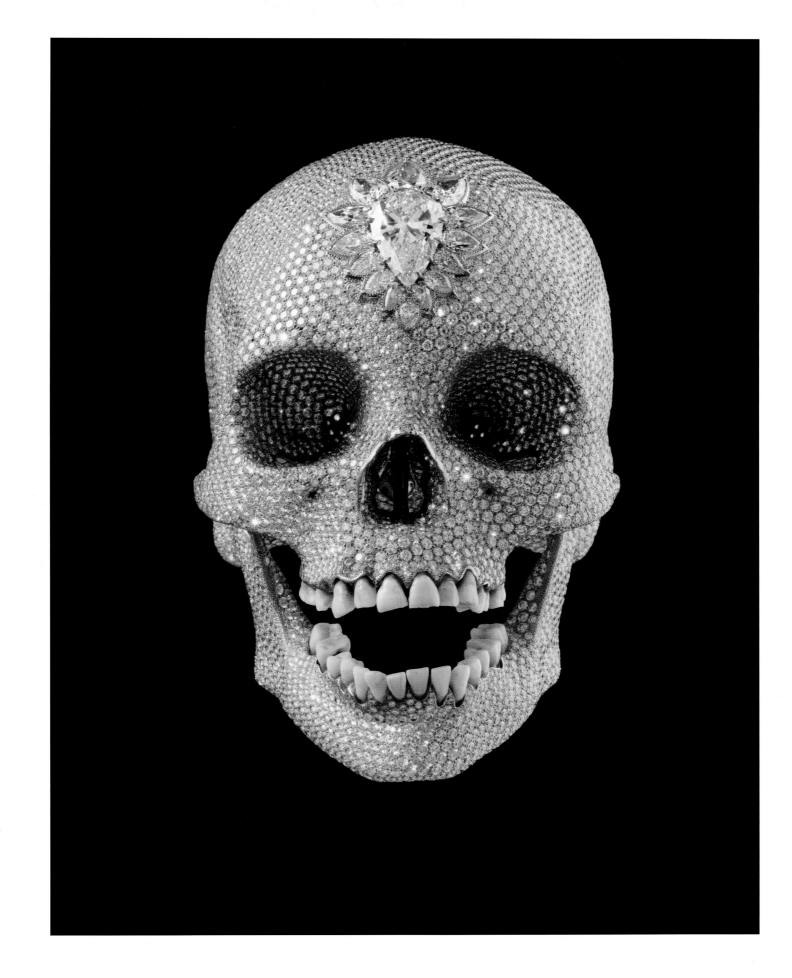

043 Bigger Trees Near Warter or/ou Peinture sur le Motif pour le Nouvel Age Post-Photographique (2007) DAVID HOCKNEY

Bizarrely, the title of the largest painting that British artist David Hockney has ever undertaken suddenly changes languages in mid-stream: *Bigger Trees Near Warter or/ou Peinture sur le Motif pour le Nouvel Age Post-Photographique*. Why would he do that? The French phrase that begins the second half of the title, *peinture sur le motif*, refers to the practice of painting in the physical presence of a subject, as opposed to working from a drawing, photograph or sketch. The phrase translates loosely as 'painting on motivation', where *motif* is related to the English word 'motive', the psychological (rather than the physical) grounds of an action. By shifting from one language to another, Hockney may be signalling a shift in how he intends his work to communicate with his audience – a shift from a literal physical landscape to deeper ground.

The emotional territory mapped by Hockney's enormous fifty-canvas work, which collectively measures a staggering 4.57 by 12.19 metres, is at least as intriguing as the actual terrain near Bridlington, Yorkshire, where the canvases were created. The American literary critic Harold Bloom once asserted that 'the motive' behind all artistic expression is 'the desire to be different, to be elsewhere'. But pinpointing exactly which 'elsewhere' motivates the imagination of Hockney, who was born in England and studied at the Royal College of Art before shifting to the United States in his mid-twenties,

is complicated business. Works such as *A Bigger Splash* (1967), where the self disappears into the blankness of a very Californian blue, first brought Hockney's penchant for *plein air* to public attention. Four decades later, the artist's *Bigger Trees Near Warter* sees Hockney resurfacing in the landscape of his birth, piecing together the grounds of his earliest artistic motivations in Yorkshire – a poignant journey, begun in his prime during the 1990s, back to the elsewhere of his childhood.

A huge mosaic of personal memory, the work also proclaims itself as genre-defining, *le Nouvel Age Post-Photographique* (the New Post-Photographic Age), as if asserting the limitations of certain contemporary media that have recently been gaining ground, particularly digital photography. The use of electronic images, of which Hockney himself is a celebrated master, were crucial to the orchestration of the colossal work. The artist laboriously shuttled each canvas from the outdoor location in which it was executed, back to his studio, where he plotted his progress, canvas by canvas, on a digital grid of the full composite image. For Hockney, what all this restless to-ing and fro-ing ultimately demonstrates, is that the camera is a useful scaffold that must be dismantled in deference to the power of the painted image to communicate feeling – how the language of one must give way to the language of the other.

David Hockney, **Bigger Trees Near Warter or/ou Peinture sur le Motif pour le Nouvel Age Post-Photographique**, 2007. Oil paint on 50 canvases, each 91.8 × 122.5 cm (36⅛ × 48¼ in.)

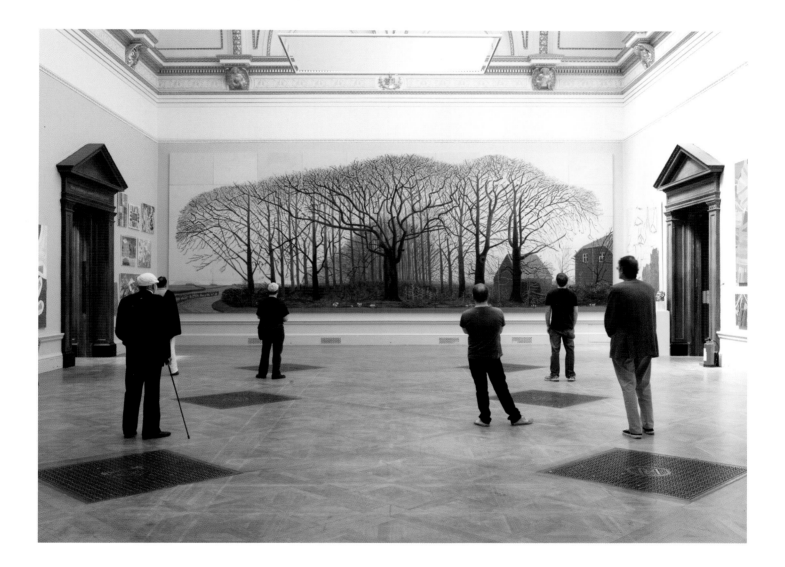

'A Freudian slip', so the sharp quip goes, 'is when you say one thing and mean your mother.' The pop-psych phrase first entered the English language in 1953, just as Freudian psychoanalysis was gaining popular ground, deepening the implications of an expression – 'slip of the tongue' – that dates back to the eighteenth century. The journey that the phrase underwent, from its attachment chiefly to the body to opening an aperture into the subconscious, is a linguistic slide that anticipates an artistic one half a century later: German artist Carsten Höller's slippery installation, *Test Site*, which he constructed in 2006 as the seventh work to feature in the celebrated Unilever Series of large-scale installations at Tate Modern in London.

At first glance, the five stainless steel slides, fitted with clear polycarbonate covers, introduced an element of childlike amusement into the cerebral surroundings of the museum, twisting like enormous spiral straws from the upper levels of the building down to the floor of the cavernous Turbine Hall. Some critics saw an iconoclastic work that forced the swift eviction of visitors from the museum's upper galleries, siphoning off through its slick system of human-sized pipes one body after another, hurling each participant feet first towards the exit. But the work is more psychologically complex than that, triggering a movement from the realm of the body to the realms of the mind.

It is not the first time the artist has flung bodies around with the aim of broadening their owners' perceptions. In 1996, Höller built an elaborate apparatus that he called *Flying Machine*, which suspended participants in the air – soaring like superheroes, their legs outstretched behind them – in order to expand their senses of perspective. Four years later, he concocted *Light Wall*, an arresting display of nearly four thousand light bulbs flashing at a carefully calibrated rate, designed to lull the observer into a hypnotic trance. The transition from the observation of an external object (over which the artist has some control) to the audience's internal experience of the piece (which is far less predictable) is what motivates Höller. In reference to *Test Site*, he has explained that his ultimate fascination is with 'the inner spectacle' that unfolds privately as participants disappear through the aesthetic plumbing of his work. There, the stability of the museum's hulking structure momentarily dissolves, leaving the visitor with a sense of cultural as well as physical free fall. Entering the very bowels of a work of art allows the material substance of the piece to slip away. One is left with a truly Freudian slip – its thrill and anxiety, terror or amusement, dependent on the interior architecture of one's own psyche and soul.

Opposite and overleaf: Carsten Höller, **Test Site**, 2006. Installation at Tate Modern, London. Stainless steel slide segments, polycarbonate upper shell, steel supports, canvas mats for sliding. Slide 1: start height: 26.57 m (87 ft 2 in.); slide length: 55.1 m (180 ft 9 in.). Slide 2: start height: 20.73 m (68 ft); slide length: 44.83 m (147 ft 1 in.). Slide 3: start height: 13.07 m (42 ft 11 in.); slide length: 30.93 m (101 ft 6 in.). Slide 4: start height: 7.20 m (23 ft 7 in.); slide length: 18.28 m (60 ft). Slide 5: start height: 7.20 m (23 ft 7 in.); slide length: 18.28 m (60 ft)

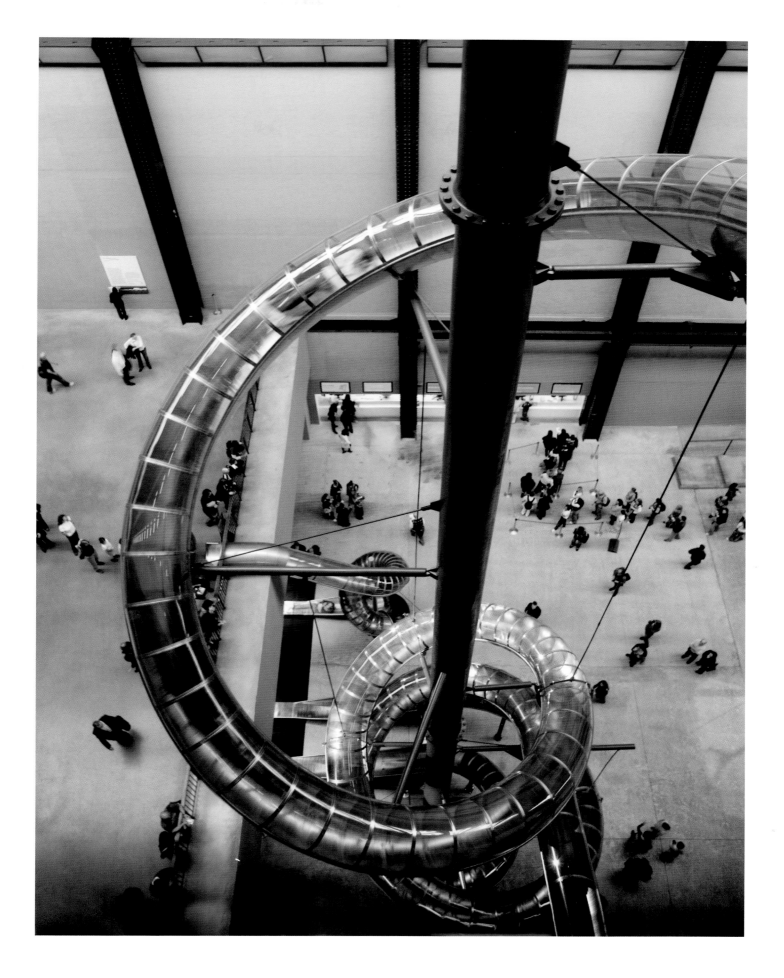

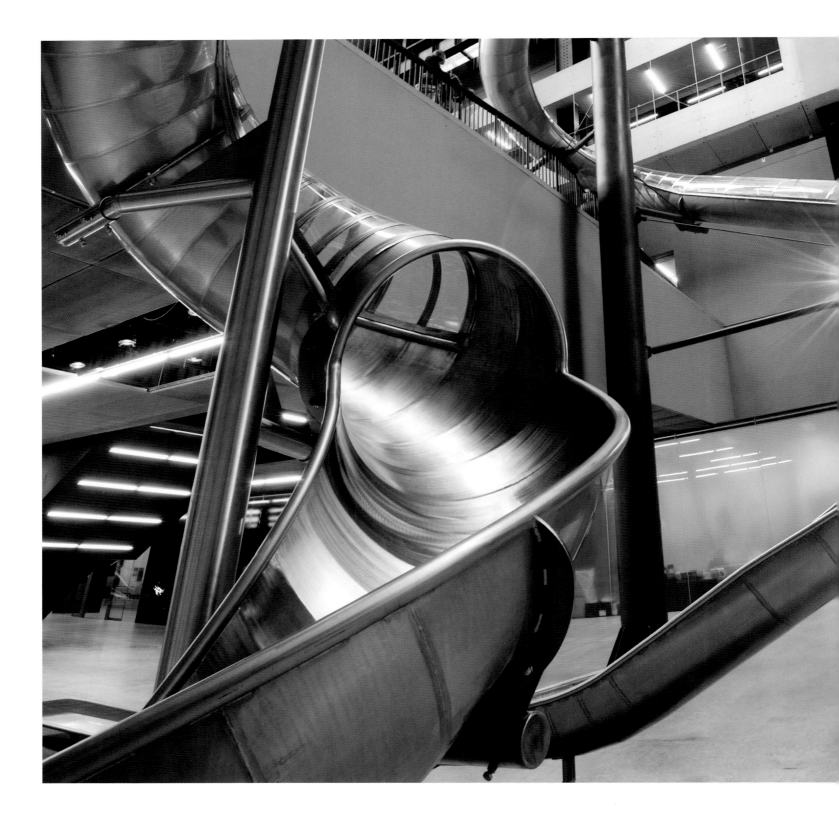

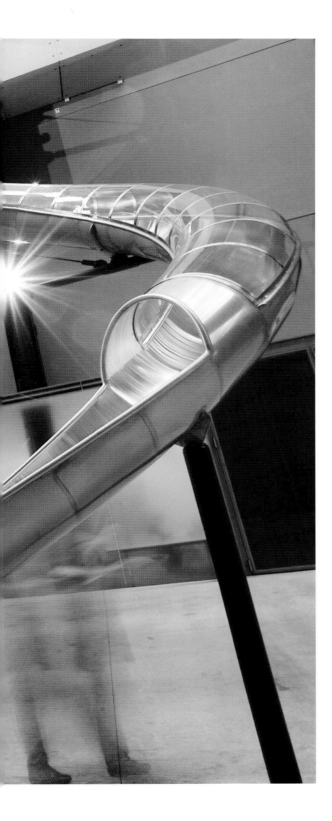
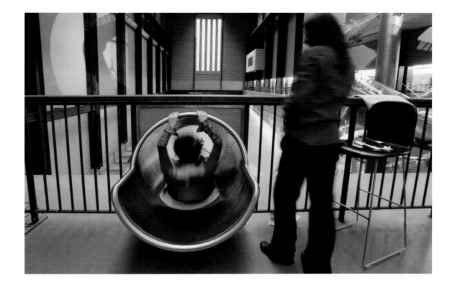

Every city is a paragraph. Every street, a sentence. Every building, a word. And those who inhabit the city whisper through its streets like syllables in search of a syntax or grammar that might give meaning to their lives. Such is the uniquely verbal vision of American artist Jenny Holzer, who for much of the past two decades has projected fragments of text at enormous size onto the sides of public structures and landscapes in nearly fifty cities across the world, from Vienna to Singapore, Rio de Janeiro to Prague, Melbourne to New York. Beginning with a stretch of blank embankment along the River Arno in Florence in 1996, Holzer has cast her fleeting graffiti against municipal landmarks, transforming the material solidity of static edifices into the fluidity of half-remembered phrases, the ephemerality of a thought.

The texts that Holzer fires like bat signals through her powerful projector are a mix of original aphoristic enunciations of the enigmatic sort that first brought her to public attention in the late 1970s – she plastered large posters of thought-provoking statements onto public walls and fences across New York – to carefully selected passages by contemporary writers, including Japanese-American poet Henri Cole, German-Israeli poet Yehuda Amichai, and, most extensively of all, Polish Nobel laureate Wisława Szymborska.

In 2007, against the time-weary façade of the Castel Sant'Angelo in Rome, originally commissioned in the second century by the Roman Emperor Hadrian as a burial monument for himself and his family, visitors were left to contemplate the scrolling threat of Palestinian poet Mahmoud Darwish: 'What crime did I commit to make you destroy me? I will never cease embracing you. And I will never release you.' Two years later, illuminating the grand neo-Renaissance exterior of Prague's National Museum, which stares down onto Wenceslas Square (where twenty years earlier the Velvet Revolution proclaimed itself), stirring phrases from Szymborska's poem 'Could Have' rippled across the institution's stones:

> You were in luck – there was a forest.
> You were in luck – there were no trees.
> You were in luck – a rake, a hook, a beam, a brake,
> a jamb, a turn, a quarter inch, an instant.
> You were in luck – just then a straw went floating by.

Holzer's city is a city of blinding words, whose mute walls 'never cease embracing you' with thoughtful utterances; a map where every 'jamb' and 'turn' and 'quarter inch' is disturbingly articulate, where each of us is lifted like a straw 'floating by' to be dipped into the invisible ink with which the atlas of being here is slowly being written.

Jenny Holzer, **For Prague**, 2009. Light projection on National Museum, Wenceslas Square, Prague, dimensions specific to site

Above: Jenny Holzer, **Projection for Chicago**, 2008. Light projection on Tribune Tower, Chicago, dimensions specific to site

Right: Jenny Holzer, **For the City**, 2005. Light projection on Rockefeller Center, New York, dimensions specific to site

'**What art offers**', the American writer John Updike once wrote, 'is space – a certain breathing room for the spirit.' But the greatest art also offers us a way out of that space, a mode of transport, a certain breathing room that enables the spirit to transcend all spaces. To encounter Spanish artist Cristina Iglesias's 2002 installation *Untitled (Passage II)*, is to experience simultaneously Updike's ideal as well as the imagined vehicle capable of fleeing it. Iglesias's work consists of huge, suspended mats, woven from raffia fibre, that float above her visitors' heads, at once resembling the roof of a modest dwelling and a traffic jam of flying carpets waiting to convey us from the insinuated enclosure.

Nor is invoking the folkloric symbols of transport associated with the stories of *One Thousand and One Nights* as fanciful as it may at first seem. Although the loose patterns of Iglesias's textiles may initially appear abstract, her woven carpets bear transcriptions of a passage from a novel by the English writer William Beckford published in 1786: *Vathek: an Arabian Tale*. Beckford's novel emerged at a moment of popular fascination with Middle Eastern cultures and purported to be a translation of a long-lost Arabic work capable, according to one edition of the novel published in 1903, of 'transporting us on [a] magic carpet'.

The gallery's light, cast through Iglesias's magic carpets, scribbles shadows of Beckford's text across the gallery's floor and visitors' skin. 'The history of the relations between text and textile, fantasy and flight,' the novelist and critic Marina Warner argues in *Stranger Music: Charmed States & the Arabian Nights* (2011), 'provides remarkable instances of the logic of the imagination at work at a profound, unconscious poetic level, and the carpet of the *Arabian Nights* metonymically enacts the work of imagination in making up a story and pursuing it.' The strange silhouettes of Beckford's words – 'text and textile' – transform the wider space in which Iglesias's ingenious work is displayed into an enchanted Islamic palace in which our imaginations find themselves weaving stories.

The nineteenth-century American writer and author of 'Sleepy Hollow', Washington Irving, might as well have been referring to Iglesias's work when he described the elaborate filigree of sacred Arabic text that adorns the walls of the Alhambra palace in Granada, Spain: 'When one looks upon the fairy traces', Irving observed, and the 'fragile fretwork of the walls ... the whole is protected by a magic charm.' Like all great works, *Untitled (Passage II)* at once inscribes a magical space and helps us transcend it.

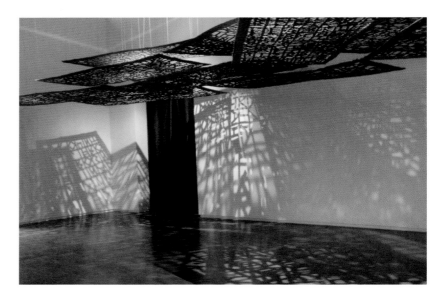

Cristina Iglesias, **Untitled (Passage II)**, 2002.
Installation at the Centre Pompidou, Paris.
17 mats, each raffia, 298 × 126 × 1 cm (117⅜ in.
× 49⅝ in. × ¼ in.)

'The contemporary art scene', a *New York Times* journalist alleged in June 2012, 'tends to favor either navel-gazing or promotion of certain agendas.' Since everyone in every walk of life 'tends to favour ... certain agendas', the latter of these charges is hardly provocative. But 'navel-gazing' is a far more serious allegation, frequently levelled by detractors of modern art. As a possible rejoinder, *Cloud Gate*, the colossal public sculpture that Indian-born British artist Anish Kapoor unveiled in 2006, suggests navel-gazing might not be a lamentable feature of contemporary art but at the very centre of its potential power.

The work, whose smooth reflective surface swells imposingly in Chicago's Millennium Park, consists of 168 stainless steel plates welded seamlessly together and weighs a staggering 110 tonnes. The metallic amoeba's bulging skin bounces back distorted images of everything that surrounds it, as if its slow stationary ooze would liquefy the world into its own mercurial substance. This distorting effect is visually amplified in the sculpture's underbelly, which visitors are encouraged to pause beneath, gazing upward at what Kapoor has called the work's *omphalos* – a Greek word, meaning 'navel'. Here, the concavity of the work's fluid mirroring warps and multiplies reflections in a profoundly disorientating fashion.

But is there a profundity to the piece greater than that achieved, albeit on a smaller scale, in the pulled faces of a fairground fun-house mirror? Kapoor's mesmerizing *omphalos* brings to mind the Omphalos Hypothesis put forward in the nineteenth century by the British naturalist Philip Henry Gosse in a book on the origins of the earth that sought to resolve, among other things, the amusing riddle, 'Did the Adam of Genesis have a navel?' Gosse wrote that the designer of the universe was a great trickster who mischievously hid forged signs of antiquity (fossils in rocks, the rings of trees) in a world that was in fact, as the Bible suggests, very young.

For Gosse and for Kapoor, creation is necessarily deceptive. We live in a world that is as dazzling as it is distorted; truth and the manipulated perception of truth bend and blur into each other. In *Cloud Gate*, the *omphalos* effect, which fabricates a weightless fluidity across a surface that merges earth and sky, is a sleight of artistic hand. Though the work appears to have dripped effortlessly from some cosmic alchemist's kiln, the polished surface conceals the conjoining seams of steel plates that took years to buff into its flowing lustre. It's through such visionary navel-gazing that contemporary art occasionally demonstrates its greatest potential.

Anish Kapoor, **Cloud Gate**, 2004. Permanent installation at Millennium Park, Chicago. Stainless steel, 10 × 20 × 12.8 m (32 ft 9⅞ in. × 65 ft 7⅜ in. × 42 ft)

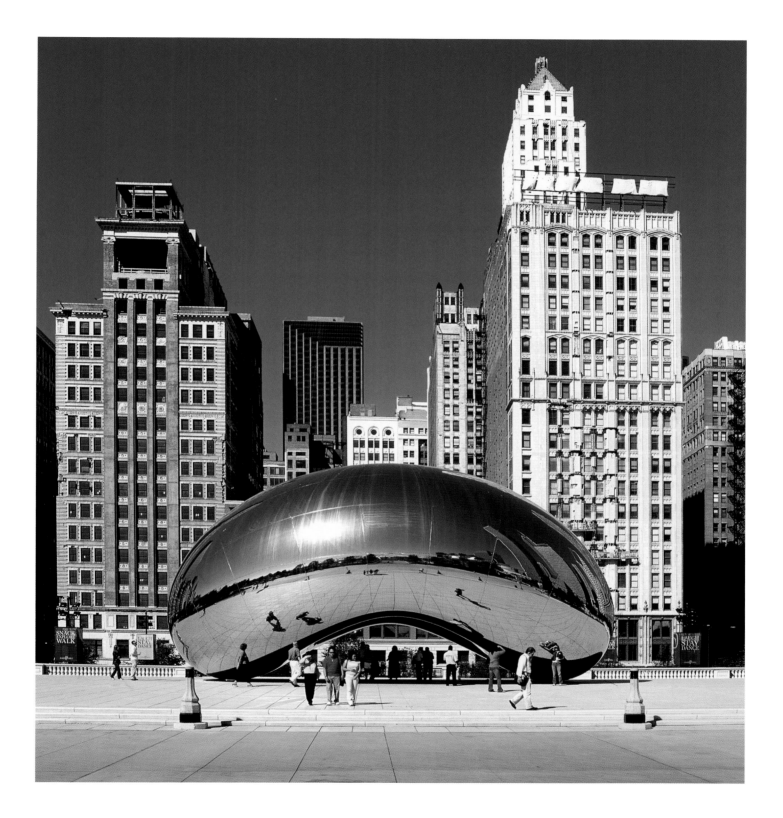

Who's counting? Japanese artist On Kawara, that's who. Since 1966, when he was thirty-three years old, Kawara has attracted attention and bemusement in the art world as the man who paints dates. Literally, and nothing else (as far as we know). Every single day Kawara paints what the calendar says in white acrylic on a solid background in an endlessly emerging series of works simply entitled *Today*. 'DEC.17,1979' one painting reads, thirteen years into the project. 'JULY 8,1981' asserts another, exactly 569 days later. From the canvas that declares '19FEB.2006', the viewer can ascertain that the artist was in Europe at the time he executed the work (notice how he flipped the day and month). Occasionally there are gaps. If the artist fails to complete a painting before the day has ended, he forever abandons the unfinished work. Critics have meditated on the meaning of such lacunae in the narrative unfolding of his magnum opus. Did someone's clock stop or did the artist simply lose track of time?

Forget about any help from Kawara himself. He avoids interviews and never introduces his art. That is not to say it is utterly voiceless. Since 1993, as a parallel project to *Today*, marathon recitations of an adjunct work, begun in 1969, that Kawara calls *One Million Years*, have been held in various cities throughout the world. The performances consist of two volunteer readers – a man and a woman – sitting side by side at a white table in a glass recording studio, as though swallowed by Damien Hirst's shark tank. Open in front of the two participants is the work itself: page after page after page of printed dates (twenty heavy volumes in all) listing progressively every year from AD 1996 until AD 1,001,995, or (as is read out every other day) the years from 998,031 BC to AD 1969. Hour after hour the male and female voices alternate reading year after year.

Those who have taken turns inside the vitrine attest to the sudden and surprising waves of emotion they experience as the syntax of weeks and months and years clock up. Now self-conscious, now bored, now entranced, now euphoric. Day after night, night after day, the pairs are led into the transparent ark to navigate the passage of time as though, without the colloquy of their throats, the invisible tabulation that harmonizes our distant, dissonant existences may cease altogether and, with it, life itself. And who can say it wouldn't? Not Kawara, that's who. He's somewhere squeezing a tube of white paint, tracing the ghost of a dying day, not breathing a word.

On Kawara, **One Million Years**, 1969–.
Performance at Trafalgar Square, London,
2004, duration 7 days, 7 nights

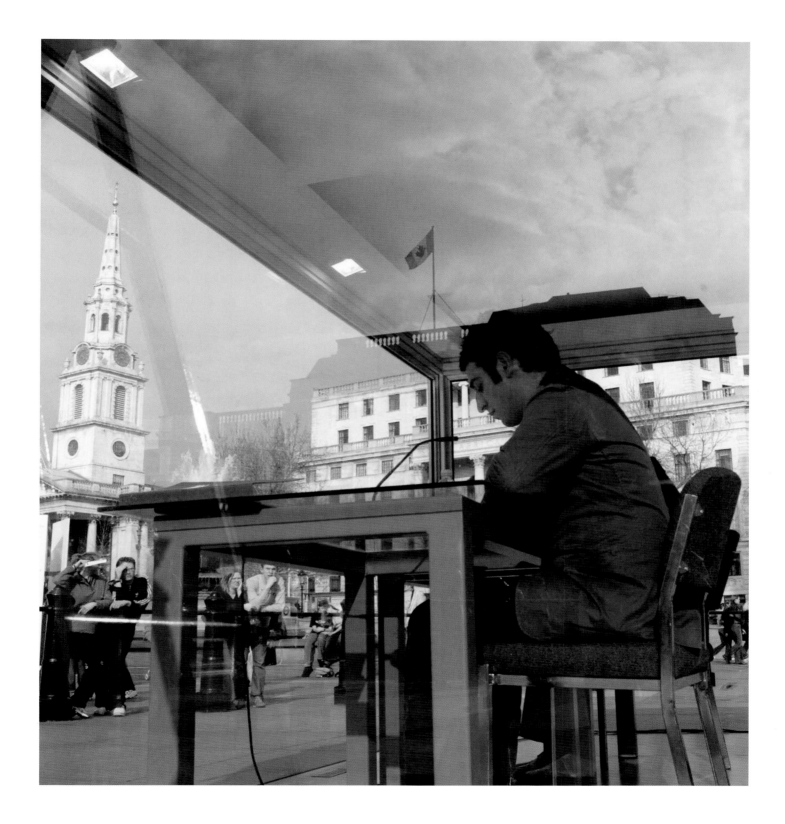

Is all art nostalgic? To take the question seriously, particularly in relation to American artist Mike Kelley's vast and often clangorous 2005 installation, *Day Is Done*, one must first strip the word of its relatively recent connotations of wistfulness and sentimentality and restore its original, more psychically wrenching meaning, along with the vaguely absurd circumstances of its coinage. It was a Swiss doctor, Johannes Hofer, who invented the term 'nostalgia' in 1688 to describe the anguish suffered by mercenaries commissioned away from their native Switzerland by joining the Greek *nostos* (homecoming) and *algos* (pain). Some of Hofer's colleagues doubted his diagnosis of acute emotional homesickness and argued that the sensation was purely physical, likely triggered by damage inflicted to the brain in childhood by the clanging of alpine cowbells.

In Mike Kelley's case, the competing explanations are not mutually exclusive, as it's the brutal cacophony of the artist's adolescent soundtrack that motivates the painful nostalgia that makes *Day Is Done* at once irresistible and insufferable. The work, which filled the Gagosian Gallery's expansive Chelsea, New York, space when it was first exhibited, featured two dozen 'sculptural viewing stations' – mini multimedia installations designed to recreate a scene of Americana recalled from the countless high-school photographs that Kelley had been collecting for years.

Kelley had archived these images into files devoted to everything from pictures of people tied up and gagged to individuals in pig pens; from kids covered in cream pie to those participating in fairground 'slave-day' rituals, where volunteers were sold on blocks to peers.

Fully aware of the unseemliness of many of these folk activities, Kelley nevertheless manages to find in the clang of their nostalgic cowbells an insidious music with an allure all its own, restaging, filming, then displaying song-and-dance vignettes inspired by the photographs alongside relevant sculptural material and works on paper. The result is a gallimaufry of engrossing God-awfulness – think glee club mashed with Hollywood horror films – which includes viewing stations devoted to 'hick and hillbilly' motifs, 'Goths and Hallowe'en', and religious and satanic performances. 'I consider *Day Is Done*', the artist has explained, 'to be a kind of fractured, feature-length musical ... made up of multiple simultaneous and sequential scenes playing in architectural space.' 'The experience of viewing it', he continued, 'is somewhat akin to channel-surfing on television.' Yes, or nostalgically flicking through one's high-school yearbook only to see the photographs suddenly burst into sinister song, exposing the most unpleasant of social prejudices. Is all art nostalgic? As Mike Kelley's discordant installation reveals, it certainly rings a bell.

Opposite: Mike Kelley, **Day Is Done**, 2005. Installation at the Gagosian Gallery, New York. Mixed media with video projection and photographs, dimensions specific to site

Right: Mike Kelley, **Singles Mixer**, from **Day Is Done**, 2005

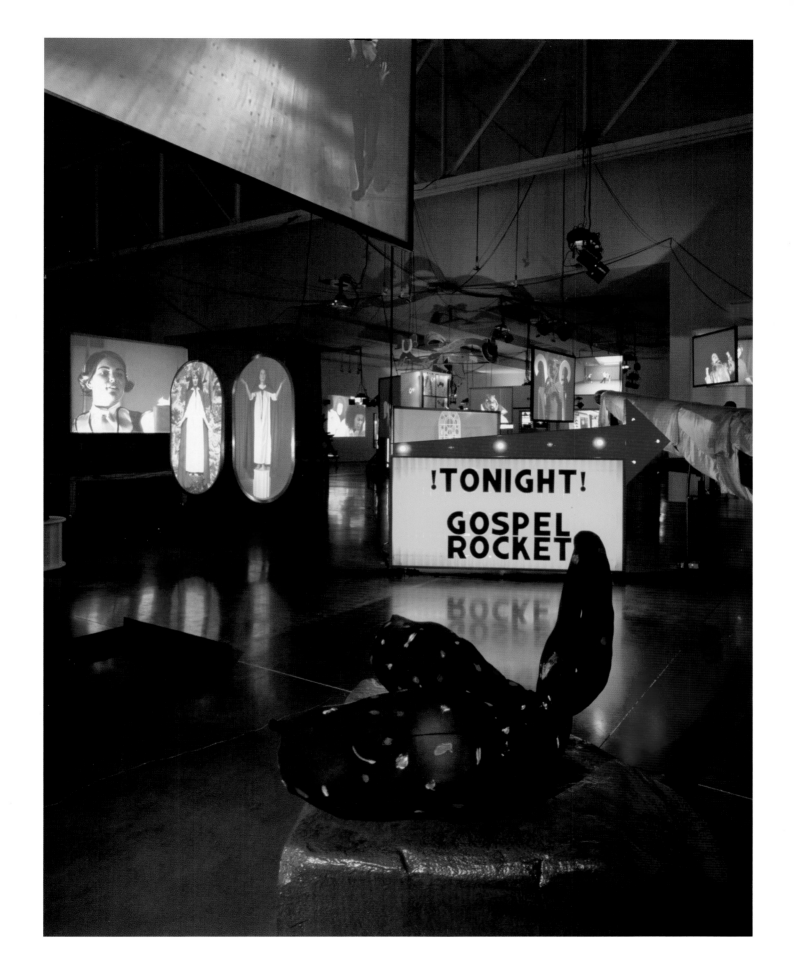

Above: Mike Kelley, **Shy Satanist**,
from **Day Is Done**, 2005

Right: Mike Kelley, **Day Is Done**,
2005. Installation at the Gagosian
Gallery, New York

050 Stereoscope (1998–99) WILLIAM KENTRIDGE

'I therefore propose', the English scientist Charles Wheatstone declared in an article on human vision published in the *Philosophical Transactions of the Royal Society of London* in 1838, 'that it be called a Stereoscope, to indicate its property of representing solid figures.' Wheatstone was introducing to the world an optical gadget he had recently invented: a handheld viewing device that creates an illusion of three-dimensional depth when two cards of the same image are placed side by side and viewed from a prescribed distance. A version of the contraption featuring pictures of Queen Victoria created such a stir when exhibited at London's Great Exhibition of 1851 that hundreds of thousands of stereoscopes were soon being sold in a craze that lasted for years.

It is Wheatstone's famous gizmo that South African artist William Kentridge's emotionally intense animated film adopts as its title. The eight-minute film, which Kentridge constructed by meticulously photographing, still by still, pastel drawings in the process of their gradual creation, features a recurring character in his works – a stocky, pin-striped quasi-self-portrait by the name of Soho Eckstein. Allusion to the stereoscope takes the form of an occasional split-screen that obliquely recalls the structure of Wheatstone's handheld viewer. But rather than creating a sense of optical depth, the separation allows Kentridge to illustrate divisions in Eckstein's identity, a decomposition of self that establishes a multi-dimensional depth of psychological rather than physical character. In that sense, Kentridge's melancholic film recalls an even more obscure device proposed decades earlier, in 1813, by John 'Walking' Stewart, an eccentric English philosopher and traveller. Stewart envisioned an unlikely gadget that could mystically synchronize telescopic and microscopic functions in order to bring into focus man's simultaneously infinite and infinitesimal position in the universe, as well as what Stewart believed was man's endless atomistic decomposition and recomposition into the material world around him.

Devised in the aftermath of the French Revolution, which Stewart witnessed at first hand in Paris, his 'panoscope' speaks eloquently to the synchronized emotional and political perspectives attempted by Kentridge in the aftermath of the upheavals that ended apartheid. Like Stewart's strangely spiritual device, which was, needless to say, never actually constructed, *Stereoscope* seeks to expose the complex coordinates that plot our lives and to offer a level of vision that sees beyond ephemeral politics to something fundamental in the formation of humanity. Throughout the otherwise monochrome sequence of stills, a blue line zags in and out of view, a pulse of indeterminate energy that shifts from an electrical wire in one drawing to a telecommunication cable in the next, from a ray of light to a stream of fluid.

'I believe that in the indeterminacy of drawing', Kentridge has said, 'lies some kind of model of how we live our lives. The activity of drawing is a way of trying to understand who we are or how we operate in the world.' The constant draughting and erasing of lines and figures that morph before our eyes – a cat shape-shifting now into a telephone, now into a bomb – is in harmony with the vision of material oneness that Stewart hoped his 'panoscope' might one day achieve. The final scene of Kentridge's film, which depicts Soho Eckstein standing in an empty office, his forlorn body leaking a soulful fluid that begins to fill up the room around him, is a fitting metaphor for the total immersion of self into the universe, one that lies behind both Kentridge's and Stewart's era-defining contraptions.

William Kentridge, drawings for the film **Stereoscope**, 1998–99. Charcoal, pastel and coloured pencil on paper, 120 × 160 cm (47¼ × 63 in.)

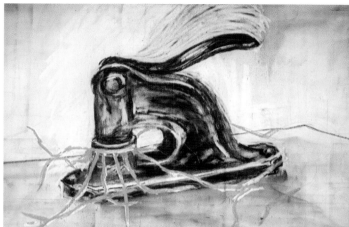

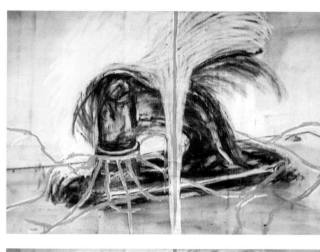

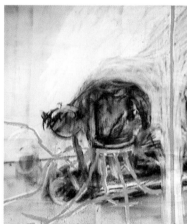

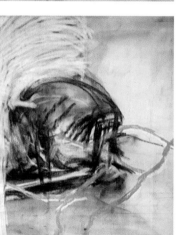

'What is history?', Victor Hugo asks in his novel *The Man Who Laughs* (1869), before proposing an answer: 'An echo of the past in the future; a reflex from the future on the past.' History it seems, is what comes back. If so, in order to propose a work that defines the present (and what is the present but tomorrow's past?) one must be prepared to nominate a work that is capable of defining all times, all pasts and all futures, a work that embodies the echoes of history, a work that keeps coming back. Few cultural figures working today are as preoccupied with the cyclical rhythms of time than artist Anselm Kiefer, and few recent works are as redolent of history's echoes than his 1997 painting *Die berühmten Orden der Nacht* (The Renowned Orders of the Night).

Since the late 1960s, Kiefer, who was born in war-torn Germany a few weeks before Hitler's demise, has sought to survey the murky horizons where history hesitates, at once receding and beckoning. Determined to map for himself the psychological terrain of a country that was then desperate to cover its tracks, Kiefer set about in one of his most controversial works, *Occupations* (1969), to record himself in various European locations provocatively rehearsing the Nazi salute, which by then was illegal to perform. Kiefer's defiant photographs seemed to suggest that by ignoring the vibrations of the past, however unsettling, Germany's collective conscious was storing up trouble. History comes back.

Over the course of the succeeding years and decades, Kiefer's art would inscribe itself with complex references to poetry and music, mythology and mysticism, and obscure esoteric assertions (such as Russian Futurist poet Velimir Khlebnikov's belief that history divides itself by cataclysmic sea battles into epochs of 317-year durations) in an effort to explore the tortured relationship between ancestors and descendants, the now and the then, the living and the dead. Where a complicated dialogue is frequently created between the clotted texture of Kiefer's sombrous surfaces (which often incorporate found material such as dried straw, children's garments, sand and rifles) and, for example, learned allusions to the Romanian poet Paul Celan, or German composer Richard Wagner, *Die berühmten Orden der Nacht* requires fewer scholarly annotations, while still pulsating with the same emotional power.

Looked at one way, the acrylic and emulsion work is as much a reinvention of *The Starry Night* (1889) by Van Gogh (to whom Kiefer's work often responds) as John Currin's *Pink Tree*, as we saw earlier, is a rewriting of Cranach. Here, the private constellations of Van Gogh's mental agony have exploded above the outstretched figure, littering the sky with spiritual debris. To lie beneath the slow star-fall of the universe is to witness the villainous and innocent history of the cosmos winking back. Or does the faint insinuation of a slowly disintegrating crucifix in the celestial pixilation that scintillates above the figure align the work more with ostensibly outmoded conventions of Renaissance depositions and thus the cyclical reoccurrence of cultural and religious themes? The man in Kiefer's work, almost certainly a self-portrait, has, like all of us, washed up on the shore of time's relentless ebb and flow, his existence illuminated by the fraudulent glow of distant bodies whose very being may long ago have ceased. History comes back. We live in the light of death, Kiefer's work reminds us, and are destined to construct our fate from time's misleading brilliance.

Anselm Kiefer, **Die berühmten Orden der Nacht** (The Renowned Orders of the Night), 1997. Oil, acrylic and emulsion on canvas, 5.1 × 5 m (16 ft 8¾ in. × 16 ft 4⅞ in.)

In June 1997, J. K. Rowling famously revealed to the world in her first book, *Harry Potter and the Philosopher's Stone*, the entrance to 'Platform 9¾', concealed in plain sight between platforms 9 and 10 of London's King's Cross train station and connecting the dull cityscape of our humdrum world with a gloriously unknown parallel realm of wizardry and magic that lay just inches beyond. Rowling wasn't the only contemporary artist toying with the existence of invisible railways and impossible transport in the 1990s. Three months before the publication of her first Harry Potter novel, one of the most promising creators of the age, German artist Martin Kippenberger, died of liver cancer at the age of forty-four in Vienna.

Among the many visions that perished with him was a project Kippenberger had been developing for five years: the METRO-*Net* World Connection, which imagined a hidden system of subway lines webbing the world, linking far-flung fictional stations for which, one by one, he would construct entrances. The artist only managed, however, to build a small number of these entrances before he died, including one on the island of Syros in the Aegean Sea, and another in a small town of fewer than fifteen hundred people in the Yukon,

Canada, best known for its position as the halfway mark in the annual Sled Dog Race each winter.

At first glance, the absurd notion of erecting entrances to stations that do not exist, into and from which passengers can neither arrive nor depart, may seem a throwback to the Surrealist objects of over half a century earlier, as useless as Meret Oppenheim's fur-covered tea set. Look again, however, and the pulseless terminals bustle with something more existentially profound. 'Railway termini', as the English writer E. M. Forster wrote in his 1910 novel *Howards End* 'are our gates to the glorious and unknown.' Indeed, there is something poignantly prophetic about Kippenberger's vision. Begun only a year after the phrase 'surfing the net' came into use, the artist's teasingly pointless METRO-*Net* World Connection was the last stop in a world on the verge of ensnaring itself in virtual, rather than actual, networks. Kippenberger's termini, which invite our imaginations to ponder the gloriously unknown routes by which human beings may be connected, were uncannily prescient of what was just down the track: the countless life-siphoning sites on which we alight aimlessly everyday, the links that promise to connect the world but in reality take us nowhere.

Opposite: Martin Kippenberger, **METRO-*Net* Subway Entrance**, Kthma Canné, Hrousa, Syros, Greece, 1993. Concrete, cast-iron grillwork, 3.8 × 13.8 × 2.8 m (12 ft 5⅝ in. × 45 ft 3¼ in. × 9 ft 2¼ in.)

Right: **METRO-*Net* Transportable Subway Entrance**, study for Martin Kippenberger by Lukas Baumewerd for the 'documenta X' exhibition, Kassel, Germany, 1996

Above: Martin Kippenberger, **Untitled
(La Residencia)**, 1994. Mixed media on hotel
stationery, 20.9 × 29.8 cm (8¼ × 11¾ in.)

Opposite: Martin Kippenberger, poster for
the **METRO-*Net* World Connection**, 1997.
CAD Print by Lukas Baumewerd, 93.3
× 58.2 cm (36¾ × 22⅞ in.)

MARTIN KIPPENBERGER

M.K.

METRO-*Net*
WORLD CONNECTION

Martin Kippenberger has planned a world-wide project
with the title "Metro-*Net*". The network reaches from
Syros, Greece to close to Alaska.

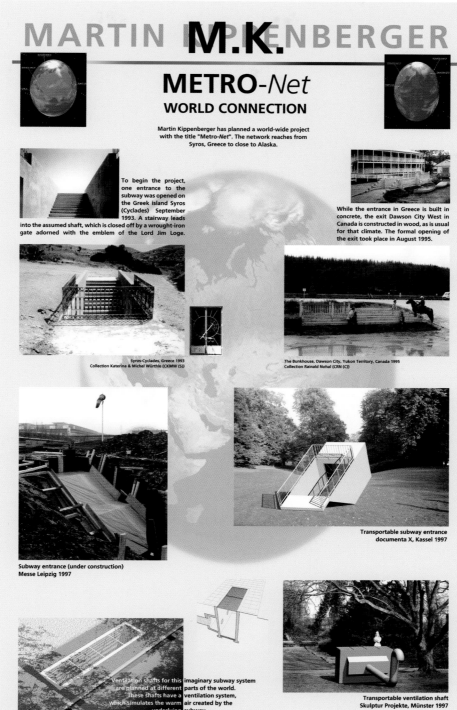

To begin the project, one entrance to the subway was opened on the Greek island Syros (Cyclades) September 1993. A stairway leads into the assumed shaft, which is closed off by a wrought-iron gate adorned with the emblem of the Lord Jim Loge.

While the entrance in Greece is built in concrete, the exit Dawson City West in Canada is constructed in wood, as is usual for that climate. The formal opening of the exit took place in August 1995.

Syros-Cyclades, Greece 1993
Collection Katerina & Michel Würthle (CKMW (S))

The Bunkhouse, Dawson City, Yukon Territory, Canada 1995
Collection Rainald Nohal (CRN (C))

Transportable subway entrance
documenta X, Kassel 1997

Subway entrance (under construction)
Messe Leipzig 1997

Ventilation shafts for this imaginary subway system are planned at different parts of the world. These shafts have a ventilation system, which simulates the warm air created by the underlying subway.

Transportable ventilation shaft
Skulptur Projekte, Münster 1997

'**Monuments of perverted taste.**' One could be forgiven for assuming that the statement was one of the many derisory remarks levelled against Jeff Koons's controversial *Made in Heaven* series of sculptures, paintings and photographs from the late 1980s, which notoriously featured the artist and his future wife, Italian pornographic star Cicciolina, in a variety of sexually explicit poses. In fact, the judgment was made over two hundred years earlier, in 1790, by an anonymous writer commenting on the accelerating European obsession with topiary – the sculpting of trees and hedges into the shape of animals and fantastical creatures – which Louis XIV's lavish gardens had helped ignite. 'The absurd and incongruous figures with which these landscapes are peopled', wrote the irascible eighteenth-century contributor to Tobias Smollett's *The Critical Review*, 'must surely disgust every genuine admirer of nature and simplicity.'

When Koons was not asked to contribute to the 'documenta 9' exhibition in Kassel, Germany, in 1992 (a slight that many took as censure for *Made in Heaven*), the American artist cleverly mounted a damage-control campaign with the erection in nearby Arolsen of what was said to be the largest topiary animal ever created: a twelve-metre-tall West Highland Terrier covered with over seventy thousand blossoming flowers. Rising enchantingly outside the Arolsen estate, the work caused an immediate stir, dwarfing not only the baroque palace that stood behind it, but also virtually everything on display in the Kassel gathering from which Koons had been excluded. With one scrape of his *Puppy*'s petalled paw, Koons buried all talk of his earlier 'monuments to perverted taste' and resurrected fascination with ones from a bygone era.

When asked about the inspiration for the work, Koons explained that *Puppy* represents what he imagines the Sun King, Louis XIV, might have dreamt up. Any such innocence investing the work, however, was jolted into horrifying reality five years later when the sculpture was installed in its permanent position beside the Guggenheim Museum in Bilbao, Spain. Before its official unveiling, three men disguised as gardeners assisting with the work were found to have packed flowerpots with a dozen remote-controlled grenades. They had planned on turning Koons's alluring structure into a kind of lethal Trojan Puppy.

The plot uncannily recalls an incident a century earlier, when the avant-garde artist and coiner of the term 'Neo-Impressionism', Félix Fénéon, concealed a bomb in a flowerpot, which he then detonated in a hotel in fin-de-siècle Paris in the name of anarchy. The three Bilbao conspirators, linked to the Basque separatist movement ETA, violently resisted apprehension and killed a Spanish policeman, Jose María Aguirre, after whom the plaza where *Puppy* now stands was renamed. For its unexpected ability to absorb such complex and contradictory connotations – innocence and terror, redemption and revenge – Koons's seemingly saccharine sculpture proves a remarkable metaphor of the age.

Opposite: Jeff Koons, **Puppy**, 1992. Installation at Schloss Arolsen, Germany. Stainless steel, wood (at Arolsen only), soil, geotextile fabric, internal irrigation system, live flowering plants, 12.34 × 12.34 × 6.5 m (40 ft 6 in. × 40 ft 6 in. × 21 ft 4 in.)

Right: Jeff Koons, **Bourgeois Bust – Jeff and Ilona**, 1991

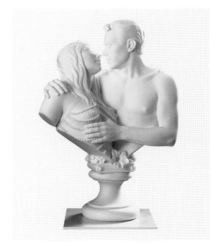

'Another sellout to the devil.' The sentence appears in a diary written during the American Civil War and is thought to be the first use of the word 'sellout', in the sense of 'one who betrays his or her principles'. The woman who wrote it was a Southerner by the name of Mary Chestnut, and she was commenting on a novel by the French writer Honoré de Balzac, *The Magic Skin* (1831), an early critique of bourgeois materialism. What is not clear from context, however, is just who the 'sellout' is in Chestnut's estimation: the main character of Balzac's work, who covets superficial objects, or the novelist himself. Had Chestnut lived to comment on our own society's obsession with consumerism and on contemporary artistic reactions to it, she might have had difficulty deciding whether the American conceptual artist Barbara Kruger is to be applauded for challenging a prevailing sellout psychology or is instead a sellout herself.

For over thirty years Kruger, who worked as a designer for *Mademoiselle* magazine after graduating from university, has developed a reputation for subverting the bold, brash advertising formats for which Madison Avenue is famous in order to create arresting slogans that ask us to rethink our relationship with the forces that control media and impel us to buy not only products, but also the social positions we espouse. Such slogans as 'I shop therefore I am' (stencilled over an infant's grasping fingers), 'It's a small world, but not if you have to clean it' (which frames a photograph of a woman from pre-women's-liberation-era America) and, most iconically of all, 'Your body is a battleground' (embossed boldly in red banners across the split portrait of a woman's face depicted half in solarized negative, half in black-and-white), established Kruger as a powerful feminist aphorist whose succinct sound bites nibbled away at public complacency during debates in the 1980s and 1990s about abortion rights and the rise of rampant consumerism.

But Kruger's decision in 2003 to engage in a lucrative three-year advertising campaign with the upmarket British department store Selfridges made some question whether she was trying to have her fake and eat it too. Art that had previously offered itself as clever 'anti-advertising' suddenly upped the ante on itself, demanding a droll postmodernist reading that some were reluctant to concede. The onioning of irony required to make meaningful the recycled signs, such as 'Buy me, I'll change your life,' now plastered above the sales floor, made the eyes of many water. Shoppers could shake heads at their own behaviour without feeling the need to shake off the behaviour itself. Seen from this vantage, the alarming declamation of her most memorable work, 'Your body is a battleground,' is perhaps more self-reflexive than Kruger initially intended and speaks as provocatively to the conflicted status of any body of artistic work as it once did to the embattled status of the female body politic.

Barbara Kruger, **Untitled (Your body is a battleground)**, 1989. Photographic silkscreen on vinyl, 2.85 × 2.85 m (9 ft 4 in. × 9 ft 4 in.)

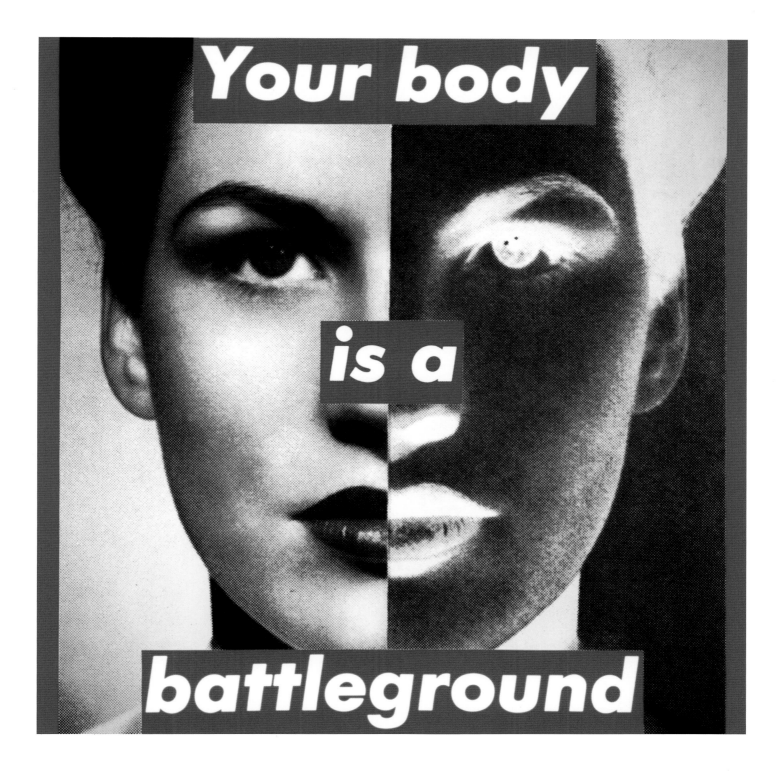

Occasionally a work knows its own significance not as the main noun or verb of a sentence in the unfolding narrative of art history, but as the final punctuation of a curious digression, a smirking end parenthesis, a full stop. One senses this may be the case for British artist Sarah Lucas's 1994 sculpture *Au Naturel*, which feels like the long-awaited punch line of a bad joke that's been building since the sixteenth century. In 1536 the Italian ceramist Francesco Urbino decorated a maiolica plate with the profile of a head composed entirely of penises. The portrait, which is surrounded by a scroll that reads 'OGNI HOMO ME GUARDA COME FOSSE UNA TESTA DE CAZI' (every man looks at me as if I were a head of dicks), is thought to have had an influence on everyone from Giuseppe Arcimboldo (the Milan-born portraitist of Rudolf II) to the Surrealists. It was Arcimboldo who fashioned faces out of fruit and vegetables, thereby blurring the boundaries between still life and portraiture. His absurdist sleight of hand was to prove crucial to the imagination of Salvador Dalí, who saw in Arcimboldo's decomposition of physical identity into seemingly unrelated elements, an adaptable technique that would enable him to smudge the distinction between conscious and subconscious constructions of reality.

Aware of where she falls in the history of art, Sarah Lucas understands the fatigue that visual puns have suffered and turns her viewers' jadedness to her advantage by poking fun at sexual double readings. In *Au Naturel* she reverses the priority of the lewd connotation over the innocent, elevating the profane to the surface level of meaning. All that's left of Arcimboldo's strange still-life portraits are two shop-worn oranges, a cucumber and a pair of melons lolling on a mattress – as well as the filthy dented bucket the artist hauled them to the exhibition in – as if society's representation of male and female interaction has finally reduced us to the crassest of adolescent jokes, to a gag line served up on Urbino's puerile plate. *Phwoar, check out those melons! I'd like a slice of that cucumber.*

Opposite: Sarah Lucas, **Au Naturel**, 1994. Mattress, melons, oranges, cucumber and bucket, 0.84 × 1.68 × 1.45 m (2 ft 9 in. × 5 ft 6 in. × 4 ft 9 in.)

Right: Francesco Urbino (attr.), maiolica plate, c. 1530–37

It is an easy slide from the sleazy slapstick of the last work we looked at, Sarah Lucas's seedy installation *Au Naturel*, to the dark humour of our next object: American artist Paul McCarthy's huge inflatable sculpture from 2003, *Blockhead*. But while Lucas's knee-slapper of a display smacks of a crass gag, McCarthy's blow-up doll from hell squeaks of something more deeply sordid, a giant chew toy for Satan's hounds. The angular hulk of the bulging balloon sculpture, which nodded unnervingly twenty-five metres above its onlookers, was a curious crossbreed of benign animation from popular culture (its nose was pure Pinocchio) and privately hatched avatar, which some saw as representing the darkness of consumer excess.

Like an oversized squeeze bottle of some artery-clogging condiment, plonked onto the table of our urban smorgasbord with the force of the sledgehammer that its cranium resembled, *Blockhead* loomed outside London's Tate Modern for five months in the summer and early autumn of 2003, inviting museum goers to compare McCarthy's vision with that of Henry Moore, two dozen of whose lozenge-smooth bronze and stone sculptures had been laid out inside. 'The associations they immediately bring to mind', wrote the critic Martin Gayford, comparing the achievement of McCarthy's works with that of Moore's, 'are all low, down-market ones: junk food, theme parks, kitsch toys. And the subliminal associations are nastier yet – sexual and scatological – as one might expect of an artist a great part of whose career has been devoted to performance art involving nudity, mayonnaise, hot dogs, molten chocolate and bottled sauce.'

Drawn throughout his career to the disquieting side of human behaviour, McCarthy has experimented since the 1970s with the visceral allure of the grotesque. In an early work entitled *Heinz Ketchup Sauce* (1974), the artist's instinct was to tear away the Pop Art superficiality that defined Warhol's slick packaging of Heinz ketchup and smother his own genitals in the tangy tomato sauce. In the years that followed, McCarthy embarked on a disturbing series of defacements and molestations of children's icons, subjecting much-loved characters, from Pinocchio to Snow White, to a variety of abuses intended to call attention to society's exploitation of the young. To be able to admire the grace of a Henry Moore while admitting the gruesome power of a Paul McCarthy is to be able to appreciate the austere solemnity, say, of an Iron Age standing stone while at the same time acknowledging that something equally real, if less salubrious, is crawling around in the dirt beneath it.

Opposite: Paul McCarthy, **Blockhead**, 2003. Installation at Tate Modern, London. Steel, vinyl-coated nylon, fans, rigging, wood, vending machines, hard candy bars, paint, glass and rope, 25.9 × 11.3 × 17.1 m (85 × 37 × 56 ft)

Right: Paul McCarthy, video stills from **Heinz Ketchup Sauce**, 1974

The last work we looked at, Paul McCarthy's inflatable nightmare, Blockhead (2003), relies for its effect on an unexpected tension between terror and toy – a defining theme of the age that characterizes several of the works featured in this book, especially Annette Messager's disquieting take on Pinocchio, *Casino* (2005), Ron Mueck's shrunken effigy of his deceased father, *Dead Dad* (1996–97), and Cindy Sherman's maniacal *Clowns* (2003–4). The line between levity and gravity is one that London-born artist Steve McQueen also smudges in his 1997 film *Deadpan*, which recasts a stunt from the 1928 Hollywood silent comedy *Steamboat Bill, Jr.*, starring Buster Keaton. McQueen is obsessed with the scene where a cyclone famously rips away the front of a house, sending it crashing down around the figure of the unsuspecting Keaton, who is spared a horrific crushing by the accidental alignment of his head and shoulders with an open window in the façade's frame. In McQueen's hands, a re-enactment of the toe-curling feat of actor's nerves and precise prop management is repeated over and over again from different angles for four and a half minutes, transforming a comedic near miss into a profound meditation on the precariousness of daily existence.

Though the basic dynamic of McQueen's work has been lifted from the earlier film, the artist has cleverly altered fundamental details of the narrative in order to invest the work with levels of social commentary unavailable in Keaton's earlier routine. McQueen assumes the lead role of the motionless figure around whom the world is literally falling apart, and the camera's lingering focus on his laceless, world-weary shoes and the modest nature of his dress suggests a life of hard labour, if not servitude, which is reinforced by the contours of the collapsing house itself, whose spare log-cabin design resembles that of a tenant farmer's shack from Reconstruction-era America. But if these elements seem to confine the meaning of McQueen's work to a specific cultural context, the enormous scale of the film's projection onto the gallery wall, such that there is no margin above or below, at once engulfs the visitor, who is made to feel physically imperilled by the repeated crash of the structure, and elevates the work from social commentary into something inescapably intense.

Why the title *Deadpan*? The word is thought to have been coined in the 1920s, as glossed in a theatrical supplement included in the *New York Times* the same year that *Steamboat Bill, Jr.* was released: 'Dead pan, playing a rôle with expressionless face as, for instance, the work of Buster Keaton.' Language to describe cool impassiveness in the face of absurd disaster would not go unused as the American economy collapsed a year later, inaugurating an era of austerity and depression. By gesturing back to the phrase's filmic origin, McQueen's mute homage reminds us that art often defines its age most enduringly by inspiring the very vocabulary with which we are able to describe it.

Opposite: Steve McQueen, film still from **Deadpan**, 1997. 16 mm black-and-white film, transferred to video, no sound, 4 minutes, 35 seconds

Right: Film still from Charles Reisner's **Steamboat Bill, Jr.**, 1928

Can art and life ever be in sync? We often speak of art imitating life and vice versa, but imitation assumes that one or the other must have happened first and is therefore always a step ahead. Or perhaps art and life live by different rules of time. There is a suspicion that art occurs in a suspended dimension on the margins of ordinary reality – in museums, galleries and cinemas – separate from the grind of commonplace calendars and diaries. The elevated eternity in which art plays out its slow existence knows nothing of the anxious spin of hands on wrists or the pale green click of the insomniac's bedside clock. Surely great art suspends time the way sandstone suspends the last rays of a sunset and resists the humiliating measure of hours, minutes and seconds that draw and quarter all that is living.

The Swiss-American artist Christian Marclay's cinematic feat *The Clock* ingeniously seeks to reset our assumptions about the unbridgeable divide separating 'art time' from real time. The work comprises thousands of film clips in which a watch or clock features, fastidiously spliced together so that the patchwork footage keeps perfect pace with real-world time. *The Clock* is an all-inclusive quilt of Western cinema, in which snippets from Hollywood noirs are spooled seamlessly with cuts from British slapstick or swatches from French art-house indies to create one of the most unusual chronometers ever conceived. No matter what minute of what hour, day or night, Nicolas Cage, Sean Penn or Peter Fonda may be seen pausing to contemplate the suspenseful elapse of excruciating seconds on a wristwatch, which has been synchronized to the actual time it has reached in the real world. The result is a beautifully haphazard collage in which happiness and tragedy, courage and villainy, interweave unpredictably.

That the work calibrates itself to the relentless cadence of real time has the effect of projecting onto our own sense of the day's movement a brutal narrative urgency, reminding us that every instant may be of the direst consequence. The genius of Marclay's work is its ability to invert the consciousness of cinematic time. In Hollywood thrillers, the ticking that sustains a plot's momentum is always towards a potential explosion that must be averted in the bank or on a bus in order to save fictional lives. With *The Clock*, the unmentioned device that's winding down and keeping us glued to our seats is us: our lives. Red wire, black wire. It hardly matters. Marclay's is a time bomb no one can dismantle.

Opposite: Christian Marclay, **The Clock**, 2010. Installation at White Cube Mason's Yard, London. Single channel video, 24 hours

Right: Christian Marclay, video stills from **The Clock**, 2010

CAN ART
AND LIFE
EVER BE
IN SYNC?

Life doesn't
imitate art,
it imitates bad
television.

WOODY ALLEN

'My nose is growing.' It's a simple enough statement, but when the eleven-year-old daughter of a professor of logic in Australia imagined it in 2001 coming from the wooden lips of the world's most famous fibbing puppet, the sentence inspired her father to formulate an intriguing intellectual problem that has since sparked much scholarly debate: the Pinocchio Paradox. An upgrade on the fourth-century BC Liar Paradox (which plumbs the contradictions inherent in the assertion 'this sentence is false'), the Pinocchio Paradox sheds curious light not only on one of the more compelling works of recent years, French artist Annette Messager's ambitious installation at the 2005 Venice Biennale, *Casino*, but also on the power of contemporary art generally.

According to the original story by the nineteenth-century Italian children's writer Carlo Collodi (whose vision of a marionette that dreams of becoming a real boy provided the inspiration for Messager's multi-room, mixed-media odyssey), Pinocchio's nose grows if (and only if) what he is saying is untrue. Therefore, according to the logic of the little girl's mischievously ventriloquized statement, 'My nose is growing,' the sentence can only be true if (and only if) it is not true. Pinocchio's nose is growing, in other words, only if it isn't growing. On its most basic level, the riddling journey of contemplation this cognitive pickle triggers – like the boisterous journey on which Messager invited visitors through a series of rambunctious spaces that evoked Pinocchio's transformation from toyhood to boyhood – is utterly irrelevant and ought not to interest the audience in the slightest, as it posits circumstances that can never actually occur.

In short, who cares? Our noses don't grow in proportion to our dishonesty, and none of us undergoes a transformation from inanimacy to life. Yet on a deeper level, our insistence in caring about that which logically we should not (as in the case of scholars debating the Pinocchio Paradox for what it might say about the nature of language) speaks to what moved visitors emotionally as they drifted from room to room in Messager's unsettling saga of shadows and rubber hands – from a room-sized tsunami of red silk that threatened to capsize viewers as it belched forth bizarre creatures from beneath its fiery weave to a space of preposterous projectiles that whizzed about with the ferocity of a child's overheated imagination.

The success of Messager's work, which was awarded the prestigious Golden Lion for best pavilion, relied on visitors' willingness to contemplate an analogy of emotional movement within themselves, from woodenness to humanity. By definition, representative of something that in fact it is not, all art is a lie. That we frequently accord the lie of art the power of truth is among the more intriguing paradoxes the human condition entails. *This is not a pipe*. *My nose is growing*. I am Pinocchio. So are you. Art is truest when (and only when) it is not.

Annette Messager, **Casino**, 2005.
Installation view of the *Dedans* (Inside) room
at the French Pavilion, 51st Venice Biennale.
Silk pongee, fabric, various elements, optical
fibre, neon lights, pulley, computerized
system, 4 × 16 × 12 m (13 ft 1½ in. × 52 ft 6 in.
× 39 ft 4½ in.)

Annette Messager, **Casino**, 2005.
Installation view of the *Dedans* (Inside)
room at the French Pavilion, 51st Venice
Biennale.

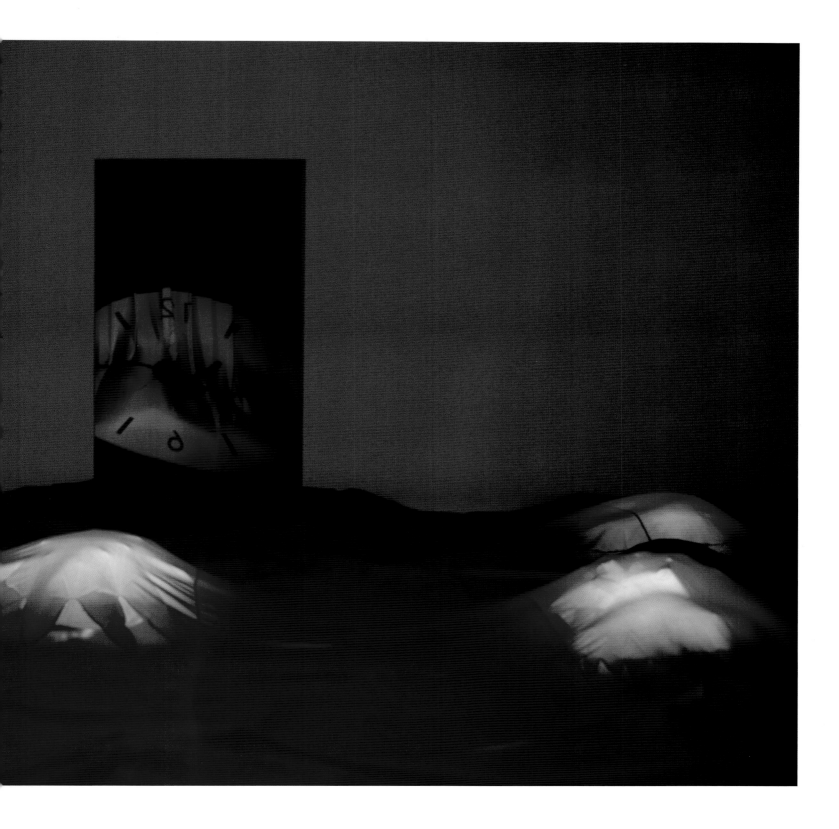

'**Creativity**', according to the Nigerian poet and novelist Ben Okri, 'is the art of the impossible.' Okri was comparing imagination with politics (what he calls 'the art of the possible'), but he could as easily have been describing the achievement of his contemporary, British sculptor Polly Morgan, and in particular her life-defying 2009 work *Departures*. Consisting of a huge golden cage that appears to be lifting from the ground under the furious propulsion of a mixed flock of over thirty birds (from vultures to finches), the work flies in the face of everything we have come to expect from the behaviour of the natural world, not least the aptitude of the dead to facilitate the emancipation of the living.

An expert taxidermist, Morgan has built a reputation recycling the found carcasses of unfortunate woodland creatures, staging the preserved remains of road kill into startling scenarios that seem to suspend their bodies in an endless instant of reanimation: a sleeping squirrel curled into a martini glass, piglets suckling at a log, a blizzard of chirping quail chicks bursting from the cracks of a decomposing coffin. Morgan's imagination maps a murky terrain between the moving and the macabre. Though death emerges as a significant motif in many of the works discussed herein – Damien Hirst's jewel-encrusted skull, *For the Love of God*, already introduced, and Ron Mueck's mannequin *Dead Dad*, still to come – in Morgan's sculptures one detects an unsettling refusal to concede any dominion to death, just as Norman Bates, in Alfred Hitchcock's film *Psycho*, refused to accept the passing of his mother, whose deteriorating body he kept in the rocking chair beside him. In the eerie motel of Morgan's inimitable imagination, beasts that have checked out from one world find themselves upgraded to the uncanny comforts of another, where the limitations of life no longer impinge upon what's possible.

In 1887, a Frenchman by the name of Charles Richard Edouard Wulff submitted an application to the American patent office for a bizarre invention that only the physical imperatives of this world kept him from constructing: a hot air balloon propelled entirely by the harnessing of birds. 'The result of these arrangements', Wulff explained in his application, 'is that the flight of the harnessed birds must produce the motion and direction of the balloon desired by the conductor.' Whether or not Morgan's morbidly magical *Departures* is a deliberate resuscitation of Wulff, her art of the impossible is darkly uplifting and among the more outrageously ingenious inventions of the age.

Polly Morgan, **Departures**, 2009. Steel,
leather and taxidermy, diameter 4 × 2.5 m
(13 ft 1½ in. × 8 ft 2½ in.)

We live in an age of forensic reconstruction, of CSIs and FBIs and endlessly rehearsed versions of criminal detection, from the constantly reincarnating Sherlock Holmes to the Danish television series *The Killing*, from the celebrated Swedish investigative drama *Wallander* to the French police series *Spiral*. But what are we really looking for? The format is invariably the same: we start with a dead body and begin dusting for prints, methodically working backwards to make sense of the troubled world in which we find ourselves.

The ability of these narratives to tap into a deep human instinct to solve the mysteries of our past is also what invigorates Ron Mueck's unsettling sculpture *Dead Dad*. The work consists of a fabricated naked body of a deceased elderly male fashioned from silicon, resin and human hair, and clinically laid out as if awaiting a coroner's scalpel. So painstakingly wrought is every sag, wrinkle and pore that visitors find themselves stooping to inspect each inch of the cold corpse as though they had just emerged from under the cordon of yellow police tape, flashing their badges. Among the puzzles we are left to ponder is the curious scale of the eerily shrunken form. At two thirds the size of an average cadaver, the body rests disturbingly between life-size mannequin and diminutive toy, its awkward stature somehow heightening, as it were, the discomforting effect. The bluntness of the work's title, *Dead Dad*, the only linguistic clue on the scene, adds to the sense that something disconcerting has led to the disposal of this lifeless, lifelike being.

In museum spaces, we are used to confronting countless versions of a dead son in lamentations, depositions and *pietàs* – a tradition whose span could virtually double for that of Western art. The foreshortened perspective of Mantegna's *Dead Christ* (c. 1480), which optically truncates Christ's body, achieves an unsettling literalness of substance in Mueck's unnervingly shortened work. *Dead Dad* shocks us out of our expectations and challenges us to consider that the creation of bodies is not a power belonging exclusively to the parent. The supine sitter for the work was, indeed, the Australian-born artist's deceased father, and the piece itself, in all its uncanny realism, represents Mueck's attempt to deal with the passing of a figure with whom he had had a difficult relationship. 'The child is father of the man,' so the soulful saying goes, only here the form to which the artist has given birth is paradoxically stillborn at the end of life.

George Orwell has been credited with saying that by the age of fifty 'every man has the face he deserves'. For Mueck, who honed his technique as a puppeteer for children's television before joining muppet-maker Jim Henson, the process of creation was one of tracing the texture of his father's worn countenance back through a childhood maze of shared experience that had etched itself into both their faces – the living son and the moribund father. Detractors of the work, which was first unveiled in Charles Saatchi's controversial 'Sensation' exhibition at the Royal Academy of Arts in London in 1997, objected to what they saw as an aggressive and tasteless defacement of another human being's memory. The mystery into which Mueck's body draws us, kneeling to examine the silicon knees and resin nails of a supposed stranger, leads us back to our culpability in shaping the existences of those with whom our own messy pasts are strewn.

Opposite: Ron Mueck, **Dead Dad**, 1996–97. Mixed media, 20 × 38 × 102 cm (7⅞ × 15 × 40⅛ in.)

Right: Andrea Mantegna, **The Dead Christ**, c. 1480

'A terrible beauty is born.' The phrase, which appeared in a poem written in 1916, belongs to the Irish writer William Butler Yeats and was written in the years after the poet claimed to have begun communicating with the spirit of a North African Renaissance traveller by the name of Leo Africanus. Almost a century later, the pattern of an artist summoning the spiritual guidance of a master from the sixteenth century would repeat itself in the curious relationship that Japanese multimedia artist Takashi Murakami, born in 1962, shares with Kanō Eitoku, a distinguished painter of the Azuchi-Momoyama period, born in 1543. Like Yeats before him, Murakami felt himself drawn to the beckoning energy of his spiritual forebear, and in particular to a quality in Eitoku's work that art historians identify as *kikikaikai*, or the ability of a work to suspend such paradoxes as 'delicate boldness' and 'refined bizarreness' (what Yeats might have called 'a terrible beauty').

Eitoku's signature technique of depicting flattened features against a timelessly minimal background, as found in one of his most famous works, a six-panel screen entitled *Chinese Lions*, invigorated Murakami's imagination and provided the guiding spirit for a style for which he has become famous: Superflat. Fascinated by how *kikikaikai* holds in tension competing artistic forces, Murakami set about reinventing the concept for a new age by snapping the term in two to form the separate entities of *Kaikai* and *Kiki*, two cartoonish characters who he believes are as fearsome in today's visual parlance as Eitoku's protective lions were five centuries ago. Variously described by the artist as spiritual guardians or 'gods of art', the smiling *Kaikai* (always depicted in white with large rabbit-like ears) and the snarling *Kiki* (distinguished by vampirish teeth and a third eye) are an ingenious fusion of ancient tradition and contemporary commercial kitsch, of high culture and cutting-edge pop. Think Hello Kitty! on acid crossed with Giotto's angels. Not everyone, however, has been convinced by the mash-up or been willing to concede the wisdom of Murakami's spiritual guide in inspiring his two impish daimons.

In 2010 the artist was invited to install large-scale fibreglass and resin statues of his creations amid the royal grandeur of the Palace of Versailles outside Paris. Encountering Kiki's fanged grin and Kaikai's insipid smirk standing sentry on either side of a statue of Louis XIV in the opulence of the Venus Salon delighted some but left others shaking their heads in bemusement. As if snipping Yeats's famous phrase in two, critics were divided in their assessment of the exhibition, attaching 'terrible' and 'beautiful' to Murakami's work in equal measure.

Opposite: Takashi Murakami, **Kaikai Kiki and Me**, 2008. Acrylic and platinum leaf on canvas mounted on aluminium frame, 1.5 × 1.5 m (4 ft 11 in. × 4 ft 11 in.)

Right: Kano Eitoku, **Chinese Lions**, Azuchi-Momoyama period, late 16th century

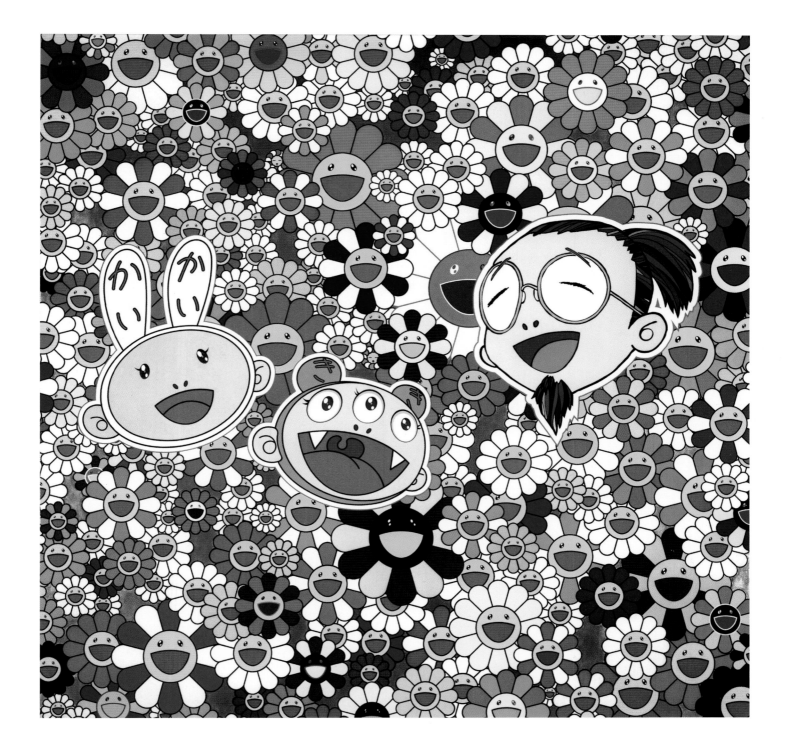

The word 'backlash' first appeared in print in an 1815 British patent application submitted by the locomotive pioneer George Stephenson. 'There is a great risk', the application warned, 'of breaking these wheels from the backlash or returning stroke of the engine.' It wasn't long before the mechanical definition of the new word gave way to a figurative one: an unintended, negative consequence of one's own aggressive action, or what Shakespeare called being 'hoist with his own petard'. So the clue to the bold meaning of Nairobi-born artist Wangechi Mutu's powerful 2004 collage *Backlash Blues* may be embedded in its title, as this work is all about the risks of modern engines pushing forward the colonization of physical as well as psychological territories. The complex machine of Mutu's image, comprised of ink, acrylic and photo-collage against a surreal shimmer of Mylar, constitutes a vibrant backlash to the brutal forces that colonized the landscapes of her native Africa (enslaving its people, economy and resources for the enrichment of the West) – a vehicle she uses courageously to reclaim the world for herself and her people.

The girl that Mutu depicts, crouched on the shore of some primordial elsewhere as if transported back to a time long before the corrosive encroachment of civilization, possesses an unselfconscious dignity that refuses to conform to contrived conventions of Western beauty. Indeed, she cuts these conventions to shreds. The dreamlike amoebic mottling of her complexion suggests she exists more as an element of the mind than a being of tangible flesh. She's an idea, a fossilized memory of a figure before 'the fall'. The work is also, therefore, a backlash against contemporary Western media campaigns that distort the shape of female African identities.

Admirers of Mutu's work have compared the cutting and splicing of glossy magazines necessary to create her collages with physical abuse, and one is tempted to read into the term 'backlash' dark hints of slavery's lashed backs – echoes of historical violence to which the artist's imagination and work are also very much alive. Seen in the context of African American art (Mutu moved to New York from Kenya in the 1990s), *Backlash Blues* can also be understood as a powerful flashback, or 'returning stroke', to some of the most innovative artworks of the Harlem Renaissance of the 1920s and 1930s. The otherwise mute musical motif implied by the work's title is suddenly amplified when the work is placed alongside Aaron Douglas's optically thrumming *Aspects of Negro Life: The Negro in an African Setting* (1934), which depicts African musicians united in the exuberance of rhythm and dance before the arrival of the slave trader. Douglas characterized the reverberating effect of his harmonizing layers of colour as 'visual emanations', whose soulful strokes one feels returning more dangerously in the brutal music of Mutu's work. 'Mr Backlash, Mr Backlash,' one can almost hear the crouched girl's mind whisper in tune with Nina Simone's throaty purr, 'I'm gonna leave you with the Backlash Blues.'

Opposite: Wangechi Mutu, **Backlash Blues**, 2004. Ink, acrylic, photo collage, contact paper on Mylar, 1.98 × 1.19 m (6 ft 6 in. × 3 ft 11 in.)

Right: Aaron Douglas, study for **Aspects of Negro Life: The Negro in an African Setting**, 1934

'The fingers', according to the twentieth-century Mauritian aphorist and artist Malcolm de Chazal, 'must be educated. The thumb is born knowing.' But what the thumb knows and teaches to the fingers is mysterious. In art, the secret ministry of digits, performing in dramas separate from the bodies to which they are attached, has invigorated works from Leonardo da Vinci's *The Virgin of the Rocks* (1483–86) to the American artist Bruce Nauman's 2010 video installation *For Beginners (all the combinations of the thumb and fingers)*. In the design of da Vinci's work some scholars have ascertained the coded initials of the artist in the three hands stacked at the centre of the painting, decrypting from Mary's left hand an esoteric sign for the letter *L*, from the sidelong point of the archangel Gabriel's index finger below it a sign for the letter *D*, and from the raised middle and index fingers of the infant saviour below that, a playful *V*. The result is a rock-paper-scissors of artistic prophecy – a sleight of hands that rouses the presence of the artist in the most intimately spiritual of congregations.

What begins initially as subliminal initials in the Renaissance master's work slowly swells in significance until all that is left in Nauman's work is the artist's hands themselves. *For Beginners (all the combinations of the thumb and fingers)* consists entirely of two pairs of uplifted hands, palms exposed, projected onto a huge screen. We watch as the hands react to the dissonant commands of two voices dictating different combinations of digital signs. This ceaseless generation of seemingly meaningless gestures slowly gathers into an epic of indecipherability. Perhaps we're being told the meaning of life. Or the meaning of death. Suddenly works from Nauman's past, such as his swirling neon sign *The true artist helps the world by revealing mystic truths* (1967), seem part of a more ambitious, misunderstood lifelong project.

The growing suspicion that a secret sign language may be emerging in *For Beginners*, as if the artist were auditioning a crude grammar before our eyes, invites us to rethink the silent eloquence of all that goes unspoken around us. Yes, we should listen to hands. In 1933 the German psychiatrist and philosopher Karl Jaspers expressed astonishment that his fellow intellectual Martin Heidegger could be seduced by the mystique of someone as dubiously cultivated as Adolf Hitler. 'Culture is of no importance,' Heidegger is said to have replied, 'look at his marvellous hands!' The minimalist notion that one's hands can be severed from the rest of his or her being, that a marvellousness of gesture might be isolated from a malevolence of purpose, likewise lies behind Nauman's work. As everyone from da Vinci to Maurizio Cattelan (whose broken-hand statue *L.O.V.E.* we looked at earlier) to Nauman reveals, there's no telling what the hands hold; the fingers aren't whispering a thing. *Shhhh*. Thumb's the word.

Opposite: Bruce Nauman, video still from **For Beginners (all the combinations of the thumb and fingers)**, 2010. Video installation (colour, stereo sound) on continuous play. 2 HD video sources, 2 HD video projectors, 4 speakers, dimensions vary with installation

Right: Leonardo da Vinci, **The Virgin of the Rocks** (detail), 1483–86

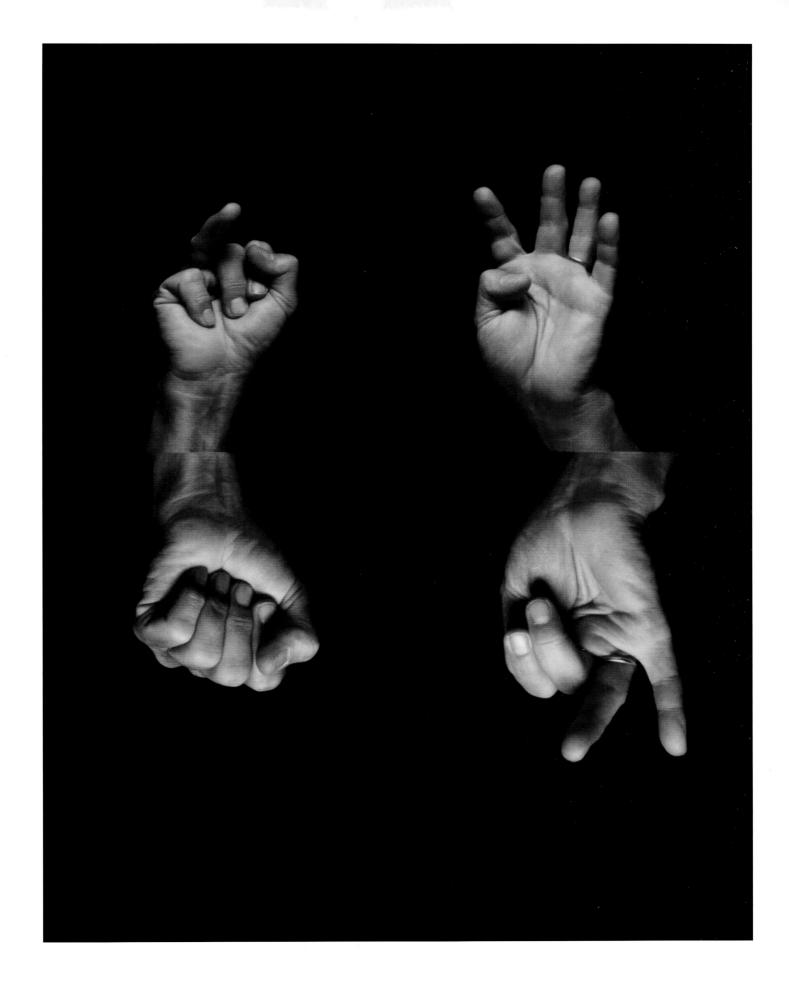

WHAT
WILL
SURVIVE
OF US?

...works of art [are]
mysterious existences,
the life of which,
while ours passes
away, endures.

RAINER MARIA RILKE

'**Inside you,**' Swedish poet Tomas Tranströmer once wrote, 'vaults behind vaults open endlessly. You will never be finished.' If the last work we looked at, Bruce Nauman's *For Beginners (all the combinations of the thumb and fingers)*, explores the ceaseless gestures we generate, our next work investigates the infinite regression of inner rooms – 'vaults behind vaults' – in which these silent pleas are desperately rehearsed, responded to, or ignored. British artist Mike Nelson's ambitious installation, or 'built environment', to use his phrase, *The Coral Reef* (2000), invited visitors into a sprawling complex of interconnecting spaces, each one recreating the squalid interior in which an unidentified individual had played out the dark drama of his or her invisible existence. Now you're in a heroin den. Now a terror cell's squat. Now a head shop where a violent scheme was brainstormed – an abandoned machine gun and rubber clown mask twitching at you under the soulless flicker of a fluorescent tube. Or is this, as the artist has suggested, merely a glimpse 'inside the mind of the absent occupant'? All around hang signs of menace and psychological decay: a trampled tabloid whose headline reads 'WAR'; a dope head's trippy motto, 'Don't Drink and Drive, Smoke a Spliff and Fly'.

Nelson's work anticipates by a couple of years other meditations on contemporary cultural spaces that we've already looked at, such as Thomas Hirschhorn's 2002 *Cavemanman*, as well as those yet to come, such as Rirkrit Tiravanija's ongoing *Apartment* series. But in Nelson's work there is no hint of the joyful utility that Tiravanija brings to his fully functional installation (in which visitors can make themselves tea or take showers), or of the surrealism of Hirschhorn's cardboard and packing-tape hideout. The blueprint of Nelson's *The Coral Reef* maps the margins of social consciousness, a world into which we rarely gain entry, save for the occasional news coverage of an early-hour police raid or the apprehension of a serial killer. And though few of the visitors to Nelson's work are likely to sympathize with the ghosts who haunt his unsettling spaces, the movement from vault to vault is an odyssey that feels fundamental: a floor plan of what we're most afraid of becoming. Exiting one room and entering the next, one cannot help wondering what occasioned the sudden evacuation of the presence who once resided here. Arrest? Death? Retraining as an artist? As the poet tells us, vaults behind vaults open inside us. But not all are safe to enter.

Mike Nelson, **The Coral Reef**, 2000.
Installation at Matt's Gallery, London.
Various media, approx. 12 × 13 × 3 m
(39 ft 4½ in. × 42 ft 7½ in. × 9 ft 10⅛ in.)

Mike Nelson, **The Coral Reef**, 2000.
Installation at Matt's Gallery, London

What is a self-portrait? According to etymology, the word 'portrait' is closely related to the Latin *prōtrahere*, meaning 'to drag forward' or 'to reveal'. By definition then, portraiture involves struggle and resistance, a dragging forward. By extension, self-portraiture may be thought to connote something more surprising still: a pulling forward of one's own being. Certainly struggle lies at the heart of Shirin Neshat's arresting self-portrait *Rebellious Silence* from her acclaimed 1994 series of photographs, *Women of Allah*. The black-and-white image depicts the face of the artist cloaked in a traditional Islamic chador and riven by the vertical imposition of a rifle's barrel, which bisects the self-portrait from the middle of her forehead, down the length of her nose, before splitting her chin and disappearing into the darkness of the veil below.

The photograph, half in shadow, half in light, poses more questions than it answers. Is the subject voluntarily holding the weapon before her or has it been oppressively foisted against her? For many who first encountered the image, it was likewise impossible to know what to make of the sinuous Persian calligraphy that had been superimposed across the artist's face. Even were an observer to be made aware that the text comes from a poem by the female Iranian writer Tahereh Saffarzadeh (who is known for praising Islamic martyrs in the Iran–Iraq war), it would not be clear whether the sitter endorses the pro-revolutionary sentiments inscribed or has had them etched onto her countenance against her will.

From nearly every angle, the image ambiguously drags both its subject and its viewer in opposite directions. In that sense, it captures fittingly the artist's own self-dissecting journey into exile from her homeland of Iran, which she left for the United States after graduating from high school in 1974. When she returned, sixteen years later, revolution and the installment of the Islamic Republic had fundamentally altered every aspect of the culture she remembered, not least the role of women in society. Symbolizing that role is the controversially concealing hijab, which Neshat returns to again and again in the *Women of Allah* series. The *Encyclopedia of Islam and the Muslim World* explains that 'the term hijab or veil is not used in the Qur'an to refer to an article of clothing for women or men, rather it refers to a spatial curtain that divides or provides privacy.' Paradoxically, by placing herself behind 'spatial curtains' of fabric, poetry and firearms, Neshat is able to pull forth a compelling portrait of Iranian women in political, religious and sexual conflict.

Shirin Neshat, **Rebellious Silence**,
from the series **Women of Allah**, 1994.
Photograph taken by Cynthia Preston.
Black-and-white, resin-coated print
with ink, 27.9 × 35.6 cm (11 × 14 in.)

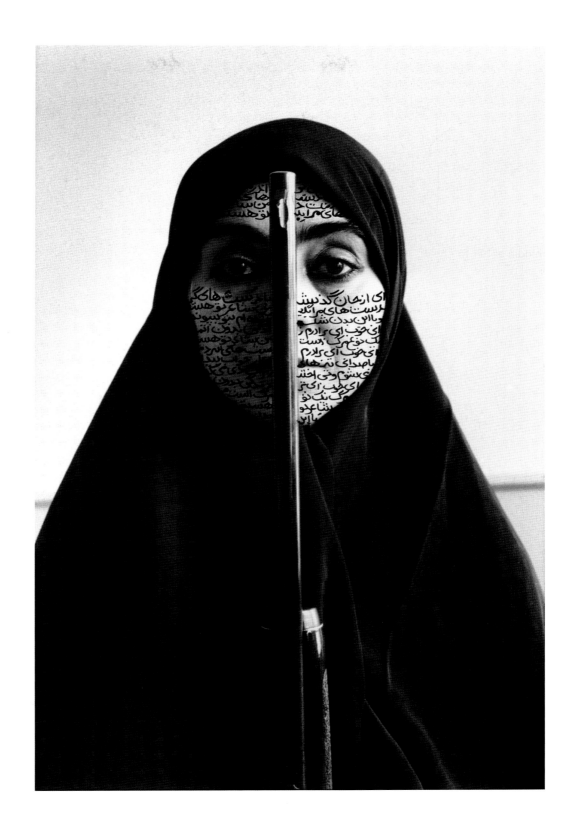

Art is a haunted space. No one has demonstrated this truth more provocatively than Brazilian artist Ernesto Neto, who installed his *Leviathan Thot* under the triple dome of the Panthéon in Paris for fifteen weeks in the autumn of 2006. As with many of Neto's large-scale displays, the work consisted of pendulous Lycra limbs flaring into Styrofoam pods. But the most intriguing dimension of Neto's sensuously swaying work was the location itself, a structure that to many epitomizes the rigidity of Enlightenment rationalism. Originally designed as a church, the Panthéon was controversially reconsecrated in the early years of the French Revolution as a shrine for pioneering social agitators and heroes of rational thought. Over time, the Panthéon would become the premier site of honorary re-interments in Paris, attracting the restless remains of everyone from Voltaire to Émile Zola, Rousseau to Alexandre Dumas. It was here, sixty years after the bones of diplomat and writer Mirabeau inaugurated the tradition of honorary burial in 1791, that French physicist Léon Foucault would test his famous pendulum, thereby proving the rotation of the earth on its axis.

But what does the colossal jostle of Neto's work seek to prove? What invisible forces are these distended sinews, gauzing the air like oversized ghosts, intended to demonstrate or put beyond doubt? As the title of Neto's dynamic work suggests, the movement it creates goes beyond the physical, the way the Leviathan itself has morphed in cultural memory from its scriptural incarnation as a whale in the Book of Job to its political significance as a metaphor for the monstrous State in the writings of Thomas Hobbes. One senses that Neto is himself wholly conscious of his intellectual forebears, especially the twentieth-century American sculptor Alexander Calder. It was Calder who invented the first mobile sculptures while living in Paris in the early 1930s. In an essay entitled 'What Abstract Art Means to Me' (1951), Calder provided a description of his art in words that today read like a prophecy of Neto's work: 'detached bodies floating in space, of different sizes and densities, perhaps of different colors and temperatures, and surrounded and interlarded with wisps of gaseous condition, and some at rest, while others move in peculiar manners.' Moving peculiarly through our imagination, Neto's bodies are haunted by the legacy of the space they inhabit, where the ghosts of religion and reason, science and the supernatural, compete for our senses.

Ernesto Neto, **Leviathan Thot**, 2006. Installation at the Panthéon, Paris. Polyamide tulle, polyamide fabric and Styrofoam balls, 53 × 62 × 56 m (173 ft 10⅝ in. × 203 ft 5 in. × 183 ft 8¾ in.)

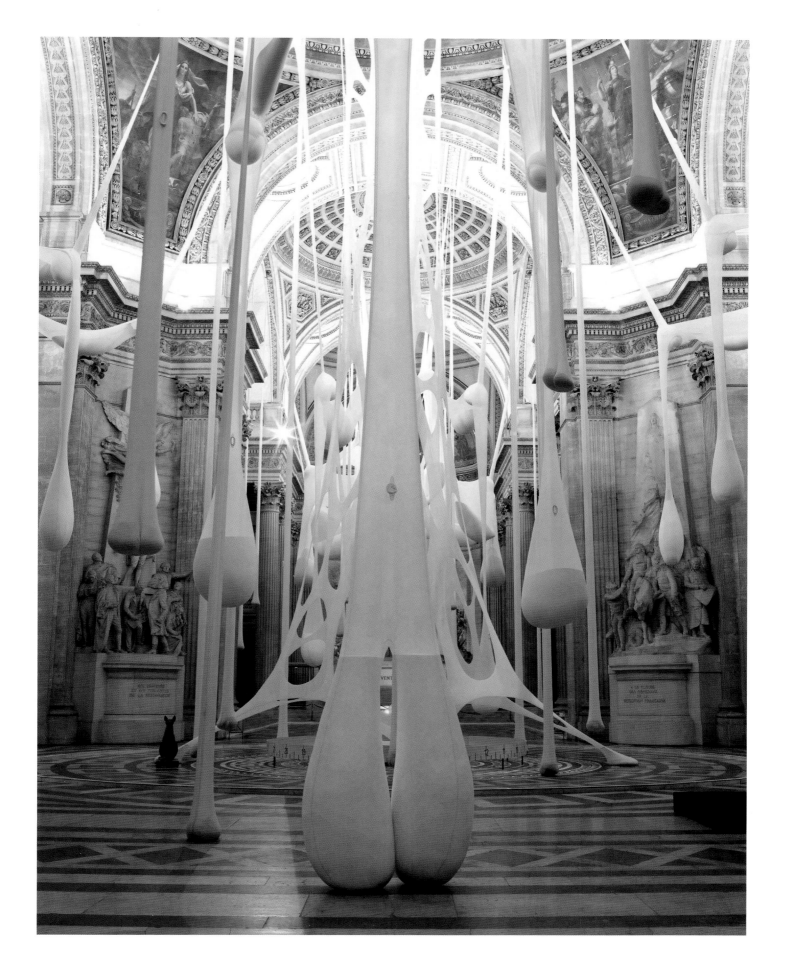

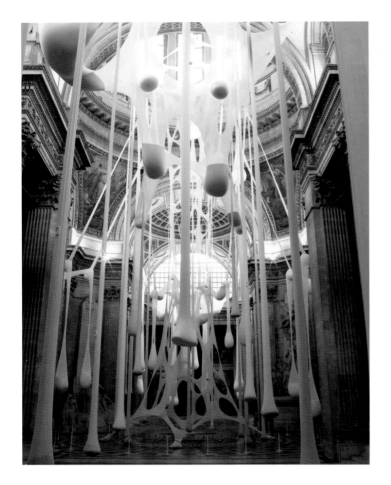

Ernesto Neto, **Leviathan Thot**, 2006.
Installation at the Panthéon, Paris

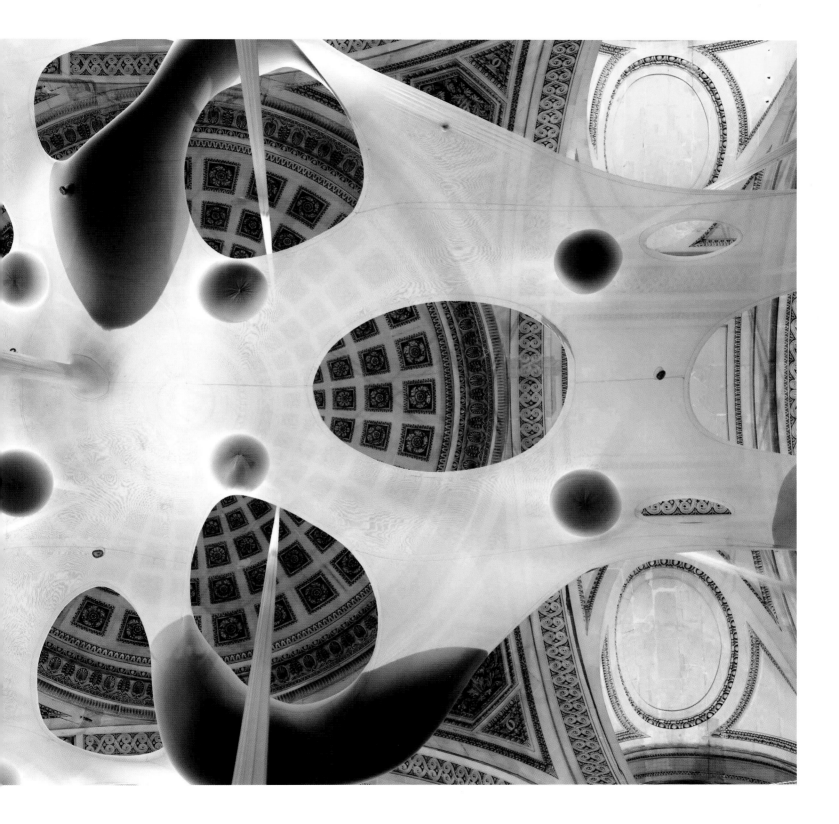

In 1987, the American artist Andres Serrano provoked front-page outrage when he dunked a plastic crucifix in a glass phial of his own urine and photographed the murky solution. After *Immersion (Piss Christ)* received an award partly sponsored by the taxpayer-funded National Endowment for the Arts, it was felt by many that Serrano had once and for all drowned all sense of shock. So it is a feat of sorts that British artist Chris Ofili managed, a decade later, to resuscitate blasphemy for a new generation with his controversial *The Holy Virgin Mary*, which depicts a black Madonna surrounded by floating cut-outs from pornographic magazines and with one of her breasts fashioned from a clump of elephant dung. Among the more notorious pieces to feature in Charles Saatchi's legendary 'Sensation' exhibition of 1997, the work was characteristic of Ofili's technique of overlapping layers of photos, resin, dots, glitter and faeces to create a glossy chaos of powerful spiritualism, coarse sexuality and hints of racial exploitation.

Featured in a show infamous for its inflammatory spirit, *The Holy Virgin Mary* sparked some of the most passionately divergent reactions. Was the work an abrasive challenge to blasé religious, racial and sexual attitudes or was it an incoherent splatter of offensiveness for offensiveness's sake? Civic leaders in jurisdictions where the piece was scheduled to travel were in little doubt about the work's merit.

The mayor of New York, Rudy Giuliani, dismissed the painting as 'disgusting' and threatened to punish the Brooklyn Museum of Art for displaying it. The National Gallery of Australia in Canberra cancelled the exhibition altogether, citing the earlier 'furore in New York'.

'I was going to the National Gallery Sainsbury wing', Ofili has said, defending the inspiration for his work, 'and looking at Van Eyck's painting of a mother and child. I just wanted the image of the breast, really. The exposed breast is hinting at motherhood, but those images are very sexually charged.... I think the Virgin Mary was an excuse for pornography in the homes of these holy priests and godfearers.' Though several commentators scoffed at Ofili's explanation – pointing out that no such representation of Mary by Van Eyck can be found in the gallery – it was the artist's alleged abuse of sacred iconography from Zimbabwean San culture that rankled the most. Critics accused the British-born black painter of demeaning the spiritual system of cosmic representation from the San – symbolized by the dots that cover much of the surface of Ofili's work – which they claimed he neither respected nor understood. 'Triumph', declared a critic for *The Telegraph* newspaper. 'Posturing, pretentious, dumb', insisted another for the *Sunday Times*. Teetering between the excretory and the exquisite, the scatological and the sublime, *The Holy Virgin Mary* is an egregiously scintillating sign of the times.

Opposite: Chris Ofili, **The Holy Virgin Mary**, 1996. Acrylic, oil, polyester resin, paper collage, glitter, map pins and elephant dung on linen, 2.44 × 1.83 m (8 × 6 ft)

Right: Andres Serrano, **Immersion (Piss Christ)**, 1987

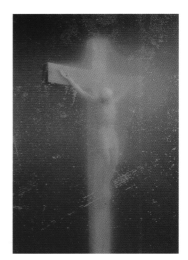

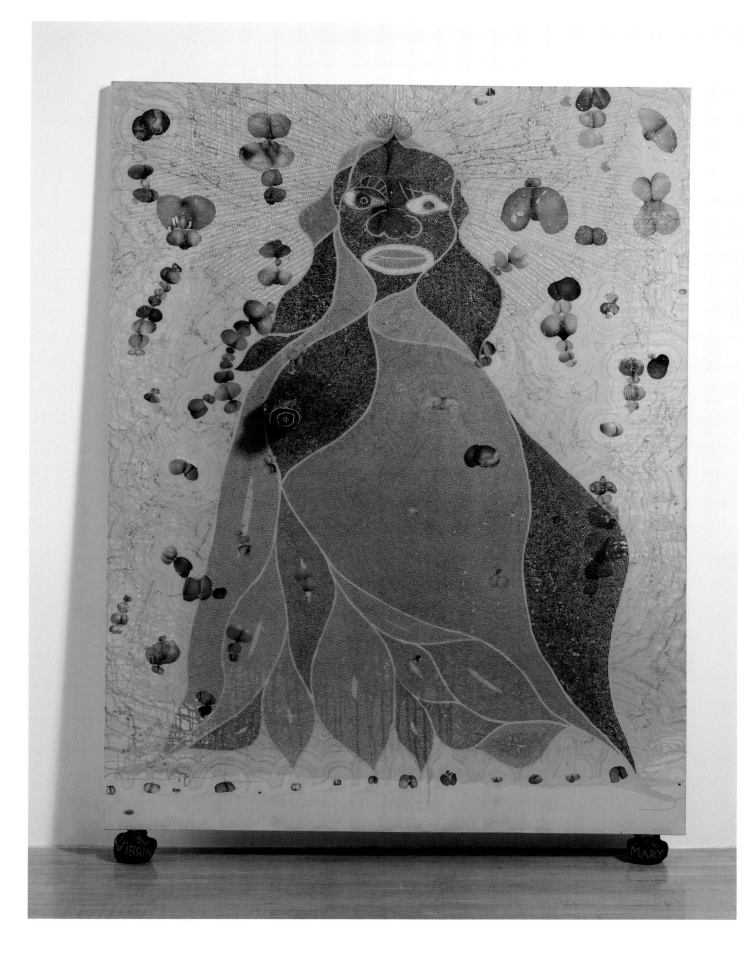

The story of art is the story of skulls. In November 2010, a group of scientists began removing stones in the floor of a church in Prague's Old Town Square. The team was searching for the remains of the sixteenth-century astronomer and alchemist Tycho Brahe in the hope of solving an enduring mystery surrounding Brahe's suspicious death: whether he had been poisoned by his protégé Johannes Kepler. If historical testimony were to be trusted, the scientists would know they had located the right set of bones by a distinctive design that time would have etched in verdigris patina across Brahe's skull: a stencil of ghostly green where the pioneering celestialist had worn a brass prosthetic in place of the nose he had lost in a duel.

That the universe ultimately alchemizes our material selves into alluring artefacts is the flip-side of the *memento mori* coin that art history has been tossing for centuries, from the countless crania of Adam found in medieval and Renaissance crucifixion scenes set in Golgotha ('the place of the skull') to the anamorphic skull that crumples our perception in Hans Holbein's *The Ambassadors* (1533), from Cézanne's uncharacteristically macabre *Pyramid of Skulls* (1898–1900) to Mexican artist Gabriel Orozco's contemporary reinvention of the genre, *Black Kites* (1997). Like all great works, *Black Kites* manages to convert the base metal of the deeply personal into the precious metal of the compellingly universal, transcending the local Day of the Dead traditions of the artist's native region.

After one of his lungs suddenly collapsed in the winter of 1996, Orozco, who had previously been healthy and fit, began contemplating the random designs that fate scores into our existence. For years obsessed with merging the empty grids of graph-paper with the unpredictable chaos of doodles (and even his own spittle), the recuperating artist began to plot in graphite a timeless chess-like grid of alternating black and white chequers on an actual human skull, which he had acquired from a nature store in New York.

But the skull's contours and sharp undulations of cheekbone and jaw, its deep recesses of sockets and sudden divisions of septum, were as awkward to survey as mapping the uneducated sky or fumbling in the dirt for lost bones. What conforms to a uniform pattern at the pate and forehead, warps as the surface stretches at the temples or slips into the black holes where eyes once blazed. Though the overt design may be that of a genteel parlour-room diversion, the work reminds us of the absurdist stakes and non-negotiable rules of life's ultimately unwinnable game: our minds may trace a destiny in the stars, but the rest of us is headed in the opposite direction.

Opposite: Gabriel Orozco, **Black Kites**, 1997. Graphite on skull, 21.6 × 12.7 × 15.9 cm (8½ × 5 × 6¼ in.)

Right: Paul Cézanne, **Pyramid of Skulls**, 1898–1900

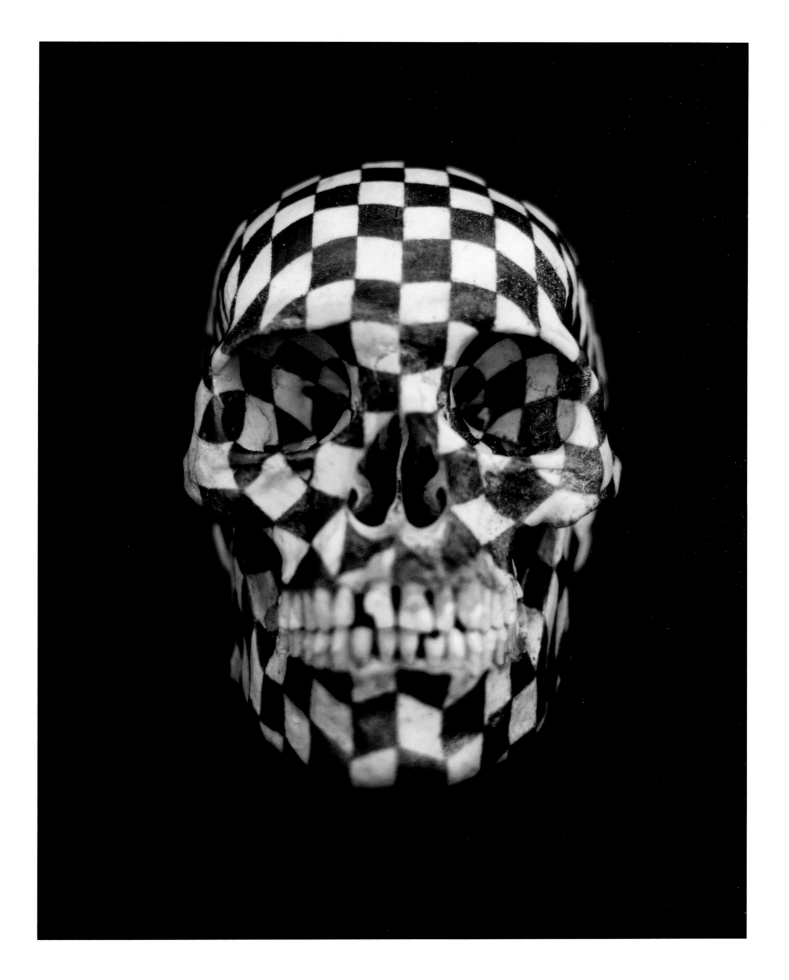

Is all art elegiac? In the weeks and months following the mass murders in New York and Washington, DC, on September 11, 2001, a traumatized public sought solace wherever it might be scrounged. Readers of the weekly magazine *The New Yorker* took brutal comfort from a poem printed on the last page of a special issue devoted to the horrors of that day: Polish writer Adam Zagajewski's 'Try to Praise the Mutilated World', with its fierce assertion, 'You've heard the executioners sing joyfully.' The poem had presciently been written some eighteen months earlier.

In London a few weeks later, the British sculptor Cornelia Parker unveiled a work at the Victoria and Albert Museum that had also been conceived and constructed prior to 9/11, yet whose very premise seemed also uncannily in tune with the altered air the world was then breathing. Described by Parker as heralding 'a ghostly last gasp' of empire, *Breathless* consists of some fifty-four brass musical instruments that have been violently mutilated – crushed by a powerful hydraulic system that was once used to raise London's Tower Bridge. The mangled husks fanned out in Parker's squashed mobile like so much debris from an exploding fuselage, their crumpled notes suspended like the harsh music of an air-raid siren. The work represented a gradual refinement of the themes and techniques that Parker had been experimenting with since at least 1991, when she recovered the fragments of a garden shed that the British Army had blown up for her as the basis for *Cold Dark Matter: An Exploded View*, which froze in mid-air the outward propulsion of the blast. Subsequent works found the artist tuning into the frequencies of American traumas, such as her rearrangement of the scorched remnants of a Texas church that had been struck by lightning for her 1997 sculpture *Mass (Colder Darker Matter)*.

Breathless is different. Where the earlier works seek to rescue a sombre music from the dark wreckage of catastrophe, their bleak notes never manage fully to transcend the literal context of their expression. In contrast, *Breathless* respires with the profundity of pure metaphor. 'Heard melodies are sweet', wrote Keats, 'but those unheard are sweeter.' The mute harmonies of Parker's sculpture sync to the signature of an unfathomable array of human upheaval – past, present and to come. When first exhibited, the work was the target of local criticism levelled by those who believed the artist had vandalized otherwise salvageable instruments that could have been restored to use. But the strength of *Breathless*, like all masterpieces, is its ability to project its sound above the dissonance of the ephemeral debate in the here and now, to perform endlessly the mute elegies to which the ghosts of tomorrow will keep time.

Opposite: Cornelia Parker, **Breathless**, 2001. Permanent installation at the Victoria and Albert Museum, London. Squashed brass musical instruments and wire, 5 m × 5 m × 6 cm (16 ft 4⅞ in. × 16 ft 4⅞ in. × 2⅜ in.)

Right: Cornelia Parker, **Cold Dark Matter: An Exploded View**, 1991

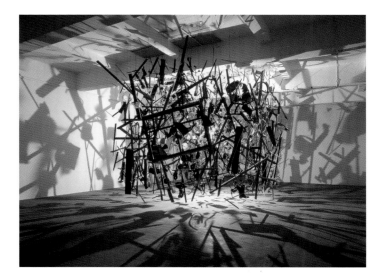

'Destiny', the poet Rainer Maria Rilke wrote, 'is like a wonderful wide tapestry in which every thread is guided by an unspeakably tender hand.' For British artist Grayson Perry, this evocative statement would likely raise important existential questions, such as what brand of hand moisturizer the mystical weaver prefers or in which exclusive shop did he buy his threads? For Perry, art and destiny, like all purchasable commodities, are functions of taste whose complex hues are dyed deeply into the fabric of our being. The six large tapestries that make up Perry's *The Vanity of Small Differences* – the creation of which inspired an acclaimed television documentary in 2012 – trace the grimly predictable fortunes of Tim Rakewell, a reincarnation of William Hogarth's eighteenth-century protagonist Tom Rakewell, whose moral, financial and psychological demise was famously chronicled in Hogarth's celebrated series of eight paintings, *A Rake's Progress* (1732–33).

Perry recasts Rakewell as a twenty-first-century computer genius, whose entrepreneurial success enables him to move from working-class origins (the subject of tapestries one and two) to the culturally self-conscious middle class (tapestries three and four) to the quasi-aristocracy of the nouveaux riches. While the broader sequence shadows Hogarth's series, each of the six individual tapestries separately echoes the compositional design of a particular Old Master work, from Mantegna's *The Adoration of the Shepherds* (c. 1450) in the first tapestry to Gainsborough's *Mr and Mrs Andrews* (c. 1750) in the penultimate one, as if the rise and fall of Perry's Rakewell might be understood

as the climactic story towards which all of art history has inevitably been tending.

The sixth and final tapestry, whose composition recalls fifteenth-century Flemish painter Rogier van der Weyden's poignant *Lamentation* (c. 1441), depicts the violent death that the middle-aged Rakewell eventually suffers after crashing his expensive sports car near an over-lit commercial retail park, the young bottle-blonde girlfriend, for whom he traded in his wife, beside him. Where in van der Weyden's work the conventional prop of Adam's skull crouches at the bottom of the painting, here the *memento mori* assumes the shape of a frivolous iPhone – the digitally programmable cranium of a materially obsessed age. Indeed, all around the expired corpse of Rakewell commercial slogans point to insatiable consumerism and unrestrained consumption: a stacked sequence of store names on a billboard in the far left that reads 'Dreams / TO LET'; a bent one-way street sign that replaces the salvational crucifix in van der Weyden's original (and now points downward); the ominous British Petroleum logo glowing like an alien orb in an apocalyptic sky, whose atomic colours echo those looming over Edvard Munch's *The Scream*. Not long before Perry undertook work on his tapestries, the energy giant's Deepwater Horizon oil rig had exploded with catastrophic consequences. For many, the subsequent spill of five million barrels of oil into the Gulf of Mexico seemed to prophesy the planet's doom. Like all great works of art, Grayson Perry's *The Vanity of Small Differences* helps us to make sense of where we've been and where the moving needle is moving next.

Opposite: Grayson Perry, **The Adoration of the Cage Fighters** and **The Agony in the Car Park**, from the series **The Vanity of Small Differences**, 2012. Wool, cotton, acrylic, polyester and silk, each 2 × 4 m (6 ft 6¾ in. × 13 ft 1½ in.), editions of 6 + 2 A. P.

Right: William Hogarth, **The Rake at the Rose Tavern**, from the series **A Rake's Progress**, 1732–33

Overleaf: Grayson Perry, **The Expulsion from Number Eight Eden Close** (top left), **The Annunciation of the Virgin Deal** (bottom left), **The Upper Class at Bay** (top right) and **#Lamentation** (bottom right), from the series **The Vanity of Small Differences**, 2012. Wool, cotton, acrylic, polyester and silk, each 2 × 4 m (6 ft 6¾ in. × 13 ft 1½ in.), editions of 6 + 2 A. P.

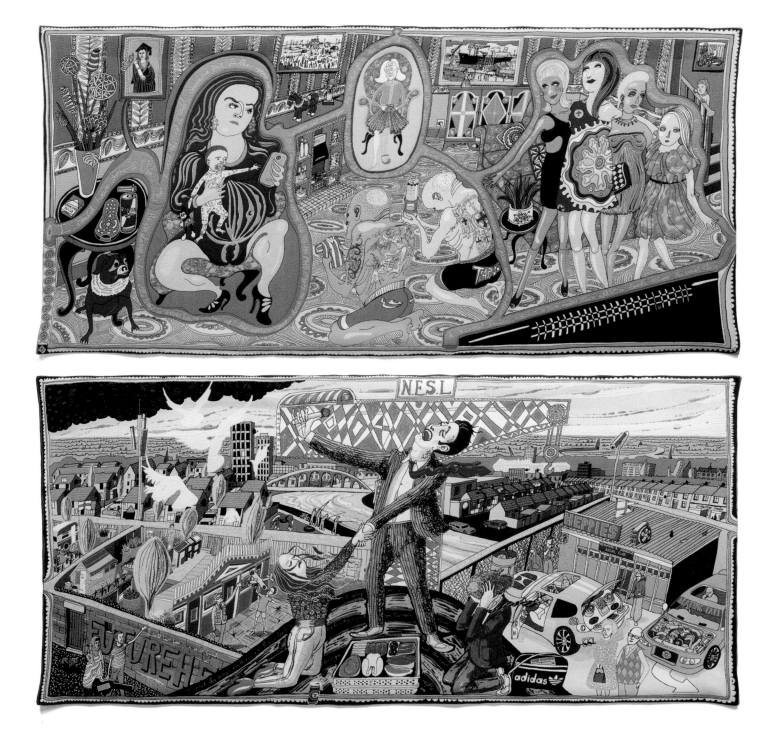

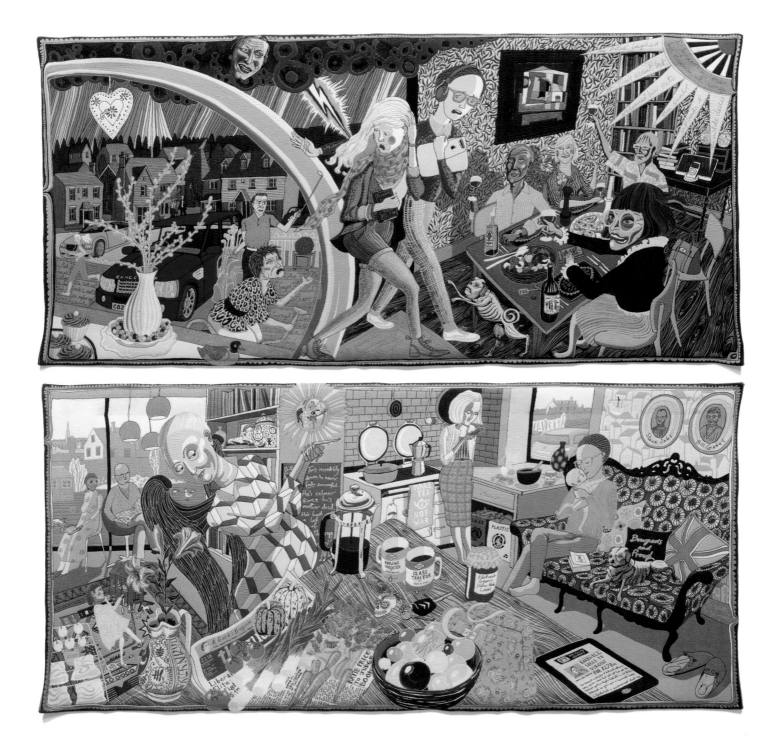

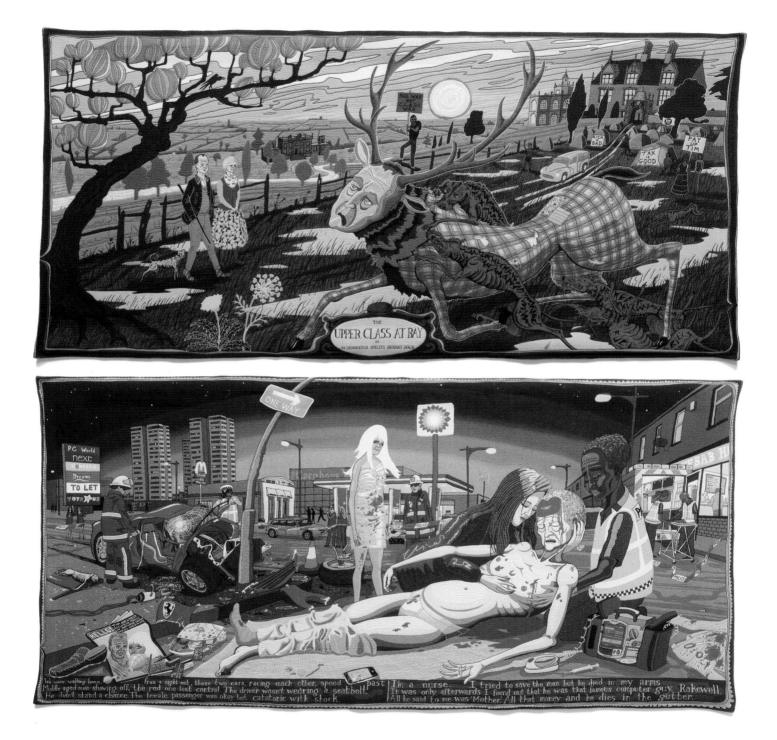

Every seven years you disappear. Look in the mirror. Not a single atom that forms the figure you see before you was present seven years ago. Over the course of the next seven years, every molecule that currently comprises this you-shaped you will have vanished – left behind on the seats of buses, brushed off by the abrasive elbows of strangers nudging against you on crowded streets, dissolving back into the surging ocean of everyone and everything else. The person you behold at this instant is a slightly different flux of cells than the one you saw yesterday and the one you will see tomorrow.

There is no suspending this endless lava-lamping of identity, no slowing the slow morphing into and out of all that surrounds you. Or is there? This is the question that British artist Marc Quinn poses precisely every five years with his decidedly unsqueamish series of sculptures, *Self*, begun in 1991. That's how often Quinn repeats the process of filling a recently cast mould of his head with four litres of his own blood, gradually siphoned off over a period of months. The results are vampiric jellies requiring constant freezing, terrines of congealed fluid that preserve in ghoulish limbo static dollops of material selfness. Philosophically, the concept could hardly be more profound, as the artist annexes his very atoms to create versions of himself arguably more stable than his own body. Here, art does not merely resemble life; it becomes it. Quinn has compared his serial self-portraiture with that of Rembrandt, who likewise sought to preserve a record of time's ravagings in successive canvases created throughout his career. But, for Quinn, the scabby browns and coagulating ochres of the Dutch master have melted into something less artificial, more arterial. The son of a physicist and fellow of the Royal Society, Quinn's imagination is more susceptible than most to the atomistic profundities of our fluid nature, our endless dissolution and reconstitution. Every five years Quinn looks inside the freezer and finds a familiar stranger blinking back.

Marc Quinn, **Self**, 1991. The artist's blood, stainless steel, Perspex and refrigeration equipment, 208 × 63 × 63 cm (81⅞ × 24⅞ × 24⅞ in.)

'The whole purpose of biography', according to the British historian and novelist Peter Ackroyd, 'is to create a work of art which can be as convincing as fiction while remaining as substantial as history....In fiction one is obliged to tell the truth, whereas in biography you are permitted indeed often compelled to make things up.' The provocative claim that art bears a greater obligation to tell the truth than history likewise motivates Beirut-born artist Walid Raad's quasi-collective archive, *The Atlas Group Archive*. The work consists of multimedia documentation – written, photographic, video – that purports to chronicle the recent history of Lebanon. This much, and this much alone, is straightforward. Attempt to interrogate almost any aspect of the work, from the group's inception to the provenance of any item supposedly collected by it, and you have the sensation of reading a book whose words are dissolving before your eyes.

The so-called Atlas Group responsible for compiling the material was established in 1976, or so Raad told the poet Alan Gilbert in an interview for *BOMB* magazine in 2002. In the same breath, however, he also confessed to earlier claims he had made that 'the imaginary foundation' was in fact founded in Beirut nine years earlier, in 1967, the year of his own birth. And on several other occasions, Raad admitted to Gilbert, he had insisted it all began in 1999. If this is evasive, the artist's varying attributions of partial or total credit to a celebrated Lebanese historian, Dr Fadl

Fakhouri, for the curation of materials are made all the more intriguing when one discovers that Fakhouri is a figment of Raad's imagination.

Though the foundation of the archive may therefore appear unreliable, there is little doubting the authenticity of the turbulence and anguish to which it attests. For Raad, if a truth is to be trusted, it must itself have been born out of confusion, trauma and fabrication. How else to present a credible narrative of an era that has witnessed so much relentless upheaval? For if history is told by the victors, who writes the official narrative when there is only loss? So complexly contested is the history of Lebanon, so unfixed the facts, particularly the civil war years between 1975 and 1990 to which *The Atlas Group Archive* is chiefly devoted, that textbooks in the country do not dare offer an account of events after 1943, the year independence was internationally recognized.

What Raad's archive demonstrates is how such a chasm in cultural identity can be as empowering as it is paralyzing. 'It's a place', Gilbert concludes, 'where the language of disappearance and the disappearance of language are blurred' – 'a palimpsest carefully recording the personal and collective accretion of memory and forgetting.' Just as Nan Goldin reveals in her photographs of contrived identities in New York, sometimes the most accurate biography, the most honest, is the one you make up.

Opposite: Walid Raad, **I Might Die Before I Get A Rifle**, 1989/2010, from **The Atlas Group Archive**. 13 digital prints, each 162.9 × 215.6 cm (64⅛ × 85 in.)

Right, above: Walid Raad, **Let's be Honest, The Weather Helped**, 1998/2006–7, from **The Atlas Group Archive**. 5 digital prints, each 48.9 × 74.5 cm (18¼ × 28¼ in.)

Right, below: Walid Raad, **Notebook volume 38: Already Been in a Lake of Fire** (detail), 1999–2002, from **The Atlas Group Archive**. Digital print, 111.8 × 198.8 cm (44 × 78⅛ in.)

Above: Walid Raad, **Notebook volume 72: Missing Lebanese Wars**, 1996/2003, from **The Atlas Group Archive**. Digital print, 111.8 × 127 cm (44 × 50 in.)

Opposite, top: Walid Raad, **Untitled**, from the series **We Decided To Let Them Say 'We Are Convinced' Twice. It Was More Convincing This Way**, 1982/2004, from **The Atlas Group Archive**. Digital print, 120.7 × 180.8 cm (47½ × 71⅛ in.)

Opposite, bottom: Walid Raad, **My Neck is Thinner Than a Hair: Engines** (detail), 2000/2003, from **The Atlas Group Archive**. Digital print, 1 of 100 plates, each 25.5 × 35.5 cm (10 × 14 in.)

AG_AGA_AGP_Neck: 020788S

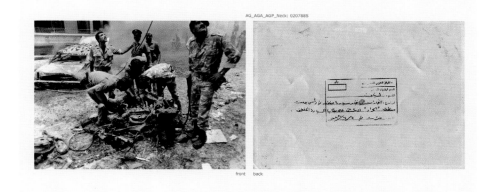

front　　back

The words we coin, no less than the art we make, define the age we live in. Just as every era provokes the aesthetic objects it needs to know itself, so too does every generation forge the language necessary to record its singular contours. It says something about the unfolding of human history that the world had no use for the word 'pessimism' until the end of the eighteenth century or, more troublingly still, 'genocide' until the middle of the twentieth. And the survival of a word in common currency is no less predictable than the endurance of a particular work of art in popular imagination. The past is as strewn with the debris of lost lexicons as it is littered with forgotten masterpieces – disused coinages that, could they be rehabilitated, might help us appreciate not only where we've been but also where we're going.

Take the moribund coinage 'betweenity', devised by the English novelist and letter writer Horace Walpole in 1760 (some six years after he invented the word 'serendipity'). We could use a salvaged 'betweenity' – which captures like no other word a state of shifting indeterminacy that blurs past and present – in our vocabulary today if for no other reason than to define the otherwise elusive achievement of an artist whose work is frequently described as indescribable: German painter Neo Rauch. His canvases represent a suspension of visual language somewhere between the distant past and the troubled present. Signs and symbols that appear anachronistically to have been lifted from another era are assigned fresh and often incongruous meanings in his paintings through bizarre dislocations of expected context.

In his disorientating 2007 portrait *Vater* (Father), for instance, a sense of generational 'betweenity' invests the work with unlikely poignancy. Rising in its centre is a substantial self-portrait of the artist as a young man dressed ostentatiously in colonial, French Revolution-era garb and implausibly cradling an out-of-scale older man who appears to be wearing an artist's smock. Critics have recognized the posture as a bizarre subversion of the conventional parent-and-child trope endlessly rehearsed in early Western art. But what is the viewer to make, in this odd mash-up of period self-portraiture and mother-and-child predecessors, of the enormous Mickey Mouse hands that hold the embraced body, whose face, shadowed by facial hair, appears to belong to the younger man's father?

Anticipating Freudian psychoanalysis, Romantic poetry of the early nineteenth century tells us that 'the child is father of the man' (a formulation that previously invigorated our interpretation of Ron Mueck's affecting effigy *Dead Dad*), and knowing that Rauch's own parents, who were both art students, were killed in a train accident shortly after his birth, invests the composition with layers of profundity. The formative relationship of mother, father and child has been pulled inside out, distorted through the lens of the child's grown-up artistic mind.

The third principal player in the emotional drama, entering the painting on the right, is a middle-aged man with greying temples holding a camera. Some commentators have identified him as a more mature and contemporary incarnation of the artist at a point in his life when he has lived beyond the age of his dead parents. Through the aperture of Rauch's singular imagination, *Vater* is a ceaselessly irresolvable celluloid not only of personal and existential time (the son becoming father and father becoming son) but also of creative media (painting, photography, commercial cartoon), all suspended in the timeless 'betweenity' of this age-defying studio.

Neo Rauch, **Vater** (Father), 2007. Oil on canvas, 2 × 1.5 m (6 ft 6¾ in. × 4 ft 11 in.)

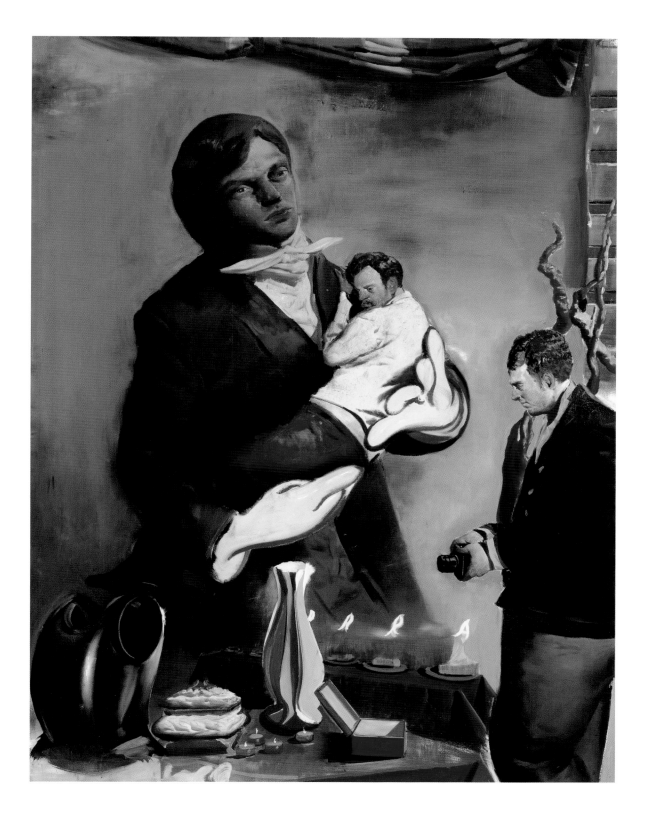

Does art still have the power to forge new myths? In 1994 Portuguese-born painter Paula Rego embarked on a series of portraits that struck many as revealing a fresh archetype of feminine empowerment. The works, which collectively became known as the *Dog Woman* series, depict female figures in curious canine postures: now on all fours howling wildly; now unselfconsciously gnawing on furless limbs; now perched uneasily in an armchair like a listless stray. Rego's choice of medium for the works, the less conventional pastel on canvas, brought to mind for many observers Degas's portraits of dancers, as though she were deliberately opening a dialogue with a very different and more traditional portrayal of femininity. But the seemingly soft medium unexpectedly summons too Francis Bacon's tortured triptychs from the late 1960s to the early 1980s. Bacon's unsettling elasticity of human form is more closely aligned with the fraught imagination of Rego.

It's been said that the inspiration for Rego's series was a story written for her by a friend, though the rawness of the works feels much older, if not folkloric, as though the figures have been transported from that strange border region of creative consciousness where dark fairy-tale creatures loom in and out of view. Tellingly perhaps, the *Dog Woman* series coincided with the display in the mid-1990s of paintings and drawings based on traditional nursery rhymes, which the artist had undertaken for her granddaughter. As with any memorable myth, however, the precise source of Rego's creations is difficult to isolate. On the one hand, the fancy calls up gothic connotations of werewolfism, or lycanthropy, the origins of which have been traced back to antiquity. On the other hand, the visceral blurring of animal forms – woman and dog – may constitute a wholly modern and progressive challenge to social expectations about the place of women in society. Significantly, in Rego's vision, the figure portrayed does not metamorphosize *into* a dog, but rather dog-like qualities appear fundamental to her very being.

When discussing the essence of her portraits, Rego has insisted the depiction is intended to capture positive aspects of womanhood and an irrepressibility of spirit, coinciding with themes explored two years earlier by the American writer Clarissa Pinkola Estés in her study *Women Who Run With the Wolves: Myths and Stories of the Wild Woman Archetype*. In terms of forgotten cultural context, it is worth reminding ourselves that the very year Rego introduced her enigmatic series, a British pop group calling itself the Spice Girls was also taking shape, preparing to offer a very different brand of what would become known as 'girl power'.

Opposite, clockwise from top left:
Paula Rego, **Baying**, from the series
Dog Woman, 1994. Pastel on canvas,
100 × 76 cm (39⅜ × 30 in.)

Paula Rego, **Bad Dog**, from the series
Dog Woman, 1994. Pastel on canvas,
120 × 160 cm (47¼ × 63 in.)

Paula Rego, **Sitting**, from the series
Dog Woman, 1994. Pastel on canvas,
160 × 120 cm (63 × 47¼ in.)

Paula Rego, **Grooming**, from the series
Dog Woman, 1994. Pastel on canvas,
76 × 100 cm (30 × 39⅜ in.)

Right: Edgar Degas, **Dancers**, 1899

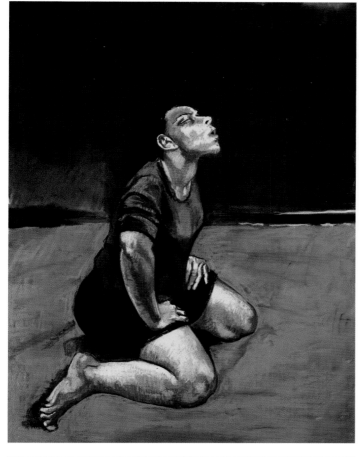

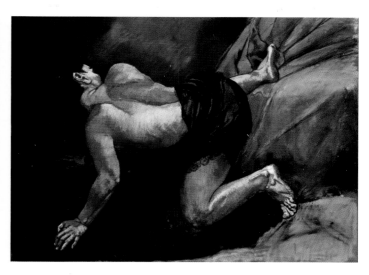

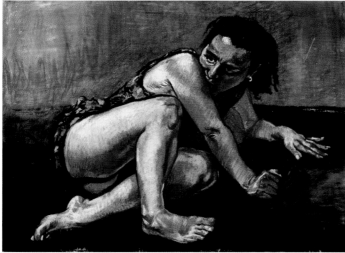

Can a work of art possess a consciousness distinct from that of the artist who made it? It would be banal to assert that meanings, unintended by an object's creator, might attach themselves to a work, or that these could even come to dominate its identity. But can a painting or sculpture actually be self-determining, recall the past or merge contradictory incarnations of itself in a palimpsest of being in a way analogous to that of a living mind? Gerhard Richter's series of abstract canvases undertaken for the 2007 Venice Biennale, the *Cage* paintings, dare us to believe that art can do just that. Unlike the painstakingly photo-realist works for which the German artist is also known – works that he has said 'directly reflect what I am thinking and feeling' – the *Cage* series is all about the independent memory of the paintings themselves.

That sense of a separate conscience is achieved through an extraordinary technique that Richter devised, which transforms loosely applied layers of paint into waves of vibrant experience across what was the tabula rasa of the initially blank linen. Generation after generation of paint is applied then scraped away with a wide squeegee, like so many sense impressions streaking across the work's psyche.

As with any consciousness, some experiences stick, gaining traction against earlier ordeals of colour and pressure, while some slip away or are repressed. The result is a psychology of texture beyond the artist's intention or control in which memories of earlier applications are excavated, smeared into the reality of subsequent layers. The canvas, we discover, never forgets previous traumas as the beauty of the present becomes a blur of what is past and future. A key, perhaps, to the paintings' resolve to separate themselves from the artist's own anxieties and motivations, is the collective title's allusion to the American avant-garde composer John Cage, who famously wrote, 'I have nothing to say / and I am saying it / and that is poetry / as I needed it.'

Though it has been suggested that Richter's creativity at the moment when he was making the *Cage* series was intensified by escalations in the tensions between Israel and Palestine, the works themselves resist the tether of precise and ephemeral political caption. Instead, all of life has been compressed into their beguiling surfaces: hatred and redemption, triumph and fear. In that sense Richter's works can be said to transcend any one age – and to have minds all their own.

Gerhard Richter, **Cage 6**, from the
Cage series, 2006. Oil on canvas,
3 × 3 m (9 ft 10⅛ in. × 9 ft 10⅛ in.)

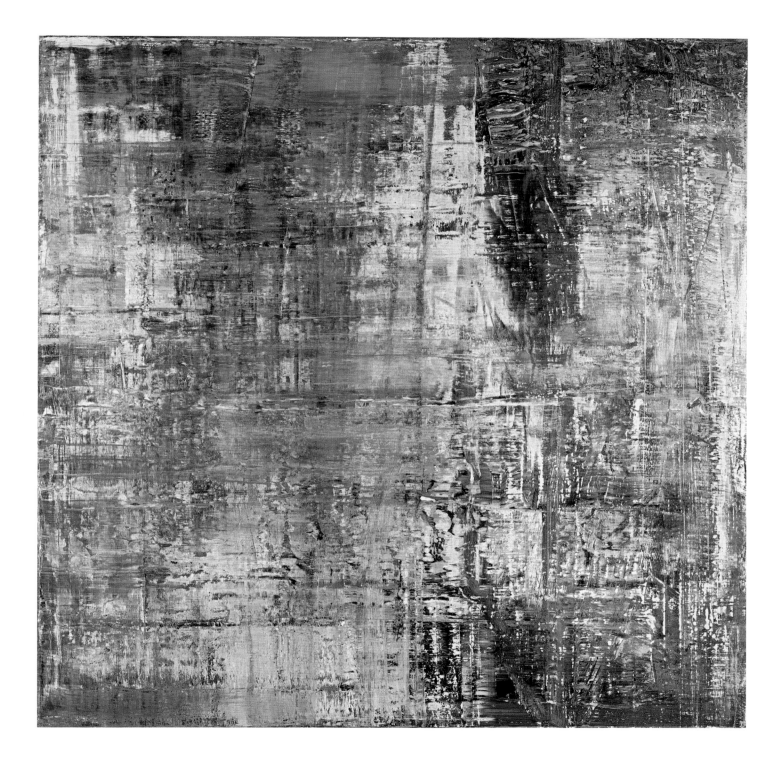

Can art escape itself? Or does the act of creation inevitably confine the thing created? Though artists often speak of the liberation their art is intended to excite in the viewer, does the work of art ever participate in the resulting sense of freedom? Few works of contemporary art have compelled observers to contemplate the borders where art and life clash and blur as emphatically as Swiss artist Pipilotti Rist's video installation *Open My Glade (Flatten)*. Projected onto an enormous screen in New York's Times Square in 2000, Rist's work consisted of sixteen short video segments that were designed to intercut the usual television programming aired day and night. Each clip featured a close-up of the artist's face pressed disturbingly against the oversized screen like a ghost trapped in crystal. As each short video played, the artist dragged her squished cheeks and squashed nose back and forth across the lens, her eyes gaping desperately wide at the onlookers below as lipstick, eye shadow and tinted foundation smudged and streaked across the glass.

It wasn't long before the initially comic effect – similar to watching a child pulling faces through a school bus window – became genuinely unsettling. Broadcast as it was over a bustling crossroads in midtown Manhattan, where lives thread together in a tight mesh of humanity, *Open My Glade (Flatten)* was seen by many as an uncomfortable metaphor for the inescapability of the everyday. Is this the breaking point of a woman no longer able to bear the pressures of presenting to the world an approved image or commercially sanctioned version of beauty? Is this every nude or bather in the history of art trying to smash free, head-butting the accumulated glaze of centuries of objectification?

The video sequence recalled other works that challenge the permeability of the membrane separating art and life, such as Buster Keaton's 1924 silent film *Sherlock Jr.*, in which a dreaming cinema projectionist imagines entering a film, or Woody Allen's 1985 romantic comedy, *The Purple Rose of Cairo*, in which a 1930s moviegoer and an on-screen character meet and fall in love. But in Rist's confrontation with the fourth wall, the barrier holds. Watching her video, one experiences the intense discomfort of seeing someone being crushed, the victim of a psychological stampede. Displayed at height on the side of a New York City landmark in the year before the attacks of September 11, 2001, what could be considered the distressed countenance of someone struggling to free herself from confinement (a collapsing office tower? an aeroplane?) was as bizarrely prophetic as it is, in the wake of that horror, unrepeatable.

Opposite: Pipilotti Rist, **Open My Glade
(Flatten)**, 2000. Video installation at Times
Square, New York. Single-channel digital
video, silent, 9 minutes, 52 seconds

Overleaf: Pipilotti Rist, video stills from
Open My Glade (Flatten), 2000

'**Empty chairs,**' Vincent Van Gogh wrote to his brother Theo in December 1882, 'there are many of them, there will be even more, and sooner or later there will be nothing but empty chairs.' Van Gogh was reacting to a drawing by the English painter and illustrator Luke Fildes of the empty chair that Charles Dickens left behind when he died in 1870. In December 1888, empty chairs would begin eccentrically substituting in for sitters in Van Gogh's own paintings, leading to two contrasting metaphoric portraits of Gauguin and the artist that eerily anticipated his premature death nineteen months later. The process of slowly removing himself from the world had begun; within a few days of painting that solid shadow of himself in the form of an empty chair, the artist lopped off his earlobe and presented it to a prostitute.

The astonishing crush of some 1,550 empty chairs that composed Colombian artist Doris Salcedo's untitled installation for the 2003 Istanbul Biennial not only participated in a tradition that poignantly equates human disappearance with empty chairs, but also fulfilled one of the more curious prophecies of modern art: 'sooner or later there will be nothing but empty chairs.' For Salcedo, her mangle of empty chairs, dumped three-storeys high in a derelict lot and deprived of their purpose, symbolized the collective disappearance of those victimized in her native country's long civil war. The haphazard tangle of backs and legs and arms – the ghost bones of those who once sat in schools and churches, waiting rooms and kitchens – calls to mind the horrific mangle of a mass grave.

In Salcedo's hands, the history of the empty chair becomes the history of human struggle, each one the mute echo of someone who has risen up or been violently removed. Her work accesses the everyday ambiguity of a chair's archetypal existence, being at once an object that invites rest yet demands the strict discipline of the body's posture. To accept its invitation is to accept the rules of the chair. Chairs are the empty vessels we fill our lives with: high chairs, barber chairs, rocking chairs, electric chairs. By investing personal symbolism into public display, political meaning into domestic utility, Doris Salcedo constructed a powerful icon of the age.

Opposite: Doris Salcedo, **Untitled**, 2003. Installation for the 8th International Istanbul Biennial. Wooden chairs, dimensions specific to site

Right: Vincent Van Gogh, **Van Gogh's Chair**, 1888

In 1991 a clash between feminists erupted after the publication of *The Beauty Myth: How Images of Beauty Are Used Against Women*, in which the American writer Naomi Wolf argued that society's attitudes about female attractiveness had become surprisingly more harmful and insidious with the acceleration of equal rights. Claiming that expectations about the very shape of a woman's body were being wielded as implements of torment, Wolf's analysis was at once celebrated by such leading feminist voices as Germaine Greer and Gloria Steinem and condemned as appallingly oversimplified by such critics as Camille Paglia. The rift was a preliminary tremor heralding some of the distinctive, if contradictory, cultural contours of the ensuing years, with fashion model Kate Moss and the heroin chic she symbolized at one end of the spectrum, and the morbidly corpulent quasi self-portraits of British painter Jenny Saville at the other.

Saville's *Propped* (1992) was among a group of art-school submissions that caught the eye and wallet of collector Charles Saatchi when the aspiring painter was just twenty-two years old. Not since the curious convex mirror mounted at the back of Jan Van Eyck's celebrated *Arnolfini Portrait* (1434) had warped perspectives and distorted self-image been so powerfully evoked. In Van Eyck's work, the curved reflection inflates the physiques of the two principle subjects who stand with their backs to the medallion-like fixture, which also reflects a tiny image of the artist himself, standing (as he must have done when leaning in to his easel and canvas) precisely where viewers stand today. The result, as with Saville's painting over half a millennium later,

is a complex collapsing of the painter and the painted – a mingling of manipulated forms.

In Saville's work the mirror has been sublimated and the entire canvas has become a kind of disfiguring surface. Though aspects of the subject's face are recognizably those of the young artist, the grotesque girth of her body, which seems to devour the acres of linen on which it is depicted, has been pushed to popping point, well exceeding the artist's actual shape. In Saville's hands, the canvas has become an echo chamber daring the viewer to defy the vulnerable subject's protoplasmic beauty. My allusion to the pioneering perspectives of Van Eyck is less fanciful than it might initially seem: Saville's awareness of how social constructs of beauty blur in and out of focus in Old Master works is discernible in every brush stroke, and her rolling fields of flesh call to mind the pudgy portraits of everyone from Rubens to Lucian Freud.

Propped's appearance, one year after Wolf's provocative critique, tapped into a timely dialogue and helped hoist Saville into popular consciousness. For some, her decision to scrawl discursively across the work overtly feminist slogans ('If we continue to speak in this sameness – speak as men have spoken for centuries, we will fail each other again...') was a mistake that aligned the artist too resolutely with one side of the debate and suggested a lack of faith in the power of painting. Others may have read into Saville's textual intrusions, which were applied da Vinci-style in backwards lettering right to left (as though inscribed by the sitter herself), an attempt to see past the obsolete language in which beauty is debated to something unspeakably raw.

Jenny Saville, **Propped**, 1992. Oil on canvas,
2.13 × 1.83 m (7 × 6 ft)

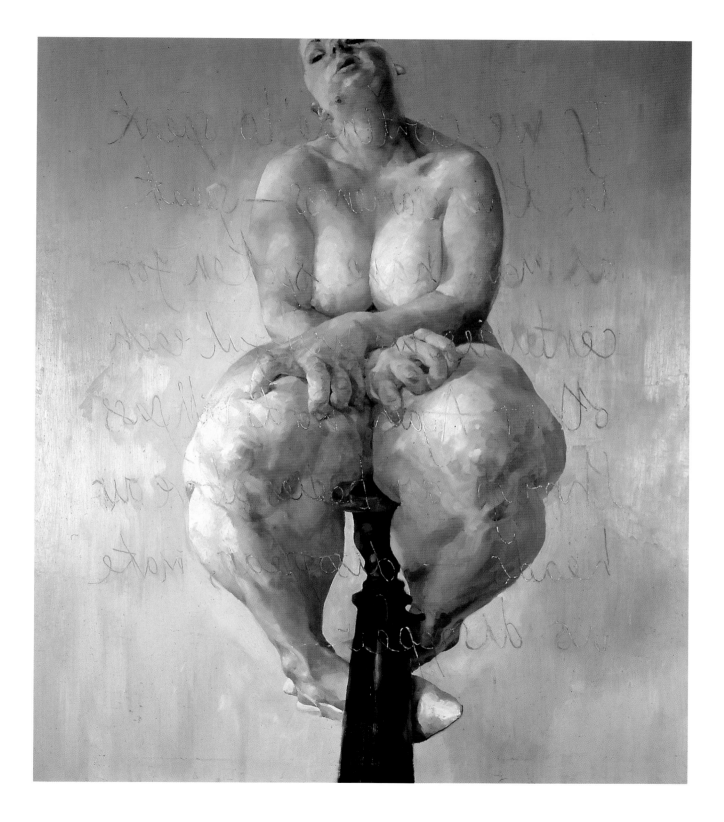

Can there ever be an art of pure idea? A significant leitmotif of twentieth-century visual expression was the emergence of Conceptual Art, in which ideas – whether those of the artist or those that observers bring to their perception of a work – supersede the object's material construction. In the realm of Conceptual Art, a small wad of paper, hastily crumpled, is as credible, and potentially as meaningful, as the most painstakingly executed portrait. But what about a work that takes no physical form at all, not even that of a flimsy wad of paper – one whose provocative force is felt exclusively on the level of proposition, one that is unveiled only in the museum of the mind? That has been the achievement of a never-realized work of art by the German artist Gregor Schneider: a dignified artistic venue, room or gallery, in which dying persons would play out the last hours, minutes and seconds of their lives. 'I want', the artist has said, 'to display a person dying naturally in the piece or somebody who has just died. My aim is to show the beauty of death.'

The premise is an extreme extension of the artist's preoccupations over the past two decades with the spiritualism of space. Since the mid-1980s, when he was just a teenager, Schneider has experimented with architectural constructions that challenge our understanding of the metaphysics of living spaces, building rooms inside of rooms that can slip, slide or even hide themselves with the aid of invisible engineering. His work adopted a more overtly spiritual tone in 2005 when, for the Venice Biennale that year, Schneider proposed to erect an enormous black box inspired in part by the cuboid dimensions of the black silk draped Kaaba in Mecca, the most holy site in Islam. The large-scale work, however, was rejected by Biennale officials on political grounds. It was eventually realized two years later in Hamburg.

Schneider's dream of one day showcasing human death was met with outrage by many in the art world when the artist raised it in an interview with the *Art Newspaper* in 2008. The heated reaction, which incongruously took the form of death threats aimed at Schneider, surprised the artist, who responded that his ambition was to exult the nobility of dying rather than to sensationalize it – to reclaim that final human action from both the crass portrayal it receives in entertainment media and the hidden shame to which it is often reduced by a society that seems only to celebrate youth. 'My aim', he says, 'would be to find a way of death that is beautiful and fulfilled.' But how to convert that laudable aspiration into the currency of art, with all its potentially devaluing forces of voyeurism, celebrity and sales? Is Schneider asking art to do something beyond its power? Perhaps. But in doing so he may be helping to construct a higher form of inexpressible expression, whose blueprints are measured in the mind and can never be executed.

Opposite: Gregor Schneider, **Toter Raum** (Death Space), 2005–7. Installation at Kunstraum Innsbruck, Austria, 2011

Right: Gregor Schneider, **Cube Hamburg**, 2007. Installation at the Hamburger Kunsthalle, Germany

Can art go beyond art? Such is the mystical dilemma posed by Irish-American artist Sean Scully's series of monumental paintings, *Doric* (2008–), conceived as a grand tribute to the manifold legacies of ancient Greece. Given Scully's career-long obsession with architectural motifs, it would be easy to measure the width and breadth of the alabaster and onyx blocks that comprise the *Doric* paintings against a lexicon of entablatures, abacuses and architraves. Much of the artist's vast output over the past forty years has been self-categorized along the way into sub-styles accentuating draughtsmanship and carpentry: 'Bridge', 'Enter', 'Fort', 'Landline', 'Post and Lintel', 'Towers', 'Window' and most recently 'Wall of Light'. But there is a sense in which *Doric* constitutes a radical shift in the artist's achievement, a shift that involves an abandonment of the physical altogether in favour of something utterly numinous – architecture beyond architecture – which, rather than evoking palpable construction, builds itself instead on absence and erasure.

'We must realize', according to the third-century BC philosopher Plotinus 'that our thought cannot grasp the One as long as any other image remains active in the soul....To this end, you must set free your soul from all outward things and turn wholly within yourself.' Plotinus's emphasis on absence over presence, darkness over light, became a cornerstone of so-called apophaticism (from the Greek *apophēmi*, meaning 'to deny') and would influence subsequent mystical thinkers of negative theology (or *via negativa*), from Pseudo-Dionysius the Areopagite in the sixth century to Meister Eckhart in the thirteenth, from Gregory of Nyssa in the fourth century to Jakob Boehme in the seventeenth.

In visual art, some have detected sympathies with this dissolution of 'outward things' and erasure of 'objects of the sense' in the dramatic contrasts of Caravaggio's chiaroscuro, the stygian sfumato of Rembrandt, the luminous darkness of the Rothko 'Chapel' paintings and the spiritual expressionism of Arshile Gorky, who once remarked that he painted not things themselves but the emptiness between them. Gorky's emphasis on absence anticipates Scully's own insistence, when describing the parallels between the *Doric* series and the proportions of the eponymous classical order, that the gaps between columns provide the space in which his paintings materialize.

Up until the present series, residual fibres of formative lived experiences – whether in Morocco or Mexico, Ireland's Aran Islands or Barcelona – weaved themselves into the fabric of the artist's work. In such signature canvases as *Araby* (1981) and *Uriel* (1997), which invoke the textiles of North Africa and atmosphere of Catalonia, there is a 'thereness' that invigorates the palpability and psychological materiality of the pieces – a substantiveness that is entirely understandable given the artist's personal connection with the places evoked. But in the *Doric* paintings, absence is all. What could be equated with sculpted stone could as credibly be described as tabula rasa, blank slate – the tangible emptiness of ossified air. These paintings represent a maturing philosophy of negation that transcends dependence on the actual: art beyond art. For similar trajectories of intensity and achievement, think of the journey that brought J. M. W. Turner from his early and architecturally careful *Norham Castle on the Tweed* (1806–7) to his late *Interior at Petworth* (1837), which paradoxically defines the physical by way of an annihilating light. As with all great works, Scully's paintings absorb the world, then move us beyond it.

Opposite: Sean Scully, **Doric Sky**, 2011, from the series **Doric**, 2008–. Oil on aluminium, 2.80 × 4.06 m (9 ft 2¼ in. × 13 ft 3⅞ in.)

Right: Sean Scully, **Uriel**, 1997

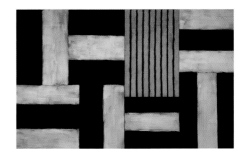

R L

Close one of your eyes and fix the stare of your other eye on the corresponding letter above: L for left, R for right. Now slowly move the book either away from or towards your face until the other letter vanishes from sight. This is your blind spot. Unless you are a squid or a cuttlefish, you have a blind spot. It's where the optic nerve is bolted to the back of the eye, disrupting the curve of light-detecting cells on which seeing depends. When both eyes are open, your mind deduces which patterns and colours most likely fill these blind spots and then welds your field of vision with a seamless mental solder, fooling you into believing your sight is whole. In a sense, every mind is a craftsman, every blind spot a studio. In a sense, every brain is a liar, constructing deceptive structures on which we base a false understanding of reality. Don't believe what you see; it's never the complete picture.

Now, more troublingly, what if the balance were suddenly tipped, and the blind spot became all that we see and the mind's deceptive art all that we observe? Such is the predicament faced by anyone who enters American artist Richard Serra's 2002–3 sculpture *Blind Spot*, whose huge concentred squints of steel resemble, from above, the sleepy lids of an oversized eye. Four-metre-high walls of rust tower over the visitor, leaning unsettlingly into a curved path that takes you, via a series of sharp switchbacks, into the centre of the eye. Once inside, all you see is the *Blind Spot*. If the design of the piece initially brings to mind classical prototypes, such as Daedalus's elaborate maze for King Minos, the work's ability utterly to overwhelm the senses – to make visitors feel they have crossed a threshold into some other kind of interior space – conjures instead byways of the body, as though one has stepped inside the osseous labyrinth of the inner ear.

Serra has challenged the reliability of human perception for over forty years. His stark minimalist structures defy our expectations about the relationship between weight and gravity, such as the sculptor's thirty-six-metre-long *Tilted Arc* (1981), whose long lithe plane of slowly sloping steel occupied Federal Plaza in New York for eight years, before city officials controversially ordered its dismantling. Frequently requiring ample outdoor space for their display, Serra's works inevitably suffer meteorological distress, their grave patinas more often provoking comparisons with the agelessness of geology than with the fragile operations of human perception. But *Blind Spot* feels different, like a mystical vestibule whose heft goes beyond heft into something weightless – not a trick of the mind, but the invisible space where the trick will be performed. Dissolving into Serra's bold unblinking eye, it is impossible to know where the L you R, only that you're the character who is about to vanish.

Opposite: Richard Serra, **Blind Spot**, 2002–3.
Weatherproof steel, 3.96 × 16.46 × 9.86 m
(13 ft × 54 ft × 32 ft 4⅛ in.)

Right: Richard Serra, **Tilted Arc**, 1981

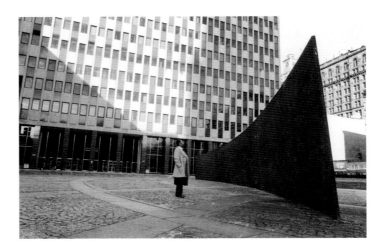

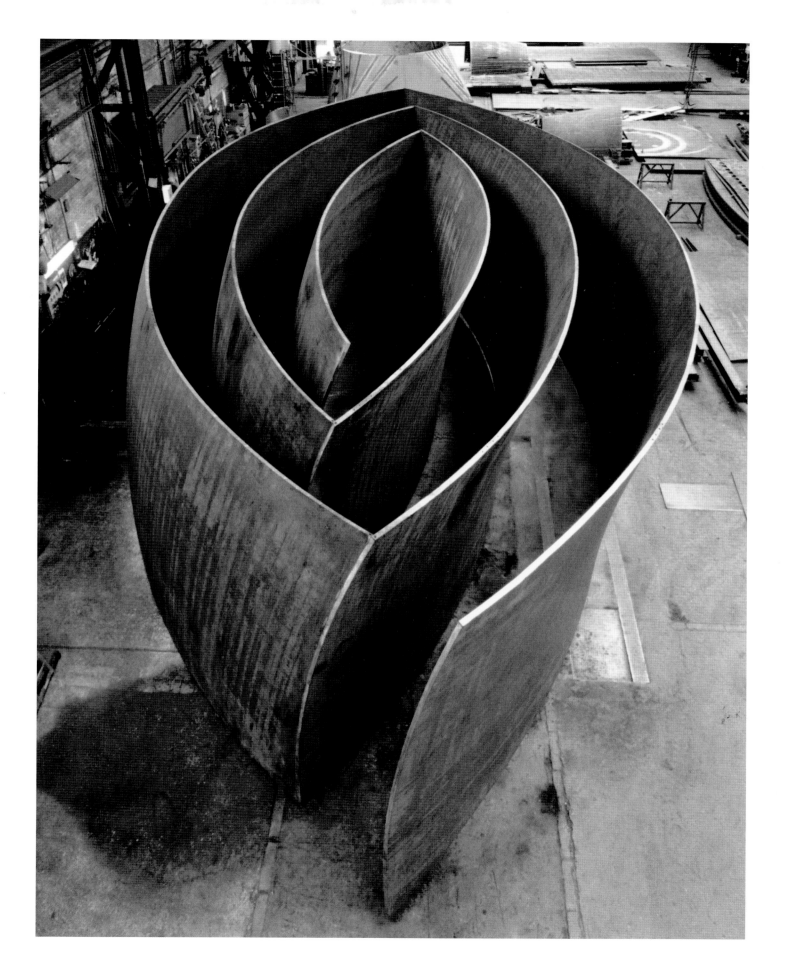

CAN
ART
ART
ESCAPE
ITSELF?

The way a
thing is made
is what it is.

SEAN SCULLY

'On the previous day,' Christopher Columbus recorded in his log on 9 January 1493, not far from the present-day Dominican Republic (the furthest extent of his first voyage into the New World), 'when the Admiral went to the Rio del Oro, he saw three mermaids, which rose well out of the sea; but they are not so beautiful as they are painted.' Since classical times, the legend of entrancing sirens luring sailors to a lustful demise has ignited the imaginations of artists. The allure of 'aquatic humanoids' (as the US National Ocean Service in July 2012 rather less romantically referred to them, in a statement officially debunking their existence) seems to emerge at moments when human vision is mapping new territories for itself – a tradition that the sumptuous surfaces of Indian artist Raqib Shaw's series of paintings *The Garden of Earthly Delights* glitteringly extends.

As the collective title suggests, the sequence assembles itself in the shadow of Hieronymus Bosch's famously disturbing triptych, completed around the time of Columbus's death, which charts the consequences of uncurbed temptation. Where Bosch's vision is frequently interpreted as reproachful of human depravity and the sensual decadence he voyeuristically depicts, Shaw swaps censure for celebration. His is a dazzling grotesquerie of hybrid beasts – lizard soldiers and flying penis-birds – of opulently implausible vegetation, fusing and blurring in a fizzing cacophony of enamel and metallic paint.

Wherever one's eye falls, debauched shapes multiply and divide like newly discovered cells on a microscope slide, while all around fish circulate in schools like manic platelets, surging through the scene with an erratic pulse. In one section, a beast (part-demon, part-elk) canoodles with a rapacious octopus, while in another, a half-piranha, half-god creature raises an ejaculating phallus like a spiritual offering. The effect is an indulgently sexual expressionism that translates the frantic flicking of Jackson Pollock (whom Shaw admires) into something fatalistically fleshy. Complicating the already cluttered surface of his paintings are entangled references to a grab bag of aesthetic traditions, from Indian shawl design and Japanese wedding patterns to Asian cloisonné and heraldic tapestries, from ceremonial Japanese panelled screens to the interlocking weave of Persian textiles.

A prism of disparate inspiration, Shaw's imagination cannot avoid refracting the anxieties of his age. In hindsight and in light of the appalling excesses the global downturn exposed in the few years following Shaw's creation, it is tempting to scan his canvases as a cartography of cultural licentiousness, undertaken as they were at the height of fiscal recklessness. Though born in a very different age and motivated by a very different sensibility of social permissiveness, Shaw, no less than Bosch, documents the dangerous insatiability of his time.

Opposite: Raqib Shaw, **The Garden of Earthly Delights III** (detail), 2003. Acrylic, glitter, enamel and rhinestones on board, 3 panels, each 3.05 × 1.52 m (10 × 5 ft)

Right: Hieronymus Bosch, **The Garden of Earthly Delights**, c. 1500–5

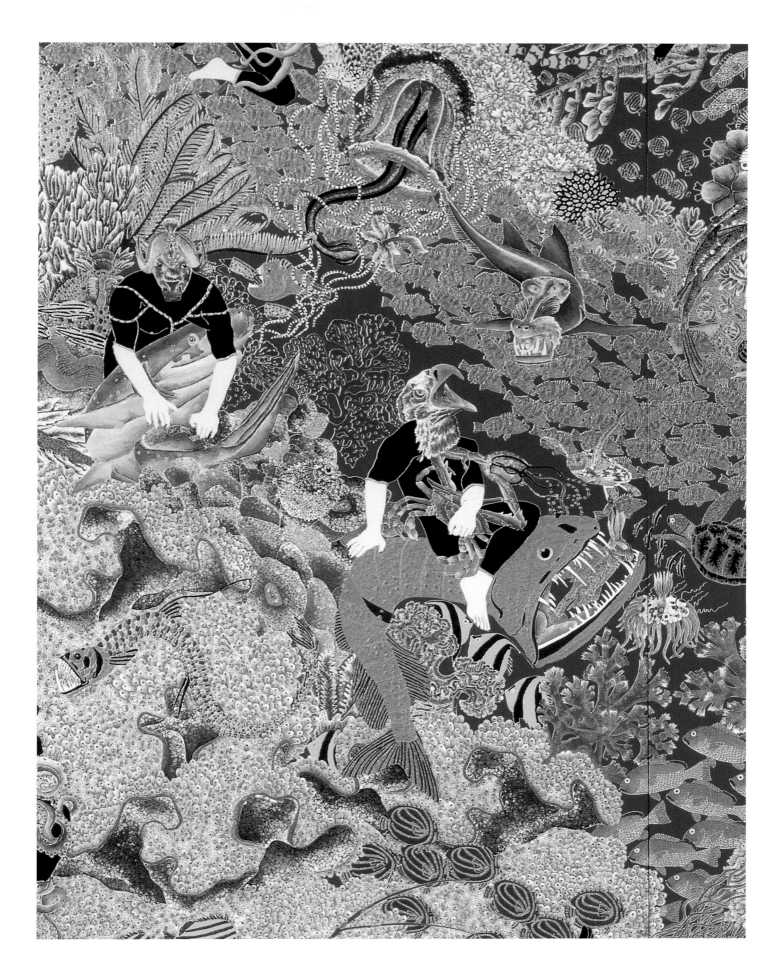

Raqib Shaw, **The Garden of Earthly Delights III**, 2003

'I have heard of your paintings,' Hamlet sneers at Ophelia in the third act of Shakespeare's play, 'God hath given you one face, and you make yourselves another.' On one level, Hamlet is referring merely to a woman's use of cosmetics. But Shakespeare never operates on just one level, and the making of faces to hide the one God has given is surely a crime that every playwright, every actor, is also guilty of committing. The equation of 'painting' with deceit begs a deeper question: is all art disguise? When it comes to the work of American photographer and filmmaker Cindy Sherman, the answer is a resounding yes. For over thirty years, Sherman has hidden herself in the broad daylight of her own camera's flash, staging series after series of pseudo-self portraits in which her own essence seems to dissolve before our eyes.

For an early project, *Untitled Film Stills* (1977–80), Sherman cast herself as a generic Hollywood lead in nearly seventy noir-style scenes – forgeries of official film stills capturing the heroine at climactic cinematic moments – in order to comment on how we construct our identities in the distortive light of movie cliché. A decade later, she widened her focus to take in the choreography of Old Master portraiture, elaborately adopting the guise of subjects associated with works by Raphael, Watteau, Titian and Goya, among others. 'I feel I'm anonymous in my work,' Sherman

confessed to an interviewer from the *New York Times* in 1990. 'When I look at the pictures, I never see myself; they aren't self-portraits. Sometimes I disappear.' But does she really? Having adopted disguise as her chief mode of identity for so long now, Sherman's deceit has surely begun to approximate truth. Disguise in no longer a postponement of her identity; it is her identity.

Hence the unnerving power of her 2003–4 series, *Clowns*, which takes as its principal guise, guise itself. In frame after frame, Sherman assumes the identity of invented strangers who have in turn concealed themselves under heavy cloaks of clown make-up. In popular culture, clowns have emerged as deeply ambiguous beings, their set expressions of relentless superficial mirth concealing something more tragic or sinister. The premise of countless horror films, a fear of clowns has even given rise to a new psychiatric complaint, the term for which etymologists date back no earlier than to the late 1980s: coulrophobia. By provoking that newly coined fear, Sherman has ironically exposed something age-old about the power of the greatest portraiture – its ability to suspend in excruciating tension both public decorum and tics of private pain. A master of inscrutable tragicomic self-veiling, Shakespeare above all others would have appreciated the manic masquerade of Sherman's strange unmaskable masks.

Opposite: Cindy Sherman, **Untitled #425**, from the series **Clowns**, 2004. C-print, 180 × 230 cm (60 × 90½ in.)

Right and far right: Cindy Sherman, **Untitled Film Still #24** and **Untitled Film Still #21**, 1978, from the series **Untitled Film Stills**, 1977–80

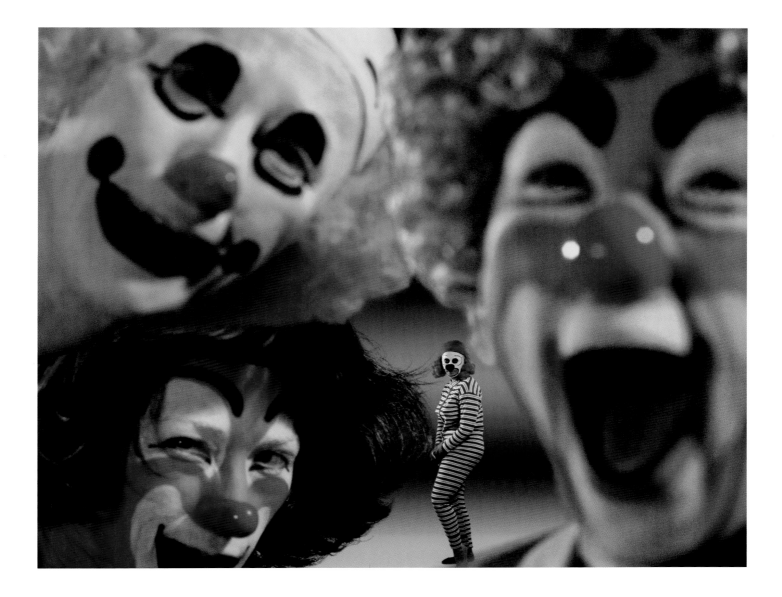

Can art go too far? Though the avant-garde of every generation is expected to push the boundaries of what society can tolerate, does there ever reach a point beyond which an object of artistic expression is simply unacceptable? One thinks of the paroxysms of disdain that works which now seem tame, even conventional, triggered when they were first exhibited. In 1877 the critic John Ruskin sparked a heated libel case when he accused the painter James Abbott McNeill Whistler of anti-socially 'flinging a pot of paint in the public's face' with his *Nocturne in Black and Gold: The Falling Rocket* (1875). From today's perspective, our sensibilities now shaped by the intervening controversies ignited by Cubism, Dadaism, Surrealism and Expressionism, one finds it difficult to imagine the outrage that Whistler's innocent nightscape once provoked.

For the past decade, the Mexico-based Spanish artist Santiago Sierra has brazenly patrolled the disputed border where taste and taboo blur. His short-lived 2006 installation *245 m3*, in particular, struck many observers as having flagrantly crossed the line. Already well known for such outrageous acts as tattooing the backs of drug-addicted prostitutes, incarcerating someone for weeks in his studio, paying an exploitative wage to desperate labourers to shove a block of concrete around his gallery, and denying access to his exhibition at the Fiftieth Venice Biennale to any visitor who could not show a Spanish passport, Sierra resolved to test the very boundaries of acceptability by constructing a functioning gas chamber inside a former synagogue in Pulheim, Germany. In an attempt to challenge what he believed was the trivialization of the Holocaust in contemporary society, Sierra siphoned into the building through a system of flexible plastic vacuum pipes the lethal exhaust from six automobiles parked outside, rendering the 245 cubic metres of space inside as toxic as a Nazi extermination chamber. Visitors wishing to enter the installation were fitted with gas masks, necessary for their survival, thereby forcing them to don the guise of a genocidal beast. Reinforcing the sense of complicity, entrants were required to sign a legal waiver acknowledging their full understanding of the risks involved in proceeding.

Opening day attracted over two hundred willing participants, many of whom insisted they had been moved to tears by the emotional intensity of the audacious installation. But far more audible were protests by those who felt that Sierra's sensational stunt was undertaken in the worst possible taste. Far from casting any new or thoughtful light, Sierra's work, so a chorus of critics charged, sought to convert excruciating memories into cheap sensation for cynical reputation gain. After efforts to assuage leaders of Jewish organizations and offended community groups, and despite the support of local civic officials for the continuation of the installation, Sierra reversed course and agreed permanently to close *245 m3* – a rare example of a principled artist retreating from his position. The work had only been open for one day.

Was Sierra's installation ahead of its time – a cultural watershed that will in the coming years and decades be thought of as groundbreaking, conventional or even passé? Or does the fate of Sierra's work suggest that we have begun to reach the very limits of tolerable artistic expression – that, as the old maps say, beyond here lie monsters?

Opposite: Santiago Sierra, **245 m3**, 2006. Installation at Stommeln Synagogue, Pulheim, Germany. Materials and dimensions specific to site

Right: James Abbott McNeill Whistler, **Nocturne in Black and Gold: The Falling Rocket**, 1875

'Lonely in Ireland,' Philip Larkin begins his poem 'The Importance of Elsewhere', 'since it was not home / Strangeness made sense.' But is elsewhere ever really elsewhere? Or do we invariably bring with us, wherever we go, some part of the places we have lived? For South Korean sculptor Do Ho Suh, strangeness and familiarity are the intersecting axes against which all of life and art can be soulfully plotted. His multi-layered, ongoing series of installations, *Home Within Home*, seeks to collapse into a single time and place (the eternal present of an exhibition space) lyrical reconstructions of every abode in which he has ever lived, from his native Seoul, where he studied Oriental painting, to Providence, Rhode Island, where he moved to pursue making art himself.

For Suh, home is a cumulative concept – a place in which one never arrives, but is forever arriving. The emotional power of his work stems from its meticulous rehabilitation of these never relinquished coordinates of memory, resuscitating an artistic tradition of depicting interiors that stretches back to the seventeenth century and such Dutch Golden Age painters as Jan Steen and Hendrik Sorgh – masters who likewise understood that the truest dimensions of the home cannot be measured in external units. But for Suh the intensity of recollected space is not conveyed through the homey reanimation of modest domesticity or warmly lit sculleries.

His vision is as eerie as it is profound, involving, in one work, the translation of his childhood dwelling into walls of spectral silk that float uncannily above visitors' heads.

A ghostliness achieved by the quasi-transparency of other pieces in the series is unnervingly at odds with their playful dollhouse scale; for one work, the artist compressed a previous home's physicality to one-eleventh its inhabitable size. Drifting through these gauzy insinuations of interiority – some hinted at impressionistically in see-through polyester, others dangling delicately from above like a blueprint traced in a curtain of rain – visitors are confronted with the irresolvable nature of what it means to 'be home'. The result is a slow dissolving of confidence in the physicality of one's presence and the externality of one's surroundings. 'I was the world in which I walked,' Wallace Stevens concludes his poem 'Tea at the Palaz of Hoon', 'and what I saw / Or heard or felt came not but from myself; / And there I found myself more truly and more strange.' In another work that forms part of *Home Within Home*, a replica of the artist's apartment from the era of his enrollment in art school has been struck from the side by a model of his earlier boyhood home, smashed open as if by an existential meteor. Being here, Suh seems to say, is the wreck of everywhere you've been before.

Do Ho Suh, **Home Within Home – 1/11 Scale – Prototype** (detail), 2009, from the series **Home Within Home**, 2008–. Resin stereolithograph, 1.84 × 1.78 × 2.36 m (6 ft ½ in. × 5 ft 10 in. × 7 ft 8 in.)

Do Ho Suh, **Home Within Home – 1/11**
Scale – Prototype, 2009, from the series
Home Within Home, 2008–

The power of the last work we explored, Do Ho Suh's ethereal revisitations of every home in which the artist has lived, relies on irresolvable frictions between here and elsewhere, the past and the present, the deceptive solidity of the physical and the resilience of memory. Similar tensions invigorate the delicate fabric of our next work: German artist Wolfgang Tillmans's luminous series of photographs, entitled *Freischwimmer*. A master of brittle beauty, Tillmans's early photographic portraiture of the 1980s and 1990s attracted attention for its success in teasing to the surface of a sitter's countenance a delicacy of expression that seemed to expose the essence of his or her anxieties and desires. In *Freischwimmer*, Tillmans pushes the instinct to its furthest extreme, abstractly isolating a semblance of human fragility by removing it from any figurative or discernibly representational context, as though vulnerability were a material substance that could be magnified on a chemist's slide.

Though concocted in a darkroom, these pictures are not the product of light passing through the aperture of a camera's lens in the manner of conventional photography, but instead record the volatile moods of the processing chemicals themselves. These images have the feel of something at once miniscule, glimpsed through a powerful microscope, and cosmically vast in scale, seen through a sophisticated telescope. The result is a ballet of what could as easily be a swab of bacteria as a nebula or a surging solar flare. The impulse to experiment with the visual vantage of the artist can be traced back, Tillmans says, to his fascination with astronomy as a child and his intuition, years later, to explore the power of aerial perspectives of cityscapes, as though flipping the lens around and adopting an alien focus. The *Freischwimmer* series shares something too with the temperament of Tillmans's photographs of lightning and stars, whose bright scratches on darkness the artist has described in quasi-mystical terms as an abstraction that emerges from deep inside him. As such, these photographs merge expressionism and realism in ways that are more likely to recall the proto-Impressionist achievement of J. M. W. Turner than the work of contemporaries.

The blurring of ambiguous shapes and states has been at the heart of Tillmans's work since the mid-1990s, when he exhibited a pair of photographs featuring bowing subjects in virtually indistinguishable postures: one crouched in supplicating prayer, the other, naked, with his body folded in sadomasochistic submission. The poetic collapsing of the spiritual and the sexual invigorates the suspended movement of the *Freischwimmer* photographs as well, where the swell and throb of each composition can be as compellingly attached to the urges of the body as the urges of the soul.

Opposite: Wolfgang Tillmans, **Freischwimmer 204**, 2012, from the series **Freischwimmer**, 2003–. C-print, 2.38 × 1.81 m (7 ft 9¾ in. × 5 ft 11¼ in.)

Right: Wolfgang Tillmans, **Freischwimmer 26**, 2003, from the series **Freischwimmer**, 2003–. C-print, 1.8 × 2.4 m (5 ft 11 in. × 7 ft 10½ in.)

WHERE DO WE GO FROM HERE?

To find a form
that accommodates
the mess, that
is the task of the
artist now.

SAMUEL BECKETT

Make yourself at home. However straightforward or hospitable the invitation may seem, can we ever really 'make ourselves' anywhere? One becomes who one is as a result of his or her relationships and interactions with others, not through sheer self-contrivance. 'To be' is to be part of a wider community that includes family and friends, acquaintances and strangers. That, at least, is the intriguing premise behind Rirkrit Tiravanija's dynamic series of *Apartment* installations, which he began exhibiting in 2002. Depending on the dimensions of the host gallery or museum, Tiravanija endeavours to replicate the interior of his New York apartment for unrestricted use by visitors. Hungry? The artist has provided a completely functional kitchen including appliances, a sink, cutlery, crockery, a full fridge and cupboards stocked with rice, pasta, canned goods and spices. While others prepare a meal, perhaps you might enjoy a shower or a power nap on the settee? Every domestic fitting is there to be enjoyed by those who happen to find themselves circulating through the artist's exhibit.

Born in Argentina to Thai parents, Tiravanija studied art in Toronto, Banff, Chicago and New York during his twenties, and a restlessness of identity has shaped his conception of art. In *Apartment*, reflection is not provoked narrowly by a single painting or sculpture, or by the debatable success of an individual artist's effort, but by the unpredictable combination of human beings temporarily inhabiting a shared space. Tiravanija merely provides the pottery wheel on which a work of authentic intensity can be spun into being.

The ephemeral energy of an artwork that cannot be varnished, framed, auctioned or sold has been met by cheers and sneers. There are those moved by its selflessness and those bored by its pretensions. The latter have tended to criticize Tiravanija's work for its lack of an enduring *objet* capable of demonstrating the slow honing of technique or the conspicuous command of any medium. What, they ask, has he got to show for all his effort? 'Tiravanija is better at being an artist', the critic Adrian Searle succinctly concluded, 'than at making art.' But in Tiravanija's world, admirers would insist, effort *is* the show – the fleeting flex of curiosity over a bowl of soup offered to you by a stranger in a gallery, the unrecorded conversation that took an unexpected turn. That nap. With *Apartment*, the artist has attempted to take the now fatigued concept of the ready-made to another level, returning the everyday objects on show to working order and shifting attention from the nature of what it means to be made back onto us.

Opposite top: Rirkrit Tiravanija, **(please do not turn off the radio if you want to live well in the next fifteen minutes)**, 2005. Installation at the Serpentine Gallery, London. Various media, dimensions specific to site

Opposite bottom, left and right: Rirkrit Tiravanija, **Untitled 2005 (apartment 21)**, 2005. Installation at the Serpentine Gallery, London. Various media, dimensions specific to site

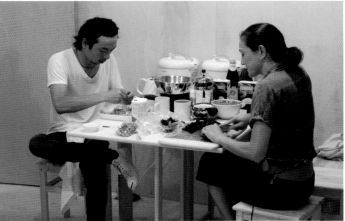

You may be surprised to discover that the word 'impressionist' does not appear in print until 1964. No, not in the sense you might assume I mean ('a style of painting, originating in Paris in the 1870s, devoted to broad impressions rather than precise details'), but apropos its later comedic connotation, designating one 'whose act consists', according to the *Oxford English Dictionary*, 'of imitations or impersonations of well-known personalities'. Though the artistic divide that separates one form of impressionism from the other may at first appear as wide as that which separates high culture from low, our next work, British artist Gavin Turk's waxwork statue *Pop* (1993), manages to blur the identities of elite and popular artistic expressions by confounding our understanding of identity itself.

An infinite regression of deferred personality, the figure is an anxious self-portrait of the artist impersonating Sid Vicious (the bassist of the 1970s punk band the Sex Pistols), who in turn was adopting the stance of Andy Warhol's famous image of Elvis Presley, who was himself assuming the camp posture of a Hollywood cowboy. As such, the work is a complex tissue of accumulated selves that weaves threads of popular culture across genres and generations. At first glance, the statue feels insurmountably artificial and contrived, frustrating any attempt to unravel the affected tangle of inauthentic gesture. Look again, and the piece is remarkable in its ability to capture the curious braid of pointless emulation – the ephemeral fads and fashions to which we spend much of our lives consciously and subconsciously tying our appearance and behaviour.

The questions the work raises about how society constructs identity is in accord with earlier works we've discussed, but here the emphasis is on the surface that celebrity culture shellacs across self-image, as though layer after layer of waxen varnish has slowly collected into consciousness and being. Since a young Marie Tussaud (later Madame) created her first paraffin figures of Enlightenment intellectuals in the 1770s (starting with Voltaire), to be memorialized as a wax effigy has been seen as an index of one's stature in society. By enshrining instead a composite countenance of confused individuality, Turk has melted the phony façade of uniqueness and originality that we naively aspire to create.

In 1997 *Pop* was included in the Royal Academy of Arts' notorious 'Sensation' exhibition, which featured works from Charles Saatchi's collection of contemporary art, including controversial works discussed elsewhere in this volume (Marcus Harvey's portrait of the murderer Myra Hindley and Chris Ofili's provocative depiction of the Virgin Mary). In deciding how to present himself at the show's opening party, Turk resolved to adopt the pose of a homeless man and arrived at the event unwashed and wearing discarded clothing he had found on the street. By doing so, the artist had in effect animated his work, bringing to life, however ironically, the essential impoverishment of a world so addicted to impersonation it can no longer recognize itself.

Gavin Turk, **Pop**, 1993. Waxwork in vitrine, 2.79 × 1.15 × 1.15 m (9 ft 1⅞ in. × 3 ft 9¼ in. × 3 ft 9¼ in.)

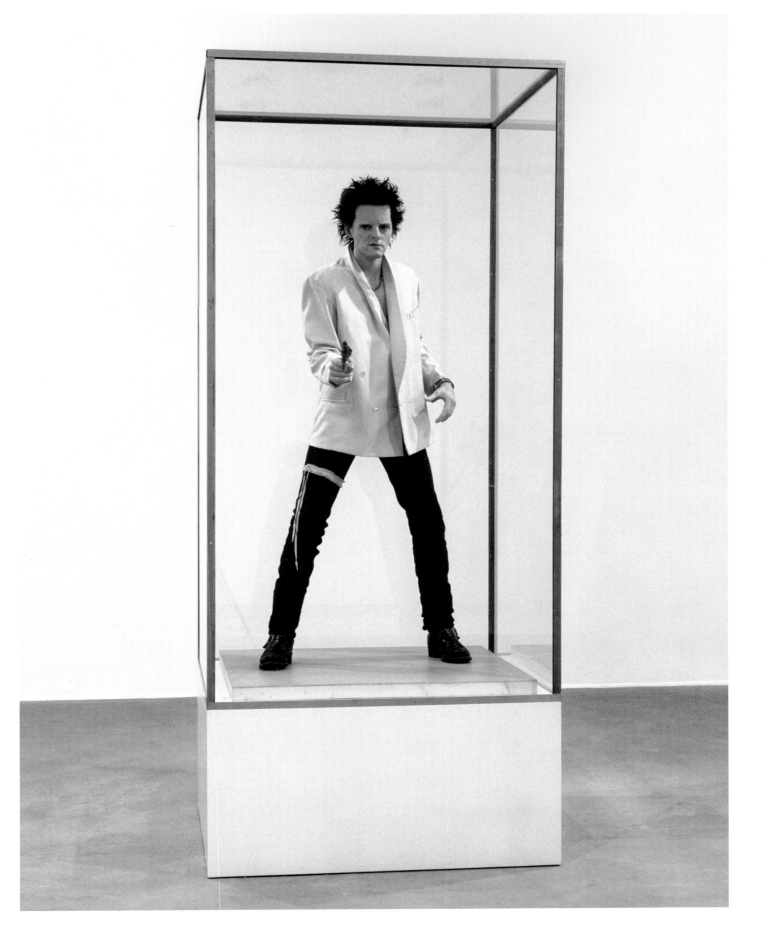

090 Easter (2006) LUC TUYMANS

Poetry, the French writer Paul Valéry once wrote, is that 'long hesitation between sound and meaning.' To judge from Belgian painter Luc Tuymans's 2006 canvas *Easter*, art might similarly be defined as that long hesitation between sight and sense – so long, in fact, that stable meaning never fully materializes. Characteristic of Tuymans's work, *Easter* relies on seemingly straightforward gestures comprising what should, on the surface, cohere into an easily interpretable narrative. The simple linearity of the painting's three figures, progressing from left to right along a low path against the sparest of overcast skies, dares the viewer to detect any complexity at all in the story from which the moment has been removed.

But lean closer and the scene suddenly unravels into a string of ambiguous signs, as opaque as the humid horizon Tuymans has occluded behind them. The three figures, clad indistinctly in ecclesiastical robes, appear to be either exiting or moving towards some kind of congregation or ceremony. Though the middle figure is frozen in mid-salute, arms either rising or falling, what has puzzled some writers is whether these gesticulations are intended to bestow goodwill or shame onto the hooded penitent who strides in front of him. Is this an excommunication, a blessing or a desperate appeal to the departing that he return? The shadow-faced figure behind him turns his countenance towards us, the haziness of his features serving only to amplify the fuzziness of our comprehension.

For Tuymans, art is a way of sorting through history's half-hints and innuendoes and *Easter* seems central to that process. The angle of the indeterminate salute at the centre of the painting recalls a gesture from a family photograph that the artist, as a boy, caught a glimpse of as it accidentally slipped out of a family album: the Nazi salute, as made by his paternal uncle, Luc. Tuymans's mother, whose family had been active in the Resistance, had been unaware of any such allegiances on his father's side and the revelation was devastating. The family was never the same again.

The best of Tuymans's work ignites in the mind of its viewers that same childhood befuddlement of suddenly beholding an image that one knows is of terrible significance but is unequipped to comprehend just why. The artist himself has explained that what is most there in a painting is what is least there. His works are like photographs forever sliding from the album of our age, their unsettled and unsettling meanings never fully clicking into place.

Luc Tuymans, **Easter**, 2006. Oil on canvas,
1.28 × 1.79 m (4 ft 2⅜ in. × 5 ft 10½ in.)

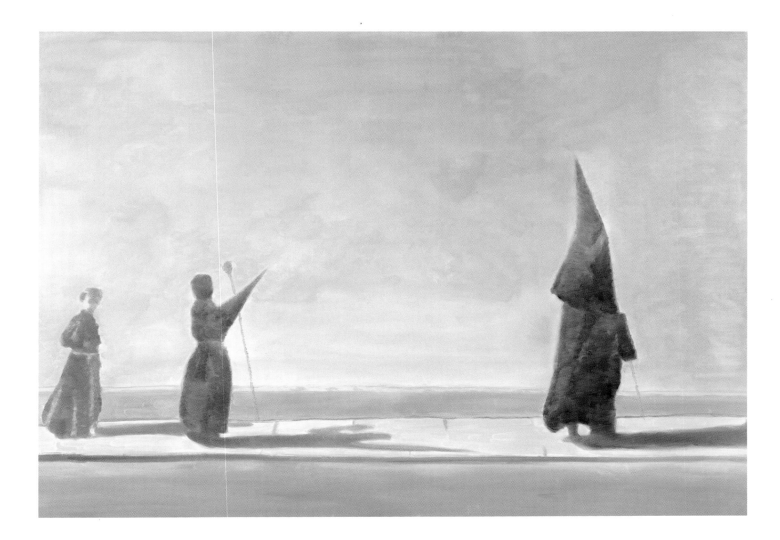

In July 2007, French police arrested a woman at a modern art gallery in Avignon for having damaged one of Cy Twombly's works by pressing her lips against it, leaving a bright smudge of lipstick floating in the emptiness of an otherwise completely white painting. 'The red stain', the vandal pleaded, 'is testimony to this moment, to the power of art.' One could be forgiven for believing the passionate defacement planted a seed in Twombly's imagination that would subsequently blossom into the dripping vibrancy of *The Rose* – the series of five enormous paintings the artist created the following year, each one featuring a trio of exploding buds, bleeding with sensual joy.

For over fifty years, Twombly, who died in 2011, dared critics to take seriously his large-scale planks and blackboards on which words, or parts of words, were scribbled in crayon and chalk, often indecipherably. What is immediately striking about *The Rose*, however, is the uncharacteristic legibility of lines from Rainer Maria Rilke's poem 'The Roses' against the signature spillage of Twombly's endlessly dripping petals. These are not intended merely to accompany Rilke's roses but to become them. In one panel, a scrawl of translated lines from the poem ('O abundant flower, / you create your own space – / you stare at yourself in a mirror / of odor') wafts from the cartwheeling flowers, as if fragrantly describing the vision of the observer as well. The result is a collapsing not only of language and symbol but also of the viewer and the viewed. Twombly's roses have 'the look', as T. S. Eliot wrote in *Four Quartets*, 'of flowers that are looked at', establishing an intimacy that many heretofore detractors of Twombly found seductive.

Followers of Twombly's career may be reminded by these five later works of an earlier cycle, exhibited by the artist in 1985 and entitled *Analysis of the Rose as Sentimental Despair*. But the distance Twombly has travelled in temperament in the intervening decades is significant. In the earlier series, sloppily jotted quotations from Rilke's *Sonnets to Orpheus* were stapled like ransom notes to wood panels on which splatters of red paint soaked into the white primer as angrily as blood on a coroner's apron. *The Rose* reveals a deeper integration of poetry and image and a jubilation that its precursor would mock as bijou. The unfolding of its petals, whose effect is enhanced by a cascade of vertical drips that propel the blossoms upward, smothers all thoughts of death and despair.

The haphazard texture of such propulsion is likely, on the one hand, to invite comparisons with the all-over action painting of Jackson Pollock, while the collage aspect of their composition has recalled for some the late paper cut-outs of Matisse. But the truest antecedent of Twombly's vision is as unmistakable as it is surprising: Van Gogh's *Sunflowers* (1888). Where Van Gogh's iconic paintings of twelve or fifteen stems fix in Byzantine gold an autumnal abundance forever on the verge of decay – 'budding more / And still more,' as Keats says in 'To Autumn' – Twombly's roses have pulled the season back an equinox to an eternal spring, allowing emotion to burst through the fabric of the canvas with the uncontrollable force of a vandal in a gallery, or a kiss.

Opposite: Cy Twombly, **The Rose (I)**, **The Rose (III)** and **The Rose (IV)**, from the series **The Rose**, 2008. Installation at the Gagosian Gallery, London, 2009. Each acrylic on plywood, 2.52 × 7.40 m (8 ft 3¼ in. × 24 ft 3⅛ in.)

Right: Vincent Van Gogh, **Sunflowers**, 1888

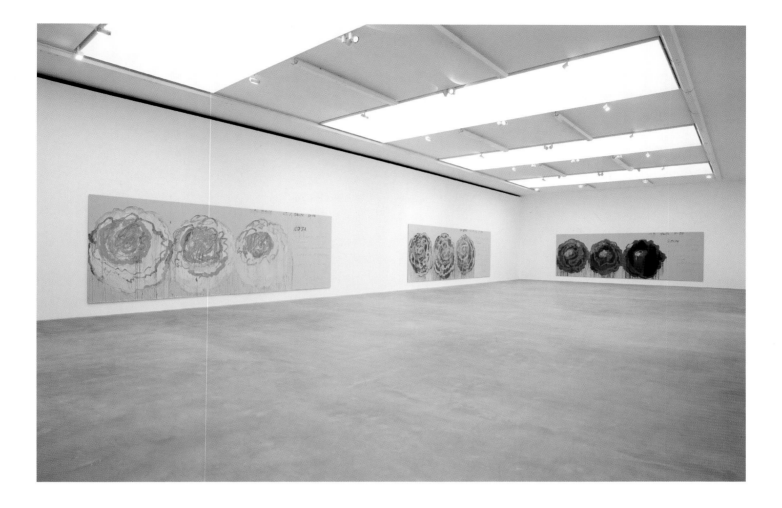

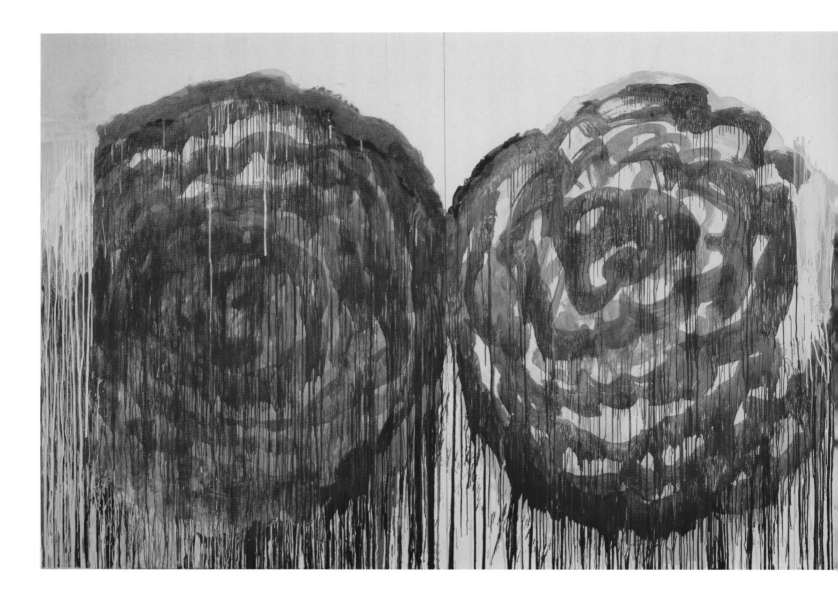

Cy Twombly, **The Rose (II)**, from the series
The Rose, 2008. Acrylic on plywood, 2.52
× 7.40 m (8 ft 3¼ in. × 24 ft 3⅜ in.)

The power of art relies less on the seen than on the unseen – on the invisible ties linking a given work not only with the past masterpieces that fathered it, but also to the unending lineage of works with which it is pregnant. No work exudes the vibrant glow of art's endless regeneration more exquisitely than American artist Bill Viola's 1995 video installation *The Greeting*. On one level, the scene that unfolds before us in Viola's slow-motion work is of the most pedestrian encounter: two female friends meet by chance on a city street and find themselves deep in conversation when they are suddenly joined by a young woman who appears to know the elder of the initial two interlocutors. A palpable discomfort at the interruption consumes the expression of the now marginalized figure, as the newly arrived woman leans in to whisper in the ear of her older friend news that occasions still greater displays of affection between the two. Nothing remarkable about that. But the mundane often disguises the extraordinary. The real drama here occurs in secrecy right before our eyes, beneath the ample skirt and loosely flowing dress of the whisperer and whisperee.

But to understand fully the concealed meaning one must be familiar with a prior work, created over four and a half centuries earlier in a small town outside Florence – a work that for nearly half a millennium has been waiting to give birth to the very possibility of Viola's installation.

The work to which *The Greeting* owes its inception is the Mannerist master Jacopo Pontormo's painting *The Visitation* (c. 1528–29), which the artist undertook as decoration for a twelfth-century church in the town of Carmignano, Italy. Pontormo's celebrated treasure depicts the moment, described in the Gospel of Luke, when the Virgin Mary, fresh from receiving the news that she is carrying the Christ child, meets her older cousin, Elizabeth, who is also miraculously pregnant, despite her age and presumed barrenness. 'For, lo, as soon as the voice of thy salutation sounded in my ears', Elizabeth exclaims to Mary, 'the babe leaped in my womb for joy.' This is the first physical encounter between Christ and John the Baptist, the child whom Elizabeth is carrying, and there is an implicit poignancy in the maternal suspension of these two figures, for whom sousing and immersion will become crucial rituals in the cosmic drama soon to unfold. The mastery displayed by both artists, the sixteenth-century painter and the twentieth-century installationist, lies in their shared ability to coax to the surface of their respective creations the submerged innocence and intensity with which their works are implausibly pregnant.

Opposite: Bill Viola, video still from
The Greeting, 1995. Colour video projection on large vertical screen mounted on wall in darkened space, amplified stereo sound, 4.3 × 6.6 × 7.8 m (14 ft 1¼ in. × 21 ft 7⅞ in. × 25 ft 7 in.)

Right: Jacopo Pontormo, **The Visitation**, c. 1528–29

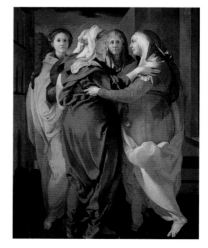

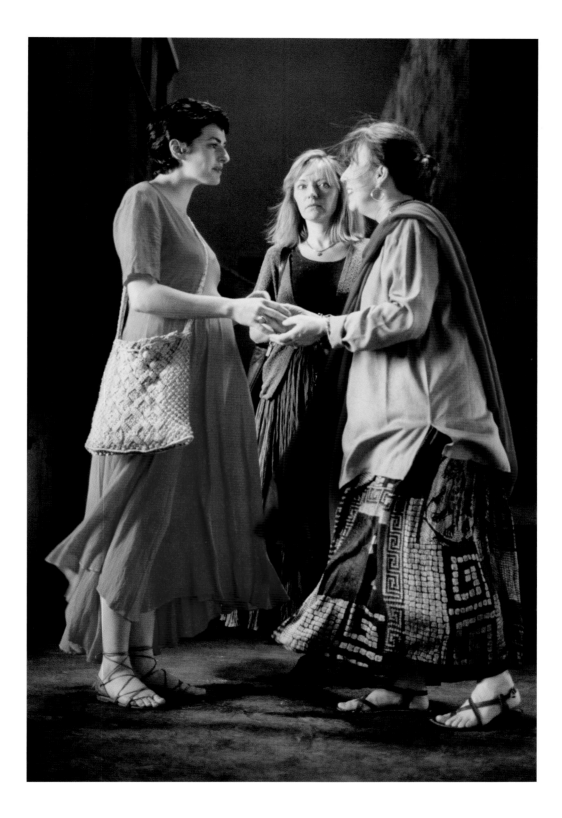

093 Gone, An Historical Romance of a Civil War as It Occurred between the Dusky Thighs of One Young Negress and Her Heart

(1994) KARA WALKER

If popular history is to be trusted, the whispery syllables of 'silhouette' – the artistic term for the traced outline of a blackened profile or portrait – survive in language as deceptively mellifluous relics of ridicule and hate. Dictionaries frequently trace the word's origins back to the eighteenth-century French finance minister Étienne de Silhouette, who implemented a swingeing programme of miserly economic reform after taking office in 1759. Despised by the French people, so the story goes, Monsieur Silhouette was lampooned by the attaching of his name to all things considered petty and trifling, including simple monochrome cut-outs of a sitter's profile set against a pale background. What the folk etymology fails to account for, however, is the restrained power of the austere technique, whose effect is anything but stingy, and which manages to define a person's presence by way of an obliterating absence. Indeed, to make the profoundest sense of the term, one need know nothing of French economic policy, but merely the etymology of the word itself – a corruption of the Basque surname Zulueta (Silhouette's father was born in French Basque country), meaning 'an abundance' (-eta) of 'absence' or 'hole' (zulo).

Properly understood, a silhouette is a gathering of emptiness, and no one understands the form and its potential better than African-American artist Kara Walker. As a twenty-two-year-old art-school student, Walker ingeniously revived the moribund form, which, having been in vogue for over a hundred years since Monsieur Silhouette's day, had been in decline since the end of the nineteenth century – eclipsed by the rise of the daguerreotype and camera. Measuring some four metres high by fifteen metres wide, Walker's 1994 silhouette saga, *Gone, An Historical Romance of a Civil War as It Occurred between the Dusky Thighs of One Young Negress and Her Heart*, consists of bold black-on-white figures participating in a static drama that can be read from left to right, similar to the way sculpted bodies on a Grecian urn are brought to life by the viewer's animating eye.

In its title and in the opening vignette on the far left of the work, which features the romantic embrace of a southern belle and her handsome beau, Walker's *Gone* recalls the clichéd ambiance of Margaret Mitchell's novel *Gone With the Wind* (1936), which was set nostalgically in Plantation-era America and has been criticized for its failure to confront issues of slavery and racial exploitation. But Walker's work is a stark corrective, gathering into itself an 'abundance' of the cultural 'absences' elided by Mitchell's celebrated narrative. What unfolds in the ensuing scenes of Walker's silhouette is a frozen phantasmagoria of all that Mitchell's novel connives to white out, both sexually and psychologically, as though Walker has peeled back the black font of *Gone With the Wind* to expose the papered-over shadows of a painful past.

Kara Walker, **Gone, An Historical Romance of a Civil War as It Occurred between the Dusky Thighs of One Young Negress and Her Heart**, 1994. Installation at the Hammer Museum, Los Angeles, 2008. Cut paper on wall, 3.96 × 15.24 m (15 × 50 ft)

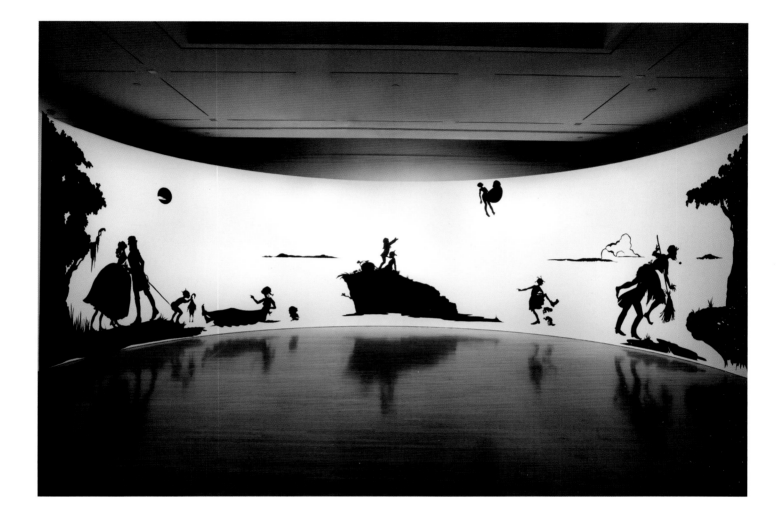

094 After 'Invisible Man' by Ralph Ellison, the Prologue

(1999–2000) JEFF WALL

'**Photography**', the French philosopher Roland Barthes once wrote 'is a kind of primitive theatre, a kind of tableau vivant, a figuration of the motionless and made-up face beneath which we see the dead.' Few contemporary artists have wielded the camera's power to penetrate life's veneer as influentially as Canadian photographer Jeff Wall. Since the 1970s, Wall has devoted himself to reviving the Victorian vogue for *tableaux vivants*, or 'living pictures', staging scenes that quote from the history of art and literature, which he then exhibits on large, backlit transparencies.

Wall's ability to strip away the surface artifice of his meticulously choreographed sets, in order to capture the invisible essence of his subject, is most evident in his vibrant turn-of-the-century work, *After 'Invisible Man' by Ralph Ellison, the Prologue*. American writer Ralph Ellison's 1952 novel *Invisible Man* explores themes of black identity in America prior to the Civil Rights movement, and Wall recreates in his photograph a passage in which the unnamed protagonist of the story describes his subterranean Harlem abode:

> My hole is warm, and full of light. Yes, *full* of light. I doubt if there is a brighter spot in all of New York than this hole of mine....Perhaps you'll think it strange that an invisible man should need light, desire light, love light. But maybe it is exactly because I *am* invisible....In my hole in the basement there are exactly 1,369 lights. I've wired the entire ceiling, every inch of it...

Converting his Vancouver studio into this imagined dwelling, Wall crammed the ceiling with a vast spider's sac of lit and burnt-out bulbs (all 1,369 of them) that hovers at once dazzlingly and threateningly above the seated hero. In the service of depicting the socially invisible, the alluring luminosity Wall achieves by mounting his photo-transparency onto an aluminium light box vibrates with an almost mystical power. His re-enactment of Ellison's imagination becomes a compelling metaphor for the role of every artist in every age – an invisible soul who scavenges, hoards and manipulates light.

Jeff Wall, **After 'Invisible Man' by Ralph Ellison, the Prologue**, 1999–2000. Silver dye bleach transparency, aluminium light box, 1.74 × 2.51 m (5 ft 8½ × 8 ft 2⅞ in.)

Q: When does a work of political art overstep the mark?
A: When it is less than one kilometre from London's Parliament Square. That, according to sections 132 to 138 of the Serious Organised Crime and Police Act 2005 (or SOCPA), is the minimum distance from the UK's House of Commons that an unauthorized work or demonstration must maintain, without risking being dismantled or confiscated by the State. The throwback provision, which feels more from the turn of the nineteenth century than the twenty-first, was bundled into legislation ostensibly intended to create a new agency to tackle serious organized crime, but more memorably it inspired one of the most ambitious works of the age: British artist Mark Wallinger's 2007 installation *State Britain*.

Like many, Wallinger was convinced that the politicians' real motivation was a determination to rid the streets of one homeless man who had come to haunt their consciences. On 2 June 2001, Brian Haw, who had devoted his life to offering guidance to troubled youths, had set up camp in Parliament Square with just a tent and a megaphone to protest sanctions against Saddam Hussein, which he felt had proved more devastating to Iraq's children than to its leader. As weeks, months and years passed and the UK's involvement in the Middle East became militarily entrenched following the terrorist attacks of September 11, 2001, Haw increasingly came to be seen as the living symbol of conscientious dissent in the country. Before long a steady stream of sympathizers were donating not only the provisions on which Haw would exclusively depend for survival, but also homespun banners, posters, flags and buttons, which, taken together, comprised an organic installation of real-time expression that stretched forty metres wide. Among the notable displays was a characteristically anti-authoritarian Banksy stencil, depicting soldiers erasing a peace sign, which would prove disturbingly prophetic. After attempts to have the site removed collapsed in the courts, the government adopted a new strategy and suggested that protesters like Haw could be in league with the enemy and could offer decoy cover to suicide bombers seeking easy access to Parliament. Before dawn on 23 May 2006, some fourscore police officers descended upon Haw's iconic camp, accusing its leader of violating sections 132 to 138 of the recently enacted SOCPA and removing virtually all six hundred objects, save for one sign.

As a tribute to Haw's perseverance and courage, Wallinger resolved to recreate the dismantled protest camp, piece by piece, and provocatively to redisplay it inside the austere walls of Tate Britain, which he calculated fell directly on the border of the forbidden zone. By doing so, Wallinger challenged bureaucrats to interpret whether his work was mainly political, and therefore in violation of SOCPA's heavy-handed provisions, or merely a comment upon a moment in cultural history and therefore protected by legal conventions respecting freedom of artistic expression. Wallinger's attention to even the minutest detail in reconstructing the protest site blurred the boundaries between art and reality and brought to even wider attention and acclaim the cause of one man, whom the government had rewritten the laws and redrawn the maps in order to encircle and silence.

Mark Wallinger, **State Britain**, 2007.
Installation at Tate Britain, London. Mixed
media, approx. 5.7 × 43 × 1.9 m (18 ft 8⅜ in.
× 141 ft 1 in. × 6 ft 2¾ in.)

Overleaf: Mark Wallinger, **State Britain**,
2007. Installation at Tate Britain, London

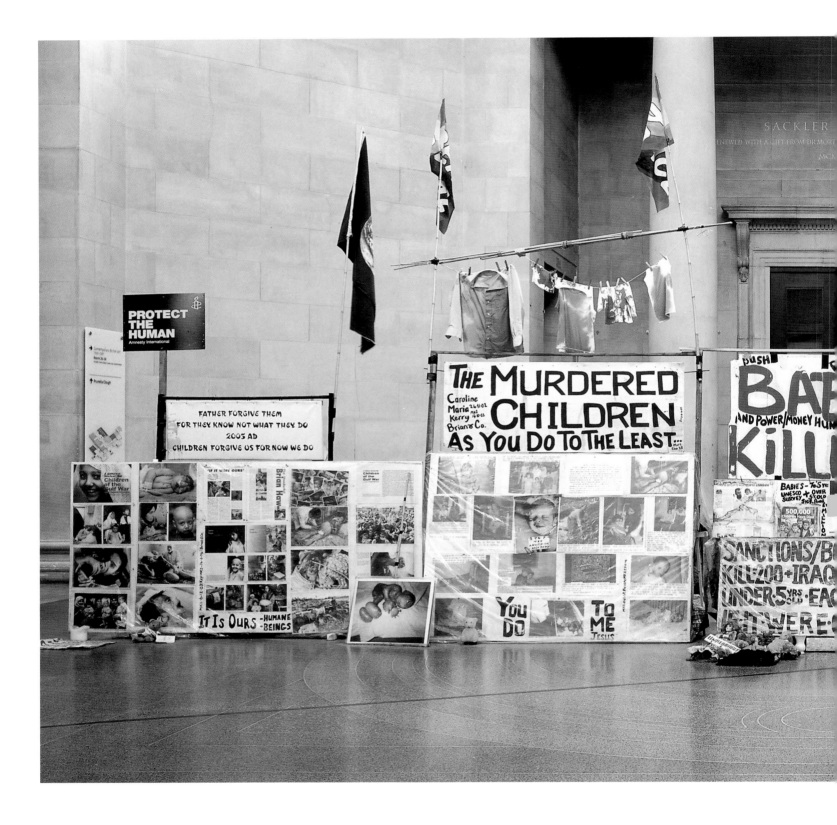

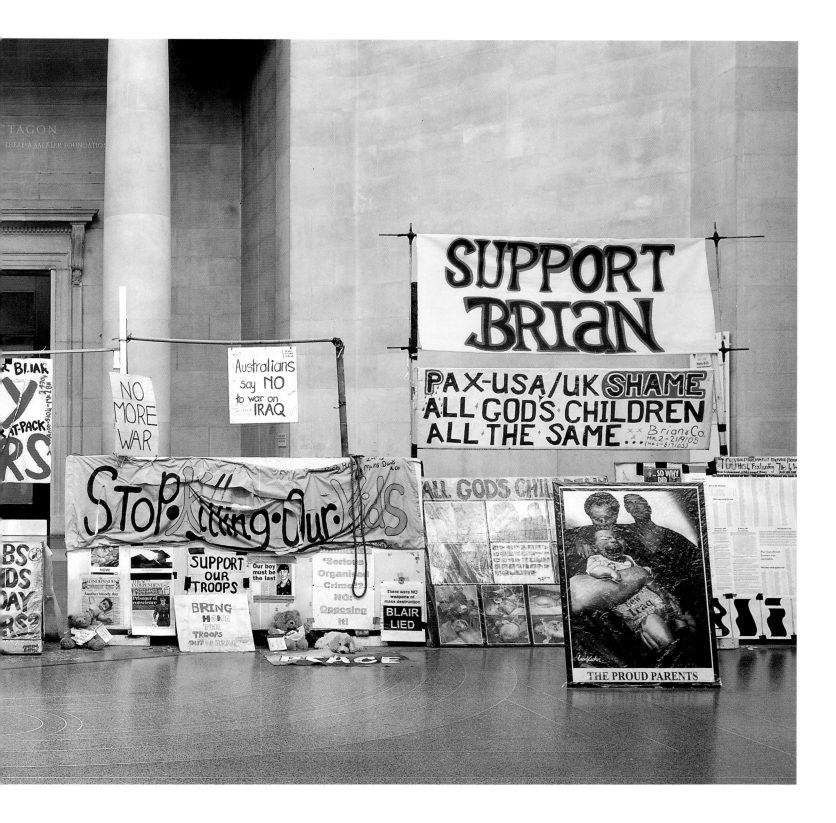

'The face of every one / That passes by me is a mystery.' So the poet William Wordsworth concluded as he strolled through London in the early 1790s, when suddenly he came upon a blind beggar 'propped against a wall'. 'Upon his chest', the poet later remembered, the beggar was 'Wearing a written paper, to explain / His story, whence he came, and who he was.' Wordsworth never reveals what that paper said, only that at the sight of it his 'mind turned round / As with the might of waters', as if he had been 'admonished from another world'.

Two hundred years after Wordsworth's encounter, British artist Gillian Wearing likewise found herself moved by the eloquent indecipherability of every countenance that drifted by her. Determined to thaw into language this glacial flow of inscrutable silence pushing past us everyday, Wearing began to stop strangers on the street and invite them to write down on blank cards statements summarizing their thoughts, which she would then photograph them holding. The result was a series of some fifty stills of ostensibly astonishing honesty, like a deck of playing cards of private suffering. A uniformed police officer gingerly holds up a single word with which he has filled the entire card: 'HELP'. A girl with a wry smirk and hair slipping from behind her ear has scrawled, 'MY GRIP ON LIFE IS RATHER LOOSE!' A man whose face has been half-eclipsed by a serpentine tattoo lifts a card that reads, 'I HAVE BEEN CERTIFIED AS MILDLY INSANE!'

For many, it was the tension between the unexpected emotional candour of the written pleas that Wearing managed to elicit and the non-verbal information communicated by the participants' appearances that was most striking, particularly as in the best-known photograph of the series, which features a seemingly well-heeled young businessman whose card incongruously admits, 'I'M DESPERATE'. Wearing's series pre-dated by nearly a decade such engines of public confession as the television series Big Brother (which began in 2000) and social media sites such as MySpace and Facebook, which were launched a few years after that. Many may feel in retrospect that *Signs that say what you want them to say and not Signs that say what someone else wants you to say* was itself a cultural signpost pointing to the as yet undiscovered territory of ceaseless self-exposure and eroded privacy whose unmapped outskirts we're only now stumbling through blindly.

Gillian Wearing, **I'M DESPERATE**, from the series **Signs that say what you want them to say and not Signs that say what someone else wants you to say**, 1992–93. Framed C-print, 133 × 93 cm (52⅜ × 36⅝ in.)

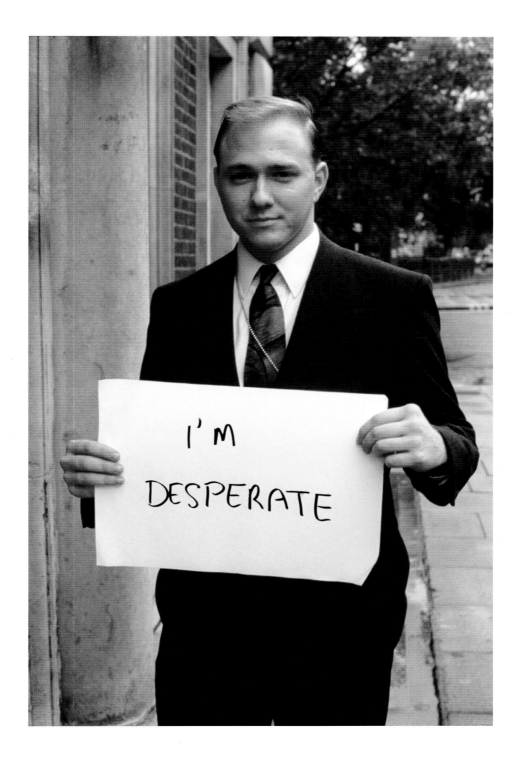

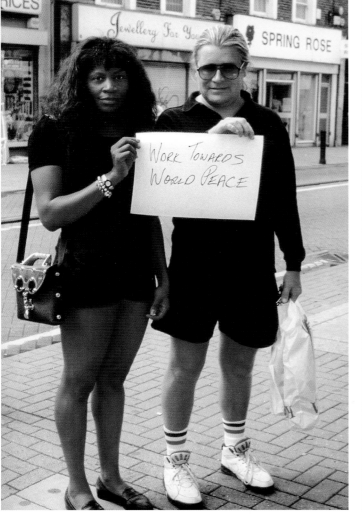

Gillian Wearing, works from the series
**Signs that say what you want them
to say and not Signs that say what
someone else wants you to say**, 1992–93.
Framed C-prints, each 133 × 93 cm
(52⅛ × 36⅝ in.)

Above left: **WORK TOWARDS WORLD PEACE**
Above right: **EVERYTHING IS CONNECTED
IN LIFE THE POINT IS TO KNOW IT AND TO
UNDERSTAND IT**
Opposite: **I HAVE BEEN CERTIFIED AS
MILDLY INSANE!**

The word 'library' is thought to derive from a prehistoric Eurasian root, *leub(h)*, meaning 'to strip or peel'. A memorial library, therefore, such as British artist Rachel Whiteread's 2000 monument in honour of Austrian victims of the Holocaust, is a work that peels away at memory, strips it bare. Exposing the hidden foundations of consciousness has been Whiteread's unique project since she first came to prominence in 1990 with her work *Ghost*. By creating a plaster cast of the interior of a room in north London, Whiteread engineered a kind of instant fossil of contemporary existence, as though the air inside the room had suddenly turned to stone, suspending in the solidified space not only every architectural contour that once defined the interior but also every incidental human vestige as well: the dent in the wall where a plate may have smashed; nicks in the skirting board where a Zimmer frame lost its way; notches in the doorjamb where a child measured her height year after year. All these were preserved in the conscience of the plaster moulds that Whiteread peeled away from the room's shell. The result is a space pulled inside out – a petrified negative of lived emptiness.

In 1993 Whiteread became the first woman to be awarded the Turner Prize for an ambitious expansion of her technique entitled *House*, which took the form of a concrete cast of an entire Victorian terraced home. Following her Turner triumph, the artist was invited, along with a small group of other leading contemporary artists, to submit a proposal for a large-scale memorial to feature permanently in Vienna's Judenplatz, the centre of Viennese Jewish life in the Middle Ages. Unanimously selected by the commission's judges, Whiteread's design once again hinged on the transformation of immaterial space – and the loss it symbolizes – into something unsettlingly palpable, hard, permanent. But when it came to commemorating the 65,000 Austrian Jews who perished in Nazi camps, the artist had no extant structures into which her cement medium could be poured and subsequently peeled away. This absence was absolute. Whiteread's solution was to fabricate an interior of a library, close in scale to rooms in houses adjacent to the square, in celebration of Jewish identity and their designation as 'People of the Book'. She then took casts from that artificial space in the manner of her earlier practice in *Ghost* and *House*.

But with *The Nameless Library*, something significant changed. Rather than preserving in the wet memory of the memorial's cement the spines of books facing outward, as one might expect, thus allowing visitors to see the titles and authors of the volumes, the monument fossilizes instead the edges of closed covers and pages, as though we were facing the books from inside the library's walls. The result is a haunting, hulking work that not only shuts the observer out of its sealed sepulchral space but also eerily situates the outside world in a kind of imagined hiding, pinched between shelf and wall, mirroring the physical concealment of self into which many Jews were forced. Widely celebrated, Whiteread's monument also provoked protest from those who were unable to confront the horrors laid bare by this gentle peeling away of historical memory.

Opposite: Rachel Whiteread, **The Nameless Library, Holocaust Memorial**, 2000. Permanent installation at the Judenplatz, Vienna. Concrete, 3.90 × 7.52 × 10.58 m (12 ft 9½ in. × 24 ft 8 in. × 34 ft 8½ in.)

Right: Rachel Whiteread, **Ghost**, 1990

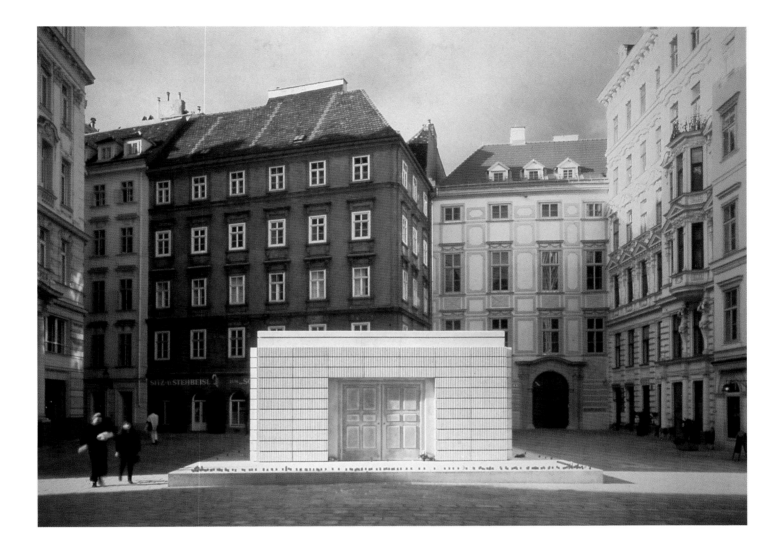

Since its adoption by modernist writers and artists in the 1930s, the mantra 'Make it new' has focused the efforts of every generation of the avant-garde. The 'it' to which the command refers is, of course, 'the old': tradition, cliché, the fatigued conventions of worn-out genres. For an artist such as Chinese filmmaker Yang Fudong, whose lyrical works at once absorb and resist his country's swift industrialization in recent decades on the one hand, and China's insistence on preserving ancient custom on the other, the aesthetic challenge to make it new is fraught with risks.

The risks are poetically negotiated, however, in Yang's five-part epic film, *Seven Intellectuals in a Bamboo Forest*, which reinvents the classic tale of the Seven Sages of the Bamboo Grove – a story that has inspired countless depictions by Chinese artists since the third century. In the traditional tale, a group of scholars and poets retreat from the tiresome politics, corruption and social squabbles that characterized the transition from the Wei to Jin dynasties, to a place of simpler and more profound philosophical and sensual stimulation. Through Yang's dreamlike lens, these seven sages have been recast as chichi youths – five men and two women, ostentatiously styled in bespoke vintage tweeds and faux-intellectual spectacles – who traipse incongruously through a mystical landscape. To the ears of some reviewers, their pretentious meditations on the nature of being, as ventriloquized by Yang, felt a little too contrived. For others, his mesmerizing cinematography, everywhere aware of its reworking of a venerable visual fable, lifted the experience into something spiritual: a work that feels neither dated nor faddish.

The five 'chapters' comprising Yang's adaptation of the traditional tale follow the wandering youths as they drift from craggy mountain ascents to rugged seasides, and eventually back into the dreary hubbub of the urban world from which they had initially sought an escape. An oil painter by training, Yang took a circuitous and unexpected journey to digital filmmaking, an interest he developed in the off hours during a stint designing video games in Shanghai. This unique background may offer a clue to the logic of Yang's work. Screened simultaneously in adjoining chambers when the cycle debuted in its entirety at the Venice Biennale in 2007, the five films and their surreal meanderings begin to resemble levels of an existential game through which the trapped actors are desperate to progress and win their freedom. The work has been seen as an allegory of the uncertain role of thinkers, artists and spiritualists in an increasingly utilitarian society, but the visionary power of the work's hypnotic grey tones, the anachronistic dress and ceaseless shuttle between eras resists tethering it to any one place or time. As such, *Seven Intellectuals in a Bamboo Forest* manages to make 'Make it new' new.

Yang Fudong, film stills from **Seven Intellectuals in a Bamboo Forest Part 2** (46 minutes, 15 seconds), 2004, and **Seven Intellectuals in a Bamboo Forest Part 3** (53 minutes), 2006. 35 mm black-and-white film transferred on DVD

Above: Yang Fudong, film stills from
**Seven Intellectuals in a Bamboo Forest
Part 5** (90 minutes), 2007, and **Seven
Intellectuals in a Bamboo Forest Part 4**
(79 minutes), 2007

Above right: Yang Fudong, film still from
**Seven Intellectuals in a Bamboo Forest
Part 1** (29 minutes, 32 seconds), 2003

Art, no less than life, maps its existence through a mystery of bloodlines. Mark Alexander's *The Blacker Gachet* (2005–6), explored near the beginning of this book, traces its dim countenance in the aesthetic DNA of its forebear (Van Gogh's portrait of his physician Dr Paul-Ferdinand Gachet) with the same genealogical urgency that the chiaroscuro of Caravaggio traces its posterity in the sculpted darkness and shovelled light of Sean Scully's *Doric* series (2008–).
The word 'bloodline' first appears in the seventeenth century and has come to mean 'a line of descent by birth or heredity; an individual forming part of this, a lineal antecedent or descendant.' The line, in other words, is woven into the blood such that the individual ('antecedent or descendant') is understood synecdochically to constitute the entire lineage: Alexander's and Scully's works are at once distinct from, and embodiments of, a forensic inheritance, a tradition, a bloodline.

Chinese painter Zhang Xiaogang considers these complexities of personal identity, cultural inheritance and assimilation to be of utter urgency. During the Chinese Cultural Revolution of the 1960s and 1970s, formative years in the development of the artist's imagination, forfeiting individual identity to the collective of Chinese civilization, past and present, was instilled in social consciousness. The unanimated faces of countless black-and-white family portraits were symptomatic of this emphasis on collectivity and etched themselves deeply into the young artist's mind. In the series known as *Bloodlines: Big Family*, Zhang exposes the absurdity of this enforced erasure of personality. His paintings, based on these impassive portraits, chip away at the façade of self-annulling oneness and conformity. The works initially appear to capture a vacant inscrutability from the docile sitters, faithful to the original photographs, but upon closer inspection one begins to detect an irrepressible strangeness in the waxen cheeks and evacuated eyes – a sense of vulnerability percolating below their deceptive veneer.

Heightening the viewer's suspicion that these are not so much faithful portraits of the living but slowly evaporating masks is the frequent and unsettling shading in red or yellow of one or more of the faces, as though something spiritually inextinguishable smoulders beneath. Some see gloaming under the surface of Zhang's portraits an inheritance of mingled Surrealism and ancient symbolism. Others point to Picasso. In art, as in life, paternity can be difficult to prove. Given the extraordinary economic, political and artistic convulsions the Chinese imagination has witnessed over the course of the recent era, where *Bloodlines*' bloodline will lead is anyone's guess.

Zhang Xiaogang, **Bloodlines: A Big Family**, from the series **Bloodlines: Big Family**, 1995. Oil on canvas, 1.79 × 2.29 m (5 ft 10½ in. × 7 ft 6⅛ in.)

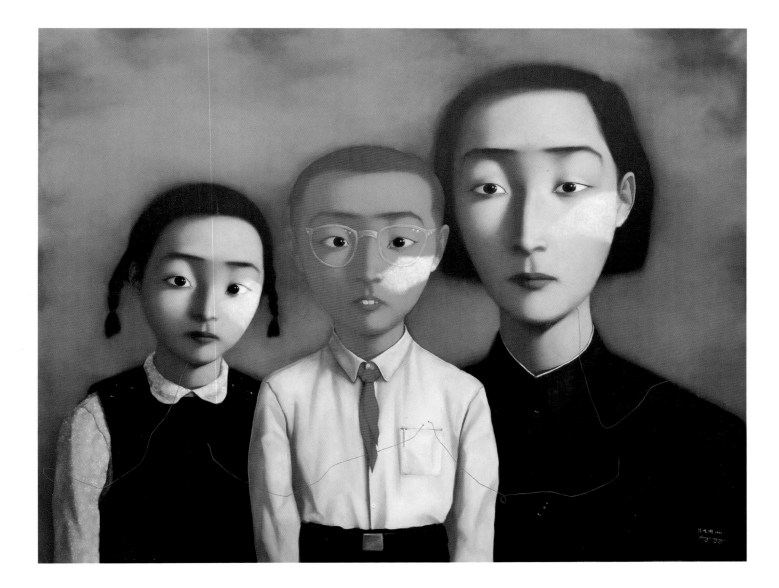

In 1817, the English poet John Keats formulated an artistic ideal he called 'negative capability'. In Keats's view, an artist should aim to chronicle life's contradictions, not reconcile them – to focus a lens on the world in all its unruliness without attempting to varnish or explain it away. Great artists, he believed, were 'chameleons' who possessed 'no identity'. Nearly two centuries later, one wonders how Keats might have responded to the achievement of Polish filmmaker Artur Żmijewski, whose 2009 collage of short films, *Democracies*, in many ways aspires to the Romantic poet's high ideal. A collection of twenty-three documentaries that capture social gatherings across the globe (from Germany to Palestine, Northern Ireland to Poland), the work is a restless witness to a startling range of congregational behaviour, from sombrous to celebratory, indignant to enraged.

Though the occasions for the assemblies that Żmijewski filmed varied – they include political protests, sectarian gatherings, funerals, Women's Day rallies, Labour Day parades, and post-football-match festivities – they share the ubiquitous presence of the artist's camera as it records the unpredictable unfolding of live events. Unlike journalistic newsreel footage, no reporter interpreted this coverage for the viewing audience. When the films were exhibited in 2009 at the DAAD Galerie in Berlin, separate screens were hung like canvases around a long gallery space as the documentaries competed with each other at full volume. The result was a riot of unsynchronized vitriol and jubilation, anger and mourning, chanting and cheers, as each event clamoured for the visitor's attention. For some critics the work raised provocative issues of surveillance, Big Brotherism and the consumption of news as entertainment, for others it opened apertures onto how communities spontaneously choreograph spectacle. Spinning from screen to screen, the observer's eye began to approximate the swing of the cameraman's zoom and, for a moment, the visitor felt a kind of omniscient catalyst of upheaval and emotion.

Whether the filmmaker realizes in *Democracies* the artistic ideal of invisibility, the negative capability of a chameleon, is a matter of debate. Reviewing the work for *Frieze* magazine, the writer Daniel Miller described the artist's gaze as at once 'distanced' yet 'occasionally passive-aggressive', noting that while Żmijewski never engaged in direct dialogue with those attending a loyalist festival in Belfast, the interposition of his camera nevertheless triggered a response. The irresolvable dilemma of whether art can ever neutrally depict a world without distorting that depiction calls to mind the assertion of another poet, William Butler Yeats, who could well have been describing the influence of Żmijewski's eye on all that his camera captures: 'O body swayed to music, O brightening glance, / How can we know the dancer from the dance?'

Artur Żmijewski, video stills from
Democracies, 2009. Colour video with
sound on 20 flat screens or 1 projection,
2 hours, 26 minutes

Artist Biographies & Selected Sources

The biographical information given below includes selected sources consulted by the author, as well as suggestions for further reading. Sources for the quotations that appear in the introduction and on the book's feature pages are given at the end of this section.

General Sources

Daniel Birnbaum, Cornelia H. Butler and Suzanne Cotter, *Defining Contemporary Art: 25 Years in 200 Pivotal Artworks* (London, 2011)
Charlotte Bonham Carter and David Hodge, *The Contemporary Art Book* (London, 2011)
Brad Finger and Christiane Weidemann, *50 Contemporary Artists You Should Know*, (Munich, 2011)
Hans Werner Holzwarth, *100 Contemporary Artists* (Cologne, 2009)
Terry Smith, *Contemporary Art: World Currents* (London, 2011)
–, *What Is Contemporary Art?* (Chicago, 2009)
Julian Stallabrass, *Contemporary Art: A Very Short Introduction* (Oxford, 2006)

Marina Abramović

Born 1946 in Belgrade, Yugoslavia; lives and works in New York. Studied at Academy of Fine Arts, Belgrade; Academy of Fine Arts, Zagreb. Represented by Sean Kelly, New York; Lisson Gallery, London.
'Chronicling the bleakness of a brutal era', Geraldine Norman, *The Independent*, 24 April 1995, Home, p. 4
Marina Abramović: The Artist is Present, Marina Abramović, Klaus Biesenbach, Arthur Danto and Chrissie Iles (New York, 2010)
Portraits in the Presence of Marina Abramović, Marina Abramović, Marco Anelli, Klaus Biesenbach and Chrissie Iles (New York, 2012)

Ai Weiwei

Born 1957 in Beijing, China; lives and works there. Studied at Beijing Film Academy; Parsons School of Design, New York. Represented by Lisson Gallery, London. www.aiweiwei.com
Ai Weiwei: Sunflower Seeds, Ai Weiwei (London, 2010)
Ai Weiwei's Blog: Writings, Interviews, and Digital Rants, 2006–2009, Ai Weiwei and Lee Ambrozy (Cambridge, Massachusetts, 2011)
Ai Weiwei Speaks, Hans Ulrich Obrist (London, 2011)

Doug Aitken

Born 1968 in Redondo Beach, California, USA; lives and works in Los Angeles and New York. Studied at Art Center College of Design, Pasadena; Marymount College, Palos Verdes. Represented by Regen Projects, Los Angeles; Victoria Miro, London; Galerie Eva Presenhuber, Zurich; 303 Gallery, New York. www.dougaitkenworkshop.com
'We all have our own creative voice – my work celebrates that', Laura Davis, *Liverpool Post*, 13 September 2012, *Culture* magazine, pp. 2–3
'Countenance over consonants', Kelly Grovier, *Times Literary Supplement*, 19 October 2012, p. 19 [My review of the work from which the present entry derives.]

Mark Alexander

Born 1966 in Horsham, UK. Studied at Ruskin School of Drawing and Fine Art, Oxford University. www.markalexanderart.com
Mark Alexander: The Bigger Victory, Ethan Wagner (London, 2005)
'Lives of the artist: An interview with Mark Alexander', *Areté* 17, (spring/summer 2005)

Francis Alÿs

Born 1959 in Antwerp, Belgium; lives and works in Mexico City. Studied at Institut Supérieur d'Architecture Saint-Luc, Tournai; Istituto Universitario di Architettura, Venice. Represented by David Zwirner, New York; Galerie Peter Kilchmann, Zurich. www.francisalys.com
'Francis Alÿs: Fabiola', Lynne Cooke, LACMA online: www.lacma.org/essay-lynne-cooke
Francis Alÿs: Fabiola: An Investigation, Stephen Bann, Martha Buskirk, Lynne Cooke and David Morgan (New York, 2008)
'On Postcards and Even in Rice, Portraits of a Beloved Saint', Roberta Smith, *New York Times*, 5 January 2008, section B, p. 7
'A gem of a one-woman show', Laura Cumming, *The Guardian*, 3 May 2009, p. 17

Janine Antoni

Born 1964 in Freeport, Bahamas; lives and works in New York. Studied at Sarah Lawrence College, New York; Rhode Island School of Design, Providence. Represented by Luhring Augustine, New York.
'A sculptor's gnawing suspicions', Rowan Gaither, *New York Magazine*, 9 March 1992, p. 24
'Women's work (or is it art?) is never done', Kay Larson, *New York Times*, 7 January 1996, section 2, p. 35
Janine Antoni, Christina Bechtler, Amy Cappellazzo, Ewa Lajer-Burcharth and Marina Warner (New York, 2000)
The Girl Made of Butter, Janine Antoni and Harry Philbrick (Ridgefield, Conn., 2001)

Miroslaw Balka

Born 1958 in Otwock, Poland; lives and works in Warsaw. Studied at Academy of Fine Arts, Warsaw. Represented by Dvir Gallery, Tel Aviv; Galeria Juana de Aizpuru, Madrid; Galerie Nordenhake, Berlin; Gladstone Gallery, New York; Raffaella Cortese Gallery, Milan; White Cube, London. www.miroslaw-balka.com
Door into the Dark, Seamus Heaney (New York, 1969)
Miroslaw Balka: How it is, Miroslaw Balka, Zygmunt Bauman, Paulo Herkenhoff, Julian Heynen, László Krasznahorkai (London, 2009)
'Gallery visitors invited into "black hole"', Vicky Shaw, *The Independent*, 12 October 2009
'Miroslaw Balka at the Turbine Hall: at the edge of darkness', Adrian Searle, *The Guardian*, 12 October 2009

Banksy

Born 1974 in Bristol, UK. www.banksy.co.uk
Wall and Piece, Banksy (London, 2007)

Matthew Barney

Born 1967 in San Francisco, USA; lives and works in New York. Studied at Yale University, New Haven. Represented by Gladstone Gallery, New York. www.cremaster.net
'Matthew Barney's surreal visions, on film and in the gallery', Michael Kimmelman, *New York Times*, 28 April 1995, p. 34
Matthew Barney: The Cremaster Cycle, Matthew Barney, Nancy Spector and Neville Wakefield (New York, 2002)
'Dream Weaver', Patricia C. Johnson, *Houston Chronicle*, 24 August 2003, p. 8

Christian Boltanski

Born 1944 in Paris, France; lives and works in Malakoff, France. Self-taught. Represented by Marian Goodman Gallery, New York.
The Possible Life of Christian Boltanski, Christian Boltanski and Catherine Grenier (Boston, 2009)
'It's a jumble out there', Adrian Searle, *The Guardian*, 14 January 2010, p. 22
'A monument to everyone and no one: With piles of old clothes', Laura Cumming, *The Observer*, 17 January 2010, p. 17
'Exploring Mortality With Lots of Clothes and a Claw', Dorothy Spears, *New York Times*, 10 May 2010, section C, p. 1

Monica Bonvicini

Born 1965 in Venice, Italy; lives and works in Berlin. Studied at Hochschule der Künste, Berlin; California Institute of Arts, Valencia. Represented by Galeria Emi Fontana, Milan; West of Rome, Los Angeles.
'Blushing While You're Flushing, and All for Art's Sake', Sarah Lyall, *New York Times*, 23 December 2003, section A, p. 4
Transgender Migrations: The Bodies, Borders, and Politics of Transition, Trystan T. Cotton (New York, 2011)

Louise Bourgeois

Born 1911 in Paris, France; died 2010 in New York. Studied at Sorbonne, Paris; École Nationale Supérieure des Beaux-Arts, Paris.
'Mr Edwards and the Spider' in *Lord Weary's Castle*, Robert Lowell (New York, 1946), p. 64
Louise Bourgeois, Louise Bourgeois, Paulo Herkenhoff and Robert Storr (London, 2003)
Louise Bourgeois, Louise Bourgeois, Paulo Herkenhoff and Frances Morris (New York, 2008)
'Giant steel-and-marble spider makes return to Tate Modern', Arifa Akbar, *The Independent*, 12 January 2008, p. 12

Glenn Brown

Born 1966 in Hexham, UK; lives and works in London. Studied at Norwich School of Art; Bath College of Higher Education; Goldsmiths College, London. Represented by Gagosian Gallery, New York/London; Patrick Painter Gallery, Los Angeles; Galerie Max Hetzler, Berlin.
'Dawn of the dead: Glenn Brown's elusive, macabre new work is his best yet – and could be the future of painting', Jonathan Jones, *The Guardian*, 16 September 2004, p. 14
Glenn Brown, Francesco Bonami, Christoph Grunenberg, Lawrence Sillars and Michael Stubbs (London, 2009)
'A conversation between Glenn Brown and Mardee Goff', Mardee Goff, 7 June 2012: www.courtauld.ac.uk/macuratingexhibition/2012/essays/documents/Glenn%20Brown%20interviewed%20by%20Mardee%20Goff.pdf

Chris Burden

Born 1946 in Boston, USA; lives and works in Los Angeles. Studied at Pomona College, Claremont, California; University of California, Irvine. Represented by Gagosian Gallery, New York.
Chris Burden, John Berger, Chris Burden, Fred Hoffman and Paul Schimmel (London, 2005)
'An Artist's Vision: Building With Toys, But on a Grand Scale', Randy Kennedy, *New York Times*, 8 June 2008, section A, p. 37

Daniel Buren

Born 1938 in Boulogne-Billancourt, France; lives and works in situ. Studied at École Nationale Supérieure d'Arts et Métiers, Paris. Represented by Lisson Gallery, London. www.danielburen.com
'Pillars of the law in Paris', Campbell Page, *The Guardian*, 7 May 1986
Daniel Buren: Interventions II, Suzanne Cotter (Oxford, 2006)
The Museum That Did Not Exist, Daniel Buren (New York, 2011)

Sophie Calle

Born 1953 in Paris, France; lives and works there. Self-taught. Represented by Paula Cooper Gallery, New York.
Sophie Calle: Take Care of Yourself, Sophie Calle (Arles, 2007)
'A Woman Scorned Turns Rejection Into an Art Form', Blake Gopnik, *Washington Post*, 13 June 2007, p. C1
'Sophie Calle', Louise Neri, *Interview*, 24 March 2009: www.interviewmagazine.com/art/sophie-calle#_
'She's lost control', Fisun Güner, *New Statesman*, 2 November 2009, p. 44

Patrick Cariou

Born 1963 in Lorient, France. Self-taught.
Yes Rasta, Patrick Cariou and Perry Henzell (New York, 2000)
Canal Zone Richard Prince YES RASTA: Selected Court Documents from Cariou v. Prince et al, Greg Allen, Hollis Gonerka Bart, Steven M. Hayes and Richard Prince (Washington, DC, 2011)
'Appeal may proceed in copyright case', Randy Kennedy, *New York Times*, 16 September 2011, Section C, p. 2
'Apropos appropriation', Randy Kennedy, *New York Times*, 1 January 2012, Section AR, p. 1

Maurizio Cattelan

Born 1960 in Padua, Italy; lives and works in New York and Milan. Self-taught. Represented by Emmanuel Perrotin, Paris; Massimo de Carlo, Milan; Marian Goodman Gallery, New York.
Maurizio Cattelan, Francesco Bonami, Massimiliano Gioni, Nancy Spector and Barbara Vanderlinden (London, 2003)
Maurizio Cattelan: All, Nancy Spector and Maurizio Cattelan (New York, 2011)

Jake and Dinos Chapman

Dinos Chapman: Born 1962 in London; lives and works there. Studied at Ravensbourne College of Art, London; Royal College of Art, London. Jake Chapman: Born 1966 in Cheltenham, UK; lives and works in London. Studied at North East London Polytechnic; Royal College of Art, London. Represented by White Cube, London. www.jakeanddinoschapman.com
Insult to Injury, Balthasar Burkhard, Jake Chapman and Dinos Chapman (London, 2003)
Jake and Dinos Chapman: Bad Art for Bad People, Tanya Barson, Christoph Grunberg, Chris Turner and Clarrie Wallis (Liverpool, 2006)
Flogging a Dead Horse: The Life and Works of Jake and Dinos Chapman, Dinos Chapman, Jake Chapman and Nick Hackworth (New York, 2011)

Christo and Jeanne-Claude

Christo: Born 1935 in Gabrovo, Bulgaria; lives and works in New York. Studied at Fine Arts Academy, Sofia. Jeanne-Claude: Born 1935 in Casablanca, Morocco; died 2009 in New York. Studied at University of Tunis. www.christojeanneclaude.net
Christo and Jeanne-Claude: Through the Gates and Beyond, Jan Greenberg and Sandra Jordan (New York, 2008)
Christo and Jeanne-Claude, Christo and Jeanne-Claude, Paul Goldberger and Wolfgang Volz (London, 2010)

Chuck Close

Born 1940 in Monroe, Washington, USA; lives and works in New York. Studied at University of Washington School of Art, Seattle; Yale University School of Art and Architecture.

Represented by Pace Gallery, New York. www.chuckclose.com
Chuck Close, Chuck Close, Robert Storr, Kirk Varnedoe and Deborah Wye (New York, 1998)
Chuck Close: Work, Christopher Finch (New York, 2010)
'Close encounters', Jada Yuan, *Sunday Telegraph*, 9 December 2012, Features, p. 36 ff.

Martin Creed

Born 1968 in Wakefield, UK; lives and works in London. Studied at The Slade School of Fine Art, London. Represented by Hauser & Wirth, London, and Gavin Brown's Enterprise, New York. www.martincreed.com
Martin Creed: Works, Martin Creed (New York, 2010)
Martin Creed, Briony Fer (Vancouver, 2011)

John Currin

Born 1962 in Boulder, Colorado, USA; lives and works in New York. Studied at Carnegie Mellon University, Pittsburgh; Yale University, New Haven. Represented by Gagosian Gallery, New York.
John Currin, Staci Boris, John Currin, Robert Rosenblum and Rochelle Steiner (Chicago, 2003)
Painting People: Figure Painting Today, Charlotte Mullins (New York, 2006)
John Currin, Angus Cook, John Currin, Kara Vander Weg and Tower Wells (New York, 2011)

Jeremy Deller and Alan Kane

Jeremy Deller: Born 1966 in London, UK; lives and works there. Studied at Courtauld Institute of Art, London; University of Sussex, Brighton. Alan Kane: Born 1961 in Nottingham, UK; lives and works in London. www.jeremydeller.org, www.britishcouncil.org/arts-aad-folk-archive.htm
'Jonathan Jones on an unfashionable national treasure', Jonathan Jones, *The Guardian*, 28 June 2000, Features, p. 12
'It's not art – it's pants', Richard Dorment, *Daily Telegraph*, 18 May 2005, Features, p. 20
'There's nowt as queer as folk', Charles Darwent, *Independent on Sunday*, 22 May 2005, Feature, p. 13
'Gurning and embroidered knickers', Rachel Withers, *New Statesman*, 23 May 2005
'Folk Archive', Tom Morton, *Frieze* 93 (September 2005)
Folk Archive: Contemporary Popular Art from the UK, Jeremy Deller and Alan Kane (London, 2006)

Peter Doig

Born 1959 in Edinburgh, UK; lives and works in Port of Spain, Trinidad. Studied at Wimbledon School of Art, London; St Martin's School of Art, London; Chelsea School of Art, London. Represented by Michael Werner, New York.
Peter Doig, Catherine Grenier, Kitty Scott, Adrian Searle and Hannes Schneider (London, 2007)

'The Interview: Peter Doig', Tim Adams, *The Observer*, 27 January 2008, Review, p. 8
Peter Doig, Peter Doig, Catherine Lampert and Richard Shiff (New York, 2011)

Stan Douglas

Born 1960 in Vancouver, Canada; lives and works there. Studied at Emily Carr University of Art and Design, Vancouver. Represented by David Zwirner, New York; Victoria Miro, London.
Stan Douglas, Carol J. Clover, Diana Thater and Scott Watson (London, 1998)
'Play it again, Stan', Blake Gopnik, *Globe and Mail*, 2 October 1999, section C, p. 8
Double Vision: Stan Douglas and Douglas Gordon, Lynne Cooke and Karen Kelly (New York, 2000)
'Win, Place, or Show', Tanya Barson, Tate.org.uk, February 2001: www.tate.org.uk/art/artworks/douglas-win-place-or-show-t07700/text-summary

Marlene Dumas

Born 1953 in Cape Town, South Africa; lives and works in Amsterdam. Studied at University of Cape Town. Represented by David Zwirner, New York and London; Galerie Paul Andriesse, Amsterdam; Zeno X Gallery, Antwerp; Frith Street Gallery, London; Gallery Koyanagi, Tokyo. www.marlenedumas.nl
'Mending Wall' in *North of Boston*, Robert Frost (New York, 1914), pp. 11–13
Marlene Dumas, Dominic Van Den Boogerd, Barbara Bloom and Mariuccia Casadio (London, 2009)
Marlene Dumas: Against the Wall, Marlene Dumas (New York, 2010)

Olafur Eliasson

Born 1967 in Copenhagen, Denmark; lives and works in Berlin. Studied at Royal Danish Academy of Fine Arts, Copenhagen. Represented by neugerriemschneider, Berlin; Tanya Bonakdar Gallery, New York. www.olafureliasson.net
Olafur Eliasson: The Weather Project, Susan May (London, 2003)
'Secret diary of an art gallery attendant', Adrian Hardwicke, *The Guardian*, 18 March 2004, p. 10
'Olafur Eliasson', Chris Gilbert, *BOMB* 88 (Summer 2004)
'Don't just stand there: feel it', John McDonald, *Sydney Morning Herald*, 13 February 2010, Features, p. 14

Elmgreen & Dragset

Michael Elmgreen: Born 1961 in Copenhagen, Denmark; lives and works in Berlin and London. Self-taught. Ingar Dragset: Born 1969 in Trondheim, Norway; lives and works in Berlin and London. Studied at École Internationale de Théâtre Jacques Lecoq, Paris. Represented by Galerie Emmanuel Perrotin, Paris; Victoria Miro Gallery, London; Galleri Nicolai Wallner, Copenhagen.
'Cultural desert', Charlotte Cripps, *The Independent*, 30 January 2006, p. 39

Elmgreen and Dragset: Prada Marfa, Dominic Molon and Ronald Rael (New York, 2007)

Tracey Emin

Born 1963 in London, UK; lives and works there. Studied at Maidstone College of Art, Surrey; Royal College of Art, London. Represented by White Cube, London; Lehmann Maupin, New York.
'You've made your bed', Matthew Collings, *The Observer*, 24 October 1999, Review, p. 5
The Art of Tracey Emin, Tracey Emin, Mandy Merck and Chris Townsend (New York, 2002)
Tracey Emin, Neal Brown (London, 2006)
'Tracey was here', Jonathan Jones, *The Guardian*, 5 August 2008, Features, p. 23

Lucian Freud

Born 1922 in Berlin, Germany; died 2011 in London. Studied at Central School of Art, London; East Anglian School of Painting and Drawing, Dedham; Goldsmiths College, London.
Lucian Freud, William Feaver (London, 2002)
Lucian Freud, Martin Gayford, Catherine Lampert and Frank Paul (Dublin, 2007)
Man with a Blue Scarf: On Sitting for a Portrait by Lucian Freud, Martin Gayford (London, 2010)
Lucian Freud: Painting People, Martin Gayford, David Hockney and Sarah Howgate (London, 2012)

Nan Goldin

Born 1953 in Washington, DC, USA; lives and works in Paris and New York. Studied at School of the Museum of Fine Arts at Tufts University, Boston. Represented by Matthew Marks Gallery, New York.
Nan Goldin: The Other Side, Nan Goldin (New York, 2000)

Felix Gonzalez-Torres

Born 1957 in Guáimaro, Cuba; died 1996 in Miami, USA. Studied at Whitney Museum Independent Study Program, New York; Pratt Institute, New York; International Center of Photography, New York University. www.felixgonzalez-torresfoundation.org
Felix Gonzalez-Torres, Dietmar Elger (Ostfildern, 1997)

Antony Gormley

Born 1950 in London, UK; lives and works there. Studied at Trinity College, University of Cambridge; St Martins School of Art, London; Goldsmiths College, London; The Slade School of Fine Art, London. Represented by White Cube, London. www.antonygormley.com
Making an Angel: Antony Gormley, Stephanie Brown and Iain Sinclair (London, 2002)
Antony Gormley, Richard Noble (Göttingen, 2007)
Antony Gormley, Martin Caiger-Smith (London, 2010)

Sheela Gowda

Born 1957 in Bhadravati, India; lives and works in Bangalore. Studied at Ken School of Art, Bangalore; M.S. University, Baroda, India; Visva-Bharati University, Santiniketan, India.

Sheela Gowda, Sheela Gowda and Trevor Smith (New York, 2007)
'Welcome to my world', Ed Potton, *The Times*, 3 January 2009, pp. 26–29

Subodh Gupta

Born 1964 in Khagaul, Bihar, India; lives and works in New Delhi. Studied at College of Arts and Crafts, Patna, India. Represented by Hauser & Wirth, London/Zurich/New York; Arario Gallery, Beijing.
'Mushrooming art: Subodh's Line Of Control gets a capital display', Georgina Maddox, *Mail Online*, 21 April 2012
'What's cooking: Empty pots & pans drip food for thought', *Times of India*, 22 April 2012

Andreas Gursky

Born 1955 in Leipzig, Germany; lives and works in Düsseldorf. Studied at Folkwangschule (GHS), Essen, Germany; Kunstakademie Düsseldorf. Represented by White Cube, London, and Matthew Marks Gallery, New York.
'At work or play we are all the same', Richard Cork, *The Times*, 2 February 1999
Andreas Gursky: Photographs from 1984 to the Present, Lynne Cooke (New York, 2001)
'Stun-Gun Reality, Magnificent In Its Artifice', Michael Kimmelman, *New York Times*, 2 March 2001, section E, p. 33
Another Future: Poetry and Art in a Postmodern Twilight, Alan Gilbert (Middletown, Connecticut, 2006)

Marcus Harvey

Born 1963 in Leeds, UK; lives and works in London. Studied at Leeds College of Art; Goldsmiths College, London.
'Art That Tweaks British Propriety', Sarah Lyall, *New York Times*, 20 September 1997, section B, p. 7
'Hindley art damage extensive', Dan Glaister, *The Guardian*, 20 September 1997, p. 13

Mona Hatoum

Born 1952 in Beirut, Lebanon; lives and works in London and Berlin. Studied at Beirut University College; The Byam Shaw School of Art, London; The Slade School of Fine Art, London. Represented by White Cube, London.
'Inner space terrors', William Feaver, *The Observer*, 16 May 1993, p. 60
'Has Mona Hatoum disappeared up her own bottom?', Adrian Searle, *The Guardian*, 14 April 1998, Features, p. 10
'Body of work', E. Jane Dickson, *The Independent*, 1 August 1998, Features, p. 16
Mona Hatoum: The Entire World as a Foreign Land, Mona Hatoum, Edward W. Said and Sheena Wagstaff (London, 2000)

Susan Hiller

Born 1940 in Tallahassee, Florida, USA; lives and works in London and Berlin. Studied at Smith College, Northampton, Massachusetts; Tulane University, New Orleans. Represented by Timothy Taylor Gallery, London. www.susanhiller.org
'Close encounters of the transcendental kind', Tom Lubbock, *The Independent*, 23 May 2000, Features, pp. 12–13.
'Tales of the unexpected', Richard Dorment, *Daily Telegraph*, 12 May 2004, Features, p. 19
Susan Hiller, Ann Gallagher (London, 2011)

Thomas Hirschhorn

Born 1957 in Bern, Switzerland; lives and works in Paris. Studied at Schule für Gestaltung, Zurich. Represented by Gladstone Gallery, New York/Brussels; Stephen Friedman Gallery, London.
'Art That Gives Meaning To Bits of This and That', Michael Rush, *New York Times*, 27 October 2002, Section 2, p. 33
'Thomas Hirschhorn – "Cavemanman"', Michael Kimmelman, *New York Times*, 15 November 2002, Section E, p. 39
Thomas Hirschhorn, Carlos Basualdo, Benjamin H. D. Buchloh and Alison Gingeras (London, 2004)

Damien Hirst

Born 1965 in Bristol, UK; lives and works in Devon and London. Studied at Goldsmiths College, London. Represented by White Cube, London/Hong Kong/São Paulo. www.damienhirst.com
For the Love of God: The Making of the Diamond Skull, Jason Beard, Rudi Fuchs and Damien Hirst (London, 2007)
'For the Love of God', Tom Morton, *Frieze* 109 (September 2007)
Damien Hirst, Ann Gallagher (London, 2012)

David Hockney

Born 1937 in Bradford, UK; lives and works in Bridlington, Yorkshire and London. Studied at Bradford College of Art; Royal College of Art, London. Represented by Annely Juda Fine Art, London; L.A. Louver, Los Angeles; Richard Gray Gallery, Chicago; Salts Mill: The 1853 Gallery, Saltaire, Yorkshire. www.hockneypictures.com
'The bigger picture', Martin Gayford, *Daily Telegraph*, 26 May 2007, Art, p. 1
A Bigger Message: Conversations with David Hockney, Martin Gayford (London, 2011)
David Hockney: A Bigger Picture, Tim Barringer and Edith Devaney (London, 2012)
'Canvassing views', Duncan Macmillan, *The Scotsman*, 15 March 2012, p. 8

Carsten Höller

Born 1961 in Brussels, Belgium; lives and works in Stockholm. Studied at University of Kiel, Germany. Represented by Gagosian Gallery, New York.

Carsten Höller: Test Site, Jessica Morgan (London, 2006)
'Carsten Höller: Interview', Vincent Honoré, Tate.org.uk: www.tate.org.uk/whats-on/tate-modern/exhibition/unilever-series-carsten-holler-test-site/carsten-holler-interview

Jenny Holzer

Born 1950 in Gallipolis, Ohio, USA; lives and works in Hoosick, New York. Studied at Duke University, Durham, North Carolina; University of Chicago; Ohio University, Athens; Rhode Island School of Design, Providence; Independent Study Program, Whitney Museum of American Art, New York. Represented by Cheim & Read, New York; Skarsketdt Gallery, New York/London. www.jennyholzer.com
'Lights, texts, action: Jenny Holzer's art', Iris Moon, *Korea Herald*, 13 December 2004
'The words on the street', Fiona Maddocks, *Evening Standard*, 28 March 2006
'And the word was made flash', Rosemary Sorensen, *The Australian*, 10 December 2009, Features, p. 17
'Projecting the power of words', Bob Keyes, *Portland Press Herald*, 5 December 2010, Audience, p. D1

Cristina Iglesias

Born 1956 in San Sebastián, Spain; lives and works in Madrid. Studied at Chelsea School of Art, London. Represented by Marian Goodman Gallery, New York/Paris. www.cristinaiglesias.com
'A vacuum packed', Rachel Campbell-Johnston, *The Times*, 19 March 2003, p. 13
'Space, the final frontier', Tom Lubbock, *The Independent*, 25 March 2003, Features pp. 14–15
Cristina Iglesias, Cristina Iglesias and Gloria Moure (Barcelona, 2009)

Anish Kapoor

Born 1954 in Bombay, India; lives and works in London. Studied at Hornsey College of Art, London; Chelsea School of Art, London. Represented by Lisson Gallery, London; Gladstone Gallery, New York. www.anishkapoor.com
'Bean to offer another peek', Charles Sheehan, *Chicago Tribune*, 19 August 2005
Anish Kapoor: Past, Present, Future, Nicholas Baume and Anish Kapoor (Boston, 2008)
Anish Kapoor: Flashback, Michael Bracewell, Anish Kapoor and Andrew Renton (London, 2011)

On Kawara

Born 1933 in Kariya, Japan; lives and works in New York. Self-taught. Represented by David Zwirner, New York; Yvon Lambert, Paris.
'It's a date', Adrian Searle, *The Guardian*, 3 December 2002, p. 10
'A day in the life of infinity', Richard Dorment, *Daily Telegraph*, 11 December 2002, p. 23
'A body of work to say his body still works', Julia Dault, *National Post*, 15 December 2005, p. AL10

'Reeling in the years', Jerry Saltz, *New York Magazine*, 9 February 2009

Mike Kelley

Born 1954 in Detroit, USA; died 2012 in South Pasadena, California. Studied at University of Michigan, Ann Arbor; California Institute of the Arts, Valencia.
Foul Perfection: Essays and Criticism, Mike Kelley and John Welchman (Cambridge, Massachusetts, 2003)
'Mike Kelley's toxic-comic carnival', Michael Kimmelman, *International Herald Tribune*, 30 November 2005, Features, p. 26
Mike Kelley: 'Day Is Done', Mike Kelley and John Welchman (New Haven, 2007)
Mike Kelley: Educational Complex Onwards, 1995–2008, Mike Kelley (Zurich, 2009)

William Kentridge

Born 1955 in Johannesburg, South Africa; lives and works there. Studied at University of the Witwatersrand, Johannesburg; Johannesburg Art Foundation; École Internationale de Théâtre Jacques Lecoq, Paris. Represented by Marian Goodman Gallery, New York.
'Art in review', Roberta Smith, *New York Times*, 23 April 1999, section E, p. 35
William Kentridge, Dan Cameron et al. (London, 1999)
William Kentridge, Kate McCrickard (London, 2012)

Anselm Kiefer

Born 1945 in Donauschingen, Germany; lives and works in Paris. Studied at Staatliche Akademie der Bildenden Künste, Karlsruhe; Staatliche Kunstakademie, Düsseldorf. Represented by Gagosian Gallery, New York; White Cube, London.
'Welcome to my melancholy world', Andrew Graham-Dixon, *Sunday Telegraph*, 10 July 2005, Review, p. 9
Anselm Kiefer/Paul Celan: Myth, Mourning and Memory, Andrea Lauterwein (London, 2007)
'Anselm Kiefer: "The Independent wants to know if I am a Nazi!"', Charles Darwent, *The Independent*, 11 October 2011
Anselm Kiefer: Next Year in Jerusalem, Marina Warner (New York, 2012)

Martin Kippenberger

Born 1953 in Dortmund, West Germany; died 1997 in Vienna. Studied at Hochschule für Bildende Künste, Hamburg.
Martin Kippenberger: The Last Stop West, Martin Kippenberger and Peter Noever (New York, 1999)
Martin Kippenberger: The Problem Perspective, Ann Goldstein and Lisa Gabrielle Mark (Los Angeles, 2008)

Jeff Koons

Born 1955 in York, Pennsylvania, USA; lives and works in New York. Studied at Maryland Institute College of Art, Baltimore; School of the Art Institute of Chicago. Represented by Sonnabend Gallery, Paris; Max Hetzler, Berlin; Jerome de Noirement, Paris; Gagosian Gallery, New York. www.jeffkoons.com

'How Much Is That Doggy in the Courtyard?', Roberta Smith, *New York Times*, 5 July 1992, section 2, p. 27

Jeff Koons, Hans Werner Holzwarth, Ingrid Sischy Eckhard Schneider and Katy Siegel (Cologne, 2009)

Jeff Koons: The Painter and the Sculptor, Vinzenz Brinkmann, Isabelle Graw and Joachim Pissarro (Ostfildern, 2012)

Barbara Kruger

Born 1945 in New Jersey, USA; lives and works in New York and Los Angeles. Studied at Syracuse University, New York; Parsons School of Design, New York. Represented by Mary Boone Gallery, New York; Rhona Hoffman Gallery, Chicago; Yvon Lambert, Paris; Sprueth Magers, Berlin/London. www.barbarakruger.com

Remote Control: Power, Cultures, and the World of Appearances, Barbara Kruger (Cambridge, Mass., 1994)

Barbara Kruger, Hal Foster, Martha Gever, Barbara Kruger and Miwon Kwon (New York, 2010)

'Slogans that shake society', Caroline Roux, *The Independent*, 9 May 2011, p. 18

Sarah Lucas

Born 1962 in London, UK; lives and works there. Studied at Working Men's College, London; London College of Printing; Goldsmiths College, London. Represented by Sadie Coles, London; Gladstone Gallery, New York; Contemporary Fine Arts, Berlin.

'Sister Sarah', Gordon Burn, *The Guardian*, 23 November 1996, p. 26

'Meat and two veg', Suzanne Moore, *The Independent*, 22 March 1997, Magazine, p. 24

Sarah Lucas, Matthew Collings (London, 2003)

Sarah Lucas: Au Naturel, Amna Malik (London, 2009)

Paul McCarthy

Born 1945 in Salt Lake City, Utah, USA; lives and works in Los Angeles. Studied at San Francisco Art Institute; University of Southern California, Los Angeles. Represented by Hauser & Wirth, New York/London.

Paul McCarthy, Dan Cameron, Amelia Jones, Lisa Phillips and Anthony Vidler (Ostfildern, 2001)

Blockhead and Daddies Bighead: Paul McCarthy at Tate Modern, Paul McCarthy (London, 2003)

'What's black and pink and blows up?', Martin Gayford, *Sunday Telegraph*, 25 May 2003, p. 5

Steve McQueen

Born 1969 in London, UK; lives and works in Amsterdam and London. Studied at Chelsea School of Art, London; Goldsmiths College, London; Tisch School of Art, New York. Represented by Thomas Dane Gallery, London, and Marian Goodman Gallery, New York/Paris.

'Evolving Exemplary Pluralism: Steve McQueen's "Deadpan" and Eija-Liisa Ahtila's

"Anne, Aki and God" – Two Case Studies for Conserving Technology-Based Installation Art', Mitchell Hearns Bishop, *Journal of the American Institute for Conservation* 40/3 (autumn/winter 2001), pp. 179–91

'Steve McQueen', Andrew Gellatly, *Frieze* 46 (May 1999)

Christian Marclay

Born 1955 in San Rafael, California, USA; lives and works in London and New York. Studied at École Supérieure d'Art Visuel, Geneva; Massachusetts College of Art, Boston. Represented by White Cube, London.

Christian Marclay, Jennifer Gonzalez, Kim Gordon and Matthew Higgs (London, 2005)

The Clock: Christian Marclay, Darian Leader and Christian Marclay (London, 2010)

'Killing Orson Welles at Midnight', Zadie Smith, *The New York Times Review of Books*, 28 April 2011

'Extreme sensibility', Jed Perl, *The New Republic*, 14 July 2011, p. 20

Annette Messager

Born 1943 in Berck-sur-Mer, France; lives and works in Malakoff, France. Studied at École Nationale Supérieure des Arts Decoratifs, Paris. Represented by Marian Goodman Gallery, New York/Paris.

'She Is Woman, Hear Her Roar (in French)', Alan Riding, *New York Times*, 24 June 2007, section AR, p. 27

'Puppet master: Trickster, Tinkerer, Peddler, Practical Woman', Siri Hustvedt, *The Guardian*, 21 February 2009, Review, p. 16

'These childish things', Adrian Searle, *The Guardian*, 5 March 2009, Features, p. 24

Polly Morgan

Born 1980 in London, UK; lives and works there. Studied at Queen Mary, University of London. www.pollymorgan.co.uk

'Polly Morgan's wings of desire', Miranda Collinge, *The Observer*, 18 July 2010, p. 46

Polly Morgan: Psychopomps, Tom Hunt (London, 2011)

'The Beautiful and the dead', Lynn Barber, *Sunday Times*, 13 February 2011, Magazine, Features, p. 48 ff.

Ron Mueck

Born 1958 in Melbourne, Australia; lives and works in London. Self-taught. Represented by Hauser & Wirth, London.

'Boy Wonder', Martin Gayford, *The Independent*, 2 September 2000, Features, pp. 8–9

'Less is Mueck', Peter Plagens, *Newsweek*, 24 May 2001

'It looks so real, so why is it so spooky?', Charles Darwent, *Independent on Sunday*, 23 March 2003, Features, p. 8

Ron Mueck, Lisa Baldissera, David Hurlston and Ron Mueck (Melbourne, 2011)

Presence: Sculpture and the Portrait, Alexander Sturgis (Woodbridge, Suffolk, 2012)

Takashi Murakami

Born 1962 in Tokyo, Japan; lives and works there. Studied at Tokyo National University of Fine Arts and Music. Represented by Gagosian Gallery, New York; Kaikai Kiki, Japan.

'The Murakami Method', Arthur Lubow, *New York Times*, 3 April 2005, section 6, p. 48

'Japanese kitsch in the Palace of Versailles? The French establishment is horrified', Jonathan Wingfield, *The Independent Magazine*, 16 October 2010, p. 12

Murakami: Versailles, Philippe Dagen, Jill Gasparina and Laurent Le Bon (Paris, 2011)

Murakami: Ego, Massimiliano Gioni and Takashi Murakami (New York, 2012)

Wangechi Mutu

Born 1972 in Nairobi, Kenya; lives and works in New York. Studied at Cooper Union for the Advancement of the Arts and Science, New York; Yale University School of Art and Sculpture, New Haven. Represented by Gladstone Gallery, New York; Susanne Vielmetter Los Angeles Projects; Victoria Miro Gallery, London.

'Kenya: reward for creative touch', Kevin Kelly, *Africa News*, 25 July 2004

'The selective advantages of stilettos', Soledad Santiago, *Santa Fe New Mexican*, 24 November 2006, section PA, pp. 52

Bruce Nauman

Born 1941 in Indiana, USA; lives and works in New Mexico. Studied at University of Wisconsin, Madison; University of California, Davis. Represented by Sperone Westwater, New York; Galerie Konrad Fischer, Düsseldorf/Berlin.

Please Pay Attention Please: Bruce Nauman's Words: Writings and Interviews, Bruce Nauman (Cambridge, Mass., 2005)

'2 Continents, 1 Work and 31 Hand Positions', Carol Vogel, *New York Times*, 8 July 2011, section C, p. 24

Mike Nelson

Born 1967 in Loughborough, UK; lives and works in London. Studied at Reading University; Chelsea School of Art, London. Represented by 303 Gallery, New York; Galleria Franco Noero, Turin; Matt's Gallery, London. www.mikenelson.org.uk

'Welcome to my worlds', Jonathan Jones, *The Guardian*, 4 September 2001, Features, p. 12

'Mike Nelson', Marc Werner, *Art Review* 1 (October 2001), p. 56

'Interview: Lost in space', Sean O'Hagan, *The Observer*, 23 September 2007, Magazine, p. 42

'Private view', Ben Lewis, *Prospect* magazine, 22 March 2011

Shirin Neshat

Born 1957 in Qazvin, Iran; lives and works in New York. Studied at University of California, Berkeley. Represented by Gladstone Gallery, New York; Galerie Jerome de Noirmont, Paris.

Women of Allah, Shirin Neshat (Turin, 1999)

'Dream journeys across the great divide', Richard Cork, *The Times*, 1 August 2000

Shirin Neshat, Marina Abramović and Arthur C. Danto (New York, 2010)

Ernesto Neto

Born 1964 in Rio de Janeiro, Brazil; lives and works there. Studied at Escola de Artes Visuais Pargua Lage, Rio de Janeiro; Museu de Arte Moderna, Rio de Janeiro. Represented by Tanya Bonakdar Gallery, New York; Galeria Fortes Vilaça, São Paulo.

'A Daydream: in Ernest Neto's Globiobabel Nudelioname', Philip Ursprung, *Parkett* 78 (2006), pp. 116–26

Leviathan Thot: Ernesto Neto, Ernesto Neto (Paris, 2006)

'Realm of the senses', Martin Gayford, *Daily Telegraph*, 29 May 2010, Features, pp. 46–47

'The touchy-feely world of Brazilian artist, Ernesto Neto', Mairi Mackay, CNN.com, 4 August 2010

Chris Ofili

Born 1968 in Manchester, UK; lives and works in Trinidad. Studied at Chelsea School of Art, London; Royal College of Art, London. Represented by Victoria Miro Gallery, London; David Zwirner, New York; Contemporary Fine Arts, Berlin.

'Aim was to lure crowds, but they got stuck with royal headache', Michael Daly, *New York Daily News*, 29 September 1999, p. 4

'Triumph of the elephant man', Martin Gayford, *Daily Telegraph*, 3 July 2002, p. 21

Chris Ofili, David Adjaye, Thelma Golden and Chris Ofili (New York, 2009)

'Ofili shows his heart of darkness', Rachel Campbell-Johnston, *The Times*, 26 January 2010, Features, pp. 14–15

'A beautiful and provocative Tate show', Waldemar Januszczak, *Sunday Times*, 31 January 2010, *Culture* magazine, pp. 10–11

Gabriel Orozco

Born 1962 in Jalapa, Veracruz, Mexico; lives and works in New York, Paris and Mexico City. Studied at Escuela Nacional de Arte Plásticas, Mexico City; Circulo de Bellas Artes, Madrid. Represented by Marian Goodman Gallery, New York/Paris; Galerie Chantal Crousel, Paris; Galeria Kurimansutto, Mexico City.

'Bold conceptions from destruction', Richard Cork, *The Times*, 19 May 1998

Gabriel Orozco, Ann Temkin, Gabriel Orozco, Briony Fer and Benjamin Buchloh (New York, 2009)

Gabriel Orozco, Jessica Morgan (London, 2011)

'All the right moves', Alastair Sooke, *Daily Telegraph*, 1 January 2011, Features, pp. 32–35

Cornelia Parker

Born 1956 in Cheshire, UK; lives and works in London. Studied at Gloucestershire College of Art & Design, Gloucester; Wolverhampton Polytechnic; Reading University. Represented by Frith Street Gallery, London; D'Amelio Terras, New York; Guy Bartschi, Geneva; Galeria Carles Taché, Barcelona.

'Turning History's Leftovers Into Modern Relics', Ann Wilson Lloyd, *New York Times*, 30 January 2000, section 2, p. 43

'Try to praise the mutilated world', Adam Zagajewski, *The New Yorker*, 24 September 2001, p. 96

'String up the bandarts', Rose Aidin, *The Times*, 14 November 2001

Creating the British Galleries at the V&A: A Study in Museology, Nick Humphrey and Christopher Wilk (London, 2004)

Grayson Perry

Born 1960 in Chelmsford, UK; lives and works in London. Studied at Portsmouth Polytechnic. Represented by Victoria Miro Gallery, London.

Grayson Perry: Portrait of The Artist As a Young Girl, Wendy Jones (London, 2007)

'Perry's portrait of bourgeois Britain', Kara Dolman and Richard Goodwin, *Evening Standard*, 8 June 2012, Features, p. 36

'What class am I? All three!', Anthony Horowitz, *Daily Telegraph*, 10 June 2012

Grayson Perry, Jacky Klein (London, 2013)

Marc Quinn

Born 1964 in London, UK; lives and works there. Studied at University of Cambridge. Represented by White Cube, London. www.marcquinn.com

Marc Quinn: Incarnate, Marc Quinn (London, 1998)

Walid Raad

Born 1967 in Chbanieh, Lebanon; lives and works in New York and Beirut. Studied at Boston University; Rochester University of Technology, New York; University of Rochester, New York. Represented by Anthony Reynolds Gallery, London.

'Walid Raad', Alan Gilbert, *BOMB* 81 (Autumn 2002)

'What's wrong with this picture?', Sarah Milroy, *Globe and Mail*, 30 September 2004, Review, p. 1

'Walid Raad/The Atlas Group', Mark Beasley, *Frieze* magazine 97 (March 2006)

Walid Raad: The Atlas Group, 1989–2004, Kassandra Nakas, Walid Raad and Britta Schmitz (Cologne, 2007)

Walid Raad, Alan Gilbert, Hélène Chouteau-Matikian, Walid Raad and Blake Stimson (London, 2011)

Neo Rauch

Born 1960 in Leipzig, Germany; lives and works there. Studied at Leipzig Academy of Visual Arts. Represented by Galerie Eigen + Art, Leipzig/Berlin; David Zwirner, New York.

Neo Rauch: Paintings, Bernhart Schwenk, Hans-Werner Schmidt and Neo Rauch (Ostfildern, 2010)

Neo Rauch: Para, Werner Spies, Gary Tinterow and Neo Rauch (Cologne, 2010)

Paula Rego

Born 1935 in Lisbon, Portugal; lives and works in London. Studied at The Slade School of Fine Art, London. Represented by Marlborough Fine Art, London

'Playtime', Louisa Buck, *The Times*, 18 October 2003, Magazine, p. 36

'Subversive narrative', Tom Rosenthal, *The Spectator*, 20 October 2007, p. 76

Interview with Paula Rego, John Tusa, BBC Radio 3: www.bbc.co.uk/radio3/johntusainterview/rego_transcript.shtml

Gerhard Richter

Born 1932 in Dresden, East Germany; lives and works in Cologne. Studied at Dresden Art Academy. Represented by Marian Goodman Gallery, New York; Wako Works of Art, Tokyo; Anthony Meier Fine Arts, San Francisco; Blain Southern, London. www.gerhard-richter.com

Gerhard Richter: Forty Years Of Painting, Gerhard Richter and Robert Storr (New York, 2002)

Gerhard Richter: Cage: 6 Paintings, Robert Storr (London, 2009)

'From hot to cool on the Richter scale', Aidan Dunne, *Irish Times*, 14 October 2011, Features, p. 16

Gerhard Richter: Panorama: A Retrospective, Achim Borchardt-Hume, Mark Godfrey, Nicholas Serota and Gerhard Richter (London, 2011)

Pipilotti Rist

Born 1962 in Grabs, Switzerland; lives and works in Zurich. Studied at Institute of Applied Arts, Vienna; School for Design, Basel. Represented by Hauser & Wirth, London/Zurich, and Luhring Augustine, New York. www.pipilottirist.net

'Pipilotti Rist', Michael Kimmelman, *New York Times*, 21 April 2000, section E, p. 40

Pipilotti Rist, Elisabeth Bronfen, Hans Ulrich Obrist and Peggy Phelan (London, 2001)

'Moving Matters: Pipilotti Rist at MoMA', Maja Horn, *ArtPulse*, February 2009

Doris Salcedo

Born 1958 in Bogotá, Colombia; lives and works there. Studied at Universidad de Bogotá; New York University. Represented by White Cube, London, and Alexander and Bonin, New York.

'Advance guard on the Bosporus', Benjamin Genocchio, *Weekend Australian*, 8 November 2003, Review, p. B31

Doris Salcedo: Shibboleth, Achim Borchardt-Hume (London, 2007)

Of What One Cannot Speak: Doris Salcedo's Political Art, Mieke Bal (Chicago, 2011)

Jenny Saville

Born 1970 in Cambridge, UK; lives and works in Oxford. Studied at Glasgow School of Art; The Slade School of Fine Art, London. Represented by Gagosian Gallery, London.

'She ain't heavy, she's my sister', Andrew Graham-Dixon, *The Independent*, 8 February 1994, p. 23

Jenny Saville: Territories, Mollie Dent-Brocklehurst (New York, 1999)

Jenny Saville, Jenny Saville (New York, 2005)

Jenny Saville: Continuum, Jenny Saville (New York, 2012)

Gregor Schneider

Born 1969 in Rheydt, Germany; lives and works there. Studied at Kunstakademie Düsseldorf; Kunstakademie Münster; Hochschule für Bildende Künste, Hamburg. Represented by Gladstone Gallery, New York; Galleria Massimo de Carlo, Milan; Konrad Fischer Galerie, Düsseldorf; Sadie Coles HQ, London; Wako Works of Art, Tokyo. www.gregorschneider.de

Gregor Schneider Cubes: Art in the Age of Global Terrorism, Eugene Blume, Amine Haase, Friedhelm Mennekes and Gregor Schneider (Milan, 2006)

'Death: art's final taboo', Andrew Johnson, *The Independent*, 20 April 2008, p. 22

'There is nothing perverse about a dying person in an art gallery', Gregor Schneider, *The Guardian*, 26 April 2008, Comment Pages, p. 28

End, Gregor Schneider, Anita Shah and Susanne Titz (Cologne, 2010)

Sean Scully

Born 1945 in Dublin, Ireland; lives and works in New York, Barcelona and Munich. Studied at Croydon College of Art, London; Newcastle University, Newcastle upon Tyne; Harvard University, Cambridge, Massachusetts. Represented by Galeria Carles Taché, Barcelona; Galerie Lelong, Paris; Ingleby Gallery, Scotland; Kerlin Gallery, Dublin; Timothy Taylor Gallery, London; Walter Storms Galerie, Munich; Cheim & Read, New York. www.sean-scully.com

Sean Scully: Retrospective, Maris Lluisa Borras, Danilo Eccher, Lorand Hegyi and Donald Kuspit (New York, 2007)

Doric, Kelly Grovier, Ben Luke, and Sean Scully (London, 2012) [my catalogue essay accompanying the exhibition of the work, from which the present entry derives]

Sean Scully: Light of the South, Kosme De Baranano and Kelly Grovier (New York, 2012)

Richard Serra

Born 1939 in San Francisco, USA; lives and works in Cape Breton Island, Canada, and New York. Studied at Yale University School of Art and Architecture, New Haven. Represented by Galerie m Bochum; Gagosian Gallery, New York.

Richard Serra: Torqued Ellipses, Lynne Cooke, Michael Govan, Richard Serra and Mark Taylor (New York, 1998)

'Can cold, hard steel turn sinuous?', Kenneth Baker, *San Francisco Chronicle*, 24 June 2005, section E, p. 1

Richard Serra: Sculpture, Forty Years, Lynne Cooke, Kynaston McShine, John Rajchman and Richard Serra (New York, 2007)

Raqib Shaw

Born 1974 in Calcutta, India; lives and works in London. Studied at Central St Martins College of Art and Design, London. Represented by White Cube, London; Galerie Thaddaeus Ropac, Paris.

Raqib Shaw: Absence of God, Homi Bhabha (London, 2009)

'Starting From Holbein, Then Taking Flight', Karen Rosenberg, *New York Times*, 2 January 2009, section C, p. 33

'The world's most magical artist', Norman Rosenthal, *Daily Telegraph*, 16 May 2009, Art, p. 4

Cindy Sherman

Born 1954 in New Jersey, USA: lives and works in New York. Studied at State University of New York at Buffalo. Represented by Metro Pictures, New York; Sprueth Magers, Berlin/London; Gagosian Gallery, Los Angeles/Rome/Paris.

'Being Cindy Sherman', Arifa Akbar, *Independent Extra*, 16 April 2009, Life, p. 14

Cindy Sherman, Johanna Burton, Eva Respini, Cindy Sherman and John Waters (New York, 2012)

Cindy Sherman: Clowns, Cindy Sherman (Munich, 2012)

Santiago Sierra

Born 1966 in Madrid, Spain; lives and work in Mexico City. Studied at Universidad Complutense, Madrid; Círculo de Bellas Artes, Madrid; Hochschule für Bildende Künste, Hamburg; Escuela de San Carlos, Universidad Autónoma de Mexico, Mexico City. Represented by Lisson Gallery, London. www.santiago-sierra.com

'Holocaust Remembrance: Artist Turns Synagogue Into Gas Chamber', David Crossland, *Der Spiegel* online, 13 March 2006: www.spiegel.de/international/holocaust-remembrance-artist-turns-synagogue-into-gas-chamber-a-405721.html

'Defunct German synagogue hosts gas chamber exhibit sparks outrage', Hilary Leila Krieger, *Jerusalem Post*, 14 March 2006, p. 6

Do Ho Suh

Born 1962 in Seoul, South Korea; lives and works in New York and London. Studied at Seoul National University; Rhode Island School of Design, Providence; Yale University, New Haven. Represented by Lehmann Maupin, New York.

'The Importance of Elsewhere' in *The Whitsun Weddings*, Philip Larkin (London, 1964), p. 34

Replacing Home: From Primordial Hut to Digital Network in Contemporary Art, Jennifer Johung (Minneapolis, 2011)

'Artist creates phantoms of homes, nostalgia', Noh Hyun-gi, *Korea Times*, 27 March 2012

'The Perfect Home, Between New York and Seoul', Hana R. Alberts, *Wall Street Journal*, 24 April 2012

Wolfgang Tillmans

Born 1968 in Remscheid, Germany; lives and works in London and Berlin. Studied at Bournemouth and Poole College of Art and Design, Bournemouth. Represented by Maureen Paley, London. www.tillmans.co.uk

Wolfgang Tillmans, Jan Verwoert (New York, 2002)

'Photos take on a life all of their own', Donald Eubank, *Japan Times*, 25 November 2004

Wolfgang Tillmans, Julie Ault, Daniel Birnbaum, Russell Ferguson and Dominic Molon (Los Angeles, 2006)

'The lightness of being', Liz Jobey, *The Guardian*, 26 June 2010, Review, p. 16

Rirkrit Tiravanija

Born 1961 in Buenos Aires, Argentina; lives and works in Berlin, Chiang Mai and New York. Studied at Ontario College of Art, Toronto; Banff School of Fine Arts; School of the Art Institute of Chicago; Whitney Independent Studies Program, New York. Represented by Gavin Brown's Enterprise, New York.

'Make yourself at home', Adrian Searle, *The Guardian*, 12 July 2005, Features, p. 12

'The exhibition that says, "Make yourself at home"', Richard Dorment, *Daily Telegraph*, 12 July 2005, Features, p. 21

Rirkrit Tiravanija, Hans Ulrich Obrist and Rirkrit Tiravanija (New York, 2010)

Gavin Turk

Born 1967 in Guildford, UK; lives and works in London. Studied at Royal College of Art, London. Represented by Aeroplastics Contemporary, Brussels; Aurel Scheibler, Berlin; Ben Brown Fine Arts, London; Galerie Almine Rech, Paris/Brussels; Galerie Krinzinger, Vienna; Goodman Gallery, Johannesburg; Paul Stolper, London; RS&A, London. www.gavinturk.com

'Transformer Man', Matthew Collings, *The Guardian*, 18 October 1995, section T, p. 10

'I am art, therefore I am', Judith Palmer, *The Independent*, 17 September 1998, Arts, p. 11

'Identity obscured by layers', Mary Corrigal, *Sunday Independent* (South Africa), 17 January 2010, Life, p. 25

Luc Tuymans

Born 1958 in Mortsel, Belgium; lives and works in Antwerp. Studied at École Nationale Supérieure des Arts Visuels de la Cambre, Brussels; Koninklijke Academie voor Schone Kunsten, Antwerp; Vrije Universiteit, Brussels. Represented by

David Zwirner, New York; Zeno X Gallery, Antwerp. www.luctuymans.com

Luc Tuymans, Madeleine Grynsztejn, Helen Molesworth and Luc Tuymans (New York, 2009)

Luc Tuymans: Is it Safe?, Luc Tuymans and et al. (London, 2010)

'Putting the Wrongs of History in Paint', Dorothy Spears, *New York Times*, 7 February 2010, Arts, p. 26

'Van Eyck: perfection. Van Gogh: pathetic', Rachel Campbell-Johnston, *The Times*, 8 October 2012, p. 41

Cy Twombly

Born 1928 in Lexington, Virginia, USA; died 2011 in Rome. Studied at School of Museum of Fine Arts, Boston; Washington and Lee University, Lexington; Arts Students League, New York; Black Mountain College, Asheville, North Carolina. www.cytwombly.info

Cy Twombly: A Monograph, Richard Leeman (London, 2005)

Cy Twombly: The Rose, Jonathan Jones (London, 2009)

'Budding more and still more', Kelly Grovier, *Times Literary Supplement*, 1 May 2009 [My review of the work from which the present entry derives.]

Bill Viola

Born 1951 in New York; lives and works in Long Beach, California. Studied at Syracuse University, New York. Represented by Blain Southern Gallery, London; James Cohan Gallery, New York; Kukje Gallery, Seoul. www.billviola.com

Bill Viola: European Insights: Reflections on the work of Bill Viola, ed. Rolf Lauter (New York, 1999)

'Video offers modern look at biblical scene', Dan R. Goddard, *San Antonio Express-News*, 16 January 2002, Life, p. 1G

'Modern Mannerism in slo-mo', Benjamin Genocchio, *The Australian*, 9 February 2001, Features, p. 10

The Art of Bill Viola, Cynthia Freeland and Chris Townsend (London, 2004)

Kara Walker

Born 1969 in Stockton, California, USA; lives and works in New York. Studied at Atlanta College of Art; Rhode Island School of Design, Providence. Represented by Sikkema Jenkins & Co, New York.

Kara Walker: Pictures From Another Time, Annette Dixon, Thelma Golden, Robert F. Reid-Pharr and Kara Walker (Ann Arbor, 2002)

'A Nightmare View of Antebellum Life That Sets Off Sparks', Holland Cotter, *New York Times*, 9 May 2003, section E, p. 36

Seeing the Unspeakable: The Art of Kara Walker, Gwendolyn DuBois Shaw (Durham, North Carolina, 2004)

'Kara Walker', Cheryl R. Riley, *Ebony* 62/8 (June 2007), p. 104

Jeff Wall

Born 1946 in Vancouver, Canada; lives and works there. Studied at University

of British Columbia, Vancouver; Courtauld Institute of Art, London. Represented by Marian Goodman Gallery, New York/Paris.

'Every picture tells a story', Simon Houpt, *Globe and Mail*, 17 October 2002, Review, p. 1

Jeff Wall: Selected Essays and Interviews, Peter Galassi and Jeff Wall (New York, 2007)

Jeff Wall: Works and Collected Writings, Michael Newman and Jeff Wall (Barcelona, 2007)

'Jeff Wall's photos radiant, disturbing', Carly Berwick, *Calgary Herald*, 25 February 2007, *Books and the Arts*, p. C1

Mark Wallinger

Born 1959 in Chigwell, UK; lives and works in London. Studied at Chelsea School of Art, London; Goldsmiths College, London. Represented by Anthony Reynolds Gallery, London.

Mark Wallinger: State Britain, Mark Wallinger and Clarrie Wallis (London, 2007)

'Bears against bombs', Adrian Searle, *The Guardian*, 16 January 2007, Features, p. 23

'Anti-war demo? Let's put the show on right here', Laura Cumming, *The Observer*, 21 January 2007

Mark Wallinger, Richard Grayson, Madeleine Schuppli and Janneke de Vries (Zurich 2008)

Gillian Wearing

Born 1963 in Birmingham, UK; lives and works in London. Studied at Chelsea School of Art, London; Goldsmiths College, London. Represented by Maureen Paley, London.

'Gillian Wearing', Sacha Craddock, *The Times*, 19 November 1994

Gillian Wearing: Signs that say what you want them to say and not Signs that say what someone else wants you to say, 1992–1993, Maureen O. Paley and Gillian Wearing (London, 1997)

Gillian Wearing, Daniel Herrmann, Doris Krystof and Bernhart Schwenk (2012)

Rachel Whiteread

Born 1963 in London, UK; lives and works there. Studied at Brighton Polytechnic; The Slade School of Fine Art, London. Represented by Gagosian Gallery and Luhring Augustine, New York.

The Art of Rachel Whiteread, Jennifer R. Cross and Chris Townsend (New York, 2004)

'Closed books and stilled lives', Kate Connolly, *The Guardian*, 26 October 2000, p. 5

Rachel Whiteread, Charlotte Mullins (London, 2004)

Yang Fudong

Born 1971 in Beijing, China; lives and works in Shanghai. Studied at China Academy of Fine Arts, Hangzhou. Represented by Marian Goodman Gallery, New York/Paris. www.yangfudong.com

'Casting a fresh eye on China with a computer, not ink and brush', Jane Perlez, *New York Times*, 5 December 2003, p. 5

Yang Fudong: Seven Intellectuals in a Bamboo Forest, Angie Baecker,

Jarla Partilager and Yang Fudong (Stockholm, 2008)

'From an ancient bamboo grove to modern China', Ken Johnson, *New York Times*, 29 May 2009, p. 30

Zhang Xiaogang

Born 1958 in Kunming, China; lives and works in Beijing. Sichuan Fine Arts Institute, Chonqing. Represented by Pace Gallery, Beijing. www.zhangxiaogang.org.cn

'Interview with Zhang Xiaogang', Anjali Rao, CNN.com, 9 July 2007

The Revolution Continues: New Art From China, Jiehong Jiang (London, 2008)

Artur Żmijewski

Born 1966 in Warsaw, Poland; lives and works there. Academy of Fine Arts, Warsaw; Gerrit Rietveld Academie, Amsterdam. Represented by Galerie Peter Kilchmann, Zurich.

'Artur Żmijewski', Daniel Miller, *Frieze* online, 30 April 2009: www.frieze.com/shows/review/artur_zmijewski/

'The calm after a democratic storm', Susan Mansfield, *The Scotsman*, 30 November 2010, p. 37

Artur Żmijewski: Scenarios of Dissidence, Louise Dery and Veronique Leblanc (Montreal, 2011)

Sources for Quotations

Page 11 – Arthur Danto, *The Philosophical Disenfranchisement of Art* (New York, 1986).

Page 12 – T. S. Eliot, *The Sacred Wood: Essays on Poetry and Criticism* (London, 1960).

Page 12 – T. S. Eliot, *Four Quartets* (London, 1943).

Page 13 – Augustine, *Confessions* (Oxford, 1991).

Page 50 – Anish Kapoor, interview with John Tusa for BBC Radio 3, www.bbc.co.uk/radio3/johntusainterview/kapoor_transcript.shtml

Page 68 – Orson Welles, as told to Henry Jaglom; quoted in Joseph McBride, *What Ever Happened to Orson Welles?: A Portrait of an Independent Career* (Kentucky, 2006), p. 254

Page 118 – Robert Hughes, *The Shock of the New* (London, 1991 reprint), p. 80

Page 136 – Anselm Kiefer, quoted in 'A life in art: Anselm Kiefer', Nicholas Wroe, *The Guardian*, 19 March 2011, www.guardian.co.uk/artanddesign/2011/mar/21/anselm-kiefer-painting-life-art

Page 185 – Woody Allen, *Husbands and Wives*, screenplay (1992)

Page 204 – Rainer Maria Rilke, *Letters to a Young Poet*, trans. M. D. Herter Norton (New York, 1954; revised 1993), letter dated 17 February 1903

Page 254 – Sean Scully, interview for 'A Painter Earns His Stripes', review article on *Constantinople or the Sensual Concealed: The Imagery of Sean Scully*, Kelly Grovier, *Times Literary Supplement*, 15 January 2010

Page 272 – Samuel Beckett, quoted in Tom Driver interview, Columbia University Forum, summer 1961, pp. 21–25

List of Illustrations

Full details, including materials and dimensions, of the featured 100 works are given in their corresponding captions in each entry. Full details of all contextual works are given below. Dimensions are given as height by width by depth.

Unless otherwise instructed by the artist, priority has been given to a work's English or anglicized title (followed by its original title), or to the title by which it is best known.

a = above, b = below,

c = centre, l = left, r = right

10 Vincent Van Gogh, **The Starry Night**, 1889, oil on canvas, 73.7 × 92.1 cm (29 × 36¼ in.). Museum of Modern Art, New York. Acquired through the Lillie P. Bliss Bequest, inv. 472.1941

11 Michelangelo, **David**, 1501–4, marble, height: 5.17 m (17 ft). Photo © nagelestock.com/Alamy

12l Jenny Saville, **Propped**, 1992. Courtesy Gagosian Gallery. © Jenny Saville

12r Peter Paul Rubens, **The Rape of the Daughters of Leucippus**, 1617–18, oil on canvas, 224 × 210.5 cm (88¼ × 82⅞ in.). Alte Pinakothek, Munich

13l Gabriel Orozco, **Black Kites**, 1997. Courtesy the artist and Marian Goodman Gallery, New York. © DACS 2013

13r Hans Holbein the Younger, **The Ambassadors**, 1533, oil on panel, 207 × 209.5 cm (81½ × 82½ in.). National Gallery, London

14 Rogier van der Weyden, **The Lamentation of Christ**, c. 1460–64, oil on panel, 80.6 × 130.1 cm (31¾ × 51¼ in.). Mauritshuis, The Hague. Photo Scala, Florence

15 Grayson Perry, **#Lamentation**, from the series **The Vanity of Small Differences**, 2012. Courtesy the artist and Victoria Miro Gallery. © Grayson Perry

18 Marina Abramović, re-performance of **Lips of Thomas**, 1975, for the series **Seven Easy Pieces**, 2005. Original performance at Galerie Krinzinger, Innsbruck. Original duration 2 hours. Courtesy Marina Abramović Archives and Sean Kelly Gallery New York. Photo Attilio Maranzano. © Marina Abramović

19 Marina Abramović, **The Artist is Present**, 2010. Performance at the Museum of Modern Art, New York, duration 2.5 months. Courtesy Marina Abramović Archives and Sean Kelly Gallery, New York. Photo Marco Anelli. © Marina Abramović

20 Ai Weiwei portrait, 2010. Courtesy the artist. Photo Tate, London

21 Ai Weiwei, **Sunflower Seeds**, 2010. Courtesy the artist. Photo Tate, London

22 Making sunflower seeds, 2010. Courtesy the artist. Photo Ai Weiwei

23 Ai Weiwei, **Sunflower Seeds** (detail), 2010. Courtesy the artist. Photo Eric Gregory Powell

24 Robert Mitchell, cross section of the Rotunda, Leicester Square, housing Robert Barker's **Panorama**, 1801, aquatint. Private collection/Bridgeman Art Library

25 Doug Aitken, **The Source**, 2012. An original co-production by Tate Liverpool and Sky Arts Ignition. Courtesy 303 Gallery, New York; Galerie Eva Presenhuber, Zurich; Victoria Miro Gallery, London; Regen Projects, Los Angeles. Photo © Charles Coleman

26 Vincent Van Gogh, **Portrait of Dr Gachet**, 1890, oil on canvas, 67 × 56 cm (26⅜ × 22 in.). Private collection

27 Mark Alexander, **The Blacker Gachet X**, 2005. © Mark Alexander

29–31 Francis Alÿs, **Fabiola**, 2009. Installation at the National Portrait Gallery, London. Courtesy Peter Kilchmann. Photo Mahtab Hussain/National Portrait Gallery, London

32 Janine Antoni, **Loving Care**, 1993. Courtesy the artist and Luhring Augustine, New York. © the artist

33–35 Janine Antoni, **Gnaw**, 1992. Museum of Modern Art, New York, Mrs. John Hay Whitney Bequest Fund. Courtesy the artist and Luhring Augustine, New York. © the artist

37–39 Miroslaw Balka, **How It Is**, 2009. Photo Peter Macdiarmid/Getty Images

41 Banksy, **Flower Thrower**, 2005. West Bank, Israel. Photo David Silverman/Getty Images

42–45 Matthew Barney, film stills from **Cremaster 4**, 1994. Courtesy Gladstone Gallery, New York and Brussels. Photo Michael James O'Brien. © 1994 Matthew Barney

46–47 Christian Boltanski, **Personnes**, 2010. Installation view of 'Monumenta 2010', Grand Palais, Paris, 13 January to February 2010. Courtesy Marian Goodman Gallery, New York/Paris. Photo Didier Plowy. © ADAGP, Paris and DACS, London 2013

52 Jeremy Bentham's **Panopticon**, c. 1790. Photo 2002 Topham Picturepoint/Topfoto

53 Monica Bonvicini, **Don't Miss a Sec**, 2003. Installation at Sculpture International Rotterdam, City Hall, Rotterdam, 2004. Courtesy the artist. Photo Jannes Linders. © DACS 2013

54–55 Monica Bonvicini, **Don't Miss a Sec**, 2003. Installation at Art Basel, Switzerland, 2004. Courtesy the artist. Photo Jannes Linders. © DACS 2013

57 Louise Bourgeois, **Maman**, 1999. Guggenheim Museum, Bilbao. Photo © Walter Bibikow/JAI/Corbis. © Louise Bourgeois Trust/ DACS, London/VAGA, New York 2013

59 Glenn Brown, **Sex**, 2003. Courtesy Glenn Brown. © Glenn Brown

61 Chris Burden, **What My Dad Gave Me**, 2008. Installation at the Rockefeller Center, New York, 10 June to 19 July 2009, transported from Los Angeles to New York as one piece. Courtesy Gagosian Gallery. Photo Erich Koyama. © Chris Burden

62 Daniel Buren, **Les Deux Plateaux** (The Two Levels), 1986, cement and marble columns, lights and a sunken artificial stream, dimensions specific to site. © DB-ADAGP Paris and DACS, London 2013

63 Daniel Buren, **De l'azur au Temple du Ciel** (From the sky to the Temple of Heaven), October 2004. © DB-ADAGP Paris and DACS, London 2013

64 Sophie Calle, **Take Care of Yourself**, 2007. Installation at Paula Cooper Gallery, New York, 2009. Courtesy Sophie Calle/ Paula Cooper Gallery, New York. Photo Ellen Page Wilson. © ADAGP, Paris and DACS, London 2013

65 Sophie Calle, **Rifle Shooter, Sandy Morin**, from **Take Care of Yourself**, 2007. Courtesy Sophie Calle/Paula Cooper Gallery, New York. Photo Kleinefenn. © ADAGP, Paris and DACS, London 2013

71 Patrick Cariou, photograph from **Yes Rasta** by Patrick Cariou, 2000, published by PowerHouse Books. © Patrick Cariou

73 Maurizio Cattelan, **L.O.V.E.**, 2010. Courtesy Maurizio Cattelan's Archive. Photo Zeno Zotti

74 Jake and Dinos Chapman, **Hell**, 1999–2000. Installation view of 'Apocalypse: Beauty and Horror in Contemporary Art', Royal Academy of Arts, London, 2000. Courtesy White Cube. Photo Stephen White. © Jake and Dinos Chapman

75–77 Jake and Dinos Chapman, **Hell** (detail), 1999–2000. Courtesy White Cube. Photo Stephen White. © Jake and Dinos Chapman

79 Christo and Jeanne-Claude, **The Gates**, 1979–2005. Photo Beth A. Keiser/Corbis. © Christo and Jeanne-Claude 2005

80–81 Christo and Jeanne-Claude, **The Gates**, 1979–2005. Photo by Spencer Platt/Getty Images. © Christo and Jeanne-Claude 2005

83 Chuck Close, **Self-Portrait**, 1997. Courtesy Pace Gallery. © Chuck Close

85 Martin Creed, **Work No. 227, The Lights Going On and Off**, 2000. Courtesy the artist, Museum of Modern Art, New York and Hauser & Wirth. © Martin Creed

86 Lucas Cranach the Elder, **Venus**, 1532, oil and tempera on red beechwood, 37.7 × 24.5 cm (14⅞ × 9⅝ in.). Städel Museum, Frankfurt am Main. Photo akg-images/De Agostini Picture Library

87 John Currin, **The Pink Tree**, 1999. Courtesy Gagosian Gallery. Photo Fred Scruton. © John Currin

88 Pizza Rut, Blackpool, 2005, from Jeremy Deller and Alan Kane, **Folk Archive: Contemporary popular art from the UK**, 2000–7. Courtesy the artists. © 2004 Jeremy Deller and Alan Kane

89 Kunsthalle Basel installation featuring banner by Ed Hall, 2005, from Jeremy Deller and Alan Kane, **Folk Archive: Contemporary popular art from the UK**, 2000–7. Courtesy the artists. © 2004 Jeremy Deller and Alan Kane

90al Rural Freedom Fighter, Whitehall, 1999, from Jeremy Deller and Alan Kane, **Folk Archive: Contemporary popular art from the UK**, 2000–7. Courtesy the artists. © 2004 Jeremy Deller and Alan Kane

90ar Graffiti, Leamington Spa, 2004, from Jeremy Deller and Alan Kane, **Folk Archive: Contemporary popular art from the UK**, 2000–7. Courtesy the artists. © 2004 Jeremy Deller and Alan Kane

90bl Shack, Dungeness, 2005, from Jeremy Deller and Alan Kane, **Folk Archive: Contemporary popular art from the UK**, 2000–7. Courtesy the artists. © 2004 Jeremy Deller and Alan Kane

90br Mobile food wagon, Ely, 2004, from Jeremy Deller and Alan Kane, **Folk Archive: Contemporary popular art from the UK**, 2000–7. Courtesy the artists. © 2004 Jeremy Deller and Alan Kane

91 Snowdrop the mechanical elephant and Peter Clare, Egremont, 2004, from Jeremy Deller and Alan Kane, **Folk Archive: Contemporary popular art from the UK**, 2000–7. Courtesy the artists. © 2004 Jeremy Deller and Alan Kane

93 Peter Doig, **Blotter**, 1993. National Museums Liverpool, Walker Art Gallery. Courtesy Michael Werner, New York. © the artist

95 Stan Douglas, **Win, Place or Show**, 1998. Courtesy the artist and David Zwirner, New York/London. © the artist

97a Marlene Dumas, **The Wall**, 2009, oil on linen, signed, titled, and dated verso, 1.8 × 3 m (5 ft 11⅞ in. × 9 ft 10⅛ in.). Courtesy David Zwirner, New York/London. © the artist

97b Marlene Dumas, **Wall Wailing**, 2009, oil on linen, 1.8 × 3 m (5 ft 11⅛ in. × 9 ft 10⅛ in.). Courtesy David Zwirner, New York/London. © the artist

98–99 Marlene Dumas, **Wall Weeping**, 2009, oil on linen, 1.8 × 3 m (5 ft 11⅛ in. × 9 ft 10⅛ in.). Courtesy David Zwirner, New York/London. © the artist

100 Olafur Eliasson, **The Weather Project**, 2003. Photo © Ade Rowbotham, www.aderowbotham.com. Courtesy the artist, neugerriemschneider, Berlin, and Tanya Bonakdar Gallery, New York. © 2003 Olafur Eliasson

101 Olafur Eliasson, **The Weather Project**, 2003. Photo © Eva-Lotta Jansson/Corbis. Courtesy the artist, neugerriemschneider, Berlin and Tanya Bonakdar Gallery, New York. © 2003 Olafur Eliasson

103 Elmgreen & Dragset, **Prada Marfa**, 2005. Courtesy Art Production Fund, New York; Ballroom Marfa, Marfa, and the artists. Photo Lizette Kabré/James Evans

104 Henry Fuseli, **The Nightmare**, 1781, oil on canvas, 101.6 × 126.7 cm (40 × 49⅞ in.). Detroit Institute of Arts, Founders Society Purchase with funds from Mr. and Mrs. Bert L. Smokler and Mr. and Mrs. Lawrence A. Fleischman

105 Tracey Emin, **My Bed**, 1998. Courtesy the artist's studio and The Saatchi Gallery. © Tracey Emin. All rights reserved, DACS 2013

107 Lucian Freud, **Benefits Supervisor Sleeping**, 1995. © The Lucian Freud Archive

109 Nan Goldin, **Misty and Jimmy Paulette in a taxi, NYC**, 1991. Courtesy Matthew Marks Gallery. © Nan Goldin

111 Felix Gonzalez-Torres, **'Untitled' (Golden)**, 1995. Installation view of 'Paired, Gold: Felix Gonzalez-Torres and Roni Horn', Solomon R. Guggenheim Museum, New York, 2 October 2009–2 January 2010. Curated by Nancy Spector. © The Felix Gonzalez-Torres Foundation. Courtesy Andrea Rosen Gallery, New York

112–13 Felix Gonzalez-Torres, **'Untitled' (Golden)**, 1995. Installation view of 'Specific Objects without Specific Form'. WIELS, Belgium, 2010. Version curated by Elena Filipovic. © The Felix Gonzalez-Torres Foundation. Courtesy Andrea Rosen Gallery, New York

114 Antony Gormley, **European Field**, 1993, terracotta, approx. 40,000 elements, each 8–26 cm high. Installation view at Malmö Konsthall, Malmö, Sweden, 1999. Commissioned by Malmö Konsthall. Courtesy White Cube. Photo Jan Uvelius, Malmö. © the artist

115 Antony Gormley, **Angel of the North (Gateshead)**, 1998. Permanent installation at Gateshead, England, commissioned by the Gateshead Metropolitan Borough Council, UK. Courtesy White Cube. Photo Colin Cuthbert, Newcastle. © the artist

120 Sheela Gowda, **Darkroom** (interior view), 2006. Courtesy the artist. © Sheela Gowda

121 Sheela Gowda, **Darkroom**, 2006. Astrup Fearnley Collection, Oslo. Photo Kristine Jakobsen. © Sheela Gowda

123 Subodh Gupta, **Line of Control**, 2008. Installation view of 'Altermodern', 4th Tate Triennial, Tate Britain, London, 2009. Courtesy the artist, Hauser & Wirth and Arario Gallery, Beijing. Photo Mike Bruce

124–25 Andreas Gursky, **Chicago, Board of Trade II**, 1999. © Courtesy Sprüth Magers Berlin London/DACS 2013

127 Marcus Harvey, **Myra**, 1995. © Marcus Harvey. All Rights Reserved, DACS 2013

128–29 Mona Hatoum, **Light Sentence**, 1992. Courtesy Centre Georges Pompidou, Paris/White Cube. Photo Philippe Migeat. © Mona Hatoum

130 Susan Hiller, **Witness**, 2000 (suspended element). Courtesy Timothy Taylor Gallery, London. Commissioned by Artangel. Photo Prudence Cuming, London. © Susan Hiller

131–33 Susan Hiller, **Witness**, 2000. Courtesy Timothy Taylor Gallery, London. Commissioned by Artangel. Photo Parisa Taghizadeh. © Susan Hiller

139 Thomas Hirschhorn, **Cavemanman**, 2002. Installation view of 'Life on Mars', 55th Carnegie International, Carnegie Museum of Art, Pittsburgh, 2008. Courtesy Gladstone Gallery, New York and Brussels

140–41 Thomas Hirschhorn, **Cavemanman**, 2002. Installation of 'Walking in my mind', Hayward Gallery, London, 2009. Courtesy Gladstone Gallery, New York and Brussels

141r Thomas Hirschhorn, **Cavemanman**, 2002. Installation of 'Heart of Darkness', Walker Art Center, Minneapolis, 2006. Courtesy Gladstone Gallery, New York and Brussels

143 Damien Hirst, **For the Love of God**, 2007. Photo Prudence Cuming Associates. © Damien Hirst and Science Ltd. All rights reserved, DACS 2013

145 David Hockney, **Bigger Trees Near Warter or/ou Peinture sur le Motif pour le Nouvel Age Post-photographique**, 2007. Photo David Hockney and Richard Schmidt. © David Hockney

147–49 Carsten Höller, **Test Site**, 2006. Courtesy the artist, Tate Modern, London. Photo Attilio Maranzano. © 2012 Carsten Höller

151 Jenny Holzer, **For Prague**, 2009. Text: 'V noci' Kafka, Franz. Povídky III (Manželský pár a jiné texty z pozůstalosti), Dílo Franze Kafky sv. 3, Nakladatelství Franze Kafky, Praha: 2003. Photo Attilio Maranzano/Ela Bialkowska. Jenny Holzer © ARS, NY and DACS, London 2013

152l Jenny Holzer, **Projection for Chicago**, 2008. Text: 'Could Have' from **View with a Grain of Sand** by Wislawa Szymborska. Text © 1993 the author. English translation by Stanislaw Baranczak and Clare Cavanagh © 1995 Houghton Mifflin Harcourt Publishing Company. Photo John Faier. Jenny Holzer © ARS, NY and DACS, London 2013

152–53 Jenny Holzer, **For the City**, 2005. Text: 'He Embraces His Murderer' from **Unfortunately, It Was Paradise** by Mahmoud Darwish. Text © 2003 by the Regents of the University of California. 'My Sad Self' from **Collected Poems, 1947-1980** by Allen Ginsberg. Text © 1958 by the author. Presented by Creative Time. Photo Attilio Maranzano. Jenny Holzer © ARS, NY and DACS, London 2013

154–55 Cristina Iglesias, **Untitled (Passage II)**, 2002. Photo Sarah Guilbaud. Courtesy the artist and Marian Goodman Gallery, New York/Paris

157 Anish Kapoor, **Cloud Gate**, 2004. Photo Jose Fuste Raga/Corbis

159 On Kawara, **One Million Years**, 2004. Photo Joshua Roberts/AFP/Getty Images

160 Mike Kelley, **Singles Mixer**, from **Day Is Done**, 2005, mixed media with video projection and photographs, 284.5 × 762 × 429.3 cm (112 × 300 × 169 in.). Installation at the Gagosian Gallery, New York. Courtesy Mike Kelley Foundation for the Arts and Gagosian Gallery. Photo Fredrik Nilsen. © Kelley Studio Inc./Mike Kelley Foundation for the Arts

161, 162–63 Mike Kelley, **Day Is Done**, 2005. Courtesy Mike Kelley Foundation for the Arts and Gagosian Gallery. Photo Fredrik Nilsen. © Kelley Studio Inc./Mike Kelley Foundation for the Arts

162l Mike Kelley, **Shy Satanist**, from **Day Is Done**, 2005, mixed media with video projection and photographs, 218.4 × 284.5 × 294.6 cm (86 × 112 × 116 in.). Installation at the Gagosian Gallery, New York, 2005. Courtesy Mike Kelley Foundation for the Arts and Gagosian Gallery. Photo Fredrik Nilsen. © Kelley Studio Inc./Mike Kelley Foundation for the Arts

165 William Kentridge, drawings from **Stereoscope**, 1998–99. Courtesy Marian Goodman Gallery, New York. © the artist

167 Anselm Kiefer, **Die berühmten Orden der Nacht** (The Renowned Orders of the Night), 1997. Guggenheim Museum, Bilbao. Photo FMGB Guggenheim Bilbao Museo. Courtesy White Cube. © the artist

168 Martin Kippenberger, METRO-**Net** Transportable Subway Entrance, study for Martin Kippenberger by Lukas Baumewerd for 'documenta X' exhibition, Kassel, Germany, 1996. Courtesy Galerie Gisela Capitain, Cologne. © The Estate of Martin Kippenberger

169 Martin Kippenberger, METRO-**Net** Subway Entrance, Kthma Canné, Hrousa, Syros, Greece, 1993. Courtesy Galerie Gisela Capitain, Cologne. © The Estate of Martin Kippenberger

170 Martin Kippenberger, **Untitled (La Residencia)**, 1994. Courtesy Galerie Gisela Capitain, Cologne. © The Estate of Martin Kippenberger

171 Martin Kippenberger, poster for the METRO-**Net** World Connection, 1993–97. Courtesy Galerie Gisela Capitain, Cologne. © The Estate of Martin Kippenberger

172 Jeff Koons, **Bourgeois Bust – Jeff and Ilona**, 1991, marble, 113 × 71.1 × 53.3 cm (44½ × 28 × 21 in.). © Jeff Koons

173 Jeff Koons, **Puppy**, 1992. © Jeff Koons

175 Barbara Kruger, **Untitled (Your body is a battleground)**, 1989. Collection of The Broad Art Foundation, Santa Monica, California. Courtesy Mary Boone Gallery, New York. © Barbara Kruger

176 Francesco Urbino (attr.), Maiolica plate, c. 1530–37, diameter: 23.3 cm. The Art Archive/Ashmolean Museum, Oxford

177 Sarah Lucas, **Au Naturel**, 1994. Courtesy Sadie Coles HQ, London. © the artist

178 Paul McCarthy, **Heinz Ketchup Sauce**, 1974, colour video, 17 minutes, 28 seconds. Courtesy the artist and Hauser & Wirth. © Paul McCarthy

179 Paul McCarthy, **Blockhead**, 2003. Courtesy the artist and Hauser & Wirth. Photo Goswin Schwendinger with Christiana Liao

180 Film still from Charles Reisner's **Steamboat Bill, Jr.**, 1928. United Artists/The Kobal Collection

181 Steve McQueen, **Deadpan**, 1997. Courtesy Marian Goodman Gallery, New York. © the artist

182 Christian Marclay, video stills from **The Clock**, 2010. Courtesy White Cube. Photo Ben Westoby. © Christian Marclay

183 Christian Marclay, **The Clock**, 2010. Installation view at White Cube Mason's Yard, London, 2010. Courtesy White Cube. Photo Ben Westoby. © Christian Marclay

189–91 Annette Messager, **Casino**, 2005. Courtesy the artist and Marian Goodman Gallery, Paris and New York. Photo Laurent Lecat/Stéphane Pons. © ADAGP, Paris and DACS, London 2013.

193 Polly Morgan, **Departures**, 2009. Photo Tessa Angus. © the artist

194 Andrea Mantegna, **The Dead Christ**, c. 1480, tempera on canvas, 68 × 81 cm (26¾ × 31⅞ in.). Pinacoteca di Brera, Milan

195 Ron Mueck, **Dead Dad**, 1996–97. Stefan T. Edlis Collection. Courtesy Hauser & Wirth. © Ron Mueck

196 Kano Eitoku, **Chinese Lions**, Azuchi–Momoyama period, late 16th century, 6-panel screen, colour, ink and gold leaf on paper, 2.24 × 4.52 m (7 ft 4 in. × 14 ft 10 in.). Imperial Household Agency, Tokyo

197 Takashi Murakami, **Kaikai Kiki and Me**, 2008. Courtesy Galerie Emmanuel Perrotin, Paris. © 2008 Takashi Murakami/Kaikai Kiki Co., Ltd. All Rights Reserved.

198 Aaron Douglas, study for **Aspects of Negro Life: The Negro in an African Setting**, 1934, gouache with touches of graphite on illustration board, 37.2 × 40.6 cm (14⅝ × 16 in.). Art Institute of Chicago, Solomon Byron Smith and Margaret Fisher funds. © Heirs of Aaron Douglas/DACS, London/VAGA, NY 2013

199 Wangechi Mutu, **Backlash Blues**, 2004. Courtesy the artist and The Saatchi Gallery. © Wangechi Mutu

200 Leonardo da Vinci, **The Virgin of the Rocks** (detail), 1483–86, wood transferred to canvas, 199 × 122 cm (78¾× 48 in.). Musée du Louvre, Paris

201 Bruce Nauman, **For Beginners (all the combinations of the thumb and fingers)**, 2010. Collection of the François Pinault Foundation and the Los Angeles County Museum of Art. Courtesy Sperone Westwater, New York. © 2013 Bruce Nauman/Artists Rights Society (ARS), New York and DACS, London

207–9 Mike Nelson, **The Coral Reef**, 2000. Tate, London. Courtesy 303 Gallery, New York, Galleria Franco Noero, Turin, Matt's Gallery, London and neugerriemschneider, Berlin. Photo Mike Nelson. © Mike Nelson

211 Shirin Neshat, **Rebellious Silence**, from the series **Women of Allah**, 1994. Courtesy Gladstone Gallery, New York and Brussels. Photo Cynthia Preston. © Shirin Neshat

213–15 Ernesto Neto, **Leviathan Thot**, 2006. Festival d'Automne, 35e édition, Paris. Courtesy Tanya Bonakdar Gallery, New York and Galeria Fortes Vilaça, São Paulo. Photo Marc Domage. © the artist

216 Andres Serrano, **Immersion (Piss Christ)**, 1987, printed in 2007, cibachrome, 152.4 × 101.6 cm (60 × 40 in.). Courtesy Andres Serrano and Yvon Lambert, Paris. © Andres Serrano

217 Chris Ofili, **The Holy Virgin Mary**, 1996. Courtesy Victoria Miro Gallery, London. © Chris Ofili

218 Paul Cézanne, **Pyramid of Skulls**, 1898–1900, oil on canvas, 39 × 46.5 cm (15⅜ × 18¼ in.) Private collection

219 Gabriel Orozco, **Black Kites**, 1997. Courtesy the artist and Marian Goodman Gallery, New York. © DACS 2013

220 Cornelia Parker, **Cold Dark Matter: An Exploded View**, 1991, a garden shed and contents blown up for the artist by the British Army, the fragments suspended around a light bulb. Courtesy the artist and Frith Street Gallery, London. Photo Tate, London. © the artist

221 Cornelia Parker, **Breathless**, 2001. Courtesy the artist and Frith Street Gallery, London. Photo Victoria and Albert Museum, London. © the artist

222 William Hogarth, **The Rake at the Rose Tavern**, from the series **A Rake's Progress**, 1732–33, oil on canvas, 62.5 × 75 cm (24⅝ × 29½ in.). Sir John Soane's Museum, London

223a Grayson Perry, **The Adoration of the Cave Fighters**, from the series **The Vanity of Small Differences**, 2012. Courtesy the artist and Victoria Miro Gallery. © Grayson Perry

223b Grayson Perry, **The Agony in the Car Park**, from the series **The Vanity of Small Differences**, 2012. Courtesy the artist and Victoria Miro Gallery. © Grayson Perry

224a Grayson Perry, **The Expulsion from Number Eight Eden Close**, from the series **The Vanity of Small Differences**, 2012. Courtesy the artist and Victoria Miro Gallery. © Grayson Perry

224b Grayson Perry, **The Annunciation of the Virgin Deal**, from the series **The Vanity of Small Differences**, 2012. Courtesy the artist and Victoria Miro Gallery. © Grayson Perry

225a Grayson Perry, **The Upper Class at Bay**, from the series **The Vanity of Small Differences**, 2012. Courtesy the artist and Victoria Miro Gallery. © Grayson Perry

225b Grayson Perry, **#Lamentation**, from the series **The Vanity of Small Differences**, 2012. Courtesy the artist and Victoria Miro Gallery. © Grayson Perry

227 Marc Quinn, **Self**, 1991. Courtesy White Cube. Photo Marc Quinn Studio. © Marc Quinn

228a Walid Raad, The Atlas Group Archive, **Let's be Honest, The Weather Helped**, 1998–2006/7. Courtesy Anthony Reynolds, London. © Walid Raad

228b Walid Raad, The Atlas Group Archive, **Notebook volume 38: Already Been in a Lake of Fire**, 1999–2002. Courtesy Anthony Reynolds, London. © Walid Raad

229 Walid Raad, The Atlas Group Archive, **I Might Die Before I Get A Rifle**, 1989/2010. Courtesy Anthony Reynolds, London. © Walid Raad

230 Walid Raad, The Atlas Group Archive, **Notebook volume 72: Missing Lebanese Wars**, 1996–2003. Courtesy Anthony Reynolds, London. © Walid Raad

231a Walid Raad, The Atlas Group Archive, **Untitled**, from the series **We Decided To Let Them Say 'We Are Convinced' Twice. It Was More Convincing This Way**, 1982–2004. Courtesy Anthony Reynolds, London. © Walid Raad

231b Walid Raad, The Atlas Group Archive, **My Neck is Thinner Than a Hair: Engines**, 2000–3. Courtesy Anthony Reynolds, London. © Walid Raad

233 Neo Rauch, **Vater**, 2007. Courtesy Galerie EIGEN + ART Leipzig/Berlin and David Zwirner, New York. Photo Uwe Walter, Berlin. © Neo Rauch courtesy Galerie EIGEN+ART Leipzig/Berlin/DACS, 2013

234 Edgar Degas, **Dancers**, 1899, pastel on paper. Toledo Museum of Art, Ohio

235al Paula Rego, **Baying**, from the series **Dog Woman**, 1994. Courtesy Marlborough Fine Art Ltd. London. © the artist

235ar Paula Rego, **Bad Dog**, from the series **Dog Woman**, 1994. Courtesy Marlborough Fine Art Ltd. London. © the artist

235bl Paula Rego, **Grooming**, from the series **Dog Woman**, 1994. Courtesy Marlborough Fine Art Ltd. London. © the artist

235br Paula Rego, **Sitting**, from the series **Dog Woman**, 1994. Courtesy Marlborough Fine Art Ltd. London. © the artist

237 Gerhard Richter, **Cage 6**, 2006. Tate, London. © Gerhard Richter, 2012

239 Pipilotti Rist, **Open My Glade (Flatten)**, 2000. Courtesy the artist, Hauser & Wirth and Luhring Augustine. Photo Public Art Fund

240–41 Pipilotti Rist, video stills from **Open My Glade (Flatten)**, 2000. Courtesy the artist, Hauser & Wirth and Luhring Augustine. © Pipilotti Rist

242 Vincent Van Gogh, **Van Gogh's Chair**, 1888, oil on canvas, 91.8 × 73 cm (36⅛ × 28¾ in.). National Gallery, London

243 Doris Salcedo, Installation for the 8th International Istanbul Biennial, 2003. Courtesy Alexander and Bonin, New York. Photo Muammer Yanmaz

245 Jenny Saville, **Propped**, 1992. Courtesy Gagosian Gallery. © Jenny Saville

246 Gregor Schneider, **Cube Hamburg**, 2007, mixed media, 14 × 14 × 14 m (45 ft 11 in. × 45 ft 11 in. × 45 ft 11 in.). © DACS 2013

247 Gregor Schneider, **Toter Raum** (Death Space), 2005–7, room within a room, blockboards on a wooden construction, 2 doors, 2 window systems, 4 lamps, parquet floor, white walls and ceiling, detached, interior 7.70 × 5.44 × 2.75 (25 ft 3 in. × 17 ft 10⅛ in. × 9¼ ft © DACS 2013

248 Sean Scully, **Uriel**, 1997, oil on linen, 243.8 × 365.8 cm (96 × 144 in.). Lentos Kunstmuseum Linz, Austria. © Sean Scully

249 Sean Scully, **Doric Sky**, 2011. Private collection. © Sean Scully

250 Richard Serra, **Tilted Arc**, 1981, dismantled 1989, Corten steel, 3.66 × 36.58 × 0.06 m (12 ft × 120 ft × 2⅜ in.). Installation in Federal Plaza, New York. Photo Frank Martin/BIPs/Getty Images. © ARS, NY and DACS London 2013

251 Richard Serra, **Blind Spot**, 2002–3. Courtesy Gagosian Gallery. Photo Lorenz Kienzle. © ARS, NY and DACS, London 2013

256 Hieronymus Bosch, **The Garden of Earthly Delights**, c. 1500–5, oil on panel, 2.20 × 3.89 m (7 ft 2⅜ in. × 12 ft 9⅛ in.). Museo del Prado, Madrid

257–59 Raqib Shaw, **The Garden of Earthly Delights III**, 2003. Courtesy White Cube. Photo Stephen White. © Raqib Shaw

260l Cindy Sherman, **Untitled Film Still #24**, 1978, from the series **Untitled Film Stills**, 1977–80, gelatin silver print, 16.4 × 24 cm (6½ × 9½ in.). Courtesy the artist and Metro Pictures. © 2012 Cindy Sherman

260r Cindy Sherman, **Untitled Film Still #21**, 1978, from the series **Untitled Film Stills**, 1977–80, gelatin silver print, 19.1 × 24.1 cm (7½ × 9½ in.). Courtesy the artist and Metro Pictures. © 2012 Cindy Sherman

261 Cindy Sherman, **Untitled #425**, 2004. Museum of Modern Art, New York. Collection of Jennifer and David Stockman. Courtesy the artist and Metro Pictures. © 2012 Cindy Sherman

262 James Abbott McNeill Whistler, **Nocturne in Black and Gold: The Falling Rocket**, 1875, oil on panel, 60.2 × 46.7 cm (23¾ × 18⅜ in.) Detroit Institute of Arts. Gift of Dexter M. Ferry, Jr, inv. 46.309

263 Santiago Sierra, **245 m3**, 2006. Courtesy the artist and Lisson Gallery. © DACS 2013

265–67 Do Ho Suh, **Home Within Home – 1/11 Scale – Prototype**, 2009. Courtesy of the artist and Lehmann Maupin Gallery, New York. © Do Ho Suh

268 Wolfgang Tillmans, **Freischwimmer 26**, 2003. Courtesy Maureen Paley, London. © Wolfgang Tillmans

269 Wolfgang Tillmans, **Freischwimmer 204**, 2012. Courtesy Maureen Paley, London. © Wolfgang Tillmans

275a Rirkrit Tiravanija, **(please do not turn off the radio if you want to live well in the next fifteen minutes)**, 2005. Installation view of 'A Retrospective (tomorrow is another fine day)', Serpentine

Gallery, London, 2005. Courtesy Serpentine Gallery, London and Gavin Brown's enterprise. Photo Hugo Glendinning. © 2005 Rirkrit Tiravanija

275bl, br Rirkrit Tiravanija, **Untitled 2005 (apartment 21)**, 2005. Installation of 'A Retrospective (tomorrow is another fine day)', Serpentine Gallery, London, 2005. Courtesy Serpentine Gallery, London, and Gavin Brown's enterprise. Photo Hugo Glendinning. © 2005 Rirkrit Tiravanija

277 Gavin Turk, **Pop**, 1993. © Live Stock Market

279 Luc Tuymans, **Easter**, 2006. Courtesy Zeno X Gallery, Antwerp. Photo Felix Tirry. © the artist

280 Vincent Van Gogh, **Sunflowers**, 1888, oil on canvas, 92.1 × 73 cm (36¼ × 28¾ in.). National Gallery, London

281 Cy Twombly, installation view of 'The Rose', Gagosian Gallery, London, 2009. Courtesy Gagosian Gallery. Photo Jen McNair. © Cy Twombly Foundation

282–83 Cy Twombly, **The Rose (II)**, 2008. © Cy Twombly Foundation

284 Jacopo Pontormo, **The Visitation**, c. 1528–29, wood panel, 2.02 × 1.56 m

(6 ft 7½ in. × 5 ft 1⅜ in.). Parish Church of S. Michele, Carmignano, Florence

285 Bill Viola, video still from **The Greeting**, 1995. Performers Angela Black, Suzanne Peters, Bonnie Snyder. Production Still. Photo Kira Perov. © Bill Viola

287 Kara Walker, **Gone, An Historical Romance of a Civil War as it Occurred between the Dusky Thighs of One Young Negress and Her Heart**, 1994. Courtesy Sikkema Jenkins & Co., New York. Photo Joshua White. Artwork © Kara Walker

288–89 Jeff Wall, **After 'Invisible Man' by Ralph Ellison, the Prologue**, 1999–2000. Courtesy the artist

291–93 Mark Wallinger, **State Britain**, 2007. Courtesy Anthony Reynolds Gallery, London. Photo Dave Morgan. © the artist

295 Gillian Wearing, **I'M DESPERATE**, from the series **Signs that say what you want them to say and not Signs that say what someone else wants you to say**, 1992–93. Courtesy Maureen Paley, London. © Gillian Wearing

296l Gillian Wearing, **WORK TOWARDS WORLD PEACE**, from the series **Signs**

that say what you want them to say and not Signs that say what someone else wants you to say, 1992–93. Courtesy Maureen Paley, London. © Gillian Wearing

296r Gillian Wearing, **EVERYTHING IS CONNECTED IN LIFE THE POINT IS TO KNOW IT AND TO UNDERSTAND IT**, from the series **Signs that say what you want them to say and not Signs that say what someone else wants you to say**, 1992–93. Courtesy Maureen Paley, London. © Gillian Wearing

297 Gillian Wearing, **I HAVE BEEN CERTIFIED AS MILDLY INSANE!**, from the series **Signs that say what you want them to say and not Signs that say what someone else wants you to say**, 1992–93. Courtesy Maureen Paley, London. © Gillian Wearing

298 Rachel Whiteread, **Ghost**, 1990, plaster on steel frame, 2.69 × 3.56 × 3.18 m (8 ft 9⅞ in. × 11 ft 7 in. × 10 ft 5 in.). National Gallery of Art, Washington, gift of The Glenstone Foundation. Courtesy Gagosian Gallery. Photo Mike Bruce. © Rachel Whiteread

299 Rachel Whiteread, **Holocaust Memorial, Nameless Library**, 2000. Courtesy Gagosian Gallery. Photo Werner Kaligofsky. © Rachel Whiteread

301a Yang Fudong, film still from **Seven Intellectuals in a Bamboo Forest Part 2**, 2004. Courtesy Marian Goodman Gallery, New York/Paris. © Yang Fudong

301b Yang Fudong, film still from **Seven Intellectuals in a Bamboo Forest Part 3**, 2006. Courtesy Marian Goodman Gallery, New York/Paris. © Yang Fudong

302a Yang Fudong, film still from **Seven Intellectuals in a Bamboo Forest Part 5**, 2007. Courtesy Marian Goodman Gallery, New York/Paris. © Yang Fudong

302b Yang Fudong, film still from **Seven Intellectuals in a Bamboo Forest Part 4**, 2007. Courtesy Marian Goodman Gallery, New York/Paris. © Yang Fudong

302–3 Yang Fudong, film still from **Seven Intellectuals in a Bamboo Forest Part 1**, 2001. Courtesy Marian Goodman Gallery, New York/Paris. © Yang Fudong

305 Zhang Xiaogang, **Bloodlines: A Big Family**, 1995. Courtesy Pace Gallery, Beijing. © Zhang Xiaogang, courtesy Zhang Xiaogang studio

307 Artur Żmijewski, video stills from **Democracies**, 2009. Courtesy the artist and Galerie Peter Kilchmann, Zurich

Acknowledgments

100 Works of Art That Will Define Our Age could not have been written without the vision and support of my Commissioning Editor, Jacky Klein. I would like to express my warmest thanks to her. I am grateful too to my editors at *The Observer* and the *Times Literary Supplement* for allowing me the opportunity to write about art over the past many years. I would not have been in a position to contemplate such a project as this had it not been for their generosity and I would especially like to thank Michael Caines, Lindsay Duguid, Will Eaves, Alan Jenkins, Robert McCrum, Robert Potts and Anna Vaux. I was fortunate to receive advice and encouragement at key moments in the writing of this book and would like to record my gratitude to: Martha Kearney, Sarah Taylor and Ben Wright at the BBC; Neil Crombie and Joe Evans at Seneca Productions; Tim Taylor and Cassie Vaughan at the Timothy

Taylor Gallery; Oscar Humphries at *Apollo* magazine; Tim Cooke and Anne Stewart at the Ulster Museum, Belfast; Chris Caldwell at the Tom Caldwell Gallery; Barbara Dawson and Michael Dempsey at the Hugh Lane Dublin City Gallery; John Kennedy at the Kerlin Gallery, Dublin; to Seamus Heaney, Gavin Friday and to Edge. I would also like to convey my sincerest thanks to the extraordinary publishing team at Thames & Hudson, especially Managing Director Jamie Camplin and volume editor Laura Potter, who, on more than one occasion over the course of proofreading my prose, saved me from myself. Finally, I would like to express my gratitude to my family and friends who have helped shape the way I see, and in particular Anthony Mosawi, Jem Poster, Mark Alexander, Sean Scully, Liliane Tomasko and Sinéad Sturgeon, to whom this book is dedicated.

Page numbers in italic
refer to illustrations.

A

Abramović, Marina *18–19*
 Lips of Thomas (1975) *18*
 The Artist is Present (2010) 18, *19*
Abstract Expressionism 11, 248, 268
Ackroyd, Peter 228
Adjaye, David 24
Africanus, Leo 196
Aguirre, Jose Maria 172
Ai Weiwei 14, *20–23*
 Sunflower Seeds (2010) 14, *20–23*
Aitchison, Craigie 126
Aitken, Doug 24, *25*
 The Source (2012) 24, *25*
Alexander, Mark 13, 26, *27*, 304
 The Blacker Gachet (2005–6) 13, 26,
 27, 304
Alhambra Palace, Granada 154
Allen, Woody 185, 238
 The Purple Rose of Cairo (1985) 238
Alÿs, Francis 28, *29–31*
 Fabiola (1994–) 28, *29–31*
Amichai, Yehuda 150
Antoni, Janine *32–35*
 Gnaw (1992) 32, *33–34*
 Loving Care (1993) *32*
apophaticism 248
appropriation 70
Arab Spring 11
Arachne (legend) 56
Arcimboldo, Giuseppe 176
Arno (river), Florence 150
Arolsen 172, *173*
astrobiology 130
Auden, W. H. 94
Austen, Jane 74
Aztecs 142

B

backlash 198
Bacon, Francis 234
Balka, Miroslaw 15, 36, *37–39*
 How It Is (2009) 15, 36, *37–39*
Balmer, Johann Jakob 124
Banksy 40, *41*, 290
 Flower Thrower (2005) 40, *41*
Barker, Robert 24
 'Panorama' 24
Barney, Matthew *42–45*
 Cremaster 4 (1994) 42, *43–45*
Barthes, Roland 288
Basel, Switzerland
 Art Basel *54–55*
Beckett, Samuel 36, 272
 How It Is (1961) 36
Beckford, William 154
 Vathek: an Arabian Tale (1786) 154
Beijing, China 62, *63*
 Temple of Heaven 62, *63*
Bentham, Jeremy 52
 'Panopticon' 52
Bentley & Skinner (jewellers) 142
Berlin Wall 11
Bernard, Émile 10
betweenity 232
Big Brother (UK television series) 294

Bilbao 57
 Guggenheim Museum *57*
blind spot 248
bloodline 304
Bloom, Harold 144
Boehme, Jakob 248
Boltanski, Christian *46–47*
 Personnes (2010) 46, *47*
Bonvicini, Monica 12, 52, *53–55*
 Don't Miss a Sec (2003) 12, 52, *53–55*
Book of Job 212
Bosch, Hieronymus 256
 The Garden of Earthly Delights
 (c. 1500–5) 256
Botticelli, Sandro 86
Bourgeois, Louise 15, 56, *57*
 Maman (1999) 15, 56, *57*
Brady, Ian 126
Brahe, Tycho 218
Bridlington, Yorkshire 144
Brooklyn Museum of Art 216
Brown, Glenn 58, *59*
 Sex (2003) 58, *59*
Bulger, Jamie 74
Burden, Chris 60, *61*
 What My Dad Gave Me (2008) 60, *61*
Buren, Daniel *62–63*
 Les Deux Plateaux (The Two Levels,
 1986) 62
 De l'azur au Temple du Ciel (From
 the sky to Temple of Heaven, 2004)
 62, 63
Byron, Lord 36
 'Darkness' 36

C

Cage, John 84, 236
Cage, Nicolas 182
Calder, Alexander 212
 'What Abstract Art Means to Me'
 (1951) 212
Calle, Sophie *64–65*
 Take Care of Yourself (2007) *64–65*
Caravaggio, Michelangelo Merisi da
 248, 304
Cariou, Patrick 70, *71*
 Yes Rasta (2000) 70, *71*
Castel Sant'Angelo, Rome 150
Cattelan, Maurizio 72, *73*, 200
 L.O.V.E. (2010) 72, *73*, 200
Celan, Paul 166
Central Park, New York 78
Cervantes, Miguel de 86
Cézanne, Paul 218,
 Pyramid of Skulls (1898–1900) *218*
Chapman, Jake and Dinos *74–77*
 Hell (1999–2000) *74–77*
Chestnut, Mary 174
Chicago 124, *152*, 156, *157*, 274
 Millennium Park 156, *157*
 Tribune Tower *152*
Christ 14, *194*, 216, 284
Christie's 106
Christo and Jeanne-Claude 78, *79–81*
 The Gates (1979–2005) 78, *79–81*
Cicciolina, Star 172
climate change 100
Close, Chuck 82, *83*
 Self-Portrait (1997) 82, *83*
Cole, Henri 150
Columbus, Christopher 256
Conceptual Art 174, 246
consumerism 20, 64, 124, 174, 178, 222
coulrophobia 260
Cranach the Elder, Lucas 14, 86

 Venus (1532) 14, *86*
Creed, Martin 84, *85*
 *Work No. 227, the lights going
 on and off* (2000) 84, *85*
Crofton, Jacqueline 84
CSI (US television series) 194
Cubism 74, 262
Currin, John 14, 86, *87*, 166
 The Pink Tree (1999) 14, 86, *87*, 166

D

Dada 11, 262
Daedalus (myth) 250
Daguerre, Louis 108
Dali, Salvador 40, 176
Dante 86
Danto, Arthur 11
Darwish, Mahmoud 150
da Vinci, Leonardo.
 See Leonardo da Vinci.
de Chazal, Malcolm 200
deadpan 180
defacement 40
Degas, Edgar 102, 234
 Dancers (1899) *234*
Deller, Jeremy and Alan Kane *88–91*
 Folk Archive (2000–7) *88–91*
Dickens, Charles 242
Diller, Liz 24
Diogenes of Sinope 72
Doig, Peter 92, *93*
 Blotter (1993) 92, *93*
Domesday Book 122
Douglas, Aaron 198
 *Aspects of Negro Life: The Negro
 in an African Setting* (1934) *198*
Douglas, Stan 94, *95*
 Win, Place or Show (1998) 94, *95*
Draper, John William 108
Duchamp, Marcel 52
 Fountain (1917) 52
Dumas, Alexandre 212
Dumas, Marlene 96, *97–99*
 Against the Wall (2009) 96, *97–99*

E

Eckhart, Meister 248
Egglestone, William 24
Eitoku, Kano 196
 Chinese Lions 196
Eliasson, Olafur 15, *100–1*
 The Weather Project (2003) 15, *100–1*
Eliot, T. S. 12, 14, 142, 280
 Four Quartets 280
 'Little Gidding' (1942) 12
Elizabeth (Virgin Mary's cousin) 284
Ellison, Ralph 288
Elmgreen & Dragset 102, *103*
 Prada Marfa (2005) 102, *103*
Emin, Tracey 104, *105*
 My Bed (1998) 104, *105*
Erector Set 60
Estés, Clarissa Pinkola 234
 *Women Who Run With the Wolves:
 Myths and Stories of the Wild
 Woman Archetype* 234
ETA, Basque separatists 172
The Evening Standard (newspaper) 126

F

Facebook 294
Fauvism 11, 74
Feaver, William 128
Federal Plaza, New York 250
Fénéon, Félix 172

Fildes, Luke 242
financial crisis 11, 106, 256
Fisher, Peter 126
Fitzgerald, F. Scott 138
Fonda, Peter 182
Forster, E. M. 168
 Howards End (1910) 168
Fortnum & Mason 126
Foucault, Léon 212
Foucault, Michel 52
French Revolution 164, 212, 232
Freud, Lucian 106, *107*, 244
 Benefits Supervisor Sleeping (1995)
 106, *107*
Freudian psychoanalysis 232
Freudian slip 146
Frost, Robert 96
Fukuyama, Francis 11
Fuseli, Henry 104
 The Nightmare (1781) *104*

G

Gabriel, Archangel 200
Gachet, Paul-Ferdinand 26
Gagosian Gallery, Chelsea, New York 160
Gainsborough, Thomas 222
 Mr and Mrs Andrews (c. 1750) *222*
Gateshead, Tyneside, England 114
Gauguin, Eugène Henri Paul 242
Gayford, Martin 178
genocide 232
Gilbert, A. C. 60
 Erector Set 60
Gilbert, Alan 228
Giotto (di Bondone, Giotto) 196
girl power 234
Giuliani, Rudy 216
Goldin, Nan 108, *109*, 228
 *Misty and Jimmy Paulette in a taxi,
 NYC* (1991) 108, *109*
Golgotha ('the place of the skull') 218
Gonzalez-Torres, Felix 110, *111–13*
 'Untitled' (Golden) (1995) 110, *111–13*
Gorky, Arshile 248
Gormley, Antony *114–15*
 Angel of the North (1998) 114, *115*
 European Field (1993) *115*
Gospel of Luke 284
Gosse, Philip Henry 154
Gowda, Sheela *120–21*
 Darkroom (2006) *120–21*
Goya, Francisco 104, 260
Grand Palais, Paris 46
Great Exhibition 1851 164
Greer, Germaine 244
Gregory of Nyssa 248
Guggenheim Museum, Bilbao, Spain 172
Gupta, Subodh 122, *123*
 Line of Control (2008) 122, *123*
Gursky, Andreas *124–25*
 Chicago, Board of Trade II (1999)
 124–25

H

Hamburg *246*
Harlem Renaissance 198
Harvey, Marcus 126, *127*, 274
 Myra (1995) 126, *127*
Hatoum, Mona *128–29*
 Light Sentence (1992) *128–29*
Haw, Brian 290
Heaney, Seamus 36
 Door into the Dark (1969) 36
Heidegger, Martin 200
Henry Moore Foundation 102

Henson, Jim 194
Herzog, Jacques 24
Hiller, Susan 130–33
 Witness (2000) 130–33
Hindley, Myra 126, 274
Hirschhorn, Thomas 138, 139–41, 206
 Cavemanman (2002) 138, 139–41, 206
Hirst, Damien 142, 143, 192
 'Beyond Belief' (2007) 142
 For the Love of God (2007) 142, 143, 192
Hitchcock, Alfred 192
 Psycho (1960) 192
Hitler, Adolf 74, 200
Hobbes, Thomas 212
 Leviathan (1651) 212
Hockney, David 144, 145
 A Bigger Splash (1967) 144
 Bigger Trees Near Warter or/ou Peinture sur le Motif pour le Nouvel Age Post-Photographique (2007) 144, 145
Hofer, Johannes 160
Hogarth, William 222
 A Rake's Progress (1732–33) 222
Holbein the Younger, Hans 13, 14, 218
 The Ambassadors (1533) 13, 218
Höller, Carsten 146, 147–49
 Flying Machine (1996) 146
 Light Wall (2000) 146
 Test Site (2006) 146, 147–49
Holmes, Sherlock 194
Holocaust 74, 262, 298
Holzer, Jenny 150, 151–53
 Projections (1996–) 150, 151–53
Balzac, Honoré de 174
 The Magic Skin (1831) 174
Hughes, Robert 15, 74
 The Shock of the New (1991) 15
Hugo, Victor 166
 The Man Who Laughs (1869) 166
Hussein, Saddam 290

I
'ideal order' 12
Iglesias, Cristina 154–55
 Untitled (Passage II) (2002) 154–55
Impressionism 11, 172, 276
Innsbruck 247
 Kunstraum Innsbruck 247
Installation Art 20
Internet Art 11
Irving, Washington 154
Isabella Stewart Gardner Museum, Boston 102
Isle of Man 42
Istanbul 242, 243
 Biennale (2003) 242, 243

J
Jackson, Michael 88
Jammu and Kashmir 122
Jaspers, Karl 200
Jingdezhen, China 20, 22
John the Baptist 284
Johns, Jasper 40

K
Kaaba, Mecca 246
Kane, Alan and Jeremy Deller 88–91
 Folk Archive (2000–7) 88–91
Kapoor, Anish 156, 157
 Cloud Gate (2004) 156, 157
Kassel 172
Kawara, On 158, 159

Today (1966–) 158
 One Million Years (1969–) 158, 159
Keaton, Buster 180, 238
Keats, John 220, 280, 306
 'To Autumn' (1819) 280
Kelley, Mike 24, 88, 160–63
 Day Is Done (2005) 160–63
Kentridge, William 164, 165
 Stereoscope (1998–99) 164, 165
Kepler, Johannes 218
Kevorkian, Jack 60
 'Mercitron' 60
Khlebnikov, Velimir 166
Kiefer, Anselm 13, 166, 167
 Die berühmten Orden der Nacht (The Renowned Orders of the Night) (1997) 13, 166, 167
 Occupations (1969) 166
The Killing (Danish television series) 194
King James VI 100
Kippenberger, Martin 168–71
 METRO-Net World Connection (1993–97) 168–71
Koons, Jeff 12, 172–73
 Bourgeois Bust – Jeff and Ilona (1991) 172
 Puppy (1992) 12, 172
Kray (twins), Ronald and Reginald 88
Kruger, Barbara 174, 175
 Untitled (Your body is a battleground) (1989) 174, 175

L
Larkin, Philip 264
 'The Importance of Elsewhere' 264
Lascaux, south-west France (cave drawings), 138
Lebanon 228
Leonardo da Vinci 13, 102, 126, 130, 200, 244
 Mona Lisa (c. 1503–19) 102, 126
 The Virgin of the Rocks (1483–86) 200
 The Vitruvian Man (c. 1487) 130
Liar Paradox 188
library 298
line of control (separating India and Pakistan) 122
Liverpool 24
 Biennial 24
 Tate Liverpool 24, 25
London 20, 21–23, 28, 29–31, 32, 36, 37–39, 52, 74, 75–77, 88, 100–1, 122, 123, 126, 128, 142, 146, 147–49, 164, 178, 179, 180, 182–83, 194, 220, 221, 274, 275, 280, 281–83, 291–93, 294, 298
 Anthony d'Offay Gallery 32
 Bentley & Skinner 142
 Gagosian Gallery 280, 281–83
 Hayward Gallery 140–41
 Matt's Gallery 206, 207–9
 National Portrait Gallery 28, 29–31,
 Royal Academy of Arts 74, 75–77, 126
 Serpentine Gallery 274, 275
 Tate Britain 122, 123, 290, 291–93,
 Tate Modern 20, 21–23, 36, 37–39, 52, 100–1, 146, 147–49, 178, 179
 The Chapel 130–33
 Trafalgar Square 158, 159
 Victoria and Albert Museum 220, 221
 White Cube, Mason's Yard 18 2–83
Los Angeles 60, 62, 287
 Hammer Museum 287
Louis XIV 172, 196
Louvre Museum, Paris 102
Lowell, Robert 56

Lucas, Sarah 176, 177, 178
 Au Naturel (1994) 176, 177, 178
lycanthropia (werewolfism) 234

M
McCarthy, Paul 178–79, 180
 Blockhead (2003) 178, 179, 180
 Heinz Ketchup Sauce (1974) 178
McGrath, Thomas 114
McQueen, Steve 180, 181
 Deadpan (1997) 180, 181
'make it new' 300
Manet, Édouard 102
Mannerism 284
Mantegna, Andrea 194, 222
 Dead Christ (c. 1480) 194
 The Adoration of the Shepherds (c. 1450) 222
Manx Loaghtan (breed of sheep) 42
Marclay, Christian 182–83
 The Clock (2010) 182–83
Marfa, Texas 102, 103
Matisse, Henri 280
'Mercitron' 60
mermaids ('aquatic humanoids') 256
Messager, Annette 180, 188, 189–91
 Casino (2005) 180, 188, 189–91
Michelangelo, 10
 David (1501–4), 10, 11
Mickey Mouse 232
Milan 72, 73, 176
 Piazza degli Affari 72, 73
Millennium Park, Chicago
Miller, Daniel 306
Minimalism 11
Minneapolis 139
 Walker Art Center 139
Minos (King of Crete) 250
Mirabeau, Honoré Gabriel Riqueti, comte de, 212
The Mirror (newspaper) 126
Mitchell, Margaret 286
 Gone With the Wind 286
Modigliani, Amadeo 58
'Monumenta 2010' 46
Moore, Henry 178
Morgan, Polly 192, 193
 Departures (2009) 192, 193
Morton, Tom 142
Moss, Kate 106, 244
Mueck, Ron 180, 192, 194, 195, 232
 Dead Dad (1996–97) 194, 195, 232
Munch, Edvard 102, 222
 The Scream 222
Murakami, Takashi 196, 197
 Kaikai Kiki (2000–) 196, 197
Museum of Modern Art, New York 18
Mussolini, Benito 72
Mutu, Wangechi 198, 199
 Backlash Blues (2004) 198, 199
MySpace 294

N
Nagger, Guy 106
National Endowment for the Arts 216
National Gallery of Australia, Canberra 216
National Gallery, London 216
National Oceanic Service, US 256
Nauman, Bruce 200, 201, 206
 For Beginners (all the combinations of the thumb and fingers) (2010) 200, 201, 206
 The true artist helps the world by revealing mystic truths (1967) 200

Nazi salute 166, 278
negative capability 306
negative theology (via negativa) see apophaticism
Nelson, Mike 206, 207–9
 The Coral Reef (2000) 206, 207–9
Neo-Impressionism 172
Neshat, Shirin 210, 211
 Rebellious Silence (1994) 210, 211
 Women of Allah series (1994) 210
Neto, Ernesto 212, 213–15
 Leviathan Thot (2006) 212, 213–15
New York, 26, 56, 60, 61, 62, 63, 64, 65, 78, 79, 108, 109, 150, 153, 156, 180, 198, 216, 218, 220, 228, 238, 239, 240, 241, 250, 260, 274, 288
 Central Park 78, 79, 80, 81
 Federal Plaza 250
 Gagosian Gallery 160, 161, 162, 163
 Guggenheim Museum 18, 110, 111, 112, 113,
 Museum of Modern Art 18, 19, 84, 85,
 Paula Cooper Gallery 64,
 Rockefeller Center 60, 61, 153
 Times Square 238, 239, 240, 241
New Yorker (magazine) 220
Nicéphore Niépce, Joseph 108
nonesmanneslonde (no-man's land) 122
nostalgia 160

O
Ofili, Chris 120, 216, 217, 274
 The Holy Virgin Mary (1996) 216, 217, 274
Okri, Ben 192
omphalos 154
Omphalos Hypothesis 154
One Thousand and One Nights 154
Opdyke, George Howard 88
Ophelia 260
Oppenheim, Meret 168
Optical Art (Op Art) 11
Orozco, Gabriel 13, 218, 219
 Black Kites (1997) 13, 218, 219
Orwell, George 194
Ozymandias (Ramses II) 142

P
Paglia, Camille 244
Palace of Versailles, Venus Salon 196
panorama 24
panoscope 164
Panthéon, Paris 212
Paris 46–47, 62, 64, 128–29, 154–55, 164, 172, 196, 212, 213–15, 276
 Centre Pompidou 128–29, 154–55,
 Grand Palais, Paris 46–47
 Palais Royal 62
 Panthéon 212, 213–15
Parker, Cornelia 220–21
 Breathless (2001) 220, 221
 Cold Dark Matter: An Exploded View (1991) 220
 Mass (Colder Darker Matter) (1997) 220
Parliament Square, London 290
peinture sur le motif 144
Penn, Sean 182
Performance Art 18
Perry, Grayson 14, 222, 223–25
 #Lamentation (2012) 14
 The Vanity of Small Differences series (2012) 222, 223–25
pessimism 232
Piazza degli Affari, Milan 72

Picasso, Pablo 10, 62, 304
Pietà 194
Pinocchio 178, 180, 188
Pinocchio Paradox 188
Plotinus 14, 248
Pointillism 124
Pollock, Jackson 32, 280
Pontormo, Jacopo 284
 The Visitation 284
Pop Art 11, 178
Post-Impressionism 11
Prada (Italian fashion label) 102
Prague 150, *151*, 218
 Church of Our Lady before Týn, Old
 Town Square 218
 National Museum, Wenceslas
 Square 150, *151*,
Presley, Elvis 274
Prince, Richard 70
 Canal Zone 70
Process Art 32
prosopagnosia 82
Pseudo-Dionysius the Areopagite 248
Pulheim, Germany 262, *263*
 Stommeln Synagogue 262, *263*

Q

Queen Elizabeth II 106
Quinn, Marc 226, *227*
 Self (1991-) 226, *227*

R

Raad, Walid *228-31*
 The Atlas Group Archive (1999-)
 228-31
Raphael 260
Rauch, Neo 232, *233*
 Vater (Father) (2007) 232, *233*
Realism 11
Rego, Paula 234, *235*
 Dog Woman series (1994) 234, *235*
Reisner, Charles 180
Reynolds, Sir Joshua 24
Richter, Gerhard 236, *237*
 Cage series (2006) 236, *237*
Rilke, Rainer Maria 128, 225, 280
 Sonnets to Orpheus 280
 'The Roses' 280
Rist, Pipilotti 238, *239-41*
 Open My Glade (Flatten) (2000)
 238, *239-41*
Rockefeller Center, GE Building 60
Rolé, Jacques 126
Rothko Chapel 248
Rothko, Mark 13
Rotterdam 53
 City Hall *53*
Rousseau, Jean-Jacques 212
Rowling, J. K. 168
 *Harry Potter and the Philosopher's
 Stone* 168
Royal Academy of Arts 126
Royal Society 226
Rubens, Peter Paul 12-13, 244
 *The Rape of the Daughters of
 Leucippus* (1617-18) *12*
Rudolf II 176
Ruskin, John 262

S

Saatchi, Charles 194, 216, 244, 274
 'Sensation' exhibition (1997) 194, 216
Saffarzadeh, Tahereh 210
Saint Fabiola 28
Saito, Ryoei 26

Salcedo, Doris 242, *243*
 Untitled (2003) 242, *243*
San culture, Zimbabwe 216
Saville, Jenny 13, 244, *245*
 Propped (1992) *12*, 13, 244, *245*
Schneider, Gregor 246-47
 Cube Hamburg (2007) *246*
 The Beauty of Death (unmade)
 246, *247*
Scully, Sean 14, *248-49*, 304
 Araby (1981) 248
 Doric (2008-) 14, 248, *249*, 304
 Uriel (1997) 248
Searle, Adrian 274
self-portrait 210
Selfridges, department store 174
'Sensation' exhibition (1997) 126, 274
September 11, 2001 11, 220, 238, 290
Serious Organised Crime and Police
 Act 2005 (SOCPA) 290
Serra, Richard *250-51*
 Blind Spot (2002-3) 250, *251*
 Tilted Arc (1981) 250
Serrano, Andres 216-17
 Immersion (Piss Christ) 216
Seurat, Georges 124
 *A Sunday Afternoon on the
 Island of La Grande Jatte – 1884*
 (1884-86) *124*
Seven Sages of the Bamboo Grove 300
sfumato 13
Shakespeare, William 52, 198, 260
 Hamlet 260
Shaw, Raqib 256, *257-259*
 The Garden of Earthly Delights
 (2003) 256, *257-59*
Shelley, Percy Bysshe 110, 142
 'Ozymandias' (1818) 142
 Prometheus Unbound (1820) 110
Sherlock Jr. (1924) 238
Sherman, Cindy 180, 260-61
 Clowns (2003-4) 180, 260, *261*
 Untitled Film Stills (1977-80) 260
Sierra, Santiago 262-63
 245 m3 (2006) 262, *263*
silhouette 286
Silhouette, Étienne de 286
Simone, Nina 198
 Backlash Blues 198
Sirens (see Mermaids)
Skull (memento mori) 13, 142, *143*, 192,
 218, *219*, 222, 225
Skylab 3 130
Smollett, Tobias 172
 The Critical Review 172
Snow White 178
Sorgh, Hendrik 264
Sorites Paradox 14, 20
Spanish Civil War, 10,
Spice Girls 234
Spiral (French television series) 194
Steamboat Bill, Jr. (1928) 180
Steen, Jan 264
Steinem, Gloria 244
Stephenson, George 198
stereoscope 164
Stevens, Wallace 26, 264
 'Tea at the Palaz of Hoon' 264
Stewart, John 'Walking' 164
Stoffels, Hendrickje 104
Suh, Do Ho 264, *265-67*, 268
 Home Within Home series (2008-)
 264, *265-67*
Superflat 196
'surfing the net' 168

Surrealism 40, 56, 206, 262, 304
Swinton, Tilda 24
Syros, Greece *168*
Szymborska, Wisława 150

T

tableaux vivants 288
Tate Modern, Turbine Hall 14, 15, 20, 36,
 56, 100, 146, *147-49*
Tempestarii ('weather-makers') 100
Temple of Heaven, Beijing 62
Tezcatlipoca ('Smoking Mirror') 142
Tiananmen Square 11
Tilley, Sue 106
Tillmans, Wolfgang 268-69
 Freischwimmer series (2003-)
 268-69
Times Square, New York 238
Tiravanija, Rirkrit 206, 274, *275*
 Apartment series (2002-) 206,
 274, *275*
Titian see Vecelli, Tiziano
Tolstoy, Count Lev Nikolayevich 86
Tower Bridge, London 220
Tranströmer, Tomas 206
Trecartin, Ryan 24
Turk, Gavin 274, *275*
 Pop (1993) 274, *275*
Turner, J. M. W. 100, 248, 268
 The Angel Standing in the Sun
 (1846), 100
 Norham Castle on the Tweed
 (1806-7) 248
 Interior at Petworth (1837) 248
Tussaud, Marie 274
Tuymans, Luc 278, *279*
 Easter (2006) 278, *279*
Twombly, Cy 280, *281-83*
 *Analysis of the Rose as Sentimental
 Despair* (1985) 280
 The Rose (2008) 280, *281-83*

U

UFOs 130
Unilever Series 15
Updike, John 154
Urbino, Francesco 176

V

Valéry, Paul 278
van der Weyden, Rogier 14, 222
 The Lamentation of Christ
 (c. 1460-64) *14*, 222
Van Eyck, Jan 13, 216, 244
 Arnolfini Portrait (1434) 13, 216, 244
Van Gogh, Theo 10, 242, 280
Van Gogh, Vincent 10, 15, 26, 166,
 242, 304
 Portrait of Dr Gachet (1890)
 13, 26, 304
 Sunflowers (1888) 280
 The Starry Night (1889) 10, 13,
 15, 166
 Vincent Van Gogh's Chair (1888)
 242
Van Gogh, Willemien 26
Van Rijn, Rembrandt Harmenszoon 13,
 102, 104, 226, 248
Vecelli, Tiziano 260
Velázquez, Diego 104
Venice Biennale (2003) 262, (2005) 188,
 246, (2007) 236
Vermeer, Johannes 102
Vicious, Sid 274
Victoria and Albert Museum 220

Vienna 150, 168, 298, 299
 Judenplatz 298, 299
Vinci, Leonardo da. See Leonardo
 da Vinci.
Viola, Bill 284, *285*
 The Greeting (1995) 284, *285*
Virgin Mary 126, *200*, 216, 276, 284,
 285
Virtual Art 11
Voltaire (Arouet, François-Marie) 212

W

Wagner, Richard 166
Wailing Wall, Jerusalem 96
Walker, Kara 286, *287*
 *Gone, An Historical Romance of a
 Civil War as It Occurred between
 the Dusky Thighs of One Young
 Negress and Her Heart* (1994)
 286, *287*
Wall, Jeff *288-89*
 *After 'Invisible Man' by Ralph Ellison,
 the Prologue* (1999-2000) *288-89*
Wallander (Swedish television series)
 194
Wallinger, Mark 88, 290, *291-93*
 State Britain (2007) 290, *291-93*
Walpole, Horace 232
Warhol, Andy 28,178, 274
Warner, Marina 154
 *Stranger Music: Charmed States &
 the Arabian Nights* (2011) 154
Watteau 260
Wearing, Gillian 294, *295-97*
 *Signs that say what you want them
 to say and not Signs that say what
 someone else wants you to say*
 294, *295-97*
Webster, John 142
West Bank 40
Wheatstone, Charles 164
Whistler, James Abbott McNeill 262
 *Nocturne in Black and Gold:
 The Falling Rocket* 262
White, Jack 24
Whiteread, Rachel 298-99
 Ghost (1990) *298*
 *Holocaust Memorial, The Nameless
 Library* (2000) 298, *299*
Wilde, Oscar 108, 120
William the Conqueror 122
Wolf, Naomi 244
 *The Beauty Myth: How Images of
 Beauty Are Used Against Women*
 (1991) 244
Wordsworth, William 128, 232, 294
Wulff, Charles Richard Edouard 192

Y

Yang Fudong 300, *301-303*
 *Seven Intellectuals in a Bamboo
 Forest* (2003-7) 300, *301-303*
Yeats, William Butler 196, 306
Yukon, Canada 168

Z

Zagajewski, Adam 220
 'Try to Praise the Mutilated World'
 220
Zhang Xiaogang 304, *305*
 Bloodlines: Big Family (1993-)
 304, *305*
Żmijewski, Artur 306, *307*
 Democracies (2009) 306, *307*
Zola, Émile 212